THE CAMBRIDGE CULTURAL HISTORY OF BRITAIN

VOLUME 4 SEVENTEENTH-CENTURY BRITAIN

The Cambridge Cultural History

The Cambridge Cultural History of Britain

edited by
BORIS FORD

VOLUME 4

SEVENTEENTH-CENTURY BRITAIN

 CAMBRIDGE
UNIVERSITY PRESS

LONGWOOD COLLEGE LIBRARY
FARMVILLE, VIRGINIA 23901

NX
543
.C36
1992
v. 4

Published by the Press Syndicate of the University of Cambridge
The Pitt Building, Trumpington Street, Cambridge CB2 1RP
40 West 20th Street, New York, NY 10011–4211, USA
10 Stamford Road, Oakleigh, Victoria 3166, Australia

© Boris Ford 1989, 1992

First published 1989 as *The Cambridge Guide to the Arts in Britain:
The Seventeenth Century*
First paperback edition 1992

Printed and bound in Great Britain by
BPCC Hazells Ltd
Member of BPCC Ltd

A catalogue record for this book is available from the British Library

Library of Congress cataloguing in publication data

Cambridge guide to the arts in Britain.
The Cambridge cultural history/edited by Boris Ford.
 p. cm.
Previously published as: The Cambridge guide to the arts in Britain. 1988–1991.
Includes bibliographical references and indexes.
Contents: v.1. Early Britain – v.2. Medieval Britain – v.3. Sixteenth-century
Britain – v.4. Seventeenth-century Britain – v.5. Eighteenth-century Britain –
v. 6. The Romantic Age in Britain – v. 7. Victorian Britain – v.8. Early
twentieth-century Britain – v.9. Modern Britain.
ISBN 0-521-42881-5 (pbk.: v.1). – ISBN 0-521-42882-3 (pbk.: v.2). – ISBN
0-521-42883-1 (pbk.: v.3). – ISBN 0-521-42884-X (pbk.: v.4). – ISBN 0-521-42885-8
(pbk.: v.5). – ISBN 0-521-42886-6 (pbk.: v.6). – ISBN 0-521-42887-4 (pbk.: v.7). –
ISBN 0-521-42888-2 (pbk.: v.8). – ISBN 0-521-42889-0 (pbk.: v.9)
1. Arts, British. I. Ford, Boris. II. Title.
[NX543.C36 1992]
700′.941–dc20 91–43024
 CIP

ISBN 0 521 30977 8 hardback
ISBN 0 521 42884 X paperback

VN

LONGWOOD COLLEGE LIBRARY
FARMVILLE, VIRGINIA 23901

Contents

LONGWOOD LIBRARY

1000271045

Notes on Contributors

Geoffrey Beard was, until he retired in 1982, Director of the Visual Arts Centre at the University of Lancaster. He is Chairman of the Furniture History Society, and author of *Georgian Craftsmen, The Work of Robert Adam, Craftsmen and Interior Decoration in England 1660–1820*, and *English Furniture 1500–1840*.

Martin Butler is a lecturer in English at the University of Leeds. He is the author of *Theatre and Crisis 1632–1642* and co-editor of *The Selected Plays of Ben Jonson*.

David Daniell is Senior Lecturer in English at University College London, where he specialises in Shakespeare and Renaissance studies. He has published extensively on the English Bible, on Shakespeare, and on the literature of Empire.

Inga-Stina Ewbank is Professor of English Literature at the University of Leeds. Her publications include essays on the Masque and on the plays of Shakespeare and his contemporaries; she has co-edited *Shakespeare's Styles* and has a forthcoming book on *The Word in the Theatre: Strindberg, Ibsen and Shakespeare*.

Philippa Glanville was Curator of the Tudor and Stuart Department at the Museum of London before moving to the Victoria & Albert Museum where she is the specialist on early English silver. She is the author of *London in Maps, Tudor London*, and *Silver in Tudor and Early Stuart England*.

Andor Gomme holds a personal chair in English Literature and Architectural History at Keele University. In addition to editing a number of Jacobean plays and writing books on critical theory and Dickens, he is the author (with David Walker) of *The Architecture of Glasgow* and (with Michael Jenner and Bryan Little) of *Bristol: an Architectural History*.

Wilfrid Mellers was Professor of Music at the University of York from its inception until he retired in 1981. He has written books on (among others)

Couperin, Bach, Beethoven, on English music and poetry, and on Dylan. His compositions mostly involve words and/or the theatre.

John Murdoch is assistant Director in charge of collections at the Victoria & Albert Museum. He is the author of *English Miniatures, Byron,* and *Discovery of the Lake District.*

George Parfitt was formerly Reader in English Literature at the University of Nottingham. He is the author of a monograph on Ben Jonson, a volume on seventeenth-century English poetry, and two on literature of the First World War.

Joseph Rykwert is Paul Philippe Cret Professor of Architecture at the University of Pennsylvania. Among his publications are *The Idea of a Town, First Moderns, Necessity of Artifice* and, with his wife, Anne, *The Brothers Adam.*

Adam White was formerly Research Assistant at the Henry Moore Centre for the Study of Sculpture, and is now Keeper of Educational Services at the Leeds City Art Galleries.

General Introduction

BORIS FORD

If all people seem to agree that English literature is pre-eminent in the world, the same would not often be claimed for Britain's arts as a whole. And yet, viewed historically, Britain's achievements in the visual and decorative arts and in architecture and music, as well as in drama and literature, must be the equal, as a whole, of any other country.

The Cambridge Cultural History of Britain is not devoted, volume by volume, to the separate arts, but to all the arts in each successive age. It can then be seen how often they reinforce each other, treating similar themes and speaking in a similar tone of voice. Also it is striking how one age may find its richest cultural expression in music or drama, and the next in architecture or the applied arts; while in a later age there may be an almost total dearth of important composers compared with a proliferation of major novelists. Or an age may provide scope for a great range of anonymous craftsmen and women.

The nine volumes of this *Cambridge Cultural History* have been planned to reveal these changes, and to help readers find their bearings in relation to the arts and culture of an age: identifying major landmarks and lines of strength, analysing changes of taste and fashion and critical assumptions. And these are related to the demands of patrons and the tastes of the public.

These volumes are addressed to readers of all kinds: to general readers as well as to specialists. However, since virtually every reader is bound to be a non-specialist in relation to some of the arts under discussion, the chapters do not presuppose specialist knowledge.

This fourth volume covers the seventeenth century, in all its turbulence and revolutionary fervour. If it was an age which experienced severe religious and political dissensions, it also saw intellectual developments that profoundly affected habits of thought and the development of science. It was, in short, a period of great change and, not surprisingly, of great vitality.

In the arts, change and vitality were certainly characteristic of architecture, literature and music; and to a lesser extent of the decorative arts. And there is certainly much turbulence and dissension on the Jacobean stage. At the same time the arts reveal a growing sense of the order and balance that were to characterise the Augustan culture of the next century. The age that begins

with *Lear* and *The Revenger's Tragedy* and Dowland's 'In darknesse let me dwell', or with the strange mixture of styles of the 'prodigy' houses, ends with Dryden's urbane if trenchant satires, with the ceremonial passion of Purcell's *Dido and Aeneas*, and with the magisterial grandeur of St Paul's Cathedral. In these arts one can feel and perceive a transformation of Britain's cultural sensibility. On the other hand, painters like Van Dyck, Rubens, and Lely were drawn in from the rather different cultures of the Continent.

˙ This volume, with a considerably more detailed bibliography, was originally published in a hardcover edition under the series title *The Cambridge Guide to the Arts in Britain.*

Part I
The Cultural and Social Setting

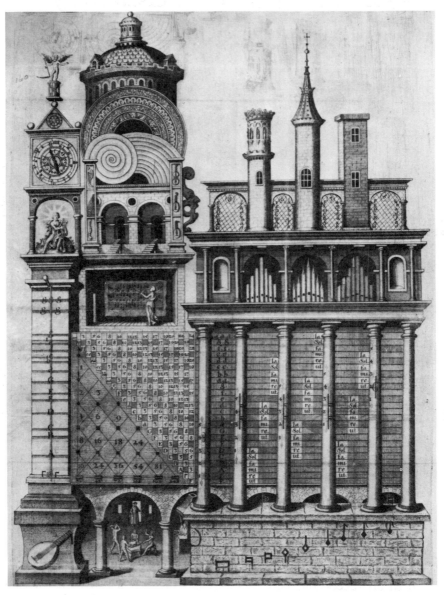

'The Temple of Music' from Robert Fludd's Utriusque Cosmi Maiori . . . et Minoris . . .
Historia. *Fludd describes this temple set high on Parnassus, surrounded by crystal streams
and decked with evergreens. In the meadows about it are shepherds, nymphs, satyrs. It is
presided over by the ineffable goddess Concord. The spiral movements at the top of the
main tower on the left signify the movements of air, which carry sound; the two doors
stand for the two ears without which one cannot enter the temple. The six columns show
the true proportions of the monochord and the different kinds of consonance. The clock
shows the importance of time measurement; the triangle above it was, according to Fludd,
to carry the legend of Pythagoras discovering harmony from the sound of the blacksmith's
anvil, but this in fact is shown in the arches below.*

The Seventeenth Century

JOSEPH RYKWERT

Introduction

To some people the seventeenth century in Britain is the age of the Stuarts. To others it is an age of revolutions. Both are, of course, correct. When Queen Elizabeth died, childless, at Richmond on 24 March 1603, the succession had barely been settled. Wily, vacillating, pedantic James VI of Scotland was the candidate preferred by most people of any social class or religious persuasion in England. He had had an ambiguously Protestant education. His mother Mary, Queen of France before she was Queen of Scotland and completely committed to the old faith, had been beheaded with Elizabeth's half-given consent. Yet the proclamation which was to declare James King of England was drawn up by Robert Cecil (the future Earl of Salisbury), son of his mother's implacable enemy Lord Burghley, while the old Queen was still alive and without her knowledge.

This proclamation looked to a continued alliance between the crown and the landowning gentry which had been the stable source of Tudor administration and of the country's skimpy prosperity. Having been crowned in Scotland when he was three years old, James had already been King for thirty-five years when he came to London. His reign until then had been all plots, counterplots, conspiracies and riots: through which he had managed to keep his head metaphorically as well as literally. Astutely he had made a diplomatic marriage with an intelligent if rather extravagant Danish princess, and assured his succession, since two sons and a daughter had been born before Elizabeth died. And 'the wisest fool in Christendom' (as the Duc de Sully, Henry IV's envoy at the time of James's accession to the English throne, called him) had very definite ideas about the exercise of power and about his role on the European, even the world, stage.

That this demanded a certain manipulation of the existing power structure as well as a measure of display, even of magnificence, seemed evident as well as desirable to the King and to his ministers once he had settled on the more opulent English throne and could see himself as much more secure than he had been in Scotland. He pinned much hope for the continuity of his policy

on his manly, forthright and puritanical heir-apparent, Henry Prince of Wales; but he died young in 1612. The succession in 1625 of James's second son, Charles, and his French wife gave another twist to the relation of the King to his subjects, since Charles had neither James's learning and wit, nor his circumspection. He did, however, inherit his father's earnestness. He, too, had ideas about his role on the world stage, a greater and much more refined taste for display, and a more extravagant wife than his father, all of which brought him into a conflict so rough with the most powerful group in the kingdom – the squirearchy – that he became the first European king to be deposed and beheaded by his subjects, an event which showed that the foundation of the whole edifice of monarchical legitimacy and dynastic territoriality, on which political power in Europe rested and which was being exported to the New World in the sixteenth century, was already very rickety.

For Britain that beheading in 1649 represented the most obvious and political revolution; though after a decade monarchy was restored, the sovereign was from now on required to have a new kind of cunning in the exercise of his prerogatives and this was to affect state patronage of the arts quite radically. After the fall of the monarchy, a new republican government could hardly extend patronage in the sense in which the word had been understood at the court of Charles and James; artists had therefore to find a new way of maintaining themselves – or emigrate. Nor did the new masters of the country see the patronage of the arts or the fostering of new talent as a matter of any urgency.

Although Charles II recovered some of the policy initiative, which was maintained by his nieces Mary and Anne, the centre of patronage in the second half of the century shifted back from the royal court to the houses of the great landowners to which Queen Elizabeth's parsimony, even meanness, had relegated it. Meanwhile, across the Channel, the court of Louis XIV was not only tightening its grip on the patronage of the arts, but even attempting (with some success) to direct artists' training and set up a unique quality control by the crown, which was to outlast the destruction of royal power by revolution a century and a half after the beheading of Charles I. This control was maintained by the French state through the changes of monarchy, empire and republic well into the twentieth century; while the relation between the arts and the state remained fitful and undecisive in Britain.

The Tudor inheritance

Defences and navigation

Since Henry VIII had defied the papacy and been excommunicated, the menace of invasion had become a constant drain on the treasury, and the immunity of island status constantly threatened – in part because of the notable improvement in navigational techniques. This menace became critical when Queen Elizabeth, too, was excommunicated by Pope Pius V in 1570. Against possible invaders, the King had created the first state-financed

standing navy; but he also patronised engineering and fortification projects, in the Thames estuary, at Deal and Tilbury and along the Channel from Kent to Pendennis and St Mawes in Cornwall. There were new walls for Hull and Chester; there were impressive works at Calais and Boulogne. All were designed to deal with artillery, the new form of warfare. So was Queen Mary's one defensive work at Berwick-on-Tweed, against the Scots.

However, Mary, though married to one of the great patrons of building in her time, Philip II of Spain, had no energy or finance left over for architecture. Elizabeth was too poor and too mean to build palaces; she relied on the reconstruction of the navy founded by her father (and neglected by both her brother and her sister) rather than on fortifications for the defence of the realm. But of course she had other advantages: her heavily-rigged ships were fast and manoeuvrable, unlike the many-oared Spanish troop-carriers. The new complex rigging replaced oars almost completely, so that the flanks of the new ships could carry the broadside guns which decided the new style of sea-battle.

Exploration and ocean-sailing were also helped by the new ease in handling of the British ships, and by the inventions of English technicians – such as the wind-gauge which would be perfected later in the seventeenth century by Robert Hooke. It was a British scientist, William Gilbert (1544–1603), physician to the Queen, who discovered a number of magnetic phenomena, including the 'dip' of the compass needle which identified the differences between the geographical and the magnetic pole (though the implications were only realised by Henry Hudson in 1608; he was to die three years later, set adrift in James's Bay by mutineers). Inevitably, too, there was a passion for globes and maps: Gerard Mercator's systematic projection of the world map, developed in the service of the Emperor Charles V, was improved by an English geographer, Edward Wright, who worked with many of the professors in Sir Thomas Gresham's college (of which more later), and whose handbook on navigation was used by sailors for many years.

Renaissance

That great things were being painted and built in other countries, especially in Italy, was very well known. But few pictures had been imported, and there was no question of an influx of Italian artists as influential as those promoted by Charles IX and Francis I in France. On the other hand, books travelled easily, and were acquired both for their texts and their visual qualities. Humphrey Duke of Gloucester ('Good Duke Humphrey' 1391–1447) was a fanatical early collector of 'humanist' manuscripts, and founded a library in the Divinity School at Oxford. The new fashions in shapely, pseudo-antique writing were adopted and practised by all the learned. Roger Ascham (1515–68), famous for his beautiful hand as well as for his proficiency in Greek, became the Princess Elizabeth's tutor, and the Queen was to pride herself on her flourishes and calligraphic Italianate hand, 'that grows out of the subject, chaste in its appropriateness, beautiful in its clarity', as Roger Ascham wrote to a German fellow humanist.

Yet royalty could (or would) do no more than fiddle with interiors at

Whitehall or Hampton Court, while the great courtiers were avid for the new style. The Duke of Somerset, Lord Protector of the Realm during his nephew Edward VI's minority, introduced this style at Somerset House on the Strand, which was being built between 1546 and his execution in 1551. After that, during the great Queen's reign, the biggest new building work was far from London: Longleat in Wiltshire (after 1572) for Sir John Thynne; the largest areas of glass at Hardwick New Hall in Derbyshire, built by the much married 'Bess of Hardwick' (Countess of Shrewsbury at her last marriage; after 1580); the craziest and most extravagant, Wollaton in Nottinghamshire, for Sir Francis Willoughby (an early proto-industrialist, whose money came from coalmining and glass-making, as well as land and wool; also after 1580); and Kirby Hall in Northamptonshire. The latter was the most 'advanced' of them all (begun for Sir Humphrey Stafford *c*.1570, continued for Sir Christopher Hatton, one of the Queen's favourites and Lord Chancellor just before his death) and it was the building which followed European, particularly French, patterns most closely. William Cecil began work on Burghley House in Northamptonshire (now in Cambridgeshire) soon after he came into his estate about 1552. He went on to build an even larger house at Theobalds in Hertfordshire, which was destroyed in the seventeenth century.

These and many others were call 'lantern' houses (Prodigy Houses, John Summerson has called them) and were magnificent draughty piles, with huge windows, whose discomforts were denounced in a much-quoted sentence of Francis Bacon's:

You shall have sometimes fair *Houses*, so full of Glass, that one cannot tell, where to become, to be out of the sun, or Cold . . .

Perhaps he was thinking of the house his father Nicholas, the Lord Keeper, built at Gorhambury in Hertfordshire, of which only ruins remain.

Little is known of the designers. Robert Smythson and the Thorpes, father and son, appear in accounts and sign drawings connected with all the houses mentioned. One Henryk, an Antwerp mason, may have been first brought to London by Sir Thomas Gresham; he also did a great deal of work for Lord Burghley, among others. Yet *who* designed *what* remains a matter for conjecture.

There was no shortage of native craftsmen. With the withdrawal of church patronage, crowds of woodworkers, glaziers, masons were thrown on private patrons. Moreover, Henry VIII had to create a new aristocracy, since the old aristocrats had killed each other in the Wars of the Roses. He endowed them richly with monastic lands. They too inevitably were affected by the Marian hiatus, when many had to return these properties to religious houses. The longing of this new class for the aristocratic securities of an earlier age was reflected in a passion for chivalry and tourneys which is evident in many of Hilliard's portraits. This earnestness about the origins of feudalism is reflected in the great popularity of the literature of chivalry and of the Arthurian romances at that time. Earlier in the century these had also been popular in southern Europe; but while in Spanish the reaction to chivalric romances was the irony of *Don Quixote*, in England at the same time it spawned the epic allegories of the *Faerie Queene* (1590–6). The fabrication of a moralised antiquity, the representation of the 'original' Britain of Arthurian

legend, was perhaps the most powerful stimulus to British artists for the whole of the seventeenth century, culminating in Dryden and Purcell's operatic *King Arthur*, first produced in 1691, though perhaps it is fair to add that a few years later Purcell wrote music for a stage *Don Quixote* as well.

However, the faery castellations of the huge Jacobethan glazed houses, and the elaborate patterns of knot and fret in the leading of the glass in the huge windows, as well as in the layout of the gardens, were features of a style which assimilated these houses to a past of romance, and seemed to give the age a semblance of continuity from Arthur to Elizabeth and James – it was all the seamless 'Matter of Britain', of which the chroniclers had spoken, and which provided the perfect subject matter for pageants and masques. Increasingly, the literate, not just the learned, demanded that anything 'ancient' in pictures or stories should be located in buildings to whose walls the 'orders' of architecture had been applied. Those antique column-and-beam ornaments and proportions which German and Flemish engravers, and consequently also joiners and masons, emulated from Italian examples, seemed to late Elizabethan, as to Jacobean and later builders, as suitable to the court of Arthur or Lear as they had been to that of Augustus.

Antwerp, which had been the scene of some of the most repressive Spanish actions, was also the great centre of printing, from which architectural books were imported by travelling as well as British craftsmen; though they were also keenly bought by patrons. As for native publications, there were a number of pattern-books showing knots and frets, which seem to have been used by glaziers, gardeners and embroiderers indifferently. The only English architectural book of the time was published in 1563 by John Shute, a painter-stainer, of whom little is known: *The First and Chief Groundes of Architecture*. It was dedicated to the Queen, though it declared itself the result of an Italian study financed by the Duke of Northumberland, who had died on the scaffold in 1554 during Queen Mary's reign for his daughter-in-law Lady Jane Grey's attempt on the throne. That learned but thin book, obviously based on Flemish examples, seems to have had little effect on current building.

Universities and the new learning

The Queen's penury had been genuine. Military expenses were merely an aspect of another crisis with which she and her advisers had to deal. The treasury Elizabeth inherited from her sister was empty, the coinage debased by her predecessors through the alloying of the metal. Sir Thomas Gresham (1519–79) adeptly raised the value of coinage (and so reduced the value of foreign debts) and insisted that all state loans be raised at home and not abroad. Gresham also built an Exchange (which the Queen named Royal) to give trade transactions institutional dignity. For that building he seems to have imported that same Flemish mason who may have been its builder, perhaps its architect. By his will Gresham also funded a series of lectures on astronomy, geometry, physics, law, divinity, rhetoric and music, to be held in rooms within the Royal Exchange, as a sort of small and independent part-time university in London: though there were proposals to start a true university throughout the sixteenth century, and later.

Gresham's lectures were to be in Latin, as at the universities, as well as in English; and the professors were to remain bachelors, like college fellows. John Bull, for instance, who was an early professor of music (appointed 1596), was dispensed to lecture in English only, since he did not speak Latin; he resigned his chair when he married in 1607. At the old universities music was taught fitfully, mathematics and astronomy hardly at all. Gresham's college catered for the vital development of these subjects, as well as the enormous avidity which townspeople were developing for scientific knowledge. A book which owed its publishing success to its being adopted as a manual at Gresham's College was the famous translation of Euclid into English by a future Lord Mayor of London and MP for the City, Henry Billingsley (London, 1570); it contained a preface by the scientist, alchemist and magus, Dr John Dee. This preface set out the creed that the manipulation of number, to whatever mechanical attainment it may be applied, could become a means for operating on stars and spirits, and that it was of the greatest importance to empirical chemists and navigators and astronomers, as well as to magicians and alchemists – and that magic, miracle-working, was in any case really a form of mechanics. It appealed for a consideration of architecture as one of the mathematical arts – like music.

In fact the university-based clerisy, and indeed the whole clergy which depended on the universities, had lost face intellectually at the Reformation, while a new kind of learning was growing fast and extending in the towns, especially in London. Immediate stimulus for new urban development, or at any rate a sharp focus for it, was provided by the change in British textile export markets through the religious wars which devastated the Spanish Netherlands, and therefore closed the old outlets at Antwerp and Bruges to the wool-trade, the staple British export. New openings were to be available later through Holland. However, a scramble for new markets had started in the reign of Henry VIII and groups of London merchants bound themselves together to finance settlements in the New World and to undertake other navigational exploits. The north-east route to the Indies and to Cathay over the Sea of Azov, and the north-west route over Canada as an alternative to the several-months' trip round the Cape of Good Hope, already attracted a number of explorers.

These Merchant Adventurers either worked on the capital of members of the group, and traded on the old Hanseatic routes – in the Baltic and in Russia – as well as the Levant; or else were financed by joint-stock companies (almost like a modern public company) which explored further afield: East India (in 1600), Africa, Hudson's Bay (1670). All were private ventures, yet both the treasury and the sovereign personally invested in them. These companies were guaranteed a monopoly of the territory – at any rate as far as rival British merchants might be concerned – and very limited naval protection wherever possible; in India it clearly was not. The line between government and private enterprise at this point was a thin one: so, for instance, when Drake cut the route of the silver convoy between Peru and the Mexican ports in the Panama isthmus, it was partly an act of war, but also a piece of private piracy; and indeed the defective Royal Navy relied on loans of private merchant-ships in any crisis, as it did inevitably at the time of the Armada.

After the closing of the monasteries academic life had to be reorganised, since universities – which provided mostly for the teaching of secular clergy – also relied on the great religious houses to supplement their learning as well as their income. The quick changes of religious allegiance – Protestant-Catholic-Protestant – demoralised and exiled many teachers; John Fisher, Bishop of Rochester and Chancellor of Cambridge, was beheaded in 1535; Cranmer, Ridley and Latimer, all Cambridge men, were burnt at the stake in Oxford in 1555. Exile and persecution hardened divisions: Catholics were siphoned off to Spanish-backed institutions, English colleges founded in Catholic universities, while the Marian refugees imbibed Calvinist ideas of worship and church government much more radical and heady than those of the Lutherans. Still, what could not be referred to Aristotle could not be taught at a university. This was a hard rule by which many academics thought they could guarantee some kind of respectability, even though many knew that abroad things were ordered otherwise. Andreas Vesalius of Antwerp was teaching anatomy by dissection, with hardly a reference to Galen, never mind Aristotle – in Paris, Padua and Basel. His pupil, Realdo Colombo, was doing the same in Pisa, Florence and Rome. Meanwhile William Harvey, who first formulated the idea of the circulation of the blood, and had been physician to both James I and Charles I, had to wait for the King to plant his defiant standard at Oxford before he was offered a place at the university – and then as Master of a College.

In the meanwhile a ferment of technological invention was rising out of the soil of proto-capitalism. The inventors and their patrons were, of course, 'rude mechanics'. There was no institutional backing, apart from the dubious one of Gresham's College, for their endeavours. And yet the pumps which were being perfected for the new mining enterprises in the north of the country were an analogue of Harvey's valves and veins, much as the notion of the circulation of capital is contemporary with Harvey's notion of blood circulating round the body, distributing benefits and absorbing impurities.

The arts in Britain between Elizabeth and James

The entry into London of King James I was a great festival, which (typically enough) had to be postponed until February 1604 because of the plague. There were processions, pageants (Ben Jonson organised one for the City), triumphal arches (designed by one Stephen Harrison, of whom very little is known), music of all kinds and finally a coronation. More money was spent on pageantry than in the whole of the previous reign. Titles were distributed. Some went to the Kings's rapacious Scottish followers, but more went to English worthies. Francis Bacon was knighted, and young Edward Herbert (1583–1648), later Lord Herbert of Cherbury (a well-heeled kinsman of the Earls of Pembroke, whose brother was the priest-poet George Herbert) was made a Knight of the Bath. Edward Herbert took his dubbing seriously, and seems to have acted out his role as knight-errant; having volunteered against the Spaniards in the Low Countries, and befriended William II of Orange, he once offered to fight any champion who would stand single-handed for the Emperor to decide the whole war in their duel; he also led an ill-fated

Huguenot army on behalf of the Piedmontese against Spain in 1615. He was the British ambassador in Paris (intermittently, because of his inclination to issue challenges to duels) from 1617 until 1624, during which time he negotiated the Prince of Wales's (later Charles I) marriage to Princess Henrietta Maria. It was during this period that he turned his attention to the philosophy of religion, for which he is now remembered, and of which more later. Another new Knight of the Bath was Roger Manners, later Earl of Rutland, who was sent out to Copenhagen to take the Garter to the King's brother-in-Law, King Christian IV. In his train went young Inigo Jones (1573–1652), who thus entered the Queen's service a year later. But the new King had to settle another debt: the Cecils' most powerful enemy, Sir Walter Raleigh (1552?–1618) – poet, courtier, privateer, explorer, politician – was imprisoned on a trumped-up charge of treason, condemned to death, and pardoned on the scaffold: he spent the next fourteen years in the Tower, conducting chemical experiments and composing his vast and best-selling *History of the World*. Then, in 1616 he was released and sent for gold to South America; he attacked a Spanish settlement contrary to orders, and on his return in 1618 the Spanish ambassador, Count Gondomar, demanded and got his head.

In fact, when James arrived in England, the cultural picture was 'all arsey-varsey', as a poet of the time put it. Literature and music were brilliant, popular and very lively: Marlowe had died ten years before, Spenser four; but Shakespeare was only forty (the great tragedies were written in James's reign). Ben Jonson (1573–1637) though he is classed as an 'Elizabethan' in some textbooks, was about thirty years old. Chapman's plays and his translation of Homer also belong to James's reign. Dekker, Massinger, Beaumont and Fletcher were at the beginning of their various careers. The theatre, even if it was subsidised by the great lords at court and the crown intermittently, remained a popular civic institution.

As for music, William Byrd (1543–1623), though a Roman Catholic, still enjoyed the monopoly of music publishing which had been granted by Elizabeth to his master, Thomas Tallis (*c.*1505–85), and which 'the English Palestrina' had inherited. Although religious intransigence kept him from court, the monopoly ensured that his music was known throughout the land. The patent was later granted to his pupil, Thomas Morley (1557–1603/4). However, Morley died just after James's accession. Byrd's and Morley's great achievement had been to translate the Italian madrigal into something which came to seem quite native and became an essential part of English musical life. It was the music which was 'made' in the great Elizabethan lantern houses, and the music, too, which developed into a powerful tradition. Later quasi-masques such as *Comus* (1634) by John Milton and Henry Lawes entirely depended on it,

> . . . whose tuneful and well measur'd song
> First taught our English music how to span
> Words with just note and accent . . .

However, John Dowland (1563–1626?) who was briefly lutenist to Queen Anne of Denmark and, shortly before his death, to Charles spent most of his

career abroad; and John Bull too, in spite of his name and putative authorship of the National Anthem, spent the latter part of his life in Antwerp as organist of the Cathedral and to Archduke Albert. Orlando Gibbons (1583–1625), died of smallpox at Canterbury, where he had gone to supervise the music he had composed for the wedding-service of Charles I. British music was not to achieve greatness again until the time of John Blow and Henry Purcell, two generations later.

In the visual arts the country was poor. The only native painter of any reputation was the miniaturist Nicholas Hilliard; a school of miniature-painters did develop under his tutelage, miniatures and medals being the essential currency of diplomatic negotiation and princely compliment. Hans Holbein had dominated English art in King Henry's reign and had inevitably also painted in miniature. The technique of gouache painting on card or ivory was derived from the old craft of book illumination which had died with the abolition of the monasteries and the early importation of printing (Caxton started his press in 1477). Its revival seems to have been stimulated by the teaching of a Flemish lady, Levina Teerlinc. Strangely enough she was employed both as a children's nurse and painter in Henry VIII's household. Hilliard, who was her successor in the second (only) of these offices, was an undisputed master however, and his better-known pupils – his son Laurence, Edward Norgate, Rowland Lockey and the most brilliant and innovative of them, Isaac Ollivier (known as Oliver; who though born to Huguenots in Rouen, came to England as a small child) formed a definite native school. On the other hand, little sculpture or architecture had been patronised by the court – or indeed at all in London, though Cardinal Wolsey had imported Italians, and some stayed on after his disgrace.

Kings, Church and Parliament

Scotland had a subsistence economy to which trade and exploration were marginal. Economic planning and the new technology were therefore rather alien to James I, who came from a very literate, theologically obsessed court and capital, and was himself fluent in the ancient languages. Indeed he went on piquing himself on his humanist pronunciation of Latin; he also read Italian and French and fussed about his courtiers' Italian accent though he never attempted to modify his Lallans Scots himself, and indeed his son Charles I spoke with a Scottish accent. In the visual arts he had little education. In Scotland the old abbeys were falling into ruin; James V's palace at Holyrood Abbey was in a sorry state; other castles were no match for what he saw in Denmark when he went to meet and marry his queen in 1589. Anne of Denmark had a very different background. In her country the court, though decidedly Protestant, was very Italianised, and the Queen's father, Frederic II, employed a number of Dutch and French architect-engineers to build palaces as well as castles. Her brother, Christian IV, applied his main energy to develop and re-fortify Copenhagen, where he also built an Exchange which was much bigger than the one in London and was undoubtedly intended to show it up.

The King had no clear intention of transforming London into a new-style city: he had neither the energy nor the interest in the visual arts which such an enterprise would have required. He took Lord Burghley's second son, Robert Cecil (whom he made Viscount in 1604 and Earl of Salisbury a year later – though by the time he died in 1612 he was in disgrace and in debt) to London as his mentor. After the eclipse of Cecil, the Howard family maintained some power, and orientated the King away from his Protestant alliances. James's only daughter Elizabeth (extremely popular in Britain, partly because she was identified with the Great Queen, her godmother) had married Frederick the Elector Palatine in 1613 who shortly afterwards (1619) was to be elected King of Bohemia, but was driven from Prague by Emperor Ferdinand and from his Rhenish Palatinate by the Flanders Spaniards. Indeed Edward Herbert lost his Paris posting for failing to interest the French in the rescue of the Palatinate; the affairs of the unfortunate Queen of Bohemia were to engage British politics for half a century. Her son, Rupert was to become a distinguished servant of the British Crown, and at his death in 1682 he was the first Lord of the Admiralty and Duke of Cumberland. He was also a brilliant amateur engraver and – reputedly – the inventor of mezzotint.

Meanwhile, James's personality slowly transformed the system of government which he had inherited from the Tudors, who had centralised power in a courtly civil service by making favourites of their managers. James, with his great belief in a miraculous, or perhaps merely sacramental, wisdom granted to kings when they were anointed in the course of the coronation ceremony, had no interest in government as administration, and attempted (and failed) to turn favourites, chosen for their good looks and charm as well as for their ability to flatter their monarch and provider, into managers. The Howards and earlier favourites were all displaced by James's last love, the elegant, witty, handsome, charming – and tactless – George Villiers, who rose from a simple gentleman to a Knight of the Garter in 1615, Viscount in 1616, Earl in 1617, Marquess in 1618, and Duke of Buckingham in 1623. He was assassinated by a private enemy in 1628.

Policy in the latter part of James's reign was controlled by Buckingham, who had an understanding with the learned and sharp Spanish ambassador, Count Gondomar (who had demanded Raleigh's execution); he led the first negotiations for a marriage between the Prince of Wales ('Baby Charles' as the King called his son) and the Infanta, daughter of Philip III. When these negotiations broke down, he benefited from Richelieu's anti-Spanish, anti-imperial policy which involved him in a number of Protestant alliances, and married his son to Henrietta Maria of France, the sister of Louis XIII. During these negotiations various arrangements with Rome were discussed, which were on the whole very unpopular in the country.

The King and parliament

The voice of the squirearchy was the Commons. The merchants also had their say in it, but they formed a minority, and not a vociferous one; and their interests were also represented in the Lords, in which many of the more

powerful investors took their seats. The high and mighty doings of the courtiers, which were indulged by the Elizabethan Commons, were viewed with increasing disfavour by the Stuart House, especially when it came to their being paid for out of taxation. And yet that is what the unwritten constitution of the British monarchy, as it had been more or less set up by Simon de Montfort, demanded: the sovereign and the executive spent the taxes but they had to summon parliament in order to be able to impose and collect them. In turn, the Lords and Commons could not sit until summoned to do so by the monarch. In order to raise tax for any enterprise, whether road-building or war, the Commons were needed and once they had gathered they inevitably discussed the merits of what the King proposed. James had found these discussions and the criticisms of his court, or of the distribution of offices and monopolies, irksome, the protests and remonstrances provoking.

Charles would find it even more difficult to raise money through parliament, which reduced his budgets and criticised his religious opinions. He tried several ruses (such as pawning the crown jewels in Holland) to make himself financially independent of the House, but could not succeed in the end. Charles, even more clearly than James, saw himself as answerable to no-one but God, and as the father of his country he sometimes used the prerogative courts to defend tenant against yeoman and squire, or to control the provisions of the poor law by central government. These actions

An early popular print (inaccurate in some architectural details) of the execution of Charles I outside the Whitehall Banqueting House.

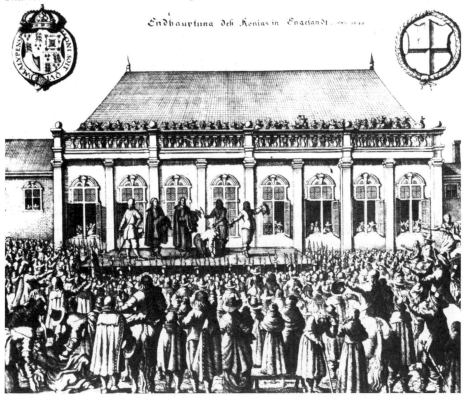

antagonised the Commons quite as much as some aspects of his foreign policy – such as his siding with Spain against the Dutch in 1631. In the final clashes Charles behaved, as he often did, aggressively and indecisively by turns – with results disastrous to himself.

The first Stuarts had failed to appreciate another development of importance in their realm, the growth of the City of London. Even in England four-fifths of the population still lived on the land, and land was the prime investment and the ultimate guarantee of much capital. The doings of the City which neither delved nor spun were therefore easy to underestimate. James I had already established monopolies on private taxation and on some home manufactured goods which he sold or gave to courtiers, but he also encroached on the monopolies essential to the trading companies. In particular the privileges granted to the Flemish banker, Sir William Courteen, and his 'Association' in exchange for loans to the crown, which were not repaid, ruined much of the business of the East India Company. Parliament later made it a matter of policy to withdraw monopolies on home goods and to maintain those on foreign trade. In 1635 Charles finally antagonised the City when he sequestered land which London merchants had bought and colonised in Ireland. By then his word was seen to be worthless. He had also been unfortunate in many of his martial enterprises; many subjects saw him as both shifty and unlucky.

The King and the Church

Royal policy had inevitably to be concerned almost as much with religious passions as with directly political issues, though less with divinity proper as with ecclesiology and church government. Henry VIII's quarrel with Rome had been about discipline, not about theology. Before the breach, Pope Leo X had named Henry 'Defender of the Faith' for publishing a book which attacked Luther's sacramental doctrines. After the breach with Rome the King went on burning heretics, but he also flirted intermittently with Lutheran alliances, as well as with a return to the Roman obedience – though neither suited his purpose.

Separation from the Papacy left Henry as the arbiter of theological as well as civil matters; and inevitably eased the tension between church and crown – the tension which made the sovereign accountable to a semi-independent religious authority for his stewardship. In the heady days of King Henry, quick changes and despotic mastery concealed the constitutional anomalies which became much clearer in the more tentative reign of Edward VI. The young King had been educated by Calvinists, and wanted reform more radical than any his father had allowed. When his short reign was over, Mary went back to the full Roman obedience overnight, though afterwards, Queen Elizabeth reverted to reformed ways in church matters. She would go little further in that direction than her father had done. She maintained old liturgical proprieties, would not put up with married bishops and did not even approve of married clergy, though she did not hesitate to appropriate cathedral revenues when money seemed short.

As a result of all this her clergy were decidedly underpaid, confused by the

quick switches in theology and worship, and somewhat under-educated. As opinions polarised, their social position declined – since changes and diversity of doctrine made personal authority more telling than the priestly office. The Queen's theological opinions, in so far as they could be ascertained, were therefore the law of the land and her views on liturgy and church government encapsulated in a Statute of Uniformity. John Whitgift, Archbishop of Canterbury, represented a compromise acceptable to her and many of her subjects, holding a Calvinist view of predestination yet accepting the church-order of a quasi-Lutheran Anglicanism. It was Whitgift who attended the Queen on her deathbed and crowned James I.

Whitgift's successor, Richard Bancroft (1544–1610), had been his chaplain, shared his beliefs, and continued his policies, attempting to give the Church of England a body of canon law and to make church courts independent of civil ones, turning sharply on the private inspiration of the Puritans. James, hoping to avoid some of his Scottish troubles, summoned a conference of Presbyterian, Low and High church clergy at Hampton Court in 1604. The most positive result of that inconclusive meeting was the demand for a bible translation consonant with new scholarship, acceptable to all parties, and without those tendentious marginal notes to which the King objected in the 'Geneva' bible. That it became the *locus classicus* of English prose style seems almost incidental.

The only major theologian of Elizabeth's reign never achieved a bishopric: the learned and 'judicious' (as his tombstone called him) Richard Hooker, who died in 1600; but his book *Of Ecclesiasticall Politie* was much favoured by James I and Charles I. Slightly younger, Lancelot Andrewes lived as Bishop of Winchester until 1626, and after the Hampton Court conference presided over the committee which translated the first part of the Authorised Version of the Bible. These learned churchmen were exceptional in their time. However, a new generation of clergy, now that affairs seemed more settled, looked to the monarchy to provide a focus for internal coherence to the body of the church, as well as a defence against what they saw as the 'Scylla and Charybdis' of the time, Rome and the Puritans. John Donne (1572–1631) was undoubtedly the ablest apologist of this view of the church: he had been persuaded to take orders by King James I when he was already over forty, and had had a much troubled career. In 1621, the King, saying that London was 'a dish Dr Donne loved well', 'carved for him' the Deanery of St Paul's; from which he would have advanced to a bishopric in 1630 – but he was by then mortally ill.

The latter years of King James's reign, therefore, and the early ones of Charles I's particularly, saw the Church of England define itself as representing the organised, and indeed hieratic, church which had existed in Britain since the seventh century, the days of Augustine of Canterbury. Though it had been in and out of communion with the Pope, its members thought of their church order as being continuous, much as the nobility wanted to confirm their link to an Arthurian antiquity. The legend of Christ's disciple, Joseph of Arimathea, coming to Glastonbury (with or without the Holy Grail) seemed to connect British Christianity beyond St Augustine to its divine Founder. Equally, although the thorn which Joseph

was said to have planted was destroyed at the Reformation, and the alleged
coffin of King Arthur had vanished earlier, the legend of its discovery
survived in chronicles, William of Malmesbury's account being the most
credited. In any case, the 'primitive' allure of the liturgy, the fidelity of the
Bible translation, and the newly acquired confidence of the native clergy led a
Jacobean bishop to proclaim that 'God is English'.

James I had early on conceived a solid loyalty to moderate sacramental
theology. He was firmly committed to episcopal government – and to ritual.
His position was in some ways closer to that of the Dutch Arminians than to
that of his Calvinist clergy. He had married a Lutheran princess, yet when he
brought her to Scotland from Denmark he insisted that she be anointed in
her coronation ceremony, as he had been, to the discomfiture of his
intransigent presbytery. And in fact she came nearer to returning to the old
faith than he did. James was a theologian of some learning, and plausibly
took on Cardinal Robert Bellarmine, one of the most brilliant intellects in the
higher echelons of the Roman church in written debate; nor did he get the
worst of the argument in which he defended his belief in his own divine
mission and in his special position as the Lord's anointed. This view in turn
required a kind of sacramental theology which no Calvinist divine would be
likely to endorse. And the King was very explicit about it. In the *Basilikon
Doron*, 'The Royal Gift', he set out for his son, Prince Henry, the nature of
kingly office, half-priest, half-magistrate, and the rules of the kingly craft.
There was also an unsavoury, credulous side to the King's faith: he was, even
by the standards of his time, very superstitious, and all his life obsessed with
a fear of necromancers and witches, whom he regarded as traitors to God and
to whom he was sometimes unforgivingly and even wantonly cruel. Again, it
was a matter on which he held definite views, which we know from his own
writings. The King's obsession with the subject brought it to the forefront of
his people's attention.

However, the firm belief in the royal priesthood (as James held it) was
inevitably threatened by the doctrine of the priesthood of all believers, which
the Protestant reformers proclaimed in various degrees. In any case, even in
the Roman church itself, doubts were being voiced, especially among Jesuit
theologians. Francisco Suarez (1548–1617; honorifically known as *Doctor
Eximius*), the most influential of them, seems to have considered monarchy as
a kind of by-product of a commonwealth based on a form of social contract,
and considered the monarch responsible to the society he ruled, and not to
God alone. He was not very interested in the sacramental nature of the
monarchy, and was convinced of the subjects' duty to rebel against an
impious or apostate monarch. Another Jesuit, Juan Mariana, had explicitly
defended tyrannicide. Suarez' *Defensio Fidei Catholicae . . . adversus
Anglicanae Sectae Errores* (1613) was dedicated to James, who had it burnt by
the common hangman for reiterating Bellarmine's view of monarchy. Yet
King James knew ('No bishop, no King' – as his first Archbishop of
Canterbury, Richard Bancroft had said) that the monarchy could not be
sustained if it was not supported by a hierarchical church, and this kept him
well away from any presbytery. All this made Puritan and Papist strange
bedfellows intellectually.

Britain and Europe

In spite of the bitterness and violence of religious conflicts, the cultural centre of Europe, whatever the political pressures from France and Spain, was still Italy. But a powerful change, which coincides approximately with the Commonwealth in Britain, was a gradual shift from Italy to France – a move which was engineered, even forced, through centralising: first of literary life under government protection or control in the French Academy which was officially established under Richelieu; and then, through the training of artists under the tutelage of the royal administration.

However, the most important change in European culture was probably linguistic: Latin principally and Italian secondarily were in turn the diplomatic and cultural international lingua franca of Europe. But Latin was lapsing as a literary language. The last major poet to write exclusively in it for an international public was the Polish Jesuit, Casimir Sarbiewski (Sarbievius; 1595–1640; English translation 1642); whereas the peripatetic Neapolitan poet, Giovanni Battista Marino (1569–1625), generally known as *Le Cavalier Marin* or even just *Il Cavaliere*, wrote in Italian, and he was the greatest international literary figure of his day, a position to which no Spanish, French or British poet could aspire. Old fashioned men of letters, like the pedant Gilles Ménage (1613–82), two generations later, prided themselves on their fluent Italian – enough to write a book on the origin of that language and publish it first in Italian. But Ménage also wrote a French grammar, though the French Academy did not admit him as one of the 'immortals'.

All these movements were perhaps superficial compared to the major rearrangement of the world-picture which occurred during the same period. The Copernican restatement of the heliocentric world-system was made just after 1540, and was generally accepted through the next half century. This acceptance was mediated by a group of astronomer-physicists: Tycho Brahe (1546–1601), whose work turned out to be essential to its support, though he himself rejected the Copernican model, and whose observatory King James visited in Denmark; Johannes Kepler (1571–1630), his assistant in Bohemia and Germany; and Galileo Galilei (1564–1642) in Tuscany. Galileo's difficulties with the church are too well known to require any comment, though it is worth noting that his first warning from the Inquisition came in 1616, and the final condemnation in 1633. He abjured publicly in the church of Sta Maria sopra Minerva in Rome on June 22 of that year. The rest of his life was spent mostly in the relative seclusion of a villa at Arcertri outside Florence. But there he went on writing, and (until he finally went blind in 1637) using his telescope. In 1638 his most important late work, the *Dialogues of the New Sciences*, was published in Antwerp by the great printer, Elzevir. That year, too, the young John Milton visited him, and he continued, throughout his 'imprisonment', to correspond with European scientists.

The international, indeed cosmopolitan, character of European scientific work at the end of the sixteenth century was itself a very important factor in the formation of the European mentality of the time. The telescope, so important to Galileo, typifies this atmosphere: it was 'invented' about the

same time (*c.*1600–10) separately in Britain, in Holland and in Italy. The very name *telescope* was coined by Demiscianus, a Greek scholar in Florence who was a member of the Academy *dei Lincei*, to which Galileo also belonged. It was first used by Galileo in 1611, by Kepler two years later and by John Bainbridge, the first Savilian professor of Astronomy, in 1619, the year of his Oxford appointment.

Such developments, some people realised, needed institutional or at any rate administrative organising; the first to attempt it was a Protestant physician and philanthropist, Théophraste Renaudot (1586–1653). His *Bureau d'Adresses* was linked to a free dispensary for chemotherapy, as well as a newspaper, even a non-profit-making pawnshop. At the same time a friar in the Paris house of the Minims (a particularly austere order), Marin Mersenne (1588–1648), who is now chiefly remembered for his long and very important correspondence with Descartes, began to organise a similar system of scientific, philosophical and theological exchanges. Mersenne, who had in fact been a school friend of Descartes, later acted as his agent in Paris, and defended his orthodoxy against French ecclesiastical attack after Descartes moved to Holland.

However, the constant flow of letters made his Parisian cell a kind of clearing-house of new ideas. Two of his correspondents were Samuel Hartlib (d.1670), a Danzig merchant of Protestant family, and Theodor Haak (1605–90), a Dutch divine and man of letters, both of whom had settled in Britain. Both were also followers of the Moravian philosopher-theologian, John Amos (Komensky) Comenius (1592–1670), whom they lured to Britain for a short period in 1641. What these four correspondents shared, and indeed held in common with a great many people in Britain, was the belief that the new developments of technology as well as of scientific theory would bring about a new and more rational state of the world in which the behaviour of men would be guided by reason rather than prejudice.

Senates, academies and the promise of harmony

There were many attempts to found such institutions as Gresham's College in Britain. Raleigh had hoped to found a teaching academy for the sons of gentry in London, with a curriculum not unlike that of Gresham's College, but in English. However, Queen Elizabeth would not finance such an undertaking; nor would James finance Bacon's later efforts in the same direction. Indeed, attempts to fund such institutions were made all over Europe. Academies in Italy and France had proliferated in the sixteenth century: sometimes, like the Accademia del Cimento in Florence, they actually had a laboratory attached to their rooms to allow members to carry out scientific experiments. More often they were concerned primarily with elevating and refining the language – partly by its practice, partly by the composition of dictionaries and handbooks. This was even on occasion matter for government policy, as it was in the case of the French Academy, which almost policed French literature, or the Accademia della Crusca (of the Bran), with a whole panoply of bakers' implements as an allegory for its work

of winnowing the Italian language to compile a dictionary which was to have almost the same authority as the French one. An analogous English effort had to wait for the private endeavour of Dr Johnson in the eighteenth century.

Sometimes such institutions had merely scientific aims, but others, like Hartlib's system of international exchange of scientific information by correspondence, his *Adresses*, were intended to advise governments, perhaps even to take power. Hartlib's importance is underlined by the fact that when John Milton sought to effect university reform he wrote about it in the form of an open letter to Hartlib.

The organisation of scholarly endeavour also had a curious and to us barely comprehensible link to secret societies and the orders of chivalry. This last connection underlines the importance of pageantry again. One important attempt to affect social transformation through a collegiate union of scholarship with chivalry was made by a little known figure, Edmund Bolton, a recusant Catholic, attached (strangely enough) to the Puritan Prince Henry's court. He tried to gather what he called a 'Senate of Honour' (in an obscure way related to the Order of the Garter) around the Prince; even after Prince Henry's death such a proposal had King James's favour, though Charles I had other priorities.

In fact Prince Henry's household was in a way such an academy. His nurse was the mother of the great neo-Platonic philosopher, Ralph Cudworth; his tutor, Lord Lumley, is chiefly remembered for his library and his patronage of the new anatomy; like the rest of his powerful family, he was another recusant. Others were distinguished, but more complying: his musician was John Bull, his 'Surveyor' Inigo Jones, and his 'Semster' George Chapman, playwright and English translator of Homer (*Incomparable Heroes*, Chapman called Prince Henry in the dedicatory epitaph of his Homer). A humbler member of the household, Giacomo Castelvetro, an Italian Protestant who had married the widow of the Swiss theologian Thomas Erastus, attempted to reform the diet of the English by encouraging them to eat less meat and corn, and more vegetable and fruit, but in vain.

In academies and pageants and in many other endeavours men pre-supposed that some end could be foreseen to the religious conflict which was ravaging Europe. Marin Mersenne was very enthusiastic about a book which proposed just that, and had been printed first in Latin in Paris in 1624, then in London in 1633 (with an imprimatur from Archbishop Laud) and was available in French in 1639 (though there is no English translation yet). *De Veritate* was written by Lord Herbert of Cherbury (mentioned earlier for his knight-errantry) while he was James I's ambassador in Paris. The book was then sent to the great Dutch jurist, Hugo Grotius, who approved it highly. It was read – and commended – by Pope Urban VIII, though it was placed on the Index in 1634. Mersenne sent two copies to Descartes, and wrote about it enthusiastically to Comenius, calling it *opus ille Heroicus*. For his part, Herbert in later life undertook a translation of the *Discourse on Method*, which he never finished. He did, however, towards the end of his life, during the Civil War – in which he would not take sides but retired to his castle at Monmouth – write *De Religione Gentilium* ('Of Pagan Religion', first published posthumously, Amsterdam 1663; English

translation, London 1705), in which he again attempted to set out a kind of comparative minimal history of religion.

Even before Herbert attempted this, a curious London clergyman, Samuel Purchas, attempted an approach to comparative anthropology by a rather uncritical collation of travellers' tales; he published *Purchas' Pilgrimage* in 1613, his *Hakluytus Postumus, or Purchas' Pilgrimes* in 1625. A more powerful method suggested itself to the French political philosopher, Jean Bodin, who in his *Colloquium Heptaplomeres* of 1588 (which was only published partially and later) recounted a fictional discussion between a Jew, a Mahommedan, a Roman Catholic, a Zwinglian, an Epicurean and a Theist; in it he seems to have produced a first treatise on comparative religion which ends in an exhortation to tolerance. It comes oddly from a lawyer who urged witch-hunts and witch-burnings. However it was a conviction he had in common with James I, another worker for religious reconciliation.

To the several proponents of religious peace and toleration, it also seemed essential to discover a universal and rational (some even said philosophical) language which would be purer, more 'receptive', less tainted by history than Latin, and whose 'letters' would have the abstract validity of mathematical symbols, and provide a kind of algebra of meaning. Comenius's most famous innovation, his method of demonstrative language teaching by rebus-pictures, were seen by many as an attempt to create such a language, and his prestige among political leaders (he received pensions from the British, Swedish and Dutch governments, corresponded with Louis XIV and so on) was due to his whole system of educational reforms based on these theories. Haak and Hartlib were both passionate advocates of such a cause. Of course the enormous curiosity about Egyptian hieroglyphs as well as Chinese writing at this time was fuelled by the notion that there could be a link between such efforts to re-formulate language in pictures, and the 'original', philosophic language of mankind. It was a problem which was to occupy a number of English philosophers and mathematicians into the eighteenth century. In 1654 Seth Ward (1617–89), astronomer and mathematician and Bishop of Salisbury after the Restoration, proposed a formula for such an 'invented' language in his *Vindiciae Academicae*.

A wholly rational form of communication was required by a wholly rational society in any case; and this would have structural characteristics quite different from the messy, and painfully, expensive changing one of sixteenth- or seventeenth-century England. Thomas More had published what some thought a rather fanciful picture of such a society in his Utopia, written just after 1500, printed (in Latin) in 1516 and in English in 1566; and still read in most European languages. It was a new kind of writing, even if it had illustrious precedents in Plato's *Republic* and *Laws*; a fictional narrative, which plays on More's contemporaries' great excitement with travel and with the discovery of a different humanity to show that a new kind of society might actually already have been in existence in some distant country. A place, More wanted to demonstrate, where the achievement of *voluptas*, honest pleasure, was the aim of any man or woman, so that the whole of society was eugenically organised to achieve it. These remote people were not Christian when 'discovered' by More's narrator, but having received

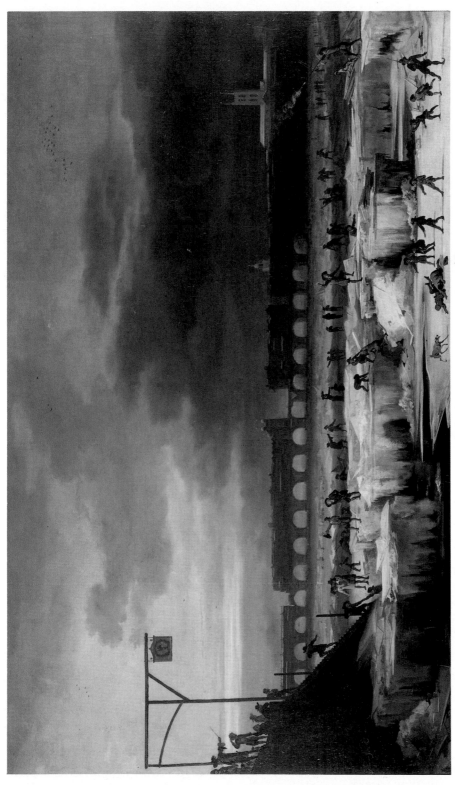

1. Abraham Hondius, The Frozen Thames (1677), looking eastward towards old London Bridge. The painting, the earliest known of the river, portrays the freeze of 1676-7. (See p.175)

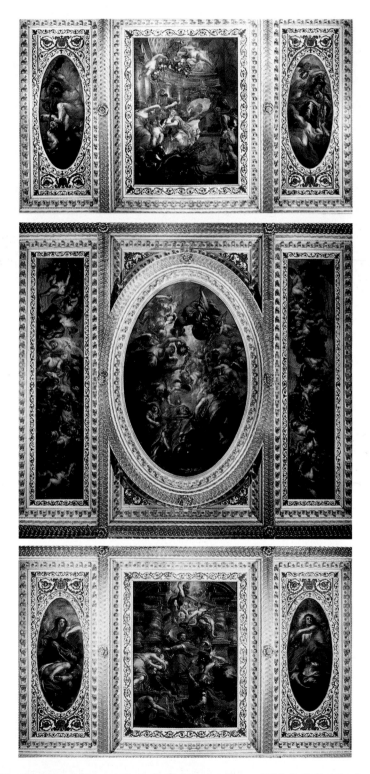

2. *Peter Paul Rubens, ceiling panels in the Banqueting House, Whitehall, London (completed 1634). (See p.249)*

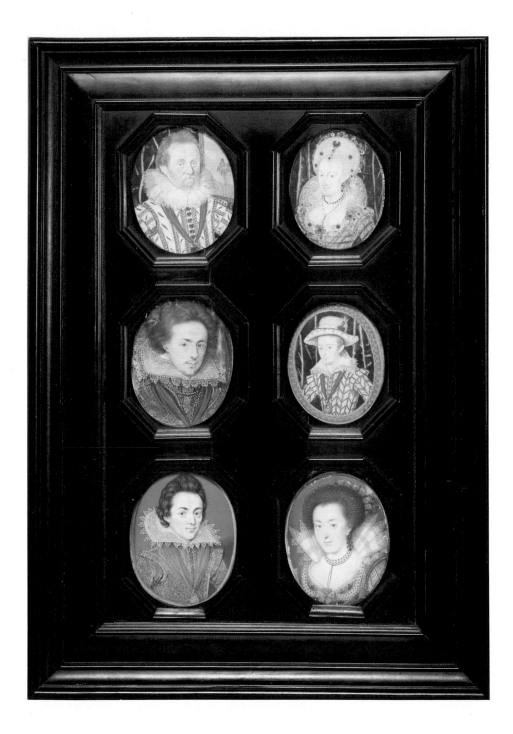

3. *Nicholas Hilliard and Isaac Oliver, framed set of royal miniatures (l to r, top to bottom):*
James I; Anne of Denmark; Henry, Prince of Wales; King Charles I when Young;
Frederick of Bohemia; Elizabeth of Bohemia. *(See p.242)*

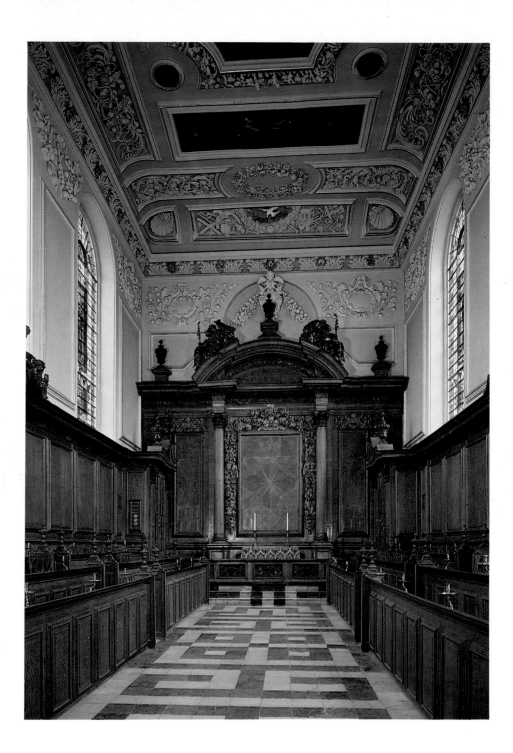

4. *The chapel, Trinity College, Oxford (1691-5); carving by Jonathan Maine. (See p.285)*

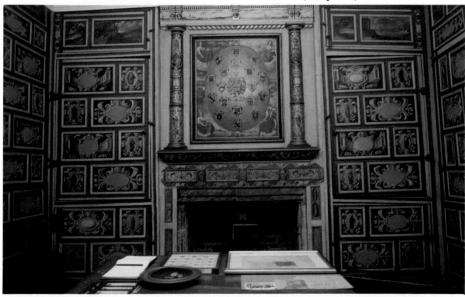

5. *Long-case clock made for William III by Thomas Tompion (c.1695-1700). (See p.299)*

6. *Kederminster Library (1617), Church of Langley Marish, Berkshire. (See p.279)*

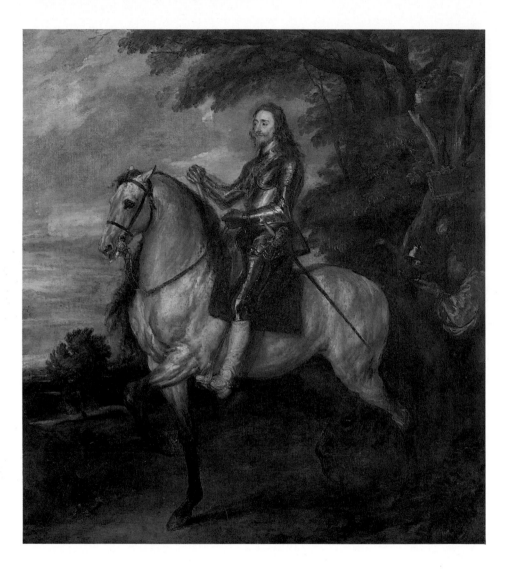

7. *Anthony van Dyck*, Charles I on horseback (c.*1635-6*). *(See p.244)*

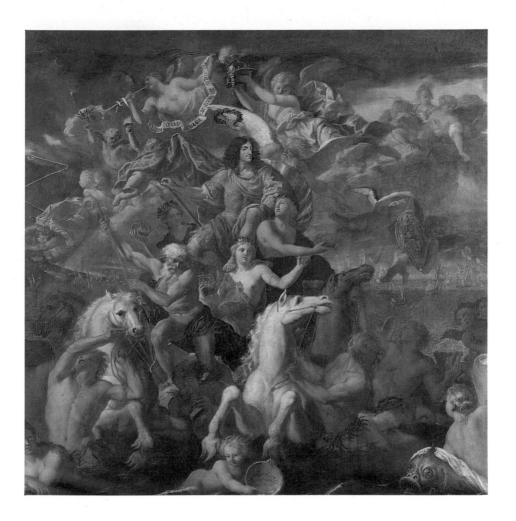

8. *Antonio Verrio*, Sea Triumph of Charles II *(c.1674). (See p.263)*

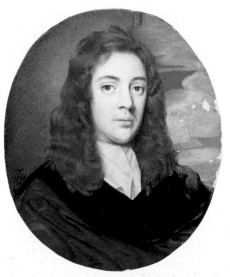

9. *Thomas Flatman*, Charles Beale
(1664). (See p.256)

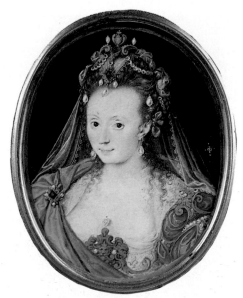

10. *Isaac Oliver*, A lady in costume,
probably for The Masque of Queens (1609). (See p.116)

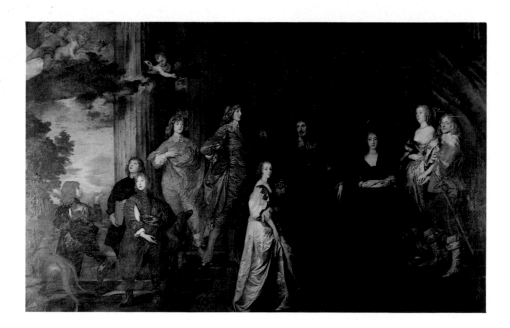

11. *Anthony van Dyck*, Family of the 4th Earl of Pembroke, *in Wilton House (1635-6)*.
(See p.246)

missionary teaching from him, many were at once converted. Since the way they lived was in any case already 'naturally' Christian, there were to be no martyrdoms. Religious coercion was not practised among them, a significant feature in a book by a judge who condemned several people to the stake for heresy, and was himself to be beheaded for his theological (or at any rate ecclesiological) convictions.

The Utopia genre became popular; Tommaso Campanella's *City of the Sun* and Johann Valentin Andreae's *Christianopolis* (1619) are among its best-known representatives, even if its consummation was the ironies and satire of *Gulliver's Travels*. However, by far the most influential if not the most popular of such novels was Francis Bacon's *The New Atlantis*. This was first printed in 1627, after Bacon's death, but was written about 1610. Although Bacon's romance is cast in a form (shipwrecked sailor discovers ideal commonwealth) borrowed from More, the structure of his society is quite different. *Honesta Voluptas* is no longer important – it is almost the by-product of the workings of a community which has been deliberately quarantined from the evils of the western world, morally, politically, as well as sanitarily. The whole state was organised for scientific research, since *to know the causes of things* is the true aim of human existence. Indeed Bacon's society also enjoyed a rational, rather deistic faith and attendant rituals, though these were presented as an inevitable fringe-benefit in a well-organised research establishment. The whole of that society turned smoothly on the recognition of the difference in talent, both qualitative and quantitative, of every citizen, who contributed according to his means to the ultimate end. As has often been pointed out, this was an idealised prophecy of the division of labour, long before it was theorised by Adam Smith or made economically essential by the new mechanisation.

The figure of Francis Bacon (1561–1626) must serve as an exemplar for the state of scientific thought in Britain at the beginning of the century. He was to become the father of German romantic historiography as the coiner of the great anti-Cartesian dictum *verum est quod factum*; in the seventeenth century he was venerated as the master of an empirical science, the man who died (at any rate in legend) in trying (prematurely) to deep-freeze a chicken in snow. Of course the legend of his death was the culmination of the effort of a long life devoted to scientific experiment which was his true vocation, in spite of time-consuming involvements in politics as well as in a legal career. He was knighted by James on his arrival in England, became attorney-general in 1613, Lord Chancellor and Baron St Albans in 1617/18 (*Verulam*, the Latin name of St Albans was the title he used in his books). He became Viscount in 1621 and was deprived of his office for corruption and negligence, though only imprisoned in the Tower for a few days. His most important theoretical work, *Novum Organum*, the *New Method*, was published the year in which he was raised to the peerage. The accusation of taking bribes, a common enough offence at the time, did not diminish his scientific prestige, nor the King's benevolence.

And yet the King – or the court generally – had little sympathy or understanding for his greatest achievement. 'It is like the peace of God, which passeth all understanding', the King is reported to have said of

Bacon's *Novum Organum*; a book whose very sub-title announced Bacon's aim and his doctrine, the *True Suggestion for the Interpretation of Nature*. It was first printed in 1620 and provided Bacon's answer to the corrosive doubt about the possibility of certain knowledge which sixteenth-century thinkers inherited from the late scholastics. Bacon's sanguine answer was a trust, in spite of ancient scepticism, in sensory evidence, and in induction from observation:

For they roundly assert that nothing can be known; we, that but a small part of Nature can be known by the present method. Their next step however is to destroy the authority of the senses and understanding, whilst we invent and supply them with assistance . . .

Of course it followed from such a faith, as Bacon clearly saw, that the more observations you accurately record, the more secure and extensive the basis of your philosophy. What seemed like real scepticism to Marin Mersenne, Bacon's questioning of the value of deductive logic, was by implication a philosophy of progress: nature shall be put to the question and racked with experiment until it yields to the inductive process those axioms which coincide with natural laws and defend men from the four kinds of idol which had hitherto governed them: *idols of the Tribe* – which arise from the fallibility of man in general and his perceptions; *of the Market*, from the fallibility of human discourse; *of the Den*, from the fallibility of individual perception; and finally *of the Theatre*, theoretical idols, which arise from false deduction from the three species of false philosophy. Bacon calls these, for short, *Sophistic* (as in Aristotle's corruption of natural philosophy by logic), *Empiric* (as in the Alchemists' overcredulousness in single experiments), and *Superstitious* (in any mixing of theology with philosophy). From these idols inductive methods, and the unity of science, will rescue mankind, and will lead to the *Great Instauration* (the title of another one of Bacon's books), when reason will govern all human affairs.

As is evident from the honours which Bacon enjoyed, and his large personal fortune (some of which was no doubt acquired through underhand methods), he was not an isolated figure whatever may have been thought of him at court. His thinking may have been outstandingly radical and brilliantly formulated, the prose more lucid than any written up to that time (and it was a great period of prose-writing), but the substance of his concern was not unlike that of his fellow-citizens over a couple of generations.

A quite different attack on early seventeenth-century commonsense was made in France. In the year before the publication of *The New Atlantis* in 1627, young René Descartes, serving in the Duke of Bavaria's army, had his momentous dream in Ulm, which allowed him the glimpse of a wholly consistent, 'admirable' science. It was to lead him to a conception of what may be known which was very different from, and in many ways much more coherent than, Bacon's. In the years which followed he constructed its exposition. The condemnation of Galileo by the Roman inquisition in June 1633 led him to withdraw his principal work, the *Treatise on Method*, from the printer – even in Holland. It was finally published in 1637. Descartes then only went back to France for relatively short periods; he lived and

worked quietly in Holland, though even there he was accused of heresy and sedition. The King of France granted him a pension in 1647 (which he seems to have been unable to collect), but he stayed in relative safety until Queen Christina invited him to Stockholm as her teacher of philosophy, and where a chill caught during early morning, snow-bound lessons led to pneumonia and his death in February 1650.

Unlike the Baconian, the Cartesian method had little place for induction. The answer to scepticism about the nature of what may be known was not the question to phenomena but the question to oneself. A summary of it is only too easy to reduce to a caricature: at the risk of doing that, if the reader were to imagine himself working through the primary intuition that when I come to question my own being the only necessary answer to my question about my own being would be, *Cogito ergo Sum*, 'I think, therefore I am', he might see that this very answer provided the basis on which the whole 'admirable science' of the dream at Ulm could be built. My thinking is the guarantee of my being which has an existence quite separate from my physical presence, my measurable selfhood. On this conviction a wholly consistent and stable structure of clear and simple ideas could be erected with the help of the syllogistic cement despised by Bacon.

'My thinking' was different, however, from 'my extension'. There was no necessary bridge between the two kinds of thing, the extensive thing, the thinking thing. Thinking needed no place, required no extension for its activity. Extension was all that could be measurable; it could be mapped according to three coordinates, with which anything extended could be enclosed and situated in relation to anything else. In that sense my extended and physical being, *res extensa*, independent of my thinking, *res cogitans*, could be described as a working piece of machinery. My thinking being, like my soul, required only a kind of nodal point at which my intention might be inserted into the extension of my flesh; however minuscule that embryo, intention would then occupy and animate the extended mass. The great machine of the universe was analogous in that once created, conceived by its Maker, it required only the initial push for the whole system to begin operating.

These two attitudes, fundamentally irreconcilable, brought to a close an age of speculation during which the uncertainties engendered by the nominalist controversy had been variously exorcised. After that, the maintaining of an unbroken nexus between what was thought and what was done or felt became increasingly difficult. The direct influence of mind on matter through the operation of number remained the aim of the various magus-figures, very powerful in the second half of the sixteenth century, and well into the seventeenth. The influence of Bacon and Descartes or their followers was neither wholly consistent nor immediate. Astrologers went on advising princes and generals – even Popes – in spite of the fact that astronomical extension, for all its vast scale, became subject to the stringent laws of measurement which conjured away its fatality.

Almost incidentally, Descartes' friend, Marin Mersenne, struck at a vital ancient doctrine. It had been believed since remote antiquity that Pythagoras, the pre-Socratic mathematician-philosopher, had discovered one of the inner

laws of the universe when hearing blacksmiths hit anvils with hammers of different sizes which produced a definite harmony. On measuring the hammers, he found that there was a definite relation between size and sound, so that the dimension of 1:2 produced an octave, and other ratios of simple numbers produced the other intervals of the musical scale. When these measurements were applied to chords, Pythagoras discovered the inner harmony of the measurable universe.

By a simple expedient (which no-one had apparently hitherto considered) Mersenne found that no such relationship existed. While there was certainly a relation of tone string-lengths, none existed for hammer sizes. It was not possible, many musicians had maintained for some time, to use the Pythagorean harmonies to compose audible music. The discontinuity between the *res extensa* and the *res cogitans* also implied that there could be no *direct* relation between what the artist thought and invented and what his audience heard or saw. Certainly there could not be any necessary relation between different senses. The effect on the arts, which were certainly transmitted to the mind and the soul through the senses, had therefore, as far as their causing agreeable or disagreeable sensation, to be explained by some methods quite different from the old account of the noble senses perceiving a harmony which was some echo of the music of the spheres of which Plato had sung, and which was still a favourite theme much beloved by seventeenth-century poets.

The harmony of faith

The quarrels of the philosophers were carried on at a rather rarified level against a background of daily and violent conflict. The Thirty-Years War (1618–48), though fought mostly in western Germany and the Low Countries, began with the expulsion from Prague of Frederick Elector Palatine, King James's son-in-law, whose marriage was mentioned earlier. He had been elected King of Bohemia by the local magnates, a title which was also claimed by the Habsburg Holy Roman Emperor. Frederick and Elizabeth, his wife, retained the affection of the Commons; partisanship for his cause made a Spanish war very popular in Britain.

As religious wars continued in Europe, so the quarrels round the monarchy in Britain continued through the reign of the first two Stuarts. They were often involved with matters of church- government. James had attempted one kind of settlement based on the accommodation of Calvinist doctrine to Episcopal church-government, but his theology and ecclesiology were not easy companions, though the two archbishops, Bancroft and Abbot, managed to sit out the conflict. It was with the appointment of the stout, energetic, martinettish, pious William Laud to Canterbury that the compromise broke down.

Since the Hampton Court conference, James I's policy in church and state was short-term, and bent on the Scottish model: by sharpening all conflict the King could keep the peace among the different factions. And yet after the murder of Henry IV of France, and while the Emperor Rudolph shut himself up with his alchemists in Prague and so retired from direct political action,

James saw himself as the senior 'tractable' European monarch. One of his dreams therefore was a general church council to be held some sixty years after the one at Trent which had solemnly deposed Elizabeth, to be presided over by the Pope and himself in tandem. This was not as radical nor as improbable as it may now seem. Although James was excommunicated, a number of approaches had been made to him, and a Spanish marriage for his son would have entailed accommodation. He was, in any case, by no means the first excommunicated British sovereign to be reconciled to Rome. The Papacy had struck at several Holy Roman Emperors, never mind a number of pre-Reformation English Kings; in fact the whole of Britain had been collectively excommunicated – the technical term was 'put under an interdict' in 1208 by Pope Innocent III, following King John's opposition to Archbishop Stephen Langton and his confiscation of monastic land.

In 1606 a new initiative seemed possible. Pope Paul V had put the Republic of Venice under an interdict. It was the culmination of a long feud over the Republic's rights to judge churchmen by the same laws and in the same court as laymen, as well as other problems of ecclesiastical rights. James wanted to open negotiations for a union of non-papal episcopal churches, in which he also attempted to involve Poland, whose large Protestant and orthodox populations were pressing for a separation from Rome.

Meanwhile the decision was taken to maintain a permanent embassy to the Venetian Republic. Sir Henry Wotton (1568–1639), whom James had already met in Scotland, had come on a secret mission to the King from the Duke of Florence, to warn him of a poisoners' plot. On that occasion dashing Wotton masqueraded as an Italian quite convincingly, so endearing himself to James on a number of counts. On his way to take up his Venetian posting he dedicated a book to a German humanist with a Latin version of his aphorism, which has become famous in his punning English, that an ambassador is 'An honest man sent to lie abroad for the good of his country'. While at his embassy Wotton lived on the Brenta canal and played the Venetian country gentleman – typically, the sort of person for whome Palladio had built the country houses two generations earlier; he appreciated these country houses and indeed the architecture of Palladio very much, and therefore recommended Palladio's treatise as essential reading to anyone who wished to know about Italian literature and civilisation.

When Wotton returned to England after his last Embassy King James was dying; he too felt an old man. The government owed him a fortune, since he had hardly been paid in the foreign service. He wanted (and obtained) the provostship of Eton for his old age. But there were six other candidates, one of whom was the – then disgraced – Francis Bacon. To establish his claim as a literary figure, Wotton wrote the *Elements of Architecture*, which was to become the most famous and lapidary English architectural book. It was recognised as a masterpiece of prose as well as clarity almost immediately, and soon translated into Latin; his literary fame with his contemporaries depended on it since the letters, which had earned him the respect of a small group of his correspondents, were not published in full until 1907. Nevertheless, the way in which the King's decision to recommend Wotton was manoeuvred via the Duke of Buckingham is an object-lesson in Stuart

place-seeking and place-buying. A great deal of money changed hands. Disappointed candidates had to be consoled with offices and honours.

Wotton himself was a sincere churchman. When he went to Eton he took minor orders, attended church daily and devoutly, continued a lively interest in theology, yet wanted his tomb inscribed 'The Itch of Disputation will prove the Scab of the Church'. With John Donne, George Herbert, Richard Hooker and Robert Sanderson, Bishop of Lincoln, he became one of the five Anglican worthies celebrated by Izaak Walton. Keen churchman though he was, Wotton's book has not a word about church-building: none were to be built in the foreseeable future; it is therefore addressed exclusively to house-builders.

The possibility of a reunion of Christendom, or of any kind of reconciliation between recriminating and warring factions of Christians, was the most constant will-o'-the-wisp of seventeenth-century intellectuals. The project was taken up again in the 1630s in the form of a number of schemes for a Protestant union. Comenius, Hartlib and others had discussed them, and even considered inviting eirenic Catholics like Mersenne into the negotiation. There were approaches to the Scandinavian and German Lutherans, to the Dutch Remonstrants, with William Laud (1573–1645) as a possible president of a reformed, more-or-less Protestant universal church. Laud had also toyed with the possibility of a return to a reformed Rome, though he was probably embarrassed rather than pleased by the offer of a scarlet hat.

Contacts with Orthodoxy, both in Russia and in the Near East, were also very attractive since the common denominator of Lutheran and Orthodox theology could be seen as the uncontaminated foundation deposit of the primitive church. In 1621 the Cretan theologian, Cyril Lucar (or Lukaris, 1572–1637) who, as a Venetian subject had studied at Padua and Geneva, became Patriarch of Constantinople and the senior prelate of Orthodoxy in spite of accusations of Calvinism against him. He had been Patriarch of Alexandria (the second Orthodox prelacy in seniority) since 1602 and throughout that time sent students to Protestant universities, including English ones. Sultan Murad IV had him murdered on a suspicion of stirring up a Cossack rebellion. No successor came as close to Protestant opinion.

It is therefore hardly surprising that Laud should be insistent on the importance of Oriental learning: he re-endowed the chair of Hebrew at Oxford and founded a new one of Arabic, while presenting the University with a large number of Hebrew, Arabic, Persian, Indian, even Chinese books. There were also a few Orthodox, mostly Greek, clergy in Britain, one of whom, placed by Laud in his own College of St John at Oxford, astonished his fellows by roasting some pungent-smelling beans which he had brought with him in a sack, from which he made a bitter black drink. This is the first recorded mention of coffee in Britain; it reappears much later in the century, when it is trafficked by an Armenian in the city of London. Tea was, however, occasionally drunk in the seventeenth century, though it was not to replace ale as the breakfast drink until the end of the eighteenth.

The Court and the visual arts

Whereas James saw the splendour of the court as an adjunct to his Royal state, Charles I had an almost instrumental, or at any rate rhetorical, view of Royal entertainments. He really did believe that harmonious music reconciled discordant hearts; and that masques could be used as declarations of royal policy.

A wholly new type of patron emerged in King Charles's reign, the most notable of whom was Thomas, a member of the great Howard clan and second Earl of Arundel (1586–1646). His grandfather had been beheaded for plotting with Mary Queen of Scots, and his father had been attaindered and condemned to death, though not executed, for having masses said for the success of the Armada. Thomas was restored to his titles by King James in 1604, and in 1609 went on his first continental tour, acting for the crown at the impeachment of Francis Bacon; in 1613 he accompanied Frederick and Elizabeth back to the Palatinate. In his train he took Inigo Jones, the designer who had been promised the reversion of the surveyorship of the King's works; as mentioned earlier, Jones had first visited Italy in Danish services. After his Palatine embassy was over, Arundel went on south, to Italy, taking Jones with him. His last service for the crown was to take Queen Henrietta Maria back to France and to safety in 1642. But he had also been involved in a late attempt (in 1636) to rescue the Palatine Elector's territories from Spanish annexation.

It is not clear how Arundel's love of art was born. He was of a generation in which the great collectors of art were a new, proliferating brood. There is little doubt that this pastime originated in Italy, with the collection of archaeological fragments – gathered in the Vatican Palace or in the Medici residences. Although the greatest of artists were commissioned to paint portraits, altarpieces in churches or decorations for castles, palaces, even town-houses, the making of easel-pictures which were not intended for a specific place and function was a relatively novel activity. Popes, the Roman nobility and Italian princes, had already begun collecting antiquities and 'objects of vertu' (which included freaks, exotic shells and plants as well as modern paintings) in the sixteenth century. Art-collecting had not touched England until the seventeenth, but then, beside Arundel, another victim of the passion was the King himself. It is worth underlining that the collection of antiquities in the first half of the seventeenth century went hand-in-hand with the patronage of modern art. On his accession Charles I attempted to attract Italian artists, such as the painters Guercino, Francesco Albani, and the sculptor Pietro Tacca to England; in the event he persuaded the aged Orazio Gentileschi – who had been a friend of Caravaggio – to come from Paris, with his daughter Artemisia, also a distinguished painter (she had brought one of the early documented cases for rape against her perspective teacher, yet another painter, Agostino Tassi).

Gentileschi painted the ceilings of the cube hall in the Queen's House at Greenwich which Inigo Jones had designed for Queen Anne of Denmark, while Rubens (1577–1640) painted the more important ones on the ceiling of the banqueting hall in Whitehall, another design of Jones's, which presented

James I as the heir of Arthur and the monarch of universal peace. The King
had been able to welcome Rubens not only as one of the great European
painters of his day, but also as a statesman working for 'the party of peace' in
Spanish Flanders to persuade the Spanish court to drop its war against the
Dutch – and the English. Rubens's friendship with the court was also
responsible for two other achievements: the settlement of his assistant
Anthony van Dyck (1599–1641), and the purchase of the Mantuan pictures.

The Gonzaga rulers of Mantua had collected avidly for two centuries, and
had employed Rubens early in the 1620s as director of their galleries.
Financial embarrassment forced the sale of their prestigious collection in
spite of local protests, though they were determined that it would not pass to
any rival Italian family. As it was, the presence of Rubens in London at the
time of the arrival of some of the Mantuan pictures ensured that London got
the best of them.

However, Rubens's presence had a quite different and more symptomatic
importance. He was recognised as a very able negotiator-diplomat by the
Kings of England and Spain as well as by the Governors of the Netherlands
and the Dukes of Mantua. In the sixteenth century, only men of letters with
clerical connexions were thought suitable for such a role, but in the
seventeenth century artists began to take over some of the places vacated by
the clergy at a time when religious intolerance made it impossible to employ
them as diplomats or international middlemen. Sir Balthazar Gerbier, painter
and architect, was another artist involved in negotiations. Easel pictures,
tapestries, sculptures and all kinds of works of art assume a part in
international exchange, just as miniatures, medals and portraits had done a
century earlier. The process snowballs until the time of Napoleon, who had
most of his Italian war indemnities paid in works of art.

As for van Dyck, Lady Arundel, herself an avid collector, had in any case
already met him on their respective Italian travels and he tried his luck in
Britain without any official invitation. The King was delighted: he was
constantly working, he was knighted, and at the outbreak of the Civil War
was contemplating the decoration of the walls of the Banqueting House with
a procession of the Order of the Garter, under that ceiling of Rubens's.

Charles I seems to have had a genuine understanding and love of art, like
his mother, Anne of Denmark. Inigo Jones (1573–1652) entered Royal service
through the Danish connexion. Starting as the decorator of court masques he
advanced to Surveyor to Prince Henry, and finally effective Royal architect
and arch-connoisseur. The masque was already an institution when Jones
became its great virtuoso. The masque was not a simple theatrical
performance, not even anything resembling a modern ballet (though music
and dancing were a very important part of it). The 'actors' – also known as
'masquers', who indeed were usually masked – were not professional actors
and actresses; though they had to buy themselves curiously expensive
costumes and were on some occasions paid large sums to take part. They
were great ladies and gentlemen, sometimes the King and Queen themselves.
The masques were therefore a mix of charade and pageant, with the verses
sometimes recited or sung by 'professionals', while the steps, the 'action',
were performed on the stage. There was no drama, in the Aristotelian sense

of being purged by pity and terror, since there was no representation: the actors 'impersonated' themselves through their allegorical attributes.

Jones regarded his duties as extending beyond the design of individual buildings – he reckoned to transform the whole of the building trade in England in the service of a 'classical' ideal. None of the other artists who had entered the country from abroad, such as the Dutch architect-garden designer, Solomon de Caus, or the rather mysterious Italian Prince Henry imported as master of *his* works could have had the enormously powerful effect which an energetic and learned native-born artist-architect had achieved. Certainly his transformation of the building trade, and the ease, the familiarity, with classical mouldings which it displays in the second half of the seventeenth century was the direct and long-term result of Inigo Jones's teaching. Of course his most important single building, the Banqueting Hall, was part of the old Palace of Whitehall, but in his mind (and with encouragement from Charles I) he was to see it as the nucleus of a Royal palace on the scale of the Vatican or the Escorial. However, Britain was not to have such a building until the beginning of the twentieth century, when Buckingham Palace was given its overbearing façade.

Jones's great achievement in transforming the building trades was paralleled by the influence which the Professors at Gresham's college had exercised on 'rude mechanics'. The science of the classical orders, which Elizabethan builders had seen as a fascinating but arbitrary innovation in its concentration on precise proportions and ornamental detail which provided the surface of the building with a narrative coherence and which told of mythical origins, seemed to Jones to display the operation of number as a wisdom analogous to that of the navigators and map-makers and engineers of his time. It is in that spirit that he 'restored' Stonehenge as a Roman temple of the sky-god.

Two of his contemporaries and friends, Robert Fludd (1574–1637) and William Harvey, saw his achievement in a similar way. Harvey has already been mentioned as having followed the King to Oxford, where he was made Master of Merton College: and he is of course famous as the first to formulate accurately the idea of the circulation of blood in the body, and of the heart as a pump. Fludd, who also practised as a physician in London, is much the less familiar. As an 'empiric' he, like Harvey, welcomed the ideas about chemotherapy which had been developed in Germany by Paracelsus; he was in correspondence (though often in violent disagreement) with Mersenne and with Kepler. He was an enemy both of the heliocentric system and of the authority of the ancients, yet relied on scripture and the examination of nature, as well as on the alchemical and cabbalistic doctrines he had imbibed from the neo-platonic philosophers of the two previous centuries. What he had in common with many other philosophers of his time was a belief that the structure of memory mirrored that of rhetorical argument, and that the theatre, as it was described by ancient writers, Vitruvius in particular, was a privileged representation of such ideas. This view seems to have been shared by many actors and tragedians (Shakespeare, though perhaps not Ben Jonson) as well as their audiences.

Philosophical and scientific ideas were not distributed politically. Fludd,

accused of witchcraft by a Laudian clergyman, was without question a royalist. William Lily, an astrologer with whom he was in correspondence, was, nominally at any rate, with the Commonwealth — though he also advised the King. Such matters did not divide parties. But then neither did interests of an economic kind – apparently. When the Civil War broke in English society, neither its causes nor its exact topography were clear, though certainly the division did not follow economic or even political or ideological divisions predictably.

Civil War and the Commonwealth

It was Charles I's rather ineffectual attempt to renew the Tudor machine of government after the death of the Duke of Buckingham which brought him into headlong conflict with parliament. James I had allowed the whole business of management both of church and state to decay through his reliance on favourites and placemen, and the extensive machinery of corruption. Monopolies on trade were a common source of income for courtiers. The accusation of simony, the sin of buying spiritual power, was hardly ever made in Jacobean England since all ecclesiastical offices were for sale. Legal offices were sometimes even auctioned. When William Laud became Bishop of London in 1628, he put an end to such practices and imposed uniformity of worship in his diocese. When he moved to Canterbury in 1633 he wanted to impose the same order on the whole Anglican church; the parish organisation was reinforced through a system of visitation, liturgical practice regulated. And of course there was an impact on architecture and sculpture. The elaborately carved porch which Laud had added to St Mary-the-Virgin, the University Church at Oxford, was one of the provocations which led to his execution. But his tenure of the Bishopric of London coincided with an ambitious programme for re-facing the Cathedral of St Paul, which was carried out with intense royal approval by Inigo Jones, and which included the largest portico of free-standing columns to be put up outside Italy since antiquity.

A brief but sustained attempt to re-establish the ascendancy of the clergy, in which Laud sometimes even saw himself playing a role analogous to his French contemporary Richelieu, could not last: Laud was no tactician. He did not reprove those who addressed him as 'Holy Father' and even 'Holiness'. When he attempted to impose the same Order of Service in Scotland, while repossessing church lands which the Scottish lords had appropriated, they made common cause with the presbytery, raised an army and invaded the north of England.

Charles then summoned his most trusted, though wholly unamiable servant, Thomas Wentworth, whom he had made President of the North in 1628 and sent to Ireland. But although Wentworth raised an army against the Scots and although he was made Earl of Strafford in 1640, it was too late to be effective. Strafford was impeached the following year and the King had to assent to his execution for fear of riots; at the same time he had to give his assent to allow parliament to sit until it had repealed itself – the Long

Parliament sat until it was terminated by Cromwell in 1653 and recalled, in 1660, in order to dissolve itself. In 1641 it issued the Grand Remonstrance accusing the King of various forms of misgovernment, and planned to impeach the Queen. The King then forced his way into the chamber and attempted to arrest the five leading opposition members. Shortly after that William Laud was also impeached and imprisoned in the Tower. He was beheaded in 1645; on the scaffold he preached a long and closely-reasoned justification of his actions. The clergy was to reconquer some of its academic positions, but Laud's attempt to reinstate it as a counterweight to the squirearchy was doomed; even if many of the men whom he appointed to high office, such as Matthew Wren, Bishop of Norwich, survived into the next reign. Wren sat out the Civil War and the Commonwealth unrepentantly in the Tower for eighteen years.

Meanwhile in 1642 the King and Queen left London. The Queen, escorted by Lord Arundel, went to Paris, while Arundel continued on to Padua, where he died in 1646. Charles went to Nottingham where he set up his standard. Though he was chronically short of funds, he had enough of an army and some able generals; however, he could not maintain his initial successes, and refused to negotiate effectively. Again, mismanagement and intransigence betrayed him.

The King's defeat, imprisonment and death bear on the story marginally. The arts suffered. The complex and sonorous music of the Laudian church was replaced by the monodic hymns and psalms of the Puritans. Henry and William Lawes fought for the King, William dying in battle. Large-scale building was limited to a few country houses in the provinces, and had not really recovered by the Restoration. The only visual genre which could have any success during such a period was the portrait; and indeed Peter Lely, who had arrived in London from Haarlem in the inauspicious year of 1641, stayed through most of the Commonwealth period to become Charles II's favourite painter. What is perhaps more material here, the dispersal of many noble collections allowed him to become one of the most remarkable artist-collectors of all time. Charles I's own collection of pictures was an obvious victim of his defeat. It was sold over a period of years, and many paintings and sculptures were bought by the German banker, Eugène Jabach, for Cardinal Mazarin who had succeeded Richelieu as the French King's chief minister.

However, the ferments acted as a stimulus to writing and publishing. John Milton (1608–74), the most 'complete' man of letters of his time: pamphleteer, logician, linguist, as well as Paradisal author and imitator of Aeschylus in *Samson Agonistes*, was a fervent Republican. Although in religion he was a convinced anti-Calvinist, as well as (for reasons not entirely impersonal) a defender of divorce, he became the Latin secretary to the Commonwealth. His assistant Andrew Marvell (1621–78), later Member of Parliament for Hull, was another man of letters who went on to argue for a Republic long after Charles II's return. The divisions of the Civil War cut strangely elsewhere also: the professors of Gresham's College, for instance, were fairly evenly divided between King and Commonwealth. Nor did the success of the New Model Army, the lower class recruits to the

parliamentary cause drawn from apprentices and tenant farmers, lead to a redistribution of wealth. Indeed many of the Puritan divines of the time, in their commentaries on the commandment to *Honour thy Father and thy Mother*, extended its mandate to the whole social hierarchy: 'that law doth extend to all that are our governors', as Henry Ireton, Cromwell's son-in-law, put it.

The one royal enterprise which Oliver Cromwell (1599–1658), Lord Protector of England supported more effectively than any king had done before him was the navy; he also, inevitably had to reorganise the army on which his power rested. For that, of course, he needed to exact taxes on a scale which the Stuart kings could envy: as Abraham Cowley said: 'he took armes against two thousand pounds a year, and raised them himself to above two million'. However, the Commonwealth navy could protect the colonies of the trading companies effectively, and on that the future prosperity of the City of London (and to some extent the rest of the country) was based.

Intellectual and economic life in transition

In Commonwealth times a British scientific academy came together almost spontaneously. It was known as the 'Invisible College', though it is not certain that it ever met under that name. Its central figure was in fact the absent Comenius, though in a way the promoter was Robert Boyle (1627–91; whom a Victorian wit called 'the father of Chemistry and Uncle of the Earl of Cork'), a rich and intensely pious amateur who was primarily responsible for the reformation of the ancient teaching of the elements and for making the fundamental distinction between mixture and compound which was essential to modern chemistry. Its other members were Theodor Haak, (already mentioned as a correspondent of Mersenne's, though now mostly remembered as the Dutch translator of Milton), Henry Oldenburgh, a German scientific amateur who was to become the first secretary of the Royal Society, and was a correspondent of the great Dutch scientist Constantin Huygens, the Hungarian chemist, Hans Hunneade (Hunyadi), John Pell, a mathematician and diplomat of great reputation but no visible achievement – and even Milton himself. Some of these seem to have met at Gresham's College, where they were joined by the mathematician John Wallis, who was an expert on cypher and the deviser of the mathematical symbol for infinity, and John Wilkins, another mathematician, later Bishop of Chester and one of the advocates of an 'artificial' philosophic language.

A later recruit to the group was the diminutive and brilliant Christopher Wren (1632–1723), who moved at the age of thirty-one from a Gresham's professorship of Astronomy to the Savilian professorship at Oxford. He was also known as a wit and an anatomist, and seems indeed to have invented the hypodermic syringe by extrapolating the idea of intravenous administration of drugs from Harvey's notion of the circulation of the blood.

The 'Invisible College' had been informal, technical and scientific rather than generally cultural. But when Charles II returned, one of the first acts of his government was to institute a *Royal Society* in London to channel and distil the intellectual ferment in the country. Inevitably Boyle and Wren as well as the other members of the College moved into the Royal Society,

which has been the centre of British scientific thought for over three hundred years. There was practically no change in the scientific community, either as a result of the Civil War, or as the result of the Restoration.

What was true for the structure of intellectual discourse was equally valid for the hierarchy of economic power, which the Commonwealth, in spite of various radical movements within it, had barely affected. Some great landowners (Lord Fairfax and Manchester) were generals in the Common-wealth army. Cromwell himself was a prosperous squire and farmer. Yet when he assumed the trappings (beyond the realities) of power, he shied away from any royal title, even the allusion to elective monarchy. Now elective monarchy was an ancient institution. The Holy Roman Empire was the most prominent example, though other states were cited more often: the city of Genoa, or the Polish Commonwealth; Venice, as has already been suggested, was the most important, even if the British Commonwealth showed none of the Venetians' pathological fear of dynastic power. In effect the British monarch had been elected occasionally, and would be in the future: William and Mary. George I had ambiguous claims to the throne – yet when the monarchy was re-established in 1660 it was as the hereditary house of Stuart.

On Oliver Cromwell's death in 1658 his son Richard (who was already a kind of life peer) was recognised by parliament as Lord Protector. He was deposed by the army. It was one of his generals, George Monck, who bridged over the interregnum and arranged the return of Charles II, who made him Duke of Albemarle for his trouble. Richard Cromwell retired to Paris, where he lived for twenty years under an assumed name before returning quietly to Britain in 1680. He died as a private citizen in 1712. The principle of primogeniture and succession, which guaranteed the passage of landed property in Britain, was mirrored and exalted by the Royal example. Indeed Oliver Cromwell would have resented any parliament which interfered with the 'sacred rights of property' and would have called it 'arbitrary', a term of abuse in his vocabulary. The Great Revolution was not about the distribution of property, as the abundant literature of the period testifies: pamphleteers did not attack wicked and extortionate landlords but unfair and extortionate lawyers. It was the greed and élitism of the professionals which enraged the Puritans. John Lilburne (1614?–57), the most important Leveller theorist and agitator, held private law classes for laymen. He maintained that there was no *natural* justification for the inequalities between man and woman, or between different classes of men; and he supported extending the property-based parliamentary franchise, though not to servants and the like who, not being free men, would voice only the opinion of their employers. There are constant reiterated appeals for free law and free medicine throughout the century from various reformers, however.

The Restoration

Of those who worked for the Restoration, several had been Commonwealth commanders, like George Monck, Fairfax and Manchester; they had retained their estates, even increased them. They were men of power, not of principle.

The case of the Russells, Earls of Bedford, is both outstanding and exemplary. John, the first Earl, a creature of Henry VIII, worked for Edward VI and Lady Jane Grey, but then joined Queen Mary and negotiated her marriage settlement with Philip II. His son and his great-nephew (both called Francis) were the second and fourth Earls (Edward the third Earl has little to add to the story – though his wife Lucy, née Harrington, was the only literary figure in the family) and it is after the death of the second Francis, who was the first large-scale property-developer in London, that the ascent of the family begins.

Covent Garden was the first (and for a long time the only) comprehensive piece of planning to include a public market and a church as part of an architectural unity in London. Its architectural importance is discussed elsewhere in this volume: moreover, Inigo Jones was not only the King's favourite architect, but more important, a member of the tough Commission for Building which controlled the quality and extent of all new construction in and around the city – he was the opportune appointment, which gives no indication of the Earl's true architectural preferences. In St Paul's, Covent Garden, Inigo Jones managed to reconcile his own (and the King's) Laudian principles of worship with the Earl's Puritan and parsimonious demand that the church should be 'like a barn'.

The Bedfords had invested in the Providence Island company, which held much land in and around Rhode Island and was much favoured by the Puritan party in the nobility. Their original land holdings were in the west country, Devon and Cornwall. It was the need to transfer money from these western estates safely that led them, like some other families, to maintain a provincial office (in their case in Exeter) where their income was paid in, and transferred to London credit through bills of exchange on a London jeweller, an arrangement which is at the origin of the whole of the modern banking system.

Earl Francis II and his son William (who was to become the first Duke under William III) also held much land in East Anglia, round the Isle of Ely. When on military service in Holland Earl Francis had already noted the advantage of dyking, and a succession of Dutch engineers advised the Russells and some other neighbouring landowners on the expensive but profitable business of draining their Fenland marshes (for which Earl Francis had to mortgage some of those west-country estates) and making them arable. This involved tampering with and even enclosing much common land, and incidentally destroying the way of life of the Fenland squires which depended on 'grazing, fishing and fowling', as William Camden has it, more than on farming. There was an anti-Russell campaign which involved the night-time cutting of new dykes and other sabotage, in which the Cromwells, the Lord Protector's family, took part. As a young Member of Parliament Oliver Cromwell had championed the squires, but later saw the economic advantages of a scheme which had been halted by civil war; it was continued with the hired labour of Scottish and Dutch prisoners and government protection, so that by the time of the Restoration all Russell land was free of mortgages.

There were to be difficulties later when, as a result of the drainage and of

soil-shrinkage, the land level fell and the sea-exits silted-up. Another Dutch remedy was applied, and windmills multiplied in East Anglia. Meanwhile Earl Francis II had died, and the vast Russell fortune was vested in William, the Earl Francis's son; another William, his son and heir known as Lord Russell, was condemned to death for high treason under James II and beheaded in Lincoln's Inn Fields. Earl Francis was made a Duke as a consolation for that death.

In 1695 that first Duke's grandson and heir, yet another William, was married to the grand-daughter of Josiah Child: baronet, Mayor of Portsmouth, the main investor in the East India Company and dubiously famous for buying parliamentary votes on a large scale. The bride and groom were both still in their teens and the marriage was performed by Gilbert Burnet, the historian of 'the Reformation' and of 'His Own Time', Bishop of Salisbury who had attended his friend Lord Russell on the scaffold. It was a grandiose and splendid affair which was to prove fruitful in many ways, and made the Russells one of the richest families – not just in Britain but in the world.

The preservation and even increase of the Russell fortune from Tudor to late Stuart times was unbroken by the disturbances of the Civil War, and yet they were not known as patrons of the arts or architecture. The only really distinguished building in their purlieus was Covent Garden: only to satisfy the King. Nor did the Child family become at all interested in the arts until Francis Child bought Osterley House (Middlesex) and commissioned the Adam Brothers to transform it for him in the 1760s.

The new King, Charles II, was a surprising figure: over six foot high, saturnine, cynical, controlled, another Stuart with strong intellectual interests – though in his case it was experimental science. He had come determined to heal and to stay. From the general indemnity he granted on his return, only the regicides were excluded. The bodies of Cromwell (who had been given a royal funeral only eighteen months earlier) and Ireton were exhumed and beheaded at Tyburn, their heads put on pikes at Westminster Hall, where they were still to be seen twenty years later. The only prominent parliamentarian who was executed, Sir Henry Vane, a Puritan mystic and brilliant administrator, had himself always been an apostle of toleration.

The King's and many of his courtiers' cynicism is sometimes thought typical of the time, and the Vicar of Bray the representative Caroline cleric. And yet two thousand Puritan clergy gave up their livings at the Restoration as many Laudian Anglicans had done twenty years earlier, rather than be bound by oath to the new King. Some went as private chaplains to Whig lords; others had to find more menial employment – the universities were closed to most of them. The new establishment marks the beginning of the comfortable Anglican church of parson and squire which was to provoke the great dissenting reaction in the eighteenth century. It was, on the whole, a well-living and frugal church: and it promoted a great distaste for court life among the upright and squires, however loyal they were to the crown.

The Restoration also signalled a return to earlier national sports: to hunting and to dancing and even racing. The King himself was a keen rider, winning the plate at the Newmarket races, twice, perhaps fairly, too. The

theatres, formally closed by Parliament in 1642, had slowly re-opened. A few companies were given Royal letters-patents in 1660, but the playhouses remained firmly under the control of a monopoly wielded by two courtiers, Killigrew and Davenant. Some open-air theatres of the previous reign were roofed-in on the French model and other buildings were adapted. Artificial lighting was also introduced and the elaborate scenery of the masque adapted to the new 'mechanical' stage. However, until the next century the theatre was largely a London phenomenon, dominated by the court and tending to the bawdy, cynical and superficial.

The public also demanded other, more substantial fare; Elizabethan and earlier Stuart drama was revived and one major poet (who was also an early fellow of the Royal Society), John Dryden (1631–1700), adapted earlier plays for the new stage, and wrote several new ones, collaborating on a number of what must now be called 'operas' (such as the *King Arthur* mentioned earlier) with the great Henry Purcell (1659–95).

As for the visual arts, though Charles II did not have his father's love or knowledge of them, he had considerably more funds at his disposal and good artists – or at least architects – to commission. He had brought with him an architect and a painter; Hugh May had been associated with Peter Lely (1618–80, even lodged with him and they had both joined Charles's court in The Hague in 1656; both returned in his train. However, in spite of retaining a high standing at court and obtaining much work through the office of Works (particularly at Windsor Castle), May's career was overshadowed by the brilliant nephew of Bishop Matthew Wren of Norwich (one of Laud's shrewdest associates), Christopher, who was mentioned earlier as a member of the 'Invisible College'. Lely, on the other hand, who remained May's lifelong friend, became the dominant painter of the court and his work is the true portrait of Caroline society and its beauties.

The tentative beginnings of the new Caroline patronage were dominated and transformed by the events of 1665–6: the plague and the Great Fire of London. The plague had affected the population of inner London quite drastically, since it hit the centre more than the country or the suburbs; inevitably mortality among craftsmen was very high. The Fire, on the other hand, put exorbitant demands on the depleted corporations. The result was an influx of 'foreigners' (by which were meant people from outside London and its corporation, rather than from across the Channel: though inevitably they, too, were attracted) and produced a great deal of miscegenation. The fire-panic resulted in the complete rehaul of English building regulations, which still mark aspects of current building construction in the country. Yet centralised control on the work of re-building was not successful, although under Christopher Wren the Office of Works became an influential organisation of building patronage for three reigns. The plan for London and its discussion engaged the King himself and the whole Royal Society for several years. Wren and the other Fellows could not maintain a plan for the City against the pressures of property-owners – who were much more concerned to retain the exact location (and preferably the exact area) of their sites than in taking part in a grander overall plan.

The post-Fire period provided the only opportunity for large-scale urban

planning in Britain for over a century. Building activity revived with
surprising vitality almost instantly on the King's return, even though he
never managed to establish himself in the style of his cousin Louis XIV:
Charles II planned to build a vast palace at Winchester where, like Louis at
Versailles, he too would be free of London mob pressure and the vicinity of
Parliament. It would be on an 'Arthurian' site and within view (at any rate
from the dome) of the sea. But parliament saw to it that the palace which
Wren designed never got higher than the ground floor. His successors, James
II (his brother) and William III (son of William of Orange) never took much
interest in the scheme. On the other hand, projects in which Charles II
invested much energy, Chelsea and Greenwich Hospitals, went on building
well past the end of the century. However, a series of fires at Whitehall
(which was the main Royal residence) inclined William III to build himself
a palace, and he chose to do so first at Kensington, and then more permanently
at Hampton Court, which until the re-building of Buckingham House by
Nash for George IV was the nearest thing Britain had to show for a Royal
palace.

The urban texture of London was expanding very quickly on the profits of
colonial trade. The politics of Charles II's reign were dominated, as had been
the Commonwealth, by the rivalry with Dutch traders in both the Americas
and the Far East. The Dutch war was Charles II's first military adventure and
it ended with a Dutch raid up the Thames and the Medway. This and the
subsequent conflicts with the Dutch were due, of course, in large part to the
success of the British trading companies and their achievement was only
marginally affected by the war. Fort Amsterdam on Manhattan Island
became New Amsterdam in 1653 but New York in 1664; and although the
Dutch took it back in 1673, it was only for a year. New York it has remained,
in honour of James II, the last prince in Europe to see political antagonisms
in religious terms.

However, James and Charles were both devoted to the navy, and both
protected the traders; Charles particularly wanted London to grow, and the
City to appear splendid. His chief minister, the Earl of Clarendon – who was
also James II's father-in-law – was granted land to the north of Green Park,
where he built a big mansion: he was followed by Berkeley, Devonshire and
Burlington. The new *faubourg* of London was lined with great houses on the
Bath–Bristol road, and succeeded to the role the Strand had in medieval and
Elizabethan London. Of course this led to the filling of the interstices with a
texture of streets and squares between the linear faubourgs, a 'west-end'
which became infinitely more agreeable to inhabit than the crowded city.
Other developments were being promoted to the north and west. In the end,
even the Russells were to pull down their great house and create Bloomsbury
as a vast and dense suburban development.

The doctrine of the Divine Right of Kings in which James I and Charles I
had so firmly believed was not restored together with the monarchy. It was
succeeded by a cynical version of the social contract, that of the Hobbes's
Leviathan in which the maintenance of sovereignty, whatever the
constitutional system, is seen as the ultimate aim of all social policy and the
one protection against the evils of anarchy. However much the humourless

and rigid James II might have protested, it was due to that kind of doctrine that he held on to his throne as long as he did – that, and the gentry's belief in the legitimacy of succession.

In any case, patronage was drifting away from the court to the great landowners. Unlike the Bedfords in the previous generation, the great lords of late Stuart Britain began to see themselves as patrons of the arts and upholders of culture, even if the vast collection of the rapacious Clarendon in his new house in Piccadilly consisted almost entirely of portraits. Charles II attempted (and to some extent succeeded) in re-constituting his father's gallery. Although he employed two Italian painters (Verrio and Gennari) who went on working for his successors, the great artists of his reign were French and Flemish rather than Italian; neither he nor his brother would sacrifice funds to woo any painter or sculptor worth having away from the French court, though there was talk of the great landscape gardener, Le Nôtre, working at Greenwich. It was not until the Edict of Nantes (by which Henry IV had promised Protestants toleration of their faith and worship) was revoked in 1685 that an influx of French artists and craftsmen, many of whom were Protestants, flooded England.

To the men of the next century, the figures which dominate the Britain of the last years of the seventeenth were not the monarchs but two heroic thinkers. One was the physicist-theologian, Isaac Newton (1642–1727), who had filled the vast, even infinite – yet potentially measurable – spaces of Descartes' Universal Mathesis with the intangible but omnipresent force of gravity:

> Mad Mathesis alone was unconfin'd,
> Too mad for mere material chains to bind,
> Now to pure space lifts her ecstatic stare,
> Now running round the circle finds it square
>
> (Alexander Pope, *The Dunciad*, IV, 31–4)

The other was the philosopher John Locke (1632–1704), who had elevated the Baconian principle of induction into a universal anthropology: all men were, according to him, born undetermined in any way – free, if not innocent: and all their thinking and feeling was determined by what they derived from experience. The work of these two men was to be the leitmotif of the eighteenth century all over Europe.

Part II
Studies in the Individual Arts

The beginning of Miles Coverdale's Bible (1535), the first complete Bible in English, dedicated to Henry VIII.

1 The Authorised Version of the Bible

DAVID DANIELL

The Authorised Version of the Bible (or King James Bible), first published in
1611, has been especially loved throughout the English-speaking world. It
has been considered the particular glory of English letters. Right through the
sixty-six books of the Bible, from 'They heard the voice of the Lord God
walking in the garden in the cool of the day' (Genesis 3) to 'God shall wipe
away all tears from their eyes' (Revelation 7), phrases of lapidary beauty have
been deeply admired: 'My days are swifter than a weaver's shuttle' (Job 7);
'How art thou fallen from heaven, O Lucifer, son of the morning?' (Isaiah
14); 'The shadow of a great rock in a weary land' (Isaiah 32); 'Ask, and it
shall be given you; seek, and ye shall find; knock, and it shall be opened
unto you' (Matthew 7); 'In him we live and move and have our being' (Acts
17); 'The unsearchable riches of Christ' (Ephesians 2); 'Fight the good fight
of faith; lay hold on eternal life' (1 Timothy 6); 'Looking unto Jesus, the
author and finisher of our faith' (Hebrews 12); 'Behold, I stand at the door
and knock' (Revelation 3).

The Authorised Version was not, of course, the first translation of the
Bible into English, though it has been considered the greatest. It was a
translation – or rather, a revision – made not from the Latin versions of the
Bible (particularly that known as the Vulgate) which had dominated the
Christian church for 1200 years, but from the best available texts of the
original Hebrew (Old Testament) and Greek (New Testament). In this the
Authorised Version was in line with the movement throughout Europe,
already two generations old, not only to make Scripture widely available in
the vernacular, but to cut straight back through the intrusive Latin, as it
were, to the primitive church. England was (and is) a Protestant country, and
this was a Protestant endeavour.

Phrases from the Authorised Version are so familiar that they are often
thought to be proverbial wisdom: 'Am I my brother's keeper?' (Genesis 4);
'Escaped with the skin of my teeth' (Job 19); 'Saying peace, peace, when
there is no peace' (Jeremiah 6); 'They have sown the wind, and they shall
reap the whirlwind' (Hosea 8); 'The salt of the earth' (Matthew 5); 'The
signs of the times' (Matthew 16); 'Fell among thieves' (Luke 10); 'Scales fell

from his eyes' (Acts 9); 'Full of good works' (Acts 9); 'A law unto themselves' (Romans 2); 'Wages of sin' (Romans 6); 'The powers that be' (Romans 13); 'All things to all men' (1 Corinthians 9); 'Filthy lucre' (1 Timothy 3); 'Let brotherly love continue' (Hebrews 13); 'The patience of Job' (James 5); 'Perfect love casteth out fear' (1 John 4). If such are not proverbs, it has been thought, then they must surely be from Shakespeare.

Within a short time of his arrival in London from Scotland, King James called a meeting of senior clergy. Tensions in the Elizabethan Church of England threatened any pretence of national religious stability. The conference was held over two days at his palace at Hampton Court in January 1604. It was a failure. Indeed, it could hardly have been otherwise, being set to squash rather than attend to the anxieties of the Puritan party, who were only allowed four representatives to face eighteen adversaries, led by the Archbishop of Canterbury and the Bishop of London, with seven other bishops, seven deans and two doctors. That failure had long effects, some of them dire. On the last day, and in the last minute, as a digression from another matter, attention was given to the suggestion by the leader of the Puritan party, Dr John Rainolds, President of Corpus Christi College Oxford, that it might be time to consider a new translation of the Bible.

The proposal was a thoughtful one, for in fact there had been advances in understanding Hebrew and Greek, as well as better texts available, since the last successful translation from those original languages into English, half a century before. The English language was changing: and church practices, the apparent cause of dissension, might be better integrated by means of a new translation in the best modern English. The King supported the idea, for, it must be said, ultimately rather unbalanced reasons of his own. The Bishop of London, and others, apparently spoke against the proposal. Nothing very much then happened. The next Convocation ignored the matter, which appeared to have been dropped. Eventually, three years later, scholarly panels were set up in Oxford, Cambridge and Westminster to go about the work, under firm instructions. It was to be a revision, not a fresh translation. The detailed directions issued to the panels have survived: they were to base their work on what had been, as it happened, the least successful of sixteenth-century translations into English, the Bishops' Bible of 1568. Multiple copies of this were issued to the revisers. The King's insistence that this should be the basis destroyed the chance of the new version being in the best modern English, for a reason which will become apparent.

Many centuries before, parts of the Bible had been translated and paraphrased from the Vulgate into Old English and Middle English. The followers of John Wyclif, in the time of Chaucer, translated the whole Bible from the Vulgate, twice: though prohibitively expensive, hand-written copies of these circulated widely. In the 1520s and 1530s, William Tyndale, a man of quite extraordinary gifts, translated and printed (while in exile, and persecuted) the New Testament, twice, and the Pentateuch (the first five books of the Old Testament); he almost certainly had half the Old Testament prepared for the press. Tyndale had made himself proficient in Hebrew at a

The first page of the first printed English translation of the Bible, begun (and never completed) by William Tyndale in Cologne in 1525. He went on to translate and print the Pentateuch (first five books of the Old Testament) and the complete New Testament twice: in 1526; and afresh in 1534, that being the basis of all New Testaments in English until recently.

time when very, very few Gentiles in Europe knew the language; and Greek was only just becoming a little more widely known in the universities. His translations are still astonishing for his understanding of how the two ancient languages function, his accuracy in rendering the original texts, and his ear for direct, compelling English. His work is still, even today, the bench-mark for translating the Scriptures into English. His New Testaments were seized and burned and their owners persecuted. He was strangled and burned in October 1536. Ironically – a grievous irony – Henry VIII was at that time changing his mind: Bibles printed in English were dedicated to him, the first being Coverdale's of 1535, which virtually (though necessarily silently) took over Tyndale. Henry VIII himself authorised the well-named 'Great' Bible, a huge, lavish lectern volume, a re-working of Coverdale back in the direction of Latinised English, to try to satisfy reactionary bishops. Other Bibles followed, during Edward VI's reign. The printing of English Bibles in England was halted overnight at the accession of Mary. Translators were among the many martyrs. Many of Britain's scholars fled to Europe.

The translation of classical and Biblical texts into the vernaculars had been a growing European activity for most of the early sixteenth century. Luther's 1522 German New Testament did a great deal to found a modern German language. The translation into English of Latin and Greek classical authors – Virgil, Ovid, Horace, Seneca; Homer, Plutarch and scores of others – often by way of intermediary languages (Aristotle had earlier come via Arabic; now Plutarch arrived via French) is one of the triumphs of sixteenth-century humanist scholarship. Germany was a centre of what slender knowledge of Hebrew there was at first: Tyndale clearly learned it there (no-one in England knew it in the 1520s). Oxford and Cambridge were becoming centres of Greek learning: scholars from Oxford had crossed the Alps at the turn of the century to learn Greek at the new Italian academies. Colet's Oxford lectures on Paul in Greek had turned Erasmus to New Testament work. Fifty years later, in mid-century, the power-house for such multilingual scholarship was the city of Geneva, where Calvin's university, under the great scholar Theodore Beza, was a centre of interest in classical, even more than Biblical, texts.

The finest of English translations of the Bible before 1611 – and some would say the finest absolutely – came from the English exiles in Geneva in 1560. It was recognised as the best, in its scholarly rendering of Hebrew and Greek. Its English phrases kept as close as was possible to Coverdale, and thus to Tyndale. It was beautifully produced: the Geneva printers were setting new standards of book-design. It was in clear Roman type, not the heavy Gothic black-letter. It had encyclopaedic explanatory notes in the margins and elsewhere, and maps, pictures, concordances, cross-references and much else. It was designed to be studied, in the hand or round the table, and wonderfully fulfilled Tyndale's purpose, shared with Luther and stemming from Erasmus, no less, that 'he that driveth the plough' should know the Bible intimately. The Geneva Bible came in all sizes in its long life. It was, for common people and clergy alike, the Bible in English, used by all wings of the English church. It ran through 150 editions before it was killed in the following century for political reasons.

This can be hard for modern readers to grasp, for it has either disappeared from view, or remained in sight only as the target of bigoted abuse. What was a *locus* of Renaissance and Reformation scholarship, a triumph of textual, theological and linguistic excellencies, universally admired, has been subject to curious mythologising. Copies of editions of the most influential Geneva Bible, containing the New Testament revised by Laurence Tomson of Magdalen College Oxford in 1576, are not common, and many who pass on or extend the misrepresentations cannot have studied a copy. The least damaging misunderstanding is to call it a 'Puritan' Bible, which mistakes both it and Puritanism. Worse is its modern reputation, usually intemperately expressed, as an extreme Calvinist tract. In fact, there is nothing in it that is in conflict with the Thirty-Nine Articles of the Church of England, and nothing from which Elizabethan or Jacobean divines would dissent (King James's paranoia is a different matter). A modern legend that it was disliked before James's anti-Geneva remarks is difficult to relate to the known facts. Worst of all has been its reduction to a snigger. Because (as other translators did) Geneva gave Adam and Eve in Paradise 'breeches', it has become known by the foolish nick-name of 'The Breeches Bible' as if it had no other significance. The survival of some of the Quarto Geneva Bibles, all falsely dated '1599', imported from the Low Countries has not helped: these squat, packed, black volumes are not attractive, and miles away from the beauty of, say, the Geneva New Testament of 1557, the forerunner of the whole Bible, which is surprisingly modern in design, type, page lay-out, clarity of text and uncluttered white spaces.

In the 1560s, the Archbishop of Canterbury, Matthew Parker, called together about a dozen bishops, scholars and dignitaries to revise Henry VIII's 'Great' Bible. Published in 1568 as a very lavish and expensive black-letter folio, even bigger than the 'Great' Bible, and sumptuously printed as a lectern Bible with few marginal notes, it was absolutely not intended for the private reader. Known since as the Bishops' Bible, it was, and is, not loved. Where it reprints Geneva it is acceptable, but much of the original work is incompetent, both in its scholarship and in its verbosity. The Bishops' opening of the twenty-third Psalm sounds wrong not only because the Authorised Version's better version (taken from Geneva) is so familiar: 'God is my shepherd, therefore I can lack nothing: He will cause me to repose myself in pasture full of grass, and he will lead me unto calm water.' The Bishops' translators went not to the Hebrew but to Latin versions (they were re-working the 'Great' Bible after all). Close acquaintance with the Bishops' Bible gives a sense of breathing the air of the Vulgate. It went through a number of editions in various sizes. It was a step back by the 'establishment' in the direction of those clergy who still believed that the true Bible was the Latin version.

Such Latinity had various effects. One strand in the original arguments against the Bible in English at the time of Henry VIII was the belief that the English language was not good enough. Tyndale maintained with passion, as well as outstanding linguistic theory and practice, that Hebrew went naturally into English and badly into Latin. The poets under Elizabeth demonstrated the superior range and subtlety of English. For King James to lay as the

foundation of his new revision the most Latinate of recent indigenous Bibles was unfortunate indeed: and it led to a quality in the Authorised Version which Geneva had more successfully avoided.

Any translator of the Bible has to come to terms with two problems. One is the sheer bulk, which modern paper-making and printing techniques tend to conceal. With the Apocrypha, the Bible contains eighty books, many of them long. The other difficulty, which is if anything harder, comes from the variety within the Hebrew and Greek. Hebrew poetry has a small vocabulary, but can vary from epic and primitive ballad-of-victory to congregational worship, private religious meditation, proverbial declaration, or the vivid, powerful, desert-wind intensity of much of Hebrew prophecy, which again is continually various. Hebrew prose, even within one book, can vary from the surreal bare narrative of Genesis 22 to the rich *Novelle* of Genesis 37–50. Similarly, though the Greek of the New Testament is the *koine*, the ordinary language of transaction throughout the Eastern Mediterranean at the time (only Luke 1/1–4 is in classical Greek), there are great differences between the Greek of the four gospels, and between them and the Hebrew mind of Paul writing in philosophical, theological Greek, to say nothing of the special effects of the Epistle to the Hebrews, or Revelation. A good translation gives some sense of these differences. Tyndale, for example, in his account of the Fall of Man, makes an English as raw as the Hebrew. Bending the English in the direction of Latin can lead to a flattening, with everything near the same sonorous level. In this way, the private erotic poems of the Song of Songs can come out sounding too much like the noisy public worship of Psalm 150; and Paul can sound musty and old-fashioned, rather than like a mind exploring the frontiers of experience.

The Authorised Version was given a further, and more serious, push towards Latinity, and thus a slightly more lofty distancing, from the exiled Catholic community at Rheims. As part of the Jesuit-led thrust to destabilise Elizabeth's England (a treasonable operation: there were martyrs) a new and polemic New Testament in English, with bitterly controversial notes and a parallel attack on the English Protestant Bibles, was circulated from Rheims in 1582. Scholars in England were quick to reply. One, William Fulke, produced a line-by-line, word-by-word refutation, printing the new Rheims New Testament in parallel with the Bishops'. The controversy was useful to the Authorised revisers, and seems to have led them to take the Rheims reading rather too often. The curious Latinate 'English' of Rheims sometimes defies belief, as in John 6, 'that you may be a new paste as you are Azymes', or Ephesians 3, 'concorporat and comparticipant', or 2 Peter 2, 'conquinations and spots, flowing in delicacies'. Misplaced admiration led the Authorised panel to the unfortunate 'if any bowels and mercies' of Phillipians 2, and other curiosities.

By a very particular mercy, however, the Authorised revisers on the whole preferred scholarship to royal whim. The Preface to the Authorised Version contains the explanation that they worked 'to make a good one better'. Though it is not spelled out, that this 'good one' is the Geneva Bible is wholly clear. For one thing, whenever in this long Preface the revisers quote Scripture, which they do fourteen times, they do so not from their own

THE
GOSPEL ACCORDING
to S. Matthew.

CHAP. I.

1 The genealogie of Chrift from Abraham to Iofeph. 18 Hee was conceiued by the holy Ghoft, and borne of the Virgin Mary when fhe was efpoufed to Iofeph. 19 The Angel fatiffieth the mifdeeming thoughts of Iofeph, and interpreteth the names of Chrift.

THe booke of the *genera-tion of Iefus Chrift, the fonne of Dauid, the fonne of Abraham.

2 *Abra-ham begate Ifaac, and *Ifaac begate Iacob, and *Iacob begate Iudas and his brethren.

3 And *Iudas begate Phares and Zara of Thamar, and *Phares begate Efrom, and Efrom begate Aram.

4 And Aram begate Aminadab, and Aminadab begate Naaffon, and Naaffon begate Salmon.

5 And Salmon begat Boos of Rachab, and Boos begate Obed of Ruth, and Obed begate Ieffe.

6 And *Ieffe begate Dauid the King, & *Dauid the King begat Solomon of her that had bin the wife of Vrias.

7 And *Solomon begat Roboam, and Roboam begate Abia, and Abia begate Afa.

8 And Afa begate Iofaphat, and Iofaphat begate Ioram, and Ioram begate Ozias.

9 And Ozias begat Ioatham, and Ioatham begate Achas, and Achas begate Ezekias.

10 And *Ezekias begate Manaffes, and Manaffes begate Amon, and Amon begate Iofias.

11 And || Iofias begate Iechonias and his brethren, about the time they were caried away to Babylon.

12 And after they were brought to Babylon, *Iechonias begat Salathiel, and Salathiel begate Zorobabel.

13 And Zorobabel begat Abiud, and Abiud begat Eliakim, and Eliakim begate Azor.

14 And Azor begat Sadoc, & Sadoc begat Achim, and Achim begat Eliud.

15 And Eliud begate Eleazar, and Eleazar begate Matthan, and Matthan begate Iacob.

16 And Iacob begate Iofeph the hufband of Mary, of whom was borne Iefus, who is called Chrift.

17 So all the generations from Abraham to Dauid, are fourteene generations: and from Dauid vntill the carying away into Babylon, are fourteene generations: and from the carying away into Babylon vnto Chrift, are fourteene generations.

18 ¶ Now the *birth of Iefus Chrift was on this wife: when as his mother Mary was efpoufed to Iofeph (before they came together) fhe was found with childe of the holy Ghoft.

19 Then Iofeph her hufband being a iuft man, and not willing to make her a publique example, was minded to put her away priuily.

20 But while hee thought on thefe things, behold, the Angel of the Lord appeared vnto him in a dreame, faying, Iofeph thou fonne of Dauid, feare not to take vnto thee Mary thy wife: for that which is conceiued in her, is of the holy Ghoft.

A 2 21 And

*Luke 3. 23.

*Gen. 21. 3. *Gene. 25. 26. *Gen. 29. 35. *Gen. 38. 27. *1. Chro. 2. 5. ruth. 4. 18.

*1. Sam. 16. 1. and 17. 12. *2. Sam. 12. 24. *1. Chro. 3. 10.

*2. King. 20. 21. 1. chro. 3. 13.

|| Some read, Iofias begate Iakim, and Iakim begat Iechonias. *1. Chro. 3. 16, 17.

*Luke 1. 27.

translation, nor even from the Bishops', but from Geneva. For another, they silently took over a great deal of Geneva's text verbatim. To drive this point home: in the first three paragraphs at the start of this chapter I quoted nearly thirty much-loved or familiar Authorised Version phrases. Without exception, they were taken by the Authorised revisers directly from Geneva.

Through the King's pressure, eventually forty-seven revisers were set up into six companies, two in Oxford, two in Cambridge and two in Westminster, dividing the Bible, including the Apocrypha, between them. The leader of the first London panel, taking the first half of the Old Testament, was the learned dean of Westminster, Lancelot Andrewes: he was later Bishop of Winchester, but he was already famous as a preacher; his sermons are still admired today as an example of how a particular set of Latin effects go into English pulpit oratory. The forty-seven were all 'establishment' figures: a number finished their lives as bishops or heads of colleges. Some care was taken to keep out anything disturbing: the finest Hebraist of the time, Hugh Broughton, was excluded; he was brilliant, original and noisy, and wrote a passionate kind of pamphleteering prose in the tradition of Nashe or Greene.

The second Cambridge panel, on the Apocrypha, worked quickly, and finished in time to assist other groups. It seems that some companies were at work by 1607, and took about two years. Then in nine months a company of twelve prepared the text for the printer. The last stages were overseen by two of them, one of whom, Miles Smith, wrote, it is generally thought, the important Preface, 'The Translators to the Reader'. Today we are fortunate in that recent work, particularly by Gustavus Paine, Ward Allen and Irene Backus, has enabled us to study a little of the process as it happened. One member of the Apocrypha panel in Cambridge, John Bois, who was also one of the twelve on the final revision committee, kept notes in Latin of the latter's proceedings. Through the modern work we can see that Miles Smith's remark in the Authorised Version's preface was accurate: 'neither did we disdain . . . to bring back to the anvil that which we had hammered'. Clearly, alternative readings were argued strongly.

The King's printer, Robert Barker, whose family had held a virtual monopoly of Bible-printing for some decades, and would continue to do so, printed the text in fine double-column folio, in black-letter, in 1611. There were chapter-summaries, but no notes: King James forbade them. Cross-references, and occasional alternative readings, were all that was permitted. The volume began with an obsequious dedication to King James, still commonly printed, which is something of an abomination, and manages to pour such praise on the royal head that it finds itself telling His Majesty that he is the 'Author of the Work', which is near-blasphemous.

Infinitely more important, though hard to find, is the eleven-page 'The Translators to the Reader'. This explains some of the origins of the undertaking, not wholly fairly, and some of the methods and intentions of the revisers. Certain passages are curiously oblique. Miles Smith seems to be asking to be seen to be avoiding something, like discussion of why the revision was necessary for example. He spends much time arguing the case for Scripture in the vernacular, as if that battle has not been won, seventy-

five years before. It is a fine and important document, nevertheless, making
its points attractively. Arguing against the sterile doctrine of always replacing
a Hebrew or Greek word with the same equivalent, and giving neat examples,
Smith says:

Thus to mince the matter, we thought to savour more of curiosity than wisdom, and
rather that it would bring scorn in the Atheist, than bring profit to the godly Reader.
For is the kingdom of God become words or syllables?

The title-page announces that it is 'appointed to be read in churches',
which is precisely right. It is first of all a lectern Bible, its Latinity very
suitable for stone buildings. It was never authorised. It has no royal seal
upon it at all. The designation 'Authorised Version' is the first of many
myths about it. Why King James did not give his name to the work he had so
enthusiastically fathered in 1604 is unknown: but he cannot have failed to
notice its dependence on Geneva.

Like all Bibles of the time, it ran through varieties of printing and edition,
and had to rival folios as well as quartos of Geneva until 1644. It was
welcomed, though not by everybody. Hugh Broughton found it 'so ill done.
Tell His Majesty that I had rather be rent in pieces with wild horses, than
any such translation by my consent should be urged upon poor churches.'
There were other, powerful, attacks. Robert Gell commented that the revisers
'had put the wrong meaning in the text and the right meaning in the margin',
surely fatal for a lectern Bible. It ran through very many editions very
quickly, which can only mean that it was popular – though there remained,
to modern ears, a surprising amount of dissatisfaction, and before 1660
further calls for a quite new translation. The author estimates that between
1611 and the official revision of 1881 there were some 1500 identifiable new
editions of the Authorised Version, many showing considerable changes in
editing, improving and tidying up. Between 1611 and 1715 there were eight
editions of the Authorised Version with Geneva's notes. The familiar version
in common use in the twentieth century has been the revision made in 1769.

Though Jonathan Swift, in one of his trickier personae (as the Earl of
Oxford), appeared to write in 1712 that he was 'persuaded that the
Translators of the Bible were Masters of an *English* Style much fitter for that
Work than any we see in our present writings . . .', the shift to full-scale
idolatry did not begin until the 1760s. With that went a growth of interest in
the version, which soon became worship of it, as something other than the
Word of God – namely, sublime English Literature. This would have been
incomprehensible, and indeed alarming, to Sir Philip Sidney, for example,
who certainly recognised the value of the Psalms as models of poetic range in
themselves: but they were the Word of God. Something called 'literature',
detached from the truths of Scripture, would be impossible for him to grasp.
God's Word was desperately, vitally, important; one's soul's life depended on
it. There would be no other reason for receiving it.

By the time of Coleridge, the shift was strong enough to induce an
o altitudo! in people who cared little for the Bible's religious truths. Some of
this adoration of the English (that is, Authorised) Bible contained a heavy
chauvinism. England, and English, had been chosen by God for His Word,

and so on. The move towards 'The Bible as Literature', shorn of all religious significance, but still the greatest glory of English letters, reached its peak between the two world wars: it was the end of a long mythologising process of exaltation – even the official revisers in 1881 had declared in their Preface that the Authorised Version had been venerated as a classic since 1611, which is untrue. Twentieth-century reactions, while maintaining deep love among the diminishing numbers of the faithful, have swung between the grotesque and world-wide bigotry of extreme fundamentalism (including reference to the 'Saint James Bible') and a dreamy nostalgia for a supposed time when England's greatness could be measured by the fact that everyone knew his Bible – and, no doubt, his place. The current fashion is near-total neglect in the wake of a dozen popular modern versions.

The frequent assertion that the Authorised Version has had enormous influence on English literature is quite hard to substantiate. Readers who approach any major writer between, say, 1550 and 1700 and who lack knowledge of an English Bible of the time, will be hampered in their understanding even more than if they lack Virgil or Ovid. Shakespeare, for example, knew his Bible very well, and it was a Geneva (probably with Tomson's New Testament), with some reference to the Bishops', and to Coverdale's version of the Psalms. It was, however, primarily the message, not the medium, which spoke to him. Bible doctrines were deep in his bones, and the frequent echoes of Geneva phrases bring their theology with them. He was not, perforce, influenced by the Authorised Version, as his work was virtually over when it appeared. (The much-bruited notion, popular across the Atlantic, that 'King James called Shakespeare in to add the poetry' belongs to Disneyland, not to serious discussion.) John Bunyan was a Bible man in every pore. But in *The Pilgrim's Progress* it is the language of everyday speech which sets the tone, and Bible quotations show as such, like raisins in a scone. If the influence of the Authorised Version means that Bible doctrines were assimilated, then that can only be agreed. Beyond that, often what the supposed influence boils down to is that when a writer uses frequent short clauses linked by *and* ('And he straitly charged him, and fortwith sent him away, and saith unto him . . .'), and especially the form *noun + of + noun* ('the fowls of the air . . . the fish of the sea . . . the wings of a dove . . . the beauty of holiness', and so on), the result sounds Biblical. This is a direct effect of Tyndale's invention of this form in 1530 to represent a Hebrew grammatical formation. General habits of Latinate archaism linked with a wash of sentimental spirituality are not worthy of association with the Authorised Version. It would be more appropriate to call strings of expressive monosyllables 'Biblical' because of Tyndale's extraordinary power with such effects.

The Authorised Version revisers could produce ugly nonsense, as they tended to in the prophetic books of the Old Testament: lacking Tyndale's genius to guide them, and deserting Geneva's discretion, they produced, for example, at Isaiah 24.16, 'The treacherous dealers have dealt treacherously: yea, the treacherous dealers have dealt very treacherously'. But when they were not derivative, and at the same time were writing English not Latin, and were at their best, they could be very good indeed. Over and over again

the panels showed, in this massive work, a sense of how the versions might be improved, like turning the Bishops' Job 39 'Hast thou given the horse his strength, or learned him to neigh courageously?' to 'Hast thou given the horse strength? has thou clothed his neck with thunder?' (a reading extravagantly admired by Thomas Carlyle: it may have come from the despised Hugh Broughton): or turning Geneva's Psalm 23 'and I shall remain a long season in the house of the Lord' to 'and I will dwell in the house of the Lord for ever'.

Though they do not quite deserve the corporate halos which later ages have given them, the revisers' imitation of the handful of exiles in Geneva half a century before in their serious attention to what they were doing; their willingness, like them (and unlike the Bishops' revisers) to use a mass of difficult material, such as many foreign-language translations and commentaries, and other versions of the ancient texts; and their determination to follow truth, not royal orders, all deserve the very highest commendation. That they kept so much of Tyndale, and Geneva, in the climate of the time, is a matter for great praise – all but one or two of the phrases in the first three paragraphs of this chapter came to Geneva from Tyndale. That they could not, or would not, more often keep his magnificent English must surely count against them. The modern reader may decide which of the two readings of Matthew 6 is to be preferred: the Authorised Version in 1611 making Jesus conclude his thought with 'Sufficient unto the day is the evil thereof': or Tyndale in 1534 rendering the everyday Greek with 'For the day present hath ever enough of his own trouble.'

St Paul's Cathedral, London (begun 1675). Christopher Wren.

2 Architecture

ANDOR GOMME

No man deserves the name of an Architect, who has not been very well versed both in those old ones of Rome, as likewise the more modern of Italy and France etc. because that with us, having nothing remarkable but the banqueting house at Whitehall and the portico at St. Paul's, it is no ways probable that any one should be sufficiently furnished with the variety of invention, and of excellent ideas, which upon several occasions it will be necessary for him to have, who has had but so great a scarcity wherein to employ his judgment, neither can it be supposed that anything should be in the Intellect, which was never in the senses.

(Roger Pratt)

Introduction

Soon after 1615 the Countess of Pembroke built a house at Houghton Conquest in Bedfordshire. It is now a melancholy ruin; but what survives, together with eighteenth-century survey drawings, enables us to reconstruct it accurately. In plan it was moderately advanced for its date – a three-sided courtyard whose main range was two rooms thick, with a hall entered centrally; but the elevations, with curvilinear gables, towers with pyramidal caps and large mullioned and transomed windows are simply in the swim of the time – except for two astonishing three-storeyed frontispieces which show a direct knowledge of Palladio and an understanding of the principles within classical design unique for their date and curiously at odds with the conventional flamboyance of the façades. Strange as it seems to us, two designers, very different in learning and inclination, worked almost, if not quite, simultaneously on the same house. One may have been John Thorpe, the other was certainly Inigo Jones.

Houghton is an emblem of English architecture in the first half of the seventeenth century, which simultaneously pursued two quite different paths that almost never crossed: the one traditional, clinging to memories of the English sixteenth century, never far from the vernacular, the creation of practising craftsmen; the other courtly, innovative, directly influenced by

continental practice and knowledge of renaissance theory. A conventional picture would show English architecture as dominated for the first and last forty years of the century by two of our most famous architects with an interregnum of unruly mannerism in between. Certainly one could not begin to describe architecture after the Restoration without pivoting on the immense phenomenon of Wren; but one could produce a consistent account of all but a tiny handful of buildings up to the Civil War without mentioning Jones at all. That that handful contains almost all the buildings that now seem to us most significant reflects our recognition of Jones's inherent greatness and the measure of his subsequent influence. But his having kept up communications with the future showed most obviously in the eighteenth century; in the seventeenth Jonesian classicism apparently led only into a dead end.

The immediate cause was the war itself. But Jones and his friends and patrons had been so closely associated with the Stuart court that there was bound to be a rejection of the court style, which was somewhat too austere, as well as too alien, for the generality of contemporary taste. After the Restoration, court taste was again dominant; but the King's stay in Holland and his close connexions with France, together with the ascendancy of the eclectic spirit of Wren, meant that the Jonesian renaissance continued out of favour. Yet Wren was so much occupied with royal works and with the rebuilding of St Paul's and the city churches after the Great Fire that his direct influence in the country was slight. Both English universities, having passed through a phase of dilettante and not always literate classicism, employed him early in his career; but the transformation of house design great and small was rather the outcome of the domestication of innovations in design and planning in the 1620s and 1630s which, whether or not Jones was ever directly involved, certainly owe much to his astylar experiments (those, that is, without classical orders); and it may be that it is through this channel that his influence and example have been more profoundly, though less obviously, experienced than in the direct application of formula Palladianism.

In contrast to times before and after, architecture in the seventeenth century cannot even roughly be described in terms of movements and fashions rising and falling and being replaced gradually or suddenly by others. There were too many cross-currents – political, religious, intellectual – too many conflicting influences from the Continent telescoped into one another, to allow any such picture of development or 'progress'. One can indeed pick out a fine pure stream – really no more than a tiny handful of buildings – running from the revolutionary classicism of Inigo Jones, through the largely unacknowledged presence of John Webb and the subtle but profound anglicisation of classical forms by Roger Pratt, to the quiet self-assurance of the post-Restoration house, which accepted a chaste balance and symmetry without the formal apparatus of classical orders, and which subsequently had so long and benign an influence on English domestic architecture. But this stream flowed through artistic jungles: a visitor early in the century would have noticed first that vast 'prodigy houses', laden with fantastic ornament taken from sources old and new, native and foreign, flourished as they had in Elizabeth's reign until the decline of the powerful courtiers sent their style slipping socially downwards into a cock-a-hoop bourgeois mannerism. In this

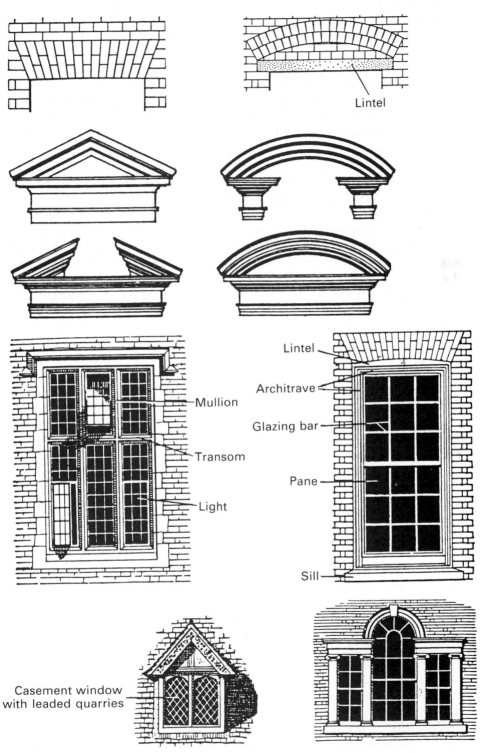

Architectural styles and details (from left to right and top to bottom). Arches: flat; relieving. Pediments: triangular; segmental; broken; open. Windows: mullion; sash; dormer; Venetian or Palladian.

style – in educated but restless hands – parodic accumulations of classical elements turned classical harmony on its head, and it was interpreted by the rough and tumble of country builders as licence to sling together features of all kinds without an understanding of their source or meaning.

But the visitor would also have seen that almost nowhere had traditional building habits been abandoned – not even where one might most expect it: half a dozen flamboyant gestures aside, Oxford built 'Tudor' colleges throughout the century; it took the Great Fire to make London realise the folly of building in timber, but years later Bristol, England's second city, was still putting up sub-medieval timber-framed houses. Gothic, in one or other of its derivative forms, is always to be found: it was present at the end of the century even among the vibrant and learned experimentation of Wren, Hawksmoor and Vanbrugh. And their introduction of the colossal baroque (in which classical orders, often of superhuman scale, are invoked to express neither classical poise nor mannerist instability but the resolution of powerful oppositions), though it produced the most memorable and monumental buildings of their time, scarcely touched the surface of the generality of English building, which went its quiet way into the eighteenth century as if the great masters had never been.

The Jacobean house

By 1600 the notion of the great house as a keep at the heart of a feudal kingdom was long outmoded. Great landowners now drew most of their income not from farming their estates but from rents, or in the topmost families from the profits of high office with the Crown, which could only be maintained by keeping in favour. This meant, among other things, royal visits; and the courtier houses became in effect spectacular hotels for entertaining the sovereign and Court. Such buildings looked out to the greater world, and so the process that started at Longleat, of putting one's bravest face forward, was confirmed: the old courtyard plan, in which all the principal rooms looked inwards, was abandoned; and the few houses such as Blickling Hall (Norfolk) and Bramshill House (Hampshire) which were built round courtyards were so because of a desire to economise by incorporating parts of older buildings. Nevertheless they too were outward-looking, though Blickling Hall (1619–22), built by Sir Henry Hobart, chief justice of the common pleas, was clearly never intended as a courtier house, and Lord Zouche of Bramshill House (1605–12) was not in the same league as the builders of Hatfield House and Audley End, palaces whose prime function was to ensure the continuing high office of their owners and which displayed themselves with consequent boldness.

Thus Hatfield House (Hertfordshire, 1607–12) was built by Robert Cecil, Earl of Salisbury and James I's Secretary of State, quite close in to the town but deliberately on the highest point of the estate. It is designed round a huge three-sided court whose welcoming projection wings contain the apartments specially contrived to accommodate the king and queen. There is nothing secretive or hidden about Hatfield, though visitors had to pass

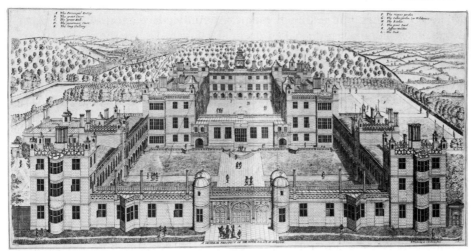

Audley End, Essex (1603–16). Bernard Janssen. Engraving by H. Winstanley.

through gates in two curtain walls before reaching the court. At the Earl of
Suffolk's Audley End (Essex, 1603–16), which, until reduced in the
eighteenth century, was one of the largest houses ever built in England, this
process was extended and further formalised in that the 'principal court' was
closed in by a lowish wall of lodgings and then extended beyond the single-
storey hall range into a narrower inner court containing the state rooms.
Vanbrugh worked there in 1708 and may well have been influenced by it in
the design of Blenheim, where the inner part of the great court is related to
the outer in something the same way, though without the dividing low ranges.

In each of these houses, and in most others of the time, the hall was still
the most imposing room, and except for the long gallery the largest, though it
had long lost its feudal function and the consequent need for a direct link
across the screens to pantry and kitchen. Yet in both Hatfield House and
Audley End the hall is entered not centrally but at one end from a screens
passage. By this period even quite modest houses had to make a show of
symmetry on their front elevation; in great houses external asymmetry was
unthinkable. Hatfield House therefore has a central doorway and passage. On
the original entrance side the asymmetrical layout within is concealed behind
a loggia and upstairs gallery; on the north front, however, which soon became
the formal entrance, large windows had to be duplicated and on one side they
light quite insignificant rooms.

At Audley End the hall itself is central, and the entrance therefore, under a
mighty two-storey classical porch, is mirrored by another porch purely for
show. Yet even before 1600, by centralising both hall and entry, there were
houses whose plans acknowledged that the hall was now only a place of
formal reception; and significantly soon after it was built on an old-fashioned
plan, Aston Hall (Warwicks), for example, was remodelled in this manner.

A further step was taken at Charlton Park, near Greenwich (1607–12), a
compact house on an H-shaped plan which adopts the layout first used at
Hardwick Hall, in which a centrally placed hall runs transversely from front

to back between a double pile of rooms. At Audley End most of the ranges were single pile, that is, one room deep; at Hatfield House the middle is, so to speak, one and a half piles, for behind the front banks of rooms are just the loggia and gallery, each only about half as deep as the hall. (The same is true at Aston Hall, where it is possible that the rear pile was an afterthought.) Compact houses make less show and there is less opportunity for the contrasting and balancing of different masses so much admired at this time, but they are far more economical. Yet Quenby Hall (Leicestershire), begun as late as 1620, is single pile throughout, with the maximum possible of external walls. One might put this down to an old-fashioned provincial designer; but stylistically Quenby Hall is no more out of date than its contemporary Blickling Hall, which is known to have been designed by Robert Lemynge, the principal architect of Hatfield House. Quenby Hall in fact is a reduced version of the north front of Hatfield – a strictly symmetrical brick façade ablaze with the fiercely rectangular grids of huge windows, jazzy with diaper patterns and with white stone dressings on all the angles of its many projections; yet the silhouette is uncompromisingly square, without gables or turrets or even a balustrade.

Hatfield House may once have had a more lively roofline; but, however enlivened with turrets, cupolas and banks of chimneys, the square-topped manner first established at Longleat and spread, even if not invented, by Robert Smythson, was the preferred way, relying for variety and climax on bold alternation of projection and recession. Eric Mercer speaks of the cliff-like mass of Charlton Park, though the façades have plenty of incident; and Quenby Hall, despite some provincial awkwardness and its retardataire plan, has a more metropolitan air than the long lax front of Blickling Hall, where symmetry is only skin-deep and the homely row of curvilinear gables set against a prominent pitched roof is no integral part of a total design. Such gables, long thought to have been imported from Holland (hence their popular name) were almost certainly a native growth: quantities were added to houses great and small, often with sad lack of imagination. The remodelling of Knole (Kent) for the Earl of Dorset in 1604–8, where, as at Blickling Hall, the gables are simply glorified dormers, shows how little the mechanical application of fashionable features has to do with architectural design.

Gables were much more intelligently handled on smaller gentry houses, especially in the south-west. The main front of Newton Surmaville (Somerset, 1608–12) is a perfect example: three flat gabled bays, in which the windows get progressively smaller from bottom to top (thus implying triangles to sort with those of the gables), alternate with narrower but boldly projecting balustraded bays which exactly fill the space between the springing of the gables, and whose contrasting rectangular form is emphasised by the upper windows precisely repeating those below. But identical five-light windows throughout the ground floor unite the contrasting bays, and light moulded strings above the windows in the flat ones confirm the visual continuity of the wall plane behind the projections and hence our sense of structural solidity. The relation between the gabled bays, wider and higher but quieter, and the narrower but more forceful projections is extraordinarily

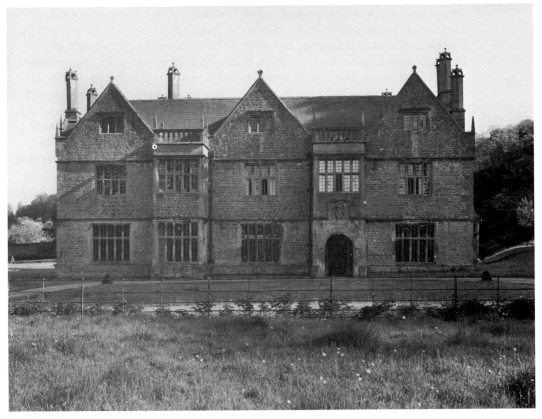

Newton Surmaville House, Somerset (1608–12).

subtle. Similar praise is due to Anderson Manor, Dorset (1622), which reverses Newton Surmaville by having gabled projecting wings and centre but bringing out the unstressed intervening bays with two linked ranks of high chimneys well above gable level. Medium-sized houses of this character, though rarely so subtle as these two, were built in quantities in the limestone belt of England from Dorset to Lincolnshire, and sometimes elsewhere: Moyns Park, Essex is a larger busier version of Newton Surmaville. The best are the work of designers of real sensitivity, who were nevertheless provincial masons without training in architectural theory.

How the greater houses were designed is still in question. Unlike Longleat, for which Sir John Thynne must take primary credit, Hatfield House and Audley End do appear to have been 'architect-designed': Salisbury and Suffolk did not, like eighteenth-century earls of creation, train themselves in practical architecture, and we may therefore call Robert Lemynge (d.1628) the architect of Hatfield and Bernard Janssen that of Audley End. But the 'architects' were in the first place contracting masons, carpenters or bricklayers, these trades being the normal ground on which they were employed. And despite the prominence of Robert Smythson in the late sixteenth century and the high repute in which he was held, no architect before Inigo Jones was ever in complete command of a building: owners,

agents and other craftsmen took a hand, and it is therefore risky in the
absence of documents to make inferences from similarity of style or even of
particular features. Lemynge is known to have designed the screens at
Hatfield, which were made by John Bucke; but other carvers were perhaps
their own designers, and the close similarity between the screens at Audley
End and Knole *may* indicate the same (unknown) hand, or simply that the
Earl of Dorset saw the Earl of Suffolk's screen and liked it.

Grand Jacobean interiors, in any case, reflect a prevailing Anglo-Flemish
taste often completely at odds with the houses' exterior architecture. But
screens and fireplaces overloaded with coarsely carved terms, grotesques and
strapwork, pilasters with inverted taper and so forth – all ornaments owing
something, though less than sometimes asserted, to continental pattern books
– such things arise not out of ignorance but as a deliberate rejection of
classical restraint and order which had gained ground and correctness
through the later sixteenth century. They can include features such as ox-
skulls and rosettes in the friezes which come stright from classical orders, and
perspective arches in the most up-to-date Italian manner – evidence of
knowledge of what was being repudiated. They represent therefore an
assertion of mannerism as a style in its own right, in which classical elements
are consciously distorted within a framework of 'classical' symmetry. The
overall effect, however, can only be called barbaric. In a few houses
decoration of this type spills on to a gargantuan frontispiece to the main
façade: Bramshill House has three tiers of inverted pilasters with grotesque
capitals, with the solecism of an additional central pilaster at the top.
Charlton's frontispiece not only has pilasters whose form has disintegrated
entirely into a riot of three-dimensional strapwork but, because the grandest
– and highest – rooms are on the top storey, an extraordinary effect of top-
heaviness caused by the huge saloon window: a total upset of the classical
principles it still mockingly reminds us of.

Eric Mercer has identified the fundamental contradiction in the Jacobean
prodigy houses – that they were

attempting to attain a classic air from essentially native buildings . . . to treat
buildings whose functions were still of a partly feudal nature in a classical fashion: an
attempt which involved . . . the contradiction of using such non-classical elements as
towers and crenellations . . . to obtain a symmetrical and classical effect.

The future was not with such buildings which proved very quickly to be a
gigantic dead end and culminated in the strangest gesture of all. In 1612,
with the help of the wayward talents of John Smythson (d.1634), Sir William
Cavendish began a toy castle at Bolsover, Derbyshire – a remarkably early
instance of self-conscious medieval revivalism. In 1629 his son, the leading
royalist in the north of England and eventually Duke of Newcastle, wanted a
suite in which to entertain the King. Smythson, who had already found place
for Flemish features on the gothic 'little castle', designed a very long free-
standing range containing a gallery back-to-back with a suite of state rooms.
all on one floor. The inner façade he graced with a row of serpentine
pedimented gables, variants of some he had admired in Holborn, London on
houses almost certainly designed by Inigo Jones (in which a pediment was

Main west doorway, Terrace Building, Bolsover Castle, Derbyshire (1629). John Smythson.

supported on S-shaped scrolls). But on the gallery front which looks outwards from Bolsover's hilltop, the spirit of parody erupts not only in a row of broken pediments but in a set of 'buttresses' in the form of vertical cannon barrels half buried in the walls: this castle which could never be defended has laid up its armoury for all the world to witness its owner's pacific intentions.

Inigo Jones and English classicism

Through much of Elizabeth's reign there is evidence of increasingly literate knowledge of classical orders (no doubt largely learnt from pattern books) and of spasmodic interest in their ornamental application to vernacular, or at any rate English, façades. Chimneypieces, doorcases, porches and architectural tombs would be given columns, more or less correct, with an entablature of sorts often incorporating an Elizabethan version of late Roman rococo scrollwork. Occasionally pieces of startling purity appeared, like the long gallery doorcase at Wolveton House, Dorset (*c.*1590). By 1600, however, interest in Italy and with it in the original sources of classical design had been swamped in the English shift towards northern Europe, especially Holland and Flanders.

The universities might have been expected to stress the classical origins of humanism, but their attitude to visual classicism was half-hearted or ambiguous. The 'splendid courteous and bountiful' Dr Thomas Nevile, master of Trinity College, Cambridge from 1593 to 1615, largely rebuilt his college: much, including the hall, is entirely traditional; the octagonal fountain is a mishmash – byzantine arches on an ionic colonnade with an ogee crown surrounded by strapwork cresting; and Nevile's new court, which appears more unified, nevertheless has, above its dainty renaissance arcade – modelled on Florentine originals – two tiers of English mullioned windows, and had a row of English gables as well. Between 1608 and 1624 three 'classical' frontispieces were built at Oxford, at Merton and Wadham Colleges and in the Schools Quadrangle: each takes the form of a 'tower of orders', a device perhaps brought from the north by the Yorkshire mason

The old Bodleian Library, Oxford (1600–36). A tower of five 'orders', probably designed and built by the Yorkshire mason John Akroyd.

Lady Cooke's house, Holborn, London (1619), drawn by John Smythson.

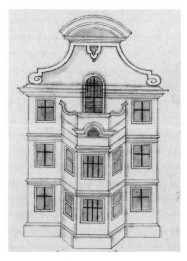

John Akroyd (1556–1613) in which pairs of coupled columns climb through four or five storeys to well above the adjoining parapet line. The towers are faced with a miscellany of Tudor and mannerist items, and they stand against buildings otherwise entirely in traditional Tudor; yet the same masons – Akroyd in two cases – built and almost certainly designed both.

Another such tower, not much more mannerly, marks the original entrance of Hatfield House: it is dated 1611, a year after Inigo Jones was paid £10 for 'drawings of some Architecture'. Two years earlier Jones had designed (speculatively) a façade for the New Exchange in London, a piece of scene-painting which, John Summerson observes, is 'obviously the work of somebody who had had little to do with architecture and nothing with building'. The orderly arcaded gallery which flanks the Hatfield tower re-uses the quieter sections of this design: its ground-floor arches do not stand on columns as in Nevile's Court but spring from imposts of square piers in front of which are pilasters carrying their own entablature above the arches – a quite different mode of construction which retains the integrity of the wall and was favoured especially by Roman and north Italian masters in the sixteenth century: it derives from the ancient Roman Theatre of Marcellus. The Hatfield House façade also is really scene-painting in stone; it is almost certainly Jones's first piece of executed architecture.

Inigo Jones (1573–1652) was already approaching forty. His first recorded commission is as a painter, and it was as a designer of masques that he first became publicly known: between 1605 and 1641 he designed over fifty masques and similar entertainments, almost all for the Court (see pp. 112–17). Though the 'buildings' involved, being no more than backdrops or wings on a stage, required no knowledge of construction, the masques established Jones's reputation at Court; and in 1613 he was given the reversion of the post of Surveyor of the King's Works, which came to him two years later on the death of Simon Basil.

Jones may have bought his all-important copy of Andrea Palladio's *Quattro Libri dell'Architettura* as early as 1601, when he was apparently on his first visit to Italy. In 1604–5 he spent eighteen months there, much of it in the company of the Earl of Arundel, one of the first and greatest of English antiquaries and art-collectors and a devoted patron and friend: it was probably Arundel who introduced Jones to the Countess of Pembroke. The copious annotations in Jones's own copy of Palladio show the minuteness with which he was now studying architecture: from Palladio or elsewhere he also learnt the principle of the true king-post roof-truss, which he was the first to introduce into England and which Wren later thought out with greater understanding: it has ever since been the most commonly used, as it is the most reliable form of truss for ordinary pitched roofs. In Venice Jones met Vincenzo Scamozzi, Palladio's most distinguished pupil, whose *Idea dell'Architettura* confirmed Jones's own inclinations towards neo-classical purity and his rejection of mannerist elements often found in Palladio. His unexecuted design for the Star Chamber (1617) shows him attempting to incorporate mannerist windows within a Scamozzian framework; yet the austere, refined and perfectly self-consistent Queen's House at Greenwich was begun the year before.

The Queen's House as we know it, however, is the result of several transformations. It was designed for Queen Anne of Denmark who wanted a foot in each of the palace gardens and Greenwich Park, then separated by a public road whose line is now represented by the colonnades added *c*.1810. So the house was built in two parts joined above the road in the middle so that the upper floor plan was H-shaped. (Additional bridges filling in the east and west façades were added in 1662.) An elevation drawn perhaps in 1616 still includes mannerist windows and conflicts in scale. But only the ground floor was completed by 1619 when the Queen's death stopped building; and even that was altered when, it seems, the whole house was redesigned for Henrietta Maria in 1630. Its plan, as Summerson has shown, derives from study of Giuliano da Sangallo's Villa Medici (1485) near Florence, also - shaped but with a hall in place of the bridge; the south elevation, with ionic loggia set into the centre of the upper storey, is a simplified inversion of one of Palladio's grandest palazzi, the Chiericati in Vicenza, which Jones thought 'very magnificent'.

From this end of the long Georgian century of Palladian classicism the Queen's House – cool, poised, its proportions calculated with exquisite delicacy, spare of ornament and without a trace of mannerism – seems familiar and even English. Indeed its characteristic reticence and understatement – no pediment, no big eaves, no order except on the loggia, hardly even window architraves – do represent an Englishing of the Italian villa formula which it absorbs. But this very quietness, as well as the accuracy and consistency of its classical information and its complete all-round symmetry, were much more obviously a rejection of the stylistic

The Queen's House (south front), Greenwich (begun 1616). Inigo Jones.

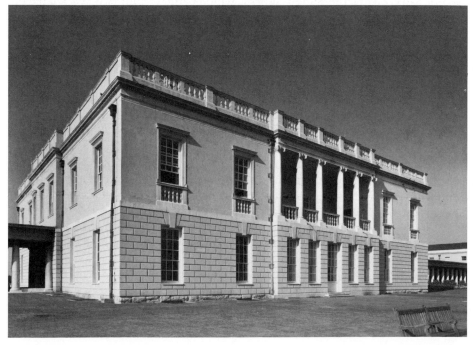

anarchy of Jacobean England: no wonder it seemed to contemporaries a 'curious device'. By the time it was finished, however, Jones had built the short-lived Prince's Lodging and the Banqueting House in Whitehall.

Precisely what was built at Newmarket in 1619 as a lodging for Prince Charles cannot be known. But two surviving drawings are of great historical importance as showing that it was designed to have the first Palladian front of any house in England: Palladian, that is, in the sense in which word and type took over the architecture of English country houses in the eighteenth century. Each drawing shows a three-storey seven-bay façade with three-bay pedimented frontispiece, one with an attached giant order through the upper floors, the other astylar. In the astylar design the ground floor is very low, and in both the first floor is treated as a *piano nobile*, or floor of state. The formula, adapted from villa designs by Palladio himself, is precisely that of innumerable villas and larger houses throughout Georgian England. Probably a reduced version of the astylar design was built, for its frontispiece, with large round-headed middle window suggestive of a triumphal arch motif, was immediately noticed and copied. Yet the lasting influence of the design arrived by a very indirect route.

The Banqueting House was intended primarily as a setting for royal masques. It consists essentially of one huge room – a double-cube variant of Palladio's so-called Egyptian Hall, but without aisles; so there is no free-standing colonnade, but superimposed orders stand against the walls: ionic half-columns below and composite pilasters above a balcony cantilevered on scroll-brackets which Jones used again in the single-cube hall at the Queen's House. Above everything a mighty geometry of beams framing Rubens's baroque Apotheosis of James I. Jones repeats the superimposed orders on the street façade, which again has Palladian prototypes which Jones's extraordinarily delicate sense of the relation between mass and detail leaves far behind. Here the outer four bays have pilasters (doubled at the ends to give appropriate visual strength to the angles); the inner three are brought slightly forward and emphasised by attached columns. (Preliminary drafts show a pediment over the centre, but this was abandoned as conflicting with the final direction of the room which is entered at the end; also it cramps the upper windows and would have upset the proportions of the façade.) All the windows have bracketed cornices, the lower ones alternating segmental and triangular pediments as well; between the capitals of the upper order swags of fruit bulge forward; both cornices project further still over each pilaster and column.

So there is a rich sense of movement along and up and down this façade, in noteworthy contrast to the immobility of the great room. Yet the sharp rustication, stressing the regular joints between the stones, vividly expresses the continuity of the wall behind the orders, whose smooth surfaces provide yet another element of contrast. Earlier drafts indicate very little of this richness and nothing of the subtlety of detailed variation: the process from them to the final design dramatises Jones's doctrine that

in all inventions of capricious ornaments one must first design the ground, or the thing plain, as it is for use, and on that vary it, adorn it . . . One must study the

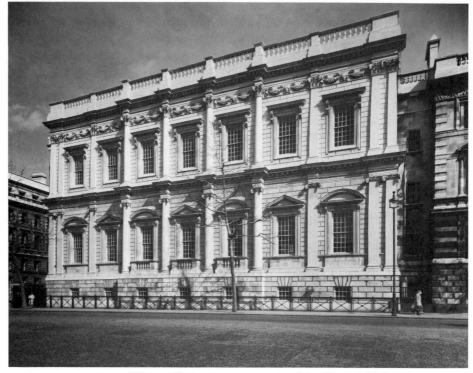

The Banqueting House, Whitehall, London (1619–22). Inigo Jones. The façade was refaced by Soane in 1829.

parts, as lodges, entrances, halls, chambers, stairs, doors windows, and then adorn them with columns, cornices, statues . . .'

The Banqueting House façade is one of those rare designs in which everything – proportion, choice, design and execution of detail, relation of details and masses each to the other – has been realised to perfection: only the subtle polychromy of white stone against buff was lost in Soane's refacing in 1829. The study of this façade is a liberal education in itself.

The Queen's Chapel at St James's (1623–7) has on its west front – a Romanised version of the frontispiece of the Prince's Lodging – nothing of the dazzling virtuosity of the Banqueting House, but its interior, lit from the east by England's first 'Venetian window' (uniting the three separate window units of its west end) must always have been a livelier room if only for the variation in volume provided by the elliptical coffered vault.

Jones's surveyorship involved him in much routine business about London which had very little to do with architecture. His imperious nature helped to make royal works in the capital unpopular and nearly brought to grief his culminating work on the King's behalf. This was the repair and re-edification of old St Paul's cathedral. In 1608 and again in 1620 schemes were afoot to restore the cathedral, but nothing was done till 1631, when during Laud's brief but active bishopric a new commission was set up with Jones as honorary architect. Within eleven years almost the whole exterior was renewed, the chancel in its fourteenth-century form with replacement only of

decayed masonry, the nave and transepts encased in a blunt renaissance
revision of the original romanesque that Summerson has identified as 'quasi-
Tuscan'; but concealing the ends of all the aisle roofs were S-shaped scrolls
quite without medieval reference (though reminiscent of the Holborn gables),
and to the west front Jones added an unpedimented 56-foot-high corinthian
portico, octostyle with the outermost columns paired with square piers. His
sources were Palladio's reconstructions of two Roman temples; and the
portico confirmed the Anglo-Roman character which Jones had given to the
whole western half of the cathedral. Jones's veneration for the medieval
fabric did not prevent this uncompromising physical assertion of his own
principles: passing through the magnificent classical narthex into the huge
romanesque nave with the gothic chancel beyond must have provided an
architectural confrontation of staggering impressiveness. The portico survived
the Great Fire which destroyed the rest of the cathedral, and Wren, whose
admiration is revealed in his own schemes for the west front (see p. 99)
would willingly have kept it: indeed the west front of the 'warrant design'
(1675) is a paraphrase of Jones's which might even have been meant to
incorporate his portico. But everything went when the site was finally cleared
in 1687.

Jones and his associates

Jones's surveyorship left him little time for private commissions. But it led to
two of immense importance in setting a pattern for the subsequent
development of London and in establishing the principles which determined
English urban street architecture for the next two centuries. In 1625 a royal
proclamation forbade any building on new foundations within two miles of
the city. A commission under Arundel's chairmanship was appointed to
implement the order; any four commissioners 'whereof the Surveyor of Our
Works to be one' had power in effect to plan new development on old land in
the interest of achieving 'Uniformity and Decency'. When, therefore, the Earl
of Bedford applied for a licence to build in Covent Garden 'houses and
buildings fit for the habitations of Gentlemen and men of ability', Jones was
already in place as supervisor; and it no doubt eased the granting of the
licence that Bedford should engage him as both architect and planner.

Covent Garden (1631–7) was London's first square. John Evelyn pointed
out that the 'first hint' for its form came from the piazza in the new town of
Leghorn, which was laid out by the Duke of Tuscany in the late 1570s. As at
Covent Garden the Leghorn piazza incorporated a church with tetrastyle
portico, which, according to a persistent legend, was actually designed by
Jones. But the house fronts absorbed the influences of the Place Royale in
Paris (begun 1605) as well as palaces seen by Jones in Bologna. In all three
squares continuous open arcades linked the houses at ground level and by a
curious linguistic perversion themselves came to be called piazzas. The
English façades were fully unified in that not only were all the house fronts
built to an identical formula but the continuous roofline (without gables)
made each terrace into a visual unit. Thus at a stroke Jones devised a

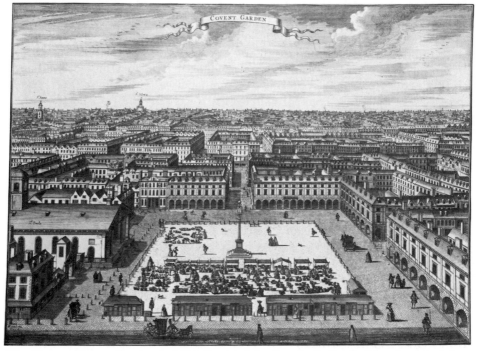

The Piazza, Covent Garden (c.1631–7, with Inigo Jones's St Paul's Church on the left.

classical dress for the narrow London house plots, invented the English urban terrace and stereotyped the architecture which expressed it (though without arcades) throughout the next two hundred years.

Though Jones certainly laid down the general design of the terraces, the executive architect was probably the naturalised French architect and garden designer Isaac de Caus, who was in Bedford's service. But Jones kept for himself the church which Bedford had piously included in his scheme. A church, however, would not bring in rent, and according to a well-known anecdote Bedford told Jones that

he wanted a chapel for the parishioners of Covent Garden, but added that he would not go to any considerable expense; 'In short', said he, 'I would not have it much better than a barn.' 'Well! then', said Jones, 'You shall have the handsomest barn in England.'

Jones's barn was the first attempt anywhere at a full-blooded revival of the archaic Tuscan order, which was described by *Vitruvius* in terms which captured Jones's imagination and which he closely reproduced at St Paul's, Covent Garden: two plain stumpy columns between projecting walls under a pediment which is simply the end of a low spreading roof with enormous eaves – 'true genius', as Henry Clutton said, to prolong the roof of a barn into a noble Tuscan portico. The barn is indeed more akin to Palladian farm buildings than to renaissance church design – deliberately blunt, with a gruff, take-it-or-leave-it air, a church for a market place. The portico (whose side walls were regrettably opened up in the nineteenth century) faces east and

has no access to the church: it had been intended as an entrance, but doctrine
on orientation ruled out a western altar. But more importantly it was to act
as visual focus for the square, and as such it mightily impressed John Strype,
the eighteenth-century editor of Stow's *London*:

How magnificent and great doth it present itself to the Beholder! . . . It is the only
View, in imitation of the Italians, we have in or about London.

Lincoln's Inn Fields, finally licensed in 1638, was laid out to a less unified
plan, though the houses on the west side were apparently identical; Jones's
involvement beyond the initial survey is doubtful. Of the original scheme
only Lindsey House remains (*c*.1640), its façade damaged by lengthening
the main windows; but its giant order over a rusticated basement survives as
evidence of a type influential then and for bigger town houses through the
eighteenth century. The façade is rather coarsely executed, crowded and
overweighted, and the house is perhaps the work of Nicholas Stone, who had
been Jones's master mason on several major buildings.

Stone's career (see Ch. 9) was, however, largely independent of Jones,
whose closest architectural associate by far was John Webb (1611–72). Webb
became Jones's pupil in 1628, later married his kinswoman and, as we know
from his own account and from the evidence of his theoretical designing as
well as his buildings, was given a thorough training in the rules of classically
inspired renaissance architecture: he never went to Italy, and learnt his
principles from the practice of his master and the study of Serlio, Palladio
and Scamozzi. He worked closely with Jones in the 1630s and 1640s, often
acting as his draughtsman, and comes prominently into his own in the
reconstruction of Wilton House, Wiltshire, in 1648–50.

In 1636 the Earl of Pembroke began a colossal rebuilding of Tudor Wilton
to the designs (Jones being too busy at Greenwich) of de Caus, who
produced a gangling elevation twenty-one bays long centred on an attached
hexastyle portico. By 1639 this had been halved and the present south front
evolved, apparently with some help from Jones who may have suggested the
pedimented corner pavilions. The south wing was burnt in 1647–8 and on
Jones's recommendation Webb designed the greatest suite of state rooms in
any house in seventeenth-century Britain. Especially the single- and double-
cube rooms are of overwhelming splendour and richness of decorative effect,
the walls dense with drops and festoons and crossed palm-leaves and bulging
swags of fruit, the ceiling coved and covered in allegorical and illusionist
painting. Projecting chimneypieces and overmantels are as elaborately
encrusted as at Audley End or Longleat, doorcases dramatically architectural;
broken pediments abound and in the grandest elements human figures or
heads are dominant.

French sources popular at Court since the arrival of Henrietta Maria were
powerful influences behind such opulence; but one has only to compare a
Wilton chimneypiece with a design from Jean Barbet's *Livre d'Architecture* to
realise how scrupulously the English design observes the integrity of classical
structure within the decoration. That is doubtless the effect of Jones's
training, though Jones himself was not a country-house architect (the
pavilions at Stoke Bruerne, Northants (*c*.1630), linked by England's first

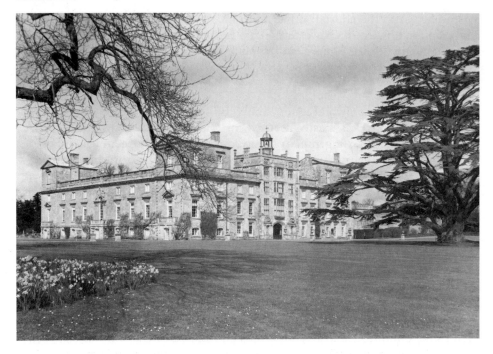

South and east fronts, Wilton House, Wiltshire (reconstruction from 1636). The original designs by de Caus for rebuilding Tudor Wilton were reduced to the present size, probably with help from Inigo Jones.

Double-cube room, Wilton House. John Webb.

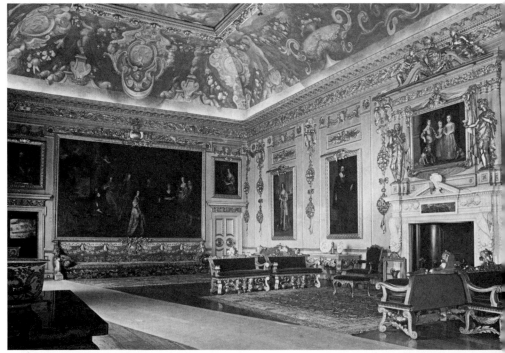

quadrant colonnades to a now vanished house, are probably the only survivals). Almost all the interior decoration of the Queen's House has gone; but the ceiling of the Queen's bedchamber is closely similar to that (probably pre-fire) in the Wilton single cube, and a group of Jones's drawings for ceilings and chimneypieces indicate that at any rate late in his life he could absorb such opulence into his own style.

Webb was by his own account trained by Jones with Charles I's express backing to succeed his master as surveyor. One consequence was that he spent much time and ingenuity on designs for a royal palace on the scale of the Louvre to replace the agglomeration of miscellaneous buildings which passed as Whitehall Palace, of which the Banqueting House was an architecturally unrelated element. This was a triumphalist Stuart fantasy which had no hope of execution but which occupied the minds of kings and their surveyors until as late as 1698. Seven separate schemes have been identified among the many surviving drawings, all in Webb's hand, though the first and most original, for a complex of eleven courtyards, measuring altogether about 900 by 1000 feet, was worked out by Jones in *c*.1638. This became the foundation of all subsequent schemes, in which Webb experiment-ed tirelessly to find ways to achieve variety and climax: an extraordinarily difficult task within an idiom whose scale was only moderate – set indeed by the Banqueting House which he retained throughout, usually in duplicate.

At the Restoration Webb was unquestionably the most talented and experienced architect in England. He petitioned the King for the surveyorship but was passed over in favour of John Denham, a placeman of whose practical knowledge of architecture Webb had an understandably low opinion. (Charles II may have learnt in Holland to prefer a more energetic, less austere style; and on Denham's death in 1669 Webb again lost out – this time to one whom he thought 'in whatever respects his inferior by far'; it can't have done Webb's subsequent popular reputation much good that this was Wren.) Denham was indeed no architect, and Webb was soon de facto in charge of much of the most important royal work of the decade.

Webb's first official engagement seems to have been for Henrietta Maria, the Queen Dowager. She returned to England in 1660 and Webb built for her the new gallery at Somerset House (1662–3), a building much admired in the eighteenth century and copied on both sides of the Atlantic but destroyed in the rebuilding of Somerset House in the 1770s. It was only five bays long but eloquently combined the arcades of Covent Garden with a less congested corinthian version of the upper storeys of Lindsey House. The arcade looks distinctly sturdy, but Palladian detail, including alternating window pediments and balustraded sills, was treated with elegant restraint. The manner was still that of Jones, and so, inevitably, was that of the enlargement of the Queen's House (1661–2) by the building of the east and west bridges, which essentially repeat the north front. (Pavilions at the four corners were not executed.) Webb designed one ceiling in the manner of Jones's late drawings for Wilton, and another is a reduced and simplified copy of that of Banqueting House.

This work was for the King, who by 1663 had decided on a wholesale rebuilding of the rambling Tudor palace at Greenwich. Webb planned a

layout round two open courtyards back to back; but though the larger one towards the river would have had flanking ranges similar to those actually built, it seems that the 'King Charles block', designed in 1663 and built by 1667, was part of a fresh plan in which it and an identical twin would be linked to the Queen's House by long colonnades. As early as 1650 Webb had sketched a twenty-five-bay elevation for Durham House, London, whose enormous length was exaggerated by the horizontal striation of banded rustication. It has an attached hexastyle or six-columned portico and weakly emphasised ends. Another long façade was proposed for Belvoir Castle, Leicestershire, in 1654, using the Prince's Lodging formula for its frontispiece. A year later, in regularising the Elizabethan front of the Vyne, Hampshire – yet another long elevation – Webb gave it the first full classical portico on any English house.

These experiments culminated in the King Charles block – twenty-three bays long and only two storeys high but probably always intended to be seen in perspective and much more boldly articulated than its prototypes, with a giant corinthian order for the attached portico and for three-storey pavilions. Webb was going now for the heroic approach which respect for the Banqueting House had ruled out at Whitehall, in a façade which points forward to the massive baroque of Hawksmoor and Vanbrugh. All the detail is in scale: rustication is deep and rugged, and the window heads show the mannerist tendencies which Jones repudiated – flat arches with exaggeratedly large voussoirs (wedge-shape stones making up an arch) and keystone impending into the window opening; in the emphasised sections of the façade these are packed into open pediments, leaving no room for bedmoulds. But a true pediment marks the end of a roof and rests on a horizontal cornice (which can be replicated in miniature over a window); Webb's device is mannerist in taking the classical form and visually disrupting its structural basis. This feature had been anticipated in the Star Chamber design. So also had been the bold sandwich of plain ashlar half way up the façade, threaded, as it were, behind the order, helping the powerful uninterrupted entablature of the giant order to hold the whole long elevation together, clamped within the strong verticals of the pavilions.

Webb also designed two of the finest mid-century houses, both now lost. Gunnersbury, Middlesex (1658–63) was an ingenious reduction of the Queen's House plan as 'completed' by Webb, in which, behind the loggia, in place of the central bridge was a saloon above a colonnaded hall. The house contained the first example in England of an imperial staircase, in which a central flight mounts to a half-landing from which it is continued by a pair of flanking return flights. At Amesbury, Wiltshire (c.1660), whose general massing was preserved in an early nineteenth-century rebuilding, Webb established the vertical proportions of the formal Georgian house – as Lindsey House had done for the town – with a lowish ground floor and the principal rooms on a *piano nobile*. Amesbury was even more compact than Gunnersbury but made majestic by a portico projecting from the upper floors, by the staircase tower rising from behind above the roof, and by a wall treatment whose deep rustication and huge flat window arches anticipated Greenwich. C. R. Cockerell, the great nineteenth-century architect, praised the ingenuity of its plan, observing that

Amesbury House, Wiltshire (c.1660). John Webb.

what is surprising is that the proportions are small and yet in the aspect of the whole
. . . there is an uncommon grandeur which fills and occupies the mind . . . For
economy of convenience with proportion and effect it may challenge any house in
England ancient or modern.

Mannerism and the vernacular tradition

Webb was a learned architect and a theoretician with a firm respect for rule
and order: he unquestionably knew what he was doing in introducing
mannerist or proto-baroque elements into a classical or renaissance elevation,
deliberately challenging its implicit harmony of structure and appearance by
features which visually, though of course not structurally, contradict this
unity. The case was very different with the mid-century mannerism which
was commonly the work of masons, carpenters or bricklayers without
specific training in the principles underlying classical design but, like their
Elizabethan predecessors, eager to show knowledge of current fashions
without much regard for architectural congruity (or even awareness that there
was such a thing).

The result is sometimes anarchic. Witness the hall-and-chapel range at
Oriel College, Oxford (1637–42). The façade has a symmetry of which the
plan makes nonsense, for while the left-hand half is the front of the hall,

whose still traditional form is expressed by the windows, the right-hand
conceals a mélange of buttery, staircase and an ante-chapel at an acute angle
to the front which forces its main window to be largely false. There is a bit of
everything on this façade – pointed windows with tracery still half-gothic,
half wanting to be something else, Tudorish bays, Jacobean strapwork,
cresting and fancy gables, a bold 'baroque' thrust through the classical
cornice at the middle – every feature treated as applied ornament and none
related to its neighbour, yet all cramped within a pedantic symmetry which
must have impressed itself on the mason as justifying all possible stylistic
licence. The contemporary furnishings of the chapel are all classical, put in
so to speak one by one, so that each stall has its own pedimented panel
enclosing a perspective arch. Brasenose College chapel (1656–66) is yet more
intricately mixed up: corinthian pilasters appear between gothic windows;
classical vases and crocketed pinnacles share the roofline; the entrance wall
gets in baroque pediments and an attic parapet swept up in two concave
curves; and inside, classical stalls, pulpit and screen are unabashed by a
pretty gothic fan vault on the ceiling.

This latter is known to have been designed by the Brasenose mason or
'overseer', John Jackson (c.1602–63), who had completed, though he did not
design, the Canterbury quadrangle at St John's College (1631–4) – a better-
co-ordinated mixture, though it still has crenellated Tudor walls above
Florentine arcades. But twin frontispieces, full of incident in a multitude of
planes and curves, force themselves upwards through the assemblage of
small-scale features. Superimposed paired columns, which (because of their
necessarily unequal spacing) always imply tension, make strong vertical
accents disrupting the dominant horizontals, but a colossal open segmental
pediment counteracts the vertical thrust, though it is not powerful enough to
reconcile the scale of the main orders and that of a much smaller niche in the
centre. In a fully achieved baroque design disparate elements may well be
yoked with violence together, but discordances of scale are resolved within an
underlying logic. In 1640, however, the Fellows' building at Christ's College
Cambridge did assert classical mannerism as a deliberate style: its
proportions are ungainly, but details are consistent, up-to-date and well-
informed on Jonesian themes. At the same time the rebuilding of Clare
College began: the first court in either university which has any claim to
renaissance unity, though its classicism is at best incipient (still mullioned
windows and originally still crenellations). It was only in 1669 that the river
front was conceived, with a giant order through the upper storeys in the
manner of Lindsey House.

Howard Colvin has recently suggested that the architect of the St John's
frontispieces, which show a sophistication beyond the range of local masons,
was Balthasar Gerbier (1592–1663), a man of many affairs who boasted that
Jones envied him his architectural skills (unfortunately in respect of York
House, London, which – except for its watergate on the embankment near
the Temple, c.1628 – vanished without record). His Dutch birth and
connexions gave him a direct knowledge of the mannerism which dominated
the Low Countries in the earlier seventeenth century. The same is true of
Nicholas Stone (1587–1647; see Ch. 9), who spent six years in Amsterdam

with Hendrik de Keyser, the leading Dutch mason/architect, and married his daughter. Stone was primarily a monumental sculptor and statuary; it was presumably his engagement as master mason at the Banqueting House which led him into architecture, though without fully committing him to the discipline of Jonesian classicism. The massive gate which Stone built (and almost certainly designed) for the Oxford Botanic Gardens (1632–3) is very characteristic: its outer face is covered in alternations of smooth and 'vermiculated' stone (in which the surface is broken into interlaced rough channels like worm-casts) – columns, arch-rings, pilasters and all. Jones occasionally experimented with rusticated columns and was conceivably responsible for the moderate use of vermiculated stone on the screen added to Castle Ashby, Northamptonshire *c.*1630, which has things in common with the Oxford gate. But though two of Stone's columns flank the archway, they do so incidentally, their primary function being to support, with columns further out, subordinate pediments which fill the outer angles of the main pediment rising behind them. The aedicules (or frames, with a pediment supported on columns) which they thus create project prominently and dissipate energy to the periphery, making the central (and functional) archway recede in visual importance. On the garden face ambiguous accents are less obvious; but its huge piers are filled with two tiers of empty niches and into the pediment is forced a raised attic carrying a clashing segmental pediment pushed up so as to jut into the mouldings of the main one.

Such disclocations of classical degree, though they may appear clumsy, do not arise from ignorance; and nor do the violent solecisms of the porch of St

Botanic Garden, Oxford: main gateway, north front (1632–3). Nicholas Stone.

Mary's church, Oxford (1637), in which 'Solomonic' twisted columns carry the ends of a segmental pediment in between which is thrust a narrow but massively weighty aedicule which appears, as it were, to have dropped through the main pediment on to the arch below. This deliberate distortion of classical congruence rejects the rule of order while keeping everywhere to classical elements and insisting on the rule of symmetry.

We should therefore be wary of assuming that Stone's most important building – the Goldsmiths' Hall, London (1634–8, demolished) – gained its somewhat gauche-looking façade, in which circular windows sat in a mezzanine above square ones, through 'default of knowing', particularly since we have Stone's word that Jones took especial care in advising and directing him. In fact the mezzanine was inserted because of a late change of plan by the clients, its particular form comes from Serlio, and Stone had used it on the new wing added to Cornbury Park, Oxfordshire, in 1631. In 1638–40 he showed considerable skill and complete security in detail in working Jonesian windows into the Elizabethan classicism of Kirby Hall, Northamptonshire. His recasting of the entrance front, though not easy to judge in its partly ruined state, may, as John Harris suggests, indicate an inability on Stone's part to relate scales within a long façade and an attempt to cover up by busy variety of detail.

There are enough similarities of idiosyncratic detail between Goldsmiths' Hall and Balls Park, Hertford (1640) to suggest Stone as architect. But Balls Park is of brick and built with a bricklayer's fascination for what one can do to mould a façade by the use of rubbed brickwork. So another possible candidate is Peter Mills (1598–1670), who in 1643 became bricklayer to the City of London, later Master of the Bricklayers' and Tilers' Company and a highly respected surveyor. Paradoxically Mills's most important house is of stone – Thorpe Hall, Peterborough (1654–6), a great block of a house, with big hipped roof, prominent chimneys, generous bracketed eaves, and no explicit classical order anywhere except on two Tuscan porches – themselves novelties and one still crowned with the rare survival of an elaborate iron railing or 'pergula'. On the two longer façades windows on the *piano nobile* are emphasised by cornices alternating with pediments, but the elevations are otherwise plain. They have been related to plates in the second volume of Rubens's *Palazzi di Genova* (1626), a rich quarry for gentry houses at this time, but a more direct debt is to Chevening (see below).

Mills's independence comes into its own especially on the east front, of only three very wide bays each with superimposed tripartite windows incorporating a 'Venetian' motif deriving ultimately from the Prince's Lodging, perhaps via the Queen's Chapel. The outer windows project boldly through the main storeys, but the centre is wider and triplicated in the attic as well – an extremely satisfying balance of contrasting geometry unique to this house. On the office wing is a singularly well-observed Holborn gable; and, contriving to appear as a natural extension of this Jonesian feature, the magnificent, partly stylar, wainscot inside (some now removed to Leeds Castle, Kent) is full of mannerist ingenuity: doorcases with pediments resting on a large keyblock flanked by scrolls, panels with the upper architrave lifted above crossed palm fronds, jointing cunningly designed to

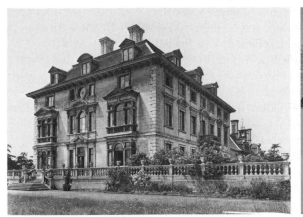 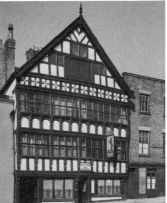

Thorpe Hall, Peterborough, Cambridgeshire (1654–6).
Peter Mills.

Bear and Billet Inn, Lower
Bridge Street, Chester (1664).

give false perspectives, scrolls and angled mouldings to the panelling which
can be read in two opposite ways. Yet each room reveals on inspection a
consistent idea within the quirky variations. Older-fashioned Flemish
mannerisms in doorcases, chimneypieces and one of the garden doorways link
Thorpe Hall with Tyttenhanger, Hertfordshire (*c*.1655), a large brick house
whose façades are clumsier and less distinctive but whose origins can
certainly be found in the same sources. Surviving interiors have similar
mannerist extravagances, but incoherently assembled. If Mills was indeed the
architect of Tyttenhanger, he must, on the evidence of Thorpe Hall, have left
the execution to lesser men.

'Artisan mannerism', as Summerson calls it, shows itself most character-
istically in the elaborate dressings of houses, especially in the south-east,
built by bricklayers almost always without an architect or surveyor in
charge: Mills started as a bricklayer and, through his own skill and
consequent employment, achieved higher status. But such buildings as
Peacock's school, Rye, Sussex (1636) or 66 Croom's Hill, Greenwich (*c*.1634)
are purely craftsmen's work, the façades conceived as showpieces for the
bricklayer's craft without regard to stylistic congruity. Thus the giant
pilasters which stride across the façade at Peacock's on pedestals ten feet high
have the same tweedy surface as the rest of the wall, the brick courses
continuous across them. But a pilaster is an imitation column and therefore
conceptually independent of the wall behind it, of which it cannot logically
be a continuation. Again the windows have flat arches made up apparently of
five oversize projecting voussoirs; but each is made up from numerous bricks
so that the voussoirs are not acting as structural units in an arch. Small
upper pilasters on the Greenwich house 'stand' on a platband with little
pendants below – contradicting the whole idea of a column as a post carrying
weight down to the ground – and the pedimented gables have non-structural
arches set within them. Thus classical elements are treated not simply as pure
ornament but as ornament which is at stylistic odds with the material.

Brick was a relatively new material for anything but grander houses; and

bricklayers were doubtless tempted to show what they could do by rubbing and moulding to rival the masons: hence their aping of ornament deriving from stone. But related things happened with timber: elevations which hitherto would have been gabled now had flat tops and arched window lights (the 'Dutch house' at Bristol (1676) was a famous example; Tewkesbury still has numerous smaller ones). Or a timber-framed building would have its façade covered in a jumble of pediments and sham rustication, all in wood. A specially delightful and swagger example is Guildford town hall (1683), whose pilastered and pedimented upper storey gives away the secret of its material by being boldly jettied out over the street.

In the areas on either side of the Welsh border which are without plentiful building stone and where, until bricks could be made cheaply, timber was the only material available in quantity, traditional house carpentry is visible throughout the seventeenth century. Box-framing, often with diagonal or curved bracing or decorative infill characteristic of Shropshire, Cheshire and north Wales, alters so little that it is impossible to date buildings even roughly on style alone – a persistence graphically demonstrated in three dated houses in Chester. The Stanley Palace (1591) is indeed the least dramatic, yet it has the most consistent application of classical decoration within the structural timbers. Bishop Lloyd's house (1615) and the Bear and Billet (1664) have virtually identical form and decoration – four storeys of close framing with continuous glass across the whole façade on the main floors, braced only by thin mullions, a huge gable over all and hardly more than gestures at classical brackets. Most timber houses did without any decoration save what was incidentally provided by the contrast of structural timber and infill. By 1700 structural brick had replaced timber-framing in all English counties, but in north and east Wales the old ways died hard, with increasing use of closely placed posts or studs in place of the open box-frame, and crucks still in use for simpler buildings.

In the stone areas houses of yeomen and the lesser gentry showed even less change. Towns and villages across the country are stocked with seemly seventeenth-century houses indistinguishable even in detail from their Elizabethan prototypes: the larger articulated by broad gabled projections, the smaller making do with gabled dormers, all with wide low mullioned windows under drip-moulds, and doorcases whose heads are still vestigially Tudor. Most make some show of symmetry, but this is usually the only acknowledgment of the renaissance until as late as 1694, when a quite swagger house like Medford House, Mickleton, Gloucestershire may have abandoned gables and collected a mannerist doorcase, miniature semicircular pediment and a timid little cornice, but keeps the old window forms unchanged.

In the northern counties, where the houses are characteristically long and low (rarely more than two storeys), shallow roofs and very oblique gables are vividly expressive of the weather they have to face. Windows have long rows of small lights divided by very thick mullions, though pleasant local variations like the ogee heads to windows in gables occur in some numbers in the central Pennines. Both in Lancashire and the western parts of Yorkshire longitudinal plans predominate, having grown out of the old common type of

hall with upper and lower ends. By the late sixteenth century two-storey halls had been abandoned but curiously were revived in the mid-seventeenth century for a new purpose: by incorporating a cantilevered balcony the hall gives access to all rooms on both storeys – an obviously coincidental parallel with the Queen's House. Wood Lane Hall, Sowerby was so built in 1649, but a few years earlier the much older Oakwell Hall, Birstall had its single-storey hall altered to this type. A few Pennine houses make small bows to classicism at the entrance door; but otherwise exteriors have barely changed since the mid-sixteenth century.

Such houses – built in quantities throughout the century – show the tenacity with which traditional forms still vestigally gothic survived in the remoter parts of the country. College buildings at Oxford were equally conservative even when decked out with classical trimmings – which not all of them were: University College is remarkable in that in its main quadrangle (1634–75) rows of Jacobean gables are the only signs of anything post-gothic, and astonishing in that a second quadrangle simply repeats the formula in 1716.

Very few churches were built in the decades before the Restoration, and those in the provinces are almost all in a generalised late gothic with perpendicular windows and towers. One would not expect the masons of Leeds (St John's, Briggate, 1634) or Leicestershire (Staunton Harold, 1653) to imitate St Paul's, Covent Garden; and indeed it is clear that to them, used to building houses still with sub-gothic door and window mouldings, perpendicular remained, as Marcus Whiffen put it, 'a living and sufficient way of building'. Yet the furnishings are gothic in neither church: at Leeds tapered columns, encrusted arches and elaborate strapwork; at Staunton Harold naïve classical reflecting in its simplicity the puritan temper of the time, even though not its churchmanship. Furnishings were equally conventional in the otherwise exceptional Holy Trinity, Berwick-upon-Tweed (1648–52), whose arcades of elegant round arches on slender Tuscan columns were imitated from St Katherine Cree, London of twenty years earlier – a unique provincial venture into ecclesiastical Italianate all the more remarkable for its Commonwealth date. (But the mason in charge was a Londoner, John Young.)

Sir Robert Shirley of Staunton Harold was an ardent royalist, and his memorial suggests that building his church was something of an act of defiance:

in the year 1653 when all things sacred were throughout the nation either demolished or profaned [he] founded this Church whose singular praise it is to have done the best things in the worst times.

The choice of gothic might also have been a gesture of faith in things ancient and established; but it was not the act of an antiquarian. Bishop John Cosin's insertion of elaborate gothic screens and canopied choir stalls into medieval churches in County Durham unquestionably was. Brancepeth and Sedgefield (both begun *c.*1638) are the most remarkable, with scrupulous attention paid to mouldings and tracery copied from medieval originals. Cosin later (1662) added a perpendicular clerestorey to the hall of his palace at Bishop

Auckland and carefully renewed its older windows. A similar spirit informed the decision in 1623 to give the new library at St John's College, Cambridge 'the old fashion of church window', on the ground that it was 'most meet for such a building'. That the choice of a fan vault for Brasenose chapel, Oxford (1659) was also a self-conscious archaism is proved by its being made of plaster, not stone, and hung as a ceiling from the roof trusses: the style of the late fifteenth century is copied very closely, the structural principles not at all.

Wren resolved that his completion of Wolsey's gateway at Christchurch (1681–2) 'ought to be gothic to agree with the founder's work'. But as Summerson says, 'he selected . . . Gothic elements and then argued them into a whole conformable to his own classical taste'; the result is eclectic, a fantasy on gothic themes, not a piece of revivalist mediaevalism. The same is true of his one wholly gothic church, St Mary Aldermary, London (1679–82), for which the style was a condition of a private donation. Accurately observed mouldings and profiles show that Wren and his masons were well acquainted with their fifteenth-century originals; but the playful plaster fan vaults give the interior an atmosphere prophetic of the light-hearted rococo gothic of the mid-eighteenth century.

The gentry house

Roger Pratt (1620–85) spent the Civil War years in Europe, mostly in Italy where, following Jones's example, he collected a library and evidently studied house plans as well as the works of 'the best authors of Architecture' – Serlio, Palladio, Scamozzi. In his notebooks he laid down the advantages of the double-pile plan and in the four large houses he designed not only demonstrated it to the benefit of their owners but evolved a refined astylar architecture of great beauty which was the model for the best country houses of later Stuart England. Alas, only Kingston Lacey, Dorset (1663–5) now remains, and it was much altered in the nineteenth century.

Coleshill, Berkshire, designed by Pratt for his cousin c.1657 and lamentably burnt down in 1953, was the first, the simplest and perhaps the grandest. In plan it was a rectangle divided lengthwise on each floor by a corridor, on either side of which the nine bays were divided into three sets of three. The most important rooms were in the middle: a two-storey hall encased in the arms of a great double staircase which climbed slowly up the side walls; behind, the great parlour on the ground floor and great dining room above. These were rooms of profound, simple grandeur, with strongly architectural doorcases and chimneypieces and nine-part ceilings on the Banqueting House plan: that over the dining room was gorgeously enriched with corinthian bracketed cornices along all the beams, and their undersides and the central ellipse encrusted with plaster arabesques, cupids and the tight rolls of fully three-dimensional fruit and flowers which remained popular for the rest of the century. On the main elevations the three central windows were more widely spaced than the others, displaying externally the position and size of the main rooms and giving an extraordinarily stately spaciousness

to the long façade, above which four tall chimneys on each side at the ends
and the main structural divisions, stood sentinel round a balustraded
platform with glazed cupola in the middle. Summerson's words cannot be
bettered: 'Massive, serene, thoughtful, absolutely without affectation,
Coleshill was a statement of the utmost value to English architecture'. It was
indeed a complete English transformation of themes which had been
suggested to Pratt by Italian prototypes: only so could its influence have been
so wide, so benign and so lasting.

Pratt of course did not invent the double-pile house: he merely gave it a
name. Substantial houses on a compact plan had been built since the later
years of Elizabeth, and their advantages to a rising gentry were obvious: they
were nothing like as showy as the prodigy houses, but they were much more
economical to build, to maintain and to heat – and much more readily
accommodated to desirable Italian-inspired symmetry and proportion. The
Prince's Lodging was just such a house, and its pedimented frontispiece was
immediately seized on for Raynham Hall, Norfolk (1619–22). Here, in a high-
waisted version, it keeps company with four Holborn gables, windows with
separate projecting voussoirs and (before eighteenth-century alterations)
Venetian windows and mezzanine ovals as well, making its façades an
anthology of Jonesian devices which Jones himself would never have
accumulated thus. The plan too is a mixture of old and new – looking as if it
only became double-pile by accident. So the much plainer four-square

East front, Coleshill, Berkshire (c.1657). Roger Pratt.

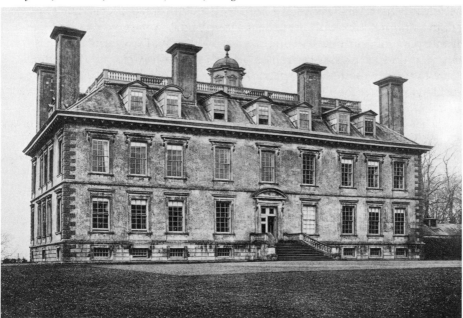

Chevening, Kent (*c.*1625, badly altered *c.*1715), in which Jones may have been directly concerned, is far more progressive. Its nearly square plan is articulated not by a longitudinal spine but by two cross-walls dividing each floor into three and allowing complete flexibility within the divisions. Though it and its derivatives became by far the commonest type for medium-sized houses in the eighteenth century, this revolutionary layout was little taken up at the time. But the square box-like form, which includes the maximum volume within a given length of outside wall, was adopted – with façades varied to taste: vernacular gables, combined with Jonesian pedimented windows (Boston Manor, Brentford, Middlesex, 1622–3): artisan brickwork and shaped gables (Kew Palace, Surrey, 1631): plain brick with the minimum of fuss (Forty Hall, Enfield, Middlesex, 1632–3).

In 1663 Jones's influence came home in one of the most influential houses ever built in England – Eltham Lodge, near Greenwich. The architect was Hugh May (1621–84), who spent several years in close contact with the Court in exile in Holland during the Commonwealth. It has long been agreed that Eltham owes much to 'Dutch Palladianism' of the 1630s and 1640s, that it is indeed a quiet domesticated English version of Jacob van Kampen's princely Mauritshuis at the Hague. An architecturally closer source is the St Sebastiaansdoelen, whose architect, Arent van 'sGravesande, was probably Arent from Gravesend, where there was a considerable Huguenot settlement. As Dr H. J. Louw has shown, close intellectual contact between the two countries was maintained at high social level by the Dutch diplomat Constantine Huygens, who was a vital force in the Dutch humanist revival and built himself a house apparently consciously modelled on Jonesian example. Louw plausibly argues that Dutch architects drew much of their Palladian or Scamozzian material from Jones and are therefore returning a compliment in providing a model for May to bring back. Eltham Lodge, which was built for Charles II's banker, is not a country house but a suburban brick box, with prominent hipped roof, plain save for one frontispiece of four pilasters under a pediment. As at Coleshill the window spacing subtly expresses the rooms behind, and as at Coleshill the ceilings have lusciously plastered geometrical forms. The staircase is of a newly fashionable type (found also at Thorpe), with richly carved openwork panels of acanthus foliage.

Eltham's exterior – a bourgeois version of Coleshill – set the pattern for an endless progeny. Robert Hooke, Wren's close associate, enlarged it at Ramsbury, Wiltshire (1680–3), Edward Pearce, Wren's master mason, turned it to stone for the bishop's palace at Lichfield, Staffordshire (1685–9). But its principal effect (groundlessly credited to Wren himself) was on the design, country wide, of innumerable small manor houses, rectories, farmhouses, schools: shrunk to five or even to three bays, with the frontispiece removed, it proved an astonishingly flexible envelope for endless varieties of internal arrangement. With its large roof and lack of ostentatious sophistication or palpable applied ornament, it was instantly assimilable by English temperaments suspicious of foreign ways or patrician dictatorship of taste; and unnoticed, it slipped an assumption of seemly classical proportion and symmetry into our instinctive expectations. It was May's genius – whatever

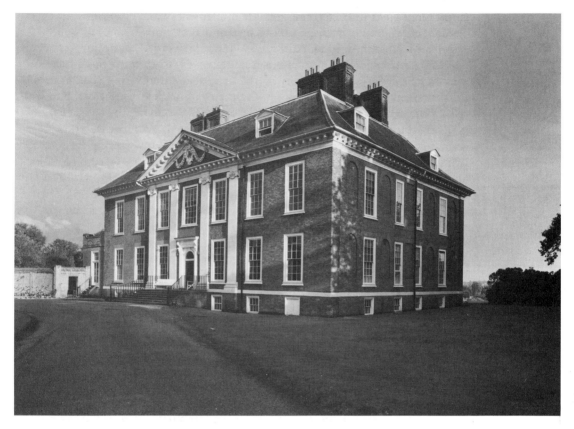

Eltham Lodge, Kent (1663). Hugh May.

his dependence on predecessors in England or Holland – to create a new form of house which was instantaneously naturalised into an inescapable part of the English scene.

William Bruce (*c*.1625/30–1710) was singlehandedly responsible for re-introducing European classicism to Scotland. Scottish architecture, whose royal spearhead had earlier been so much in advance of English and so much better-informed about the continental renaissance, almost stopped still when the throne moved to London in 1603, after which the Stuart monarchy largely ignored its homeland. The gentry continued to live in tower houses to which a little classical trim was sometimes added. Innes Castle, Moray (1640–53) is a good example: it makes mild gestures towards symmetry, and all its windows, big and small, are capped by steep triangular or semicircular pediments which look glued on to the wall. In towns tall stone tenements were taking the place of thatched timber houses, but their appearance remained vernacular and provincial. True, William Wallace (the King's master mason in Scotland, d.1631), also virtually on his own, invented a manner which earlier writers identified as Scottish high renaissance. In fact, while it incorporated some traditional items, notably towers with corbelled

drum turrets, it is made up of a medley of elements from Serlio, from
Flemish and German mannerism, with strong French overtones.

Wallace's most important building is Heriot's Hospital, Edinburgh (begun
1628), a quadrangle of ranges about a large square court with huge tower
blocks at the corners, noteworthy as the first large building in Scotland to
stress symmetry above all. Each of its eight elevations is symmetrical, but they
are all different, and even in one façade backward-looking gothic appears
alongside English ogee domes, an Italian proto-baroque doorcase and
Germanic strapwork pediments. Yet not only does the overriding large-scale
symmetry pull this surprising mélange together; the whole fortress-like block
contrives in its dark northern stone to look thoroughly Scottish, with the
stamp of native masons all over it. The style was taken up in the 1640s for
the old college of Glasgow University and even as late as 1679, when the
Duke of Queensbury reactivated a Wallace design for Drumlanrig Castle,
Dumfriesshire and James Smith crammed the façade with giant pilasters and
other baroque paraphernalia.

Exuberant and enjoyable though such buildings are, their style can't be
said to show a literate understanding of classical principles: it is without even
an implicit basis in theory. That is what Bruce learnt from his extensive
library, and the practical expression of it from direct knowledge of the Low
Countries, probably of France and certainly of his English contemporaries.
Bruce is no copier of Pratt and May, but their influence is unmistakable.
Much of his early work was the modernising of old buildings, most
importantly the enlargement of Holyroodhouse, Edinburgh (1671–9), where,
unable to build a new palace, he duplicated the medieval tower house, joined
the two by a screen and remodelled the courtyard with new state apartments
behind façades whose tall proportions, broad high windows and thin
superimposed pilasters show clearly Bruce's French leanings; yet the
principal gateway looks forward to English baroque. English craftsmen were
brought in here and in private commissions (for example, Thirlestane Castle,
Berwickshire, 1670–7); the plasterwork in particular has a dazzling brilliance
unsurpassed anywhere.

Bruce's two finest houses are Kinross (1686–93), for himself, and
Hopetoun, West Lothian (1699–1703). Kinross had a plan quite like
Coleshill's, though Bruce anticipates Easton Neston by cleverly inserting a
mezzanine at the ends within the hall storey. The long low lines, huge roof
and disposition of chimneys about a platform all recall Coleshill; yet the
atmosphere is quite different – blunter, weightier, with a noble austerity in
keeping with its exposed setting and with the formal gardens which from the
start were part of its conception. Its great bare walls, proportionately small
windows and tiny attic slits between cornice and eaves suggest a source in
Genoese palaces illustrated in Rubens's second volume of his *Palazzi di
Genova*, an indebtedness which was even clearer at Montcreiffe, Perthshire
(1679) which, unlike Kinross, had no clasping pilasters at the angles. Bruce's
Hopetoun was his version of the square English house, of which another
exponent was William Samwell (1628–76), a gentleman architect with whom
Bruce had worked on the enlargement of Ham House, Surrey (1672–4). But
at Hopetoun the square was only the centre of a spacious layout in which

forecourt wings were joined to pavilions on either side of the main block by quadrant colonnades – the first in Scotland – which were convex towards the court, a baroque gesture contradicting the idea of enclosure. Again French elements are to the fore – banded rustication, wide arcaded frontispiece, semicircular pediment to the garden, and two-bay pedimented projections on the side elevations, which Bruce made the centrepiece of two other houses. Most of Hopetoun's interiors were changed and the entrance front completely recast by William Adam, but three quarters of the exterior of Bruce's house can still be seen.

The baroque country house – the type, that is, in which classical features are deliberately strained to display the tensions within the overlying harmony – hardly arrived in England before 1700, but the century was anticipated by the strange presence of William Talman (1650–1719). In 1689 he got himself appointed Comptroller of the King's Works, from which position he did his best to undermine the Surveyor General. His public career came to a sudden end when he was dismissed on Queen Anne's accession: he was arrogant and malicious, had quarrelled with almost everyone who employed him, and no friends were left to regret his passing. But in a series of country house designs he had revealed an architectural personality at once distinctive and enigmatic; for he was apparently the architect of several hipped-roof formula houses (Uppark, Sussex *c*.1690 is the only known survivor) simultaneously with others with a new slab-like silhouette and façades heavy with baroque modelling. (Talman's authorship is, however, even for the seventeenth

Kinross House, Tayside, Scotland (1686–93). William Bruce.

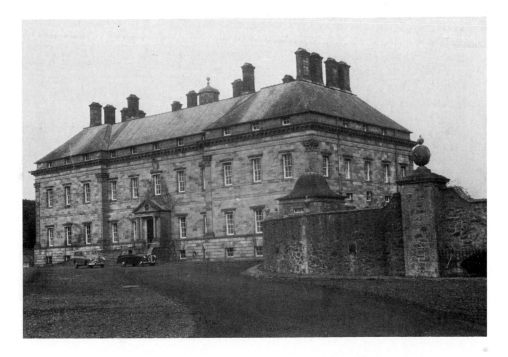

century, peculiarly elusive. John Harris insists that 'any building without quirks deserves to be questioned if attributed to Talman'.)

The slab form, in which the pitched roof is abandoned and the façade topped by a balustrade or parapet, is said to have first appeared on an English classical house at Thoresby, Nottinghamshire, with which Talman's connexion is tenuous. Its date is uncertain but cannot have been earlier than 1671, which saw the building of the almost equally advanced (though in proportion slightly lumpish) Weston Park, Staffordshire, whose design is credited to Elizabeth, Lady Wilbraham, the owner's wife. She must have been well up with the latest work in France, for the new silhouettes certainly derive either from Louis Le Vau's garden front at Versailles (1669) or from the east façade of the Louvre, finished in 1670, which in turn leant on current Italian practice. Talman certainly was influenced by recent French architecture which he had probably seen himself and undoubtedly knew from engravings in a collection of which he was very proud.

Talman's most important work, the south range of Chatsworth, Derbyshire (begun 1686) probably owed something to J. H. Mansart's much-admired Château de Marly (1679–83), the unquestioned inspiration for the west front, whose architect is unknown: it was built in 1700–3 after Talman's dismissal. The courtyard façades go back further to François Mansart at Blois and elsewhere: only one survived nineteenth-century alterations, but all were conceived by Talman, whose commission was to rebuild the Elizabethan

South front of Chatsworth, Derbyshire (begun 1686). William Talman.

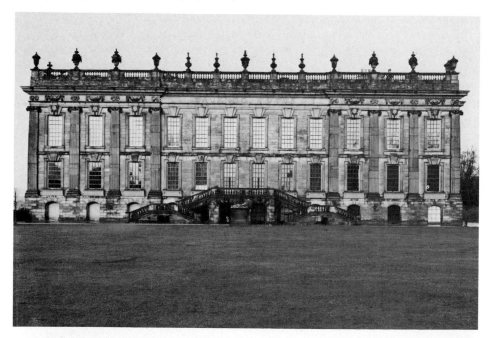

house wing by wing. The courtyard plan gave no dominant axis and presented almost insoluble problems of access and internal communication. The Duke of Devonshire, the owner of Chatsworth, intended from the start a suite of state rooms on a grand scale in the traditional place on the main upper floor: it occupied the length of the south wing. The hall and, leading from it, the grand staircase are in the east, and provide a logical approach to the great chamber (the outermost state room). But the main entrance to the house was eventually contrived on the west, from which the only way to the hall was via the open colonnade of the court. Alternatively, bypassing the hall and going up the west stairs leads straight into the state bedroom, the most intimate of all. These interiors, however, incorporating craftsmanship of the highest order – Samuel Watson's brilliant carving is pre-eminent – offer a sequence of varied perspectives and volumes, modulated by changes of level and scale, which is distinctively baroque and peculiarly Talman's, and now without rival as an evocation of late Stuart grandeur. But Mark Girouard has shown how the suite also landed Talman in a major difficulty with his elevation: the most important rooms are at the ends and are expressed by a giant order of great solemnity, but in the six middle bays 'where one would expect a portico or some external feature, there is nothing – quite logically for there is nothing to express.' The consequent anticipation of the much later neo-classical tendency to play down the centre and emphasise the ends must be pure coincidence.

Nevertheless Talman's elevation is a design of immense, even forbidding, gravity. Interestingly enough, for the equally slablike but centrally planned entrance range of Dyrham, Wiltshire (1698–1700) he again did without external central emphasis: just a little added breadth to the middle bay and a slightly larger pediment over its window. The source is this time Genoese – the Palazzo Cambiaso, which Rubens's plate significantly shows without its pitched roof. But Talman's proportions and his more sparing detail are much more relaxed: Dyrham's tripartite elevation, each section symmetrical and each with alternating forms of emphasis from bay to bay, shows Talman at his most classical. The entrance façade which he added to Drayton, Northamptonshire (1702–4; see p. 88) had by contrast a festive *gravitas*, combining seriousness with a pleasure in a rich variety of surface modelling in a manner which has echoes of France and Holland but is really Talman's own. One must read the mannerist frontispiece as a three-bay unit; then the classical outer bays become a calmer frame to an energetic central climax. Its lean proportions, large windows and high attic associate this elevation with designs by Talman and his son for a 'Trianon' at Hampton Court, aborted by William III's death in 1702: much was saved from that architectural loss.

Christopher Wren

Christopher Wren (1632–1723), whose immense shadow dominated English architecture for half a century from the mid-1660s until the Hanoverian succession ousted him from favour and position, had the most comprehensive

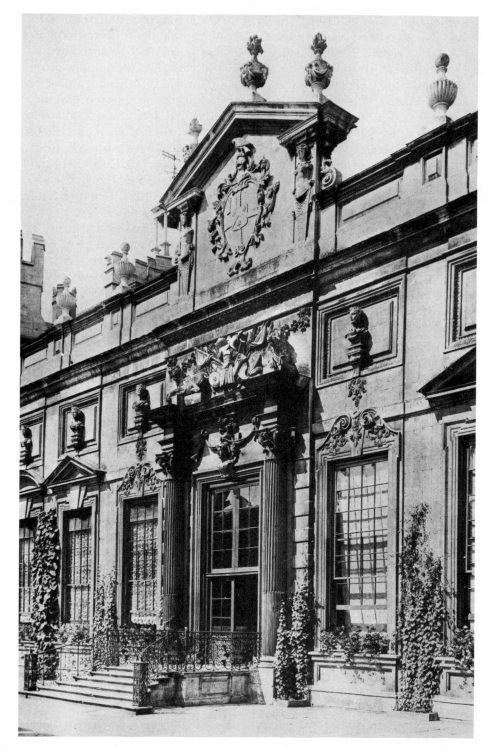

Drayton Park (inner entrance), Lowick, Northamptonshire (1702–4). William Talman.

mind of any British architect: a scientist and mathematician of standing, who made contributions to anatomy, meteorology and geometry, and held two chairs of astronomy – at Gresham's College, London from 1657 and then from 1661 as Savilian professor at Oxford, a position he only resigned in 1673 when he acknowledged that Surveyor General to the King's Works was a full-time post even for him.

Wren's engineering genius was crucial to several of his greatest and most daring achievements as an architect. In everything he combined the empirical approach and the ability to make imaginative leaps beyond what is entailed by present knowledge, which are essential to the creative scientist. Throughout his career his architecture shows a consistently exploratory habit of mind, a profound belief in reason which held fancy in check, but over and again the creative insight to see solutions to problems ahead of the calculation and constructional invention which would be necessary to bring them to physical realisation. He was the natural contemporary of Boyle, Newton and Locke. Like all progressive men of his day he believed 'a good Roman manner' superior to the 'rudeness' of gothic, and his preferred vocabulary was classical. He knew the orders and the rules which renaissance theorists had imposed on them as well as any contemporary; and he instinctively articulated façades and interiors by columns or pilasters carrying entablatures or by round-headed arches on columns or imposts. But his approach was always pragmatic, and was governed by the occasion rather than by theoretical rules.

Nothing shows this better than his first Oxford building, the Sheldonian Theatre (1663–9), designed by Archbishop Sheldon to remove rowdy degree ceremonies from St Mary's church by giving them a formal home. No such building had been conceived before: Wren saw that what was needed was a large centralised hall with an unambiguous focus visible from all points of the interior. Theatres were a characteristic setting for secular ceremony, and Wren chose the form of a Roman theatre turned back to front, so that the celebrant is in the centre of semicircular tiers of seats, the floor area being needed for processional movement. To cover the seventy-foot span without interrupting uprights, Wren devised composite beams made up of interlocking sections scarf-jointed and bolted together: the resulting roof (needlessly replaced in 1801) was strong enough to carry the university printer's stock of unsold books, which were printed in the basement. Roman theatres were sometimes covered by an awning or *velarium*, and the Sheldonian ceiling is painted to show one being rolled back to reveal the sky populated by 'Truth descending on the Arts and Sciences'.

Structure and use, as Professor Kerry Downes has shown, determine the Sheldonian's exterior equally. An ancient theatre, open to the sky, was lit entirely from above; here the sky is an opaque imitation, and light must come into the raked banks of seats through the walls. So the main windows are high up – the lower occupying the tympana of a tall ground-floor arcade otherwise filled in, the upper a continuous clerestorey interrupted only by masonry piers on which the roofbeams rest. Downes likens the resulting high-waisted elevation to a renaissance palazzo in which the *piano nobile* has been missed out, simply because there was no need for it: a brusque way with

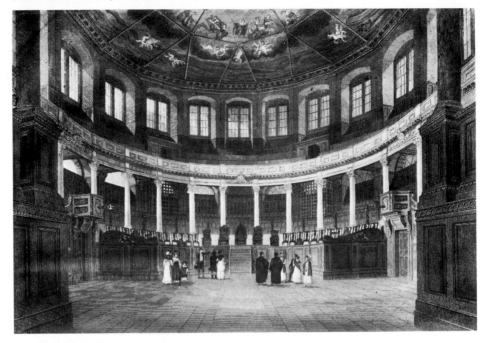

The Sheldonian Theatre, Oxford (1663–9). Christopher Wren.

rules when they do not fit the occasion. The entrance front, in which an orthodox upper-storey attached portico breaks through a much wider pediment separated from its own order by the depth of the clerestorey, shows simultaneously Wren's complete competence with classical forms and his unrulebound freedom in composing them.

Trinity College Library, Cambridge (1674–84) shows the same imagination at work to simultaneously optimise utility and style under conditions that made them especially difficult to marry. This very large building more than fills the hitherto open west side of Nevile's Court, whose sides were continued to provide subordinate wings, petite and dainty against the heroic robustness of the library. Wren's court façade has two superimposed orders of equal height: the cornice of the lower one is almost at the level of the moulding above the first-floor windows of the old ranges; moreover, since Wren's columns carry an entablature, not arches, they are more than twice as high as Nevile's, and correspondingly bulky. Wren has allowed his building to override the rest of the court, and some prefer the river front where the library stands free and its ground floor is a continuous wall pierced by conventional windows.

To the court both orders have, in the Roman manner, arches *between* the columns supported on imposts: what one sees is a row of high arched windows within an ionic pilastrade above a doric colonnade, the tympana of whose contained arches are all solid, though carved reliefs lighten the visual mass. There is thus continuous walling from the impost level to the sills of the upper windows; and the open 'cloister' is ceiled above beams carried by stubby columns the height of the imposts. These beams carry the floor of the

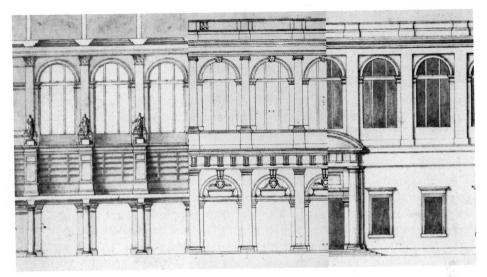

Trinity College Library, Cambridge (1674–84). Christopher Wren. Wren's drawing of the court front (centre) superimposed on the interior section (left) and river front (right). This demonstrates that the library floor is at the level of the imposts of the lesser order, with the bookshelves contained behind the solid walling below the cornice of the main order.

library proper, which is thus some twelve feet below the footing of the upper order, where one might expect it to be. So the library itself occupies two-thirds of the height of the main structure, and Wren achieves a high well-aired and well-lit room, whose windows form a clerestory well above the tops of twelve-foot high bookcases lining and projecting from the walls. Had this stood entirely above the level of the lower order the building would have been absurdly high (or the ground floor disturbingly low), very expensive and impossible to proportion satisfactorily. Wren has gained maximum utility without compromising his façade by playing a visual trick on us, knowing that inside and out cannot be seen simultaneously.

By 1665 architecture had become Wren's principal concern, and his visit to France (his only trip abroad) was made in that year to meet Bernini and François Mansart and to 'survey the most esteemed fabrics of Paris'. The effect of this was not to turn him into a French architect but to give him first-hand knowledge of some of the most advanced work of architects outside Britain on which to build an independent pragmatic practice. In particular he saw a capital city whose timber houses had largely been replaced by regular stone or brick façades such as only Covent Garden and a few other fragments could show in London. Apart from a small-scale private speculation somewhat later Wren took no part in rebuilding the ordinary streets of London after the Great Fire, though such plain but prestigious buildings as the College of Arms (1671), built and evidently designed by Maurice Emmett, master bricklayer in Wren's own office at the Office of Works, were influential in setting the lines for the sober brick rows which were the outcome of regulations in the Building Act of 1667. Wren did of course immediately give his mind to the question of how the city was to be rebuilt:

his plan was one of half a dozen produced within a few days of the disaster. It was characteristically both visionary and practical, with main streets radiating from open spaces containing the largest public buildings, churches sited so that they should not interrupt traffic but yet gain presence from axial viewpoints, and a broad open quay along the Thames like those whose beauty and usefulness had especially struck him in Paris. But such plans would have involved lengthy legal and financial bargaining, and the need to get the city working again as soon as possible ruled out anything more than a half-hearted Thames Quay and minor regularisation of a few streets. Wren, who had – to Webb's chagrin – been appointed Surveyor General on Denham's death in 1669, was, of course, a principal member of the Fire Commission, along with May and Pratt from the King's side, and Mills, Hooke and Edward Jerman for the City. But his architectural part was confined to the churches, of which about fifty were built anew or reconstructed to his designs or under his immediate supervision.

Medieval churches – mostly quite small and with tiny parishes – were scattered about pre-Fire London, as they still are in Norwich. A little under half of them (about fifty-five) were rebuilt between 1670 and the early eighteenth century, almost all on the old sites. A few, such as St Sepulchre, Newgate survived well enough to be rehabilitated in their medieval form; some were patched up only to be completely rebuilt later. The sites were often very irregular and usually cramped, too small for any space to be spared; so the church might be anything but rectangular and be built up against other buildings on two or even three sides.

Wren showed astonishingly fertile ingenuity in making virtues of these difficulties: some are quadrilaterals with no right angles, one or two irregular polygons, one coffin-shaped. At St Lawrence Jewry (1671–6) the site is trapezoidal, shorter on the north than on the south: from the outside this results in hardly perceptible distortions of perspective; inside the anomaly was removed at the west by clamping the tower between vestries which take off the awkward angles, at the east by a steady thickening of the end wall from north to south, disguised by cunning variations in the slope of the window reveals. There is only one aisle, so placed that from no possible viewpoint does the church appear asymmetrical. At St Dionis Backchurch (1670–4) the site was closed on three sides; so the church was raised high enough to allow windows over adjoining buildings, internal colonnades were made squat enough to give room for a clerestorey within a reasonable overall height, and the trapezoidal plan was used to enhance apparent length as the colonnades narrowed towards the east. St Benet Fink (1670–3), whose mannerist exterior may have been largely by Hooke, had a lozenge-shaped site, for which Wren devised a longitudinal decagon within which an elliptical dome floated over a narrow hexagon of columns. At St Antholin (1678–82) the site had one corner shaved off, which suggested to Wren an octagon of columns which defined under the dome an inner room within the outer rectangle.

One rule that Wren kept to throughout his multiform designs is that the churches, however complex in plan, are unicellular. Sightlines are direct to pulpit, reading desk and communion table, there are no dark or hidden

corners to negate the reasonableness of Christianity, and in no single instance is there a separate chancel which would have hinted at popery and isolated the priest from his congregation – at most a shallow recess for the communion table. They were all, that is, designed for a rational moderate Protestantism over which shone, through big windows full of clear glass, the light of reason. The commonest form for the larger churches is the basilica – an oblong room with clerestoreyed nave, divided from the aisles by round-arched arcades or colonnades with flat entablatures. The arches are mostly carried by Florentine columns, but St Mary-le-Bow (1671–3) has the grander Roman form (as at Trinity Library) in which the arches spring from imposts attached to a giant order. The naves are covered by plaster vaults, semicircular or elliptical in section, which typically spring from directly above the arcade, so that the clerestorey windows make three-dimensional openings into them. In a few specially large churches, however (St James, Piccadilly 1676–84, St Clement Danes 1680–2, both outside the City), the aisle walls are built up to the full height of the nave which has no clerestorey, the arches themselves biting into the vaults: these churches are double-deckers in that the raked galleries stand on rows of piers (encased in wainscot) and the main order only starts at gallery level – an acceptance of the auditorial nature of the churches more thoroughgoing than the common makeshift in which galleries simply meet the columns at architecturally arbitrary points. A specially interesting variant was at Christchurch, Newgate (1677–87; see p. 94), where galleries raked at forty degrees started only a few feet above the floor: the aisles below them thus became almost separate rooms, and the congregational space was a strange-shaped tunnel (or so it must have felt) defined by the galleries outside the columns and the nave between them.

Small box-like churches might have one aisle (St Benet, Paul's Wharf, 1677–83) or even two (St Augustine, Old Change, 1680–3), but sometimes a plain square room is magically transformed, as at St Mary Abchurch (1681–6) where a shallow dome rests weightlessly on eight pendentives or concave supports which continue the curve of the dome so that it slips imperceptibly into the wall surface: the pendentives join to make an octagon of arches, four along the middle of the walls, four cutting off the corners. William Snow's painting makes the dome darker than Wren intended but finely complements the handsome dark wainscot: the furnishings, which are exceptionally complete, include a gorgeously carved and extravagantly baroque altarpiece by Grinling Gibbons (1686), his only documented work in a City church. Furnishings were negotiated direct between each church and available craftsmen, and Wren commonly had only a general supervision if any at all. That the surviving interiors are so harmonious is testimony to effective training and apprenticeship as much as to the influence and example of the great masters, which – especially after the furnishing of St Paul's choir between 1694 and 1697 – must nevertheless have been magnetically powerful.

A way of articulating interiors of which Wren was especially fond was the inscription of a Greek cross (with equal arms) into a square which was thus divided into nine symmetrically arranged spatial units, with columns at the inner angles of the cross. The arms of the cross have short barrel vaults

Congregational space hatched

Diagrammatic examples of Wren's unicellular church interiors. (Above) Christchurch, Newgate; (middle) St Anne and St Agnes; (below) St Stephen Walbrook.

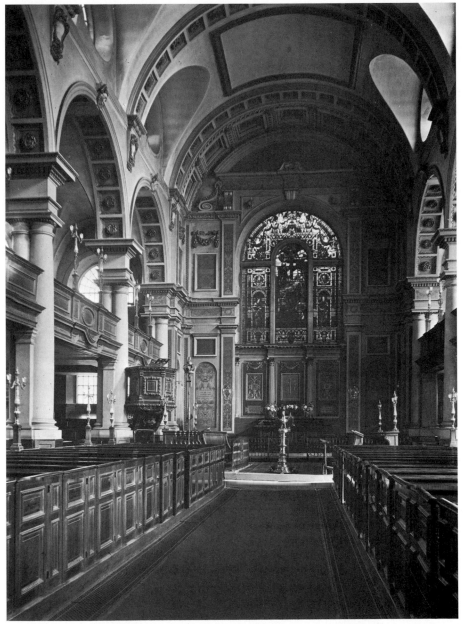

St Bride, interior, Fleet Street, London (1701–3). Christopher Wren.

supported on beams which leave small flat-ceiled 'rooms' at the corners; the
centre carries a groined vault (St Martin, Ludgate 1677–84, St Anne and St
Agnes 1677–80) of – a unique London instance of a Byzantine formula – a
dome supported on four pendentives (St Mary-at-Hill 1670–6; see p. 94). Of
all Wren's interiors the most fascinating and complex is St Stephen Walbrook
(1672–9; see p. 94): a fusion of two centralised schemes, in which the walls
supporting the dome as at St Mary Abchurch are replaced by a square

colonnade set within a larger rectangle, and the eight arches are therefore carried on columns, not responds in the wall. Alternate arches open into barrel vaults creating an inscribed cross – in this case Latin, with one longer arm from the entrance whence initially the church appears longitudinal. Further in, the symmetrical geometry of columns and beams, crowned by the circular dome above alternate semicircular and elliptical arches (foreshadowing the crossing of St Paul's) becomes all-powerful and halts the sense of a west–east directional movement. The ambiguity of accents makes St Stephen Wren's most baroque church, looking forward to the intricacies of Hawksmoor and Archer.

Wren's church exteriors show for the most part a simple geometry of rectangular outlines, pediments, round- and square-headed windows and – up to the belfry stage – plain square towers, sometimes pilastered at the top. Some steeples stop there with a parapet or balustrade or obelisks at the corners; more have cupolas, plain or with colonnettes, domelets or spirelets – not always closely integrated into the tower design. The more complex cupolas merge into the 'spires' (in inverted commas because, though some Wren spires (for example St Margaret Pattens, 1699–1703) approach gothic forms quite closely, most are made up of superimposed classically ordered storeys reducing in dimension and only capped by a small octagonal spike-stacks of little temples, as Downes calls them. Most of the greater steeples were added after 1700, but the most famous of all, St Mary-le-Bow, was built soon after the church in 1676–80: its ingenuity is characteristic. At the corners of the tower are pinnacles made of four scrolls leaning together – a tribute to the 'bows' (a sort of wigwam of quarter arches) which crowned the medieval steeple and gave the church its name and which Wren later imitated

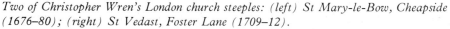

Two of Christopher Wren's London church steeples: (left) St Mary-le-Bow, Cheapside (1676–80); (right) St Vedast, Foster Lane (1709–12).

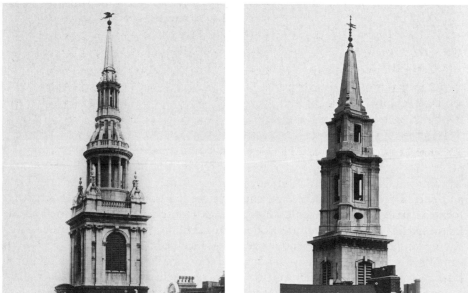

in large on the gothic St Dunstan-in-the-East; between them rises a circular 'tempietto', a free-standing colonnade round a plain drum which is carried up into the next storey where a ring of 'bows' narrows the profile in readiness for a second miniature temple, this time square with re-entrant angles which prepare for related re-entrants in the final pyramidal flèche. Wren's inerrant instinct for proportion ties these seemingly irresoluble elements together into a unity in which horizontals define stages but do not conflict with the upward movement.

Equally beautiful is St Bride (1701–3), but much simpler – four reducing octagons of arches between pilasters: a spire which isn't a spire, for until the very top there are only verticals and horizontals, and though each stage is narrower than the one below each reduction is checked by a projecting cornice so that the profile undulates. The increasingly baroque tendencies of Wren's later tower architecture reach a climax at St Vedast (1709–12) where, above a perfectly plain tower, is a square stage whose concave sides are drawn out into diagonally set clustered pilasters; these are repeated in the next stage, but the walls are now convex, sections of a continuous cylinder above which is a straight-sided obelisk, still with projecting ribs. This clash of curves and straights is the nearest that Wren gets to Borromini; soon Archer was to take the debt much further.

Nevertheless when, following the fire which in 1698 destroyed almost the whole of Whitehall Palace, Wren devised yet two more plans for that ill-fated site, both were thoroughly baroque in layout and conception. Most notable is that in which the Banqueting House is made the centre of a plan in which accents at right angles strive for dominance, and is sandwiched between domed drums whose huge windows and giant order set a new overmastering scale which is then imposed on the Banqueting House itself as an attached unpedimented portico. An intermediate scale appears on the wings whose façades, with continuous voids behind a screen of pilasters, imply single-storeyed halls – expressed, unlike the Banqueting House, powerfully on the exterior.

In 1683, for Charles II's palace at Winchester (never complete and long destroyed), Wren had devised a baroque layout with a deep open court narrowing twice to be closed by a domed and porticoed centre; and in 1694, for Greenwich Palace, transformed into the Royal Hospital for Seamen, he revived the plan, spreading the climax into a hall-and-chapel range as he had done more simply in the military hospital at Chelsea (1682). It would have stood in front of the Queen's House, but the desire to keep open the view down to the river frustrated any axial climax, and Wren's solution was, having formed a base court by replicating Webb's King Charles block, to dramatically narrow it by colonnaded screens which frame the Queen's House and open into flanking courts hidden from the main view (these last built later by Hawksmoor and others). Big domes on the projecting angles, marking the now separated hall and chapel, give vertical definition to the change of accent, but the Queen's House is too small and too far away to provide a focus, and the domes frame nothing but the sky. Wren's increasing interest in baroque is confirmed by the use throughout of coupled columns which produce constantly alternating openings, in the large round-headed

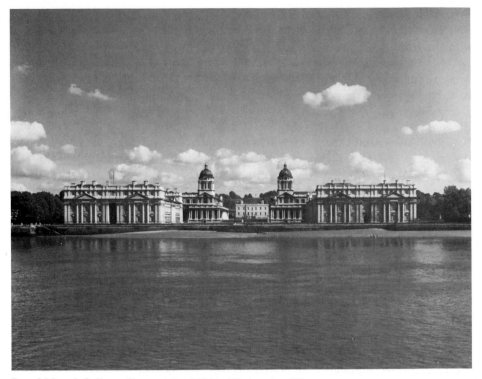

Royal Naval College, Greenwich (1694). Christopher Wren.

windows which thrust their way up into the pediments (first seen on the St Paul's Great Model), in the projecting ribs on the domes and in the linking of domes to square bases by projecting groups of columns on the diagonals.

The palace that Wren (partly) built for William III was Hampton Court (1689–1702): once again a compromise. Instead of a whole palace only the impression of one: from the south-east one sees apparently a huge square, twenty-three bays long – actually the two outer faces of Fountain Court which Wren locked into the angle between Clock Court and the chapel, providing twin state suites on the site of the old royal lodgings. The long outer façades, with their flat tops and minimum of projections obviously derive from the original garden front at Versailles, but the conventional vertical proportions are changed, lowering the ground floor to take the strain off Williams's asthmatic chest (the state rooms having to be on the first floor), and incorporating a round-windowed mezzanine above the *piano nobile*. The effect is broad, majestic, rather lacking in force, for the frontispieces are unemphatic and that to the east curiously depressed, with the pediment within the attic, weighed down by the heavy balustrade which seems even to have pushed the main windows into the basement. Fountain Court by contrast is tight and busy, full of what Pevsner calls 'little effects', the bays much narrower so that everything almost touches, the ground floor arcaded with the tympana half-filled by recessed segmental arches telling the tale of the Trinity library trick re-used.

The King's staircase climbs with regal slowness, guarded by fine though

repetitive rails by Jean Tijou, between insipid and ill-thought-out murals by Antonio Verrio, whose flabby acreages of allegory unfortunately cover most of the state rooms. Talman (who as Comptroller had special responsibility for Hampton Court gardens) may have played a part in the design: the slab-shaped form would suggest it. Of the superlative double suite of state rooms created by May for Windsor Castle (1675–84), only three rooms remain to tell of the beauty of what was recklessly destroyed in the nineteenth century. May's interior architecture was rich with exuberant movement to which Verrio responded with more brio than at Hampton, though the figures in the few surviving ceilings are anatomically incoherent and observed with monotonous carelessness. Nevertheless Verrio did show here, for the first time in England, how illusionist painting could sustain and complement the fluctuating surfaces of baroque interiors, or even – still to be seen in the Heaven Room at Burghley, Northamptonshire (1696) – create an illusionist architecture unaided.

As Wren dominated the architectural scene, so for half a century St Paul's preoccupied him. Before the fire he had been consulted about repairs to the crossing and after his visit to France designed a dome not unlike the one eventually built and on much the same scale. When the cathedral was ruined beyond repair in 1666 Wren turned to a succession of much more radical proposals. A sketch on the City plan led to the 'first model' design (1670) in which, it seems, a long chancel was to be attached to a domed circular vestibule: most interesting was the idea of having aisles within the rectangular body but walled off from the inside, exterior arcades being intended for secular business which had long disgraced the old nave. In 1673 came the Greek cross design, in which a vast melon-shaped dome curved out near its base to sit on a drum 150 feet in diameter, carried on a circle of eight huge piers opening into the arms of a cross whose outer corners were linked by externally concave quadrants. The cathedral would have been exactly symmetrical on both axes except for the absence of an east portico.

This design, purified and ennobled, was worked up into the wonderful twenty-feet-long Great Model preserved in the trophy room and arranged to stand on a hollow base so that one can walk in to inspect the interior. To the Greek cross a western vestibule is added with a small dome of its own and an octostyle portico which would have been almost as large as the whole double portico finally executed. This magnificent design, ruled by a single consistent order inside and out, the supreme architectural expression of total serenity and confidence, pleased the King. But it was too extreme a departure from traditional cathedral plans to be acceptable to the clergy, and moreover couldn't be built in sections to allow consecration and use before completion.

So in 1675 came the compromise 'warrant design', cruciform in plan with a dome at the crossing which stops half way to support a drum out of which grows a smaller dome carrying a long thin spire like a pagoda. This was the design according to which building began in 1675, and its plan is easily recognisable in that of the present cathedral. But Wren rapidly replaced it with the 'definitive design' whose two-storey elevations with superimposed orders (their top third merely screens concealing the clerestorey, aisle roofs and flying buttresses) are those that were built; the inner elevations and

vaults made of successions of saucer domes have been worked out; only the great dome and west front are in yet another preliminary form. The west portico, with its two storeys of coupled columns perfectly balancing horizontal and vertical emphases, was finally evolved in 1694, the dome and towers not till eight years later – after Wren had worked out his baroque solution for Greenwich.

But St Paul's is not a baroque building, though there are points at which energy is concentrated and tensed as in a baroque design: the apse, with its sinuously curved-up parapet and upper storey, dramatically opens to a mysterious inner replica of itself, sweeping away like the stern of a great galleon; the transept ends, more richly encrusted with carving than anywhere else on the exterior, with ever-increasing density towards the centre where even the pilasters are covered in drops of fruit and flowers and the semicircular porch is answered in the pediment with a fiery phoenix and the cathedral's motto 'Resurgam', taken, we are told, from the fragment of a gravestone accidentally picked up by a workman as a mark for the centre of the dome. Above all the west front which likewise gathers power from the extremes into the middle (the double portico springy with the inevitable tension of columns in pairs) but then spreads it wide into the restless movement of the towers – concentrated reductions of the Greenwich drums capped by an amalgam of a dozen City steeples. But between them and above the whole cathedral the dome rides with the same serene confidence as the Great Model – an exterior form of poised simplicity achieved only through calculation of great aesthetic and statistical precision.

Throughout Wren had thought in terms of a double dome, an outer one to give the cathedral commanding presence in the city, an inner, much lower, to dominate the central space at the crossing without making it into a funnel. The final design inserts a steep brick cone between the two, which meets the outer dome at its apex under the lantern whose weight it carries. A plan of this kind must have been in view by 1700 when the drum was nearing completion, for its interior colonnade leans inwards at about six degrees to the vertical: while this is important optically in preventing the drum's looking from below as if it were falling outwards, it is structurally essential in converting the thrust down the twenty-four degree slopes of the cone into a vertical loading without using external buttressing. Both domes are upright half-ellipses in profile – crucially important in the outer so that in perspective from ground level it should seem hemispherical. Seen from its own level the dome structure does look top-heavy; but that was not the point from which Wren intended it to be seen.

St Paul's is an eclectic building, evolved over forty years as Wren's own thinking and experience grew. Despite his limited direct acquaintance with the European continent, his knowledge and instinctive understanding of fifteenth- and sixteenth-century French and Italian architecture are profound beyond any possibility of plagiarism. The external elevations certainly have French characteristics; but what has been mediated via François Mansart is the anglicised renaissance of Inigo Jones's Banqueting House. The whole conception of the interior, with its combination of basilican and central plans, is that of the churches of the Roman counter-reformation; and the principle

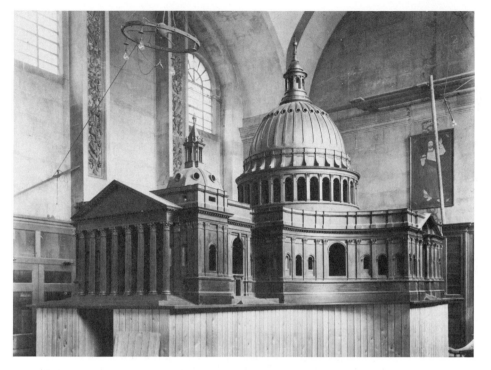

St Paul's Cathedral, the Great Model from the north-west.

of the interior elevations, a sequence of great pilastered piers with arches
between them and overwhelmingly powerful horizontal above, is
unquestionably Roman.

But whatever debt Wren may owe to Vignola, St Paul's is his Gesù in
Rome magnified, transformed and clarified by northern light and a northern
sense of structure. Where Vignola (like Alberti before and Maderna at St
Peter's after him) follows a dark sepulchral nave with a vivid flash of light at
the crossing let in by the windows of the dome, only to close all in again in
claustrophobic intensity round the altar, the light in St Paul's is not brilliant
but even, without violent contrast. And where one feels that it is hard to
make out the architectural form of the Gesù beneath encrustations of carving
so dense that pilasters and even arches seem mere incidents among
innumerable others, at St Paul's architecture is paramount, the structural
skeleton instantly recognisable. This is true even in the chancel, for all the
incomparable woodwork of Grinling Gibbons and Jonathan Maine. And at
the crossing where Wren opens all the four arms of the church into one
another, the sensation of structural form is overpowering, however little one
may understand of the engineering which suspends the dome within its huge
octagon and however little one may like the superimposed arches (of different
profiles) which Wren has been forced to thrust across the diagonals, and the
brutalist directness with which the piers continue upwards within them.

Kerry Downes has said that the Great Model 'remains as a perpetual and
unchangeable reproach for what might have been' – a monument of ideal

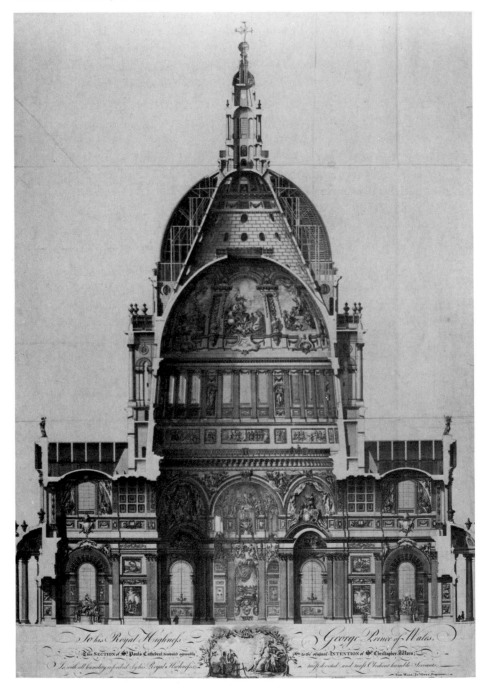

St Paul's Cathedral, engraved section, 'decorated agreeably to the original intention of Sir Christopher Wren'. Samuel Wayle and John Gwynn.

beauty which we may certainly regret but which was perhaps impossible in execution because it was an ideal. For apart from all considerations of accommodating the mind of the day to something so new and of such self-contained perfection, it is impossible to believe that Wren's restless mind would not have found many occasions for rethinking it piece by piece during the many years it would have taken to build. And no-one (except Pugin perhaps) can regret the cathedral we have, which, for all that it starts from a traditional plan, is not a compromise, not a gothic cathedral in foreign renaissance dress, but the transformation of such a plan into something rich and new: a renaissance rethinking far more complex and thoroughgoing than Brunelleschi's and more consistent than in Wren's Roman models. Yet paradoxically, with its very un-Italian long chancel, it is as distinctively English as its architect's long empirical gestation of the design: indivisible from its place in London and with unmistakable intimacy the cathedral of its own metropolis.

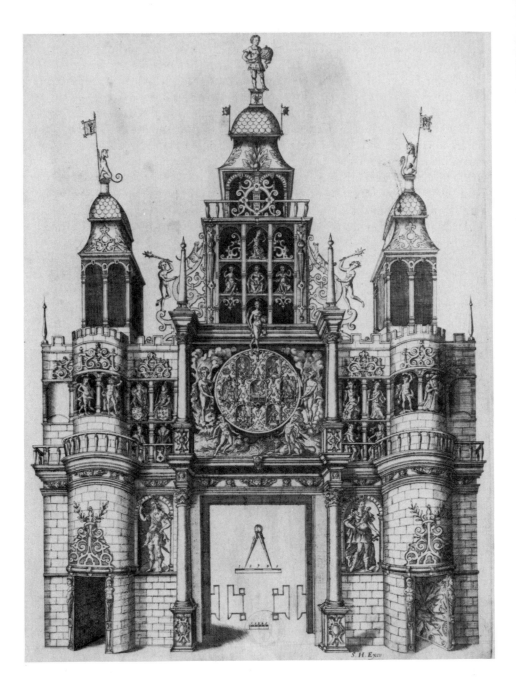

The New World, *Fleet Street, London. Temporary triumphal arch for James I, designed by Thomas Dekker and Stephen Harrison.*

3 Masques and Pageants

INGA-STINA EWBANK

'An Age full of Pageantry, of grotesque Symbolising', Carlyle wrote of the Stuart period, adding a nostalgic afterthought which also holds the key to seventeenth-century 'symbolising': 'yet not without something in it to symbolise'. For if it was an age when visual imagery and spectacle could speak 'more pregnantly than words', as the Painter in Shakespeare's *Timon of Athens* has it, this was so because it was also an age that believed in the reality of the unspeakable. The Maker who controls the seasons and the crops, the Monarch who rules the kingdom by divine appointment, the Lord Mayor in whom is vested the power and prosperity of the City – all could be approached and glorified in the imagery of pageant and masque. Whether in the form of popular festivity, civic pomp or courtly revel, such imagery aimed of course to delight and entertain, but even in doing so it also reached towards what Anthony Munday, describing the City's water-show in honour of Prince Henry (1610), called 'misticall understandings'.

To understand pageant and masque occasions, contemporary accounts and (all too few) illustrations are a guide, even if the speeches which accompanied shows must be read in the awareness that they are, as has been said of Ben Jonson's masque texts, 'not much more than the stick of the rocket after the firework has flamed and faded'. Thomas Dekker, playwright, pamphleteer and writer of city pageants, gives the most comprehensive definition of 'triumphs' (the sixteenth- and seventeenth-century word for a range of celebratory shows):

Tryumphes, are the most choice and daintiest fruit that spring from *Peace* and *Abundance*: *Love* begets them; and *Much Cost* brings them forth. *Expectation* feeds upon them, but seldome to a surfeite, for when she is most full, her longing wants something to be satisfied. So inticing a shape they carry, that *Princes* themselves take pleasure to behold them; they with delight; common people with admiration [that is, wonder].

These are the opening words of the pamphlet in which Dekker immortalised *Troia-Nova Triumphans*, the pageant he devised for the inauguration, on 29 October 1612, of Sir John Swinnerton, Merchant

Taylor, as Lord Mayor of London. It began with 'powder and smoake' on the Thames, as the new Lord Mayor made the traditional journey by barge to Westminster to take his oath. It culminated in the streets of the City where, at four separate stations around St Paul's and in Cheapside, he was addressed by Neptune in a sea-chariot, by Virtue enthroned in another chariot with the seven liberal sciences, by Envy from her cave of monsters fixed to a conduit, and by Fame from her house in which were representations of 'kings, princes and noble persons who have bene free of the Merchant-tailors'. The combination of mythological, allegorical and historical figures, all elaborately dressed and propertied, is typical of these shows; and like all artists – visual and verbal, dramatic and narrative – of the period, Dekker can rely on his audience's ability to 'read' emblems.

The assumption that they spring from '*Peace* and *Abundance*' is basic to the logic of pageantry and masque: the effect proves the cause. In real life, while King James liked to see himself as the peace-maker of Europe, his finances were by 1612 anything but abundant; and his high-handed attempts to raise revenue had led to conflicts with the City. History has a way of setting pageantry in an ironic context. But pageantry itself, even in the age of Jacobean satire, knows no irony. We can see this in the very title of Dekker's *Troia-Nova Triumphans*. It takes for granted, without illustrating it in any of its shows, the myth of London as a New Troy and its particular significance in the early years of James's reign.

'*Much Cost*' – or as Dekker also expresses it, in a telling oxymoron, 'a sumptuous thriftinesse in these civill ceremonies' – is a related principle of pageant and masque philosophy. In civic as in courtly entertainments, extravagance was not a vice but a virtue, because it was an expression, and hence a proof, of magnificence and magnanimity. Expensive devices and lavish costumes would effect wonder ('admiration') in onlookers and, leaving longing unsatisfied by their ineluctable evanescence – for these, as Prospero reminds us, were 'insubstantial' creations – stir the imagination all the more powerfully towards higher things.

In envisaging a democratic appeal (to princes and 'common people') – Dekker again defies irony, for by 1612 the ways of civic and courtly entertainments, closely overlapping in the Elizabethan age, had begun to part. King James did not attend the mayoral festivities for he did not approve of participation in popular pageantry. Nor would he have approved of the verbal imagery in which Dekker's pamphlet, justifying the show, makes the Lord Mayor as good as a king:

For the chaires of magistrates ought to be adorned and to shine like the chariot which carries the sunne; and beames (if it were possible) must be thought to be shot from the one as from the other: as well to dazle and amaze the common eye, as to make it learne that there is some excellent, and extraordinary arme from heaven thrust downe to exalt a superior man, that thereby the gazer may be drawne to more obedience and admiration.

Rolling into one the aesthetics and the ethics of pageantry, this passage pinpoints the two beliefs on which its fortunes throughout the seventeenth century were to depend: the belief in the function of all the arts to teach by

delighting; and the belief in the metaphysical and political as well as moral function of pageantry: its ability to communicate by symbolism something of the mystery of power and greatness.

When there was nothing much to symbolise, pageantry faded. Tensions between Crown and City had meant, almost from the beginning of James's reign, a bifurcation of civic and courtly entertainments. Each branch reached high points of sophistication and elaborateness during the following decades. The Civil War interrupted both, and the Commonwealth, apart from some modest attempts to revive the Lord Mayor's Show, was not a time for pageantry. The Restoration brought a short-lived renaissance of the Royal Entry and some new impetus to the Lord Mayor's Show, but the latter tired of its own clichés and by the early eighteenth century it had become the unstructured procession which it still is. The Court Masque died with Charles I and was not revived. Its ideological basis was gone. Well before the end of the seventeenth century the roots which gave Stuart pageantry its peculiar life were dead.

Folk festivities

Those roots, it is well known, stretch right down into a pre-Christian past. In the Middle Ages the Church had managed to harness pagan festivals to religious ones, and in the sixteenth century the Reformation had done away with most of the games, plays and pageants associated with Saints' Days and other festivals of an unreformed calendar, leaving only the festivities connected with the agricultural year. Midwinter or Christmas revels and Midsummer or May-Day celebrations continued throughout the country, and our *literary* records of them range from Shakespeare's use of them in his festive comedies to Philip Stubbes's fulminations against them in his *Anatomy of Abuses* (1583).

The seventeenth century saw the Puritans both win and lose: in 1644 the Long Parliament decreed the destruction of remaining May-poles, but the Restoration reversed this. The May-pole in the Strand endured until 1717; for Charles II's progress through London on 22 April 1661, the day before his coronation, it bore the King's arms and a morris, to 'ancient Musick', was danced around it. In London the pageants of the Midsummer Show seem to have merged during the sixteenth century into the Lord Mayor's Show, taking with them the traditional beasts – unicorns, antelopes, camels, dragons – as well as those folk figures, the giants and the wild or green men, which in other cities, such as Chester, continued to delight the midsummer crowds well into the seventeenth century.

Tournaments and mock-battles

Another link with the past, though one soon attenuated, was in the imagery of medieval chivalry. Elizabeth had made the chivalric myth peculiarly her own: the annual Accession Day tilts, and courtly spectacle and royal entertainments generally, were part of a symbolic fiction by which she lived and ruled. James rejected this fiction; he wanted his image expressed through

biblical and classical myth. But his eldest son, Henry, as he grew old enough to oppose his father and establish his own court in the Palace of St James, saw himself as the centre of a chivalric revival – not a return to Elizabethan myth-making but a turn to a strenuous physical and moral code. Hence, at his instigation, the courtly Twelfth Night entertainment for 1610 – the year in which he was to be made Prince of Wales – was *Prince Henry's Barriers.* Ben Jonson wrote the speeches, drawing on Arthurian romance (which he normally despised), and allowing Henry, for his part in the fiction, to take the name Moeliades, an anagram for *Miles a deo*: soldier for God – and for Protestantism. The speeches led up to the great fight at barriers at which the Prince and each of his six noble fellow assailants encountered, with pike and sword, eight defendants, one after another.

Henry did not live to pursue his chivalric symbolism, and his *Barriers* has been called the last tournament in England. Mock-battles between forces of good and evil had long been a popular element in pageantry; and displays or exercises like the one in Merchant-Taylors Hall on 18 October 1638, when eighty 'Gentlemen of the Artillery' in the presence of 'nobility, aldermen and gentry' fought each other in the guise of Christians and Saracens, are no doubt direct links with today's Royal Tournaments. But the 'something in it to symbolise' which informed Prince Henry's chivalric imagery was gone.

For the City's celebration of Prince Henry as Prince of Wales, in June 1610, Henry entered London from Richmond via the river; hence Munday's device, *London's Love to the Royal Prince Henry*, was aquatic. To greet the Prince, Neptune sent 'a huge Whale and a Dolphin' on whose backs rode two Tritons, representing the genii of Wales and Cornwall: one of these was the great Shakespearean actor, Richard Burbage. A few days later there was a water-battle between English merchants and Turkish pirates. Whether we call this a tournament or a water-show, the point is that, to celebrate Henry's princehood, City and Court met in 'misticall understandings'.

Royal entries and progresses

The most spectacular of such meetings, and a focus of civic pageantry, had long been the Royal Entry: a triumphal progress of the monarch past a series of stationary pageants, usually castles or arches built on conduits which, for the occasion, would run wine. By the time Elizabeth I made her great progress through London before her coronation, on 14 January 1559, the imagery had become sophisticated and formalised; she faced a series of speaking tableaux or mini-Moralities, with titles like 'The Uniting of the two Houses of Lancaster and York' or 'The Seat of Worthy Governance'.

For James I's entry into London, delayed by plague until 15 March 1604, Stephen Harrison designed seven magnificent arches from which a mixture of allegorical, mythological and historical figures addressed the King. Thanks to developments in theatrical art and pageant technique since 1559, the actual devices were even more elaborate: the Fenchurch Street arch, representing the City of London, was covered with a curtain of silk, 'painted like a thick cloud', which was drawn at the approach of the King. The fact that the City had commissioned two dramatic poets – Jonson and Dekker, with Middleton

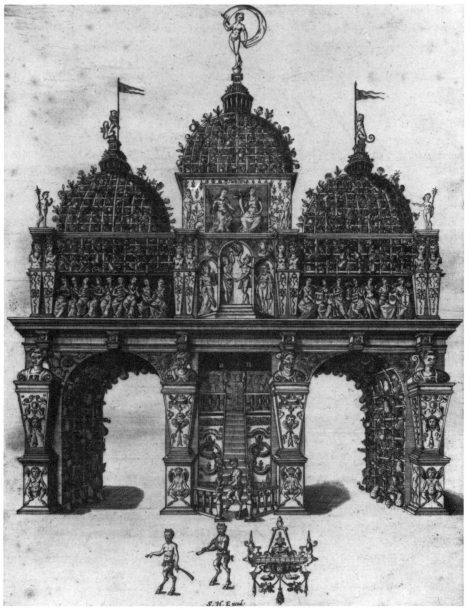

Hortus Euporiae (The Garden of Plenty), *Cheapside, London. The fifth of the seven temporary triumphal arches erected to welcome James I to his new capital in 1604. Designed by Thomas Dekker and Stephen Harrison.*

to aid him with one speech – to write the speeches at the various arches meant that James was adulated, his regenerating power affirmed, through conceits more complex and intense than those to which Elizabeth had listened.

The crucial difference between the two royal entries lay in the attitude and behaviour of the two monarchs. Elizabeth had literally taken part in the show, engaging in a continuous dialogue with actors and audience. James,

during the more than five hours it took to move from the Tower to Westminster, was mute and passive; he, we are told, 'endured the day's brunt with patience, being assured he should never have such another'. He never did. Elizabeth had been fond of shows, as long as the expense was borne by someone else; her progresses through the country and entries into provincial cities had strained the accounts of great houses and city companies. The first two Stuart kings avoided public pageantry as far as possible, projecting their image instead in the enclosed setting of the court masque.

As one might expect, the Restoration brought a brief revival of royal pageantry. Charles II's coronation progress was one of the most magnificent Entries of all times, the City sparing no expense to demonstrate its joy in the present and rejection of the immediate past. The first of the four triumphal arches (which remained up for a year or more) had statues of James I, Charles I and, at the top and in front of a drawing of the royal oak, Charles II himself. On the north side was 'a Woman personating *Rebellion*', on the south pedestal 'a Representation of Brittain's *Monarchy*, supported by *Loyalty*', and over the arch a picture of Usurpation, flying before the arrival of Charles: one of its faces was intended to represent Oliver Cromwell. But the revival did not last. There was no pageantry to accompany the coronation of James II and Queen Mary in April 1685. Instead, royalty became spectators at the Lord Mayor's Show, and for James and Mary as well as William and Mary state visits to Guildhall came to replace the Royal Entry – an *embourgeoisement* unthinkable for James I and Charles I.

Lord Mayors' Shows

Throughout the pre-Civil-War period the Company to whom the new Mayor belonged would commission a playwright to provide ideas and text for the annual pageant, but would pay possibly even more attention to the artificer who was to construct the edifices, chariots and strange beasts of this partly mobile, partly stationary show. Thomas Middleton's first pageant, *The Triumphs of Truth* (1613), in honour of his namesake, Sir Thomas Middleton, Grocer, shows something of a playwright's sense of plot and structure: there is a continuing battle between the figures of Truth and Error who keeps overspreading London's Triumphant Mount with a mist, 'a thick, sulphurous darkness', until a final *coup de théâtre*, a firebolt from the head of Zeal, sends the chariot of Error up in flames. But Middleton's later shows suggest that the City fathers, aware of what their street audiences wanted, encouraged episodic pageantry rather than coherent moral drama. His *Triumphs of Honour and Industry* (1617), for example, decks out its theme of imperialist and mercantile honour with a band of dancing Indians and speeches in their original languages by a Frenchman and a Spaniard. From the Grocers' Company's account we learn that '50 sugar loaves, 36 lb of nutmegs, 24 lb of dates and 114 lb of ginger . . . were throwen about the streetes by those which sate on the gryffyns and camells'.

Though the Lord Mayor's Show was strictly an affair where the City glorified itself – in Munday's *Metropolis Coronata* (1615) the principal pageant represented London and her twelve daughters, the Companies – it

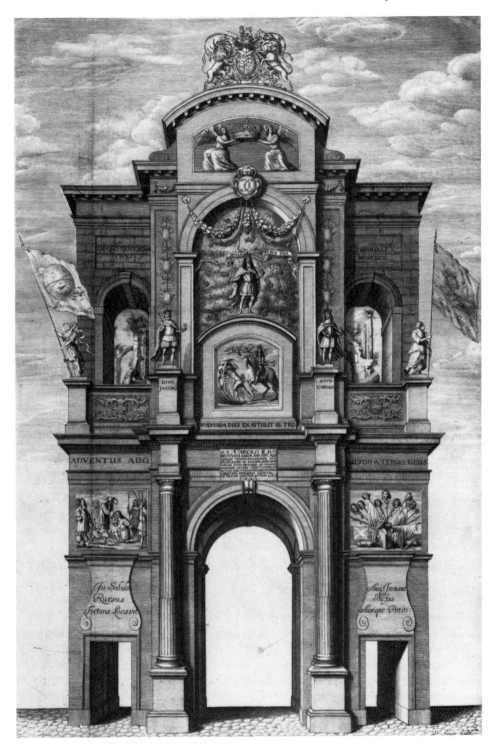

The first of four triumphal arches (1661) erected in London for Charles II's coronation.

was bound to reflect the relationship between Court and City, Monarch and Mayor. This continued to be so, and to affect the fortunes of the show, after the Civil War. The 1656 pamphlet of *London's Triumph* congratulates the Lord Mayor on restoring to the City 'those Ancient Customs of *Joy* and *Triumph* which formerly gave it the Title of the most Fortunate, Plentiful and Flourishing Citie in the World'. Tired of Puritan joylessness, the City in the 1660 show, John Tatham's *The Royal Oak*, protests its loyalty to the Stuarts by all available means. The show centres on a rustic scene round the famous oak; it has Oceanus address the Lord Mayor as 'a royall substitute' and hark back to the days of 'royall James /Whose peacefull reign did make her [that is, the Thames] murmures sweet'; and Time appears, not to rescue his daughter Truth, but to accuse those who have allowed treason to flourish.

The writer of the shows from 1671 to 1684 was himself a curious link with the past. Thomas Jordan had been a Red Bull actor until the closing of the theatres. His shows are a lithmus paper for the state of City and Crown, hailing the re-building of the City after the Great Fire in *London's Resurrection to Joy and Triumph* (1671), straining to prove loyalty through the Popish plot and the exclusion crisis, sitting on the fence when, in the early 1680s, the King had suspended the City's charter and insisted on himself appointing the Lord Mayor. At the same time the weight of the shows seems to be moving from the allegorical street pageants to less strenuous entertainments, in the form of musical comedy, between the courses of the Guildhall banquet. Indeed the faith in moral allegory as such, in 'something to symbolise', has gone out of the texts and has to be boosted with such banal self-consciousness as in the following lines from *The Triumphs of London*, the 1678 show, where the first pageant was a 'Fortress of Government' from which Fidelity spoke:

> And though this fort, thus arm'd and top'd by Glory,
> Is but a model built by allegory,
> The moral's pertinent and pregnant, too,
> It intimates your government and you.

This spells the death of the spoken Lord Mayor's pageant, and it is not surprising that the last one was written, and never performed, in 1708.

The masque

The masque as performed in the courts of James I and Charles I was the most remarkable fruit of seventeenth-century symbolising. It shared elements with other forms of pageantry – spectacle, music, songs, dances, poetry – but uniquely joined all the arts into a structure where the medium was the message (see pp. 199–202). It had grown out of a long tradition of mummings and disguisings and had begun to find artistic form in the Tudor courts – those melting pots of folk custom, native drama and foreign fashion. Under the Stuarts, through the collaboration of Inigo Jones and a row of poets, notably Ben Jonson, it reached such dignity that in his last work in the genre (*Love's Triumph through Callipolis*, 1631) Jonson could describe masques as

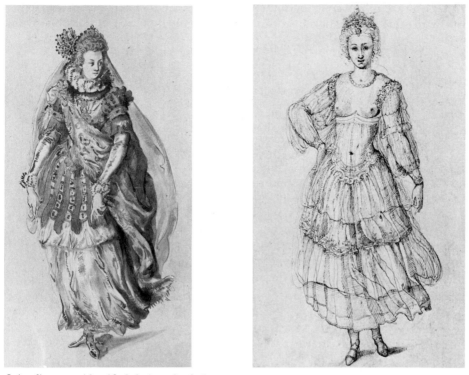

Inigo Jones, unidentified designs for lady masquers.

the mirrors of man's life, whose ends, for the excellence of their exhibitors (as being the donatives of great princes to their people) ought always to carry a mixture of profit with them no less than delight.

It is of the very essence of the masque that it is an élitist 'mirror': its audience limited to royalty, aristocrats and ambassadors (with attendant diplomatic complications); its performers (with the exception of professional actors in the antimasque) also royalty and courtiers; its subject, whatever the myth or fiction that provides the plot, the power of the King. In a Lord Mayor's Show a figure of Neptune or of Truth was a model, an ideal for the man celebrated to strive for..In the masque – with the King on his dais, there to be seen as much as to see; or, as in the case of Charles, with the Kings as a chief masquer – the emblem had to be read the other way around, signifying the King as the embodiment of all virtues. On this point rests the strength of the masque, and its function as a political instrument of both national and international importance – as well, of course, as its ultimate vulnerability when the real world, outside the court, proved the King powerless.

The statement which the masque makes is inextricably connected with its art. In the end Jones and Jonson fell out with each other over what was the most important element of that art: 'painting and carpentry', as Jonson somewhat scornfully put it, or poetry. Both were Platonists, seeing art as a mirror of the ideal. Jones saw stage machinery as the means to evoke wonder in the minds of spectators and express the greatness of monarchs. Jonson,

though aware of the contribution made by the other elements, saw the 'soul' of the masque in the spoken word, celebrating his monarch in lines like these:

> He is the matter of virtue, and plac'd high.
> His meditations, to his height, are even,
> And all their issue is akin to heaven.
> He is a god, o'er kings; yet stoops he then
> Nearest a man when he doth govern men,
>
> 'Tis he that stays the time from turning old
> And keeps the age up in a head of gold;
> That in his own true circle still doth run
> And holds his course, as certain as the sun.

The lines are from *Oberon, the Fairy Prince*, Jonson's masque for Prince Henry, performed as part of the Christmas festivities at Whitehall, on 1 January 1611, with Henry dancing the part of Oberon before King James, Queen Anne (who on other occasions herself danced in masques) and Princess Elizabeth. The moment was one which equally justified Inigo Jones's philosophy, for by an ingenious arrangement of shutters and flat

Inigo Jones, Oberon's palace, Oberon, the Fairy Prince, *scene 2.*

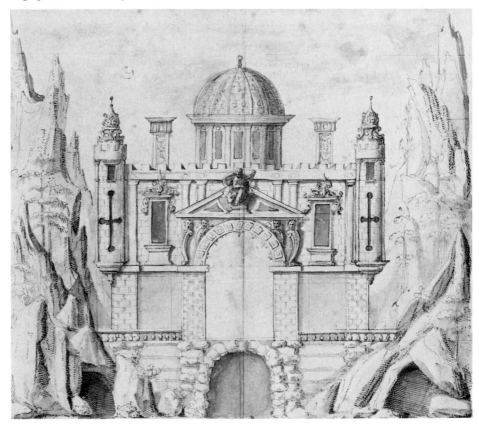

Inigo Jones, Welsh dancers (above) and Satyrs (below), in Ben Jonson's Oberon, the
Fairy Prince.

wings the spectators had been led from an opening scene of rocks and 'wildness', in which Satyrs (probably King's Men actors) made 'antic action and gestures', to 'a bright and glorious palace', which then opened to show, 'afar off in a perspective', the Knights Masquers and, behind them, Oberon in a chariot. Jones had led the spectators *in*, towards a wondrous revelation; now the wonder was thrust *out* and seen to derive from the king, divinely in control of micro- as well as macrocosmic worlds. Soon the masquers would 'take out' spectators and dance with them, affirming their place in this charmed world.

Jones's introduction of the proscenium arch and perspective scenery – his major contribution to English theatre history – thus became the perfect translation into art of James's governing idea of the Divine Right of Kings. With ever more elaborate stage machinery – (cloud machines, lighting effects, etc.) – it became, too, the perfect self-mirror for Charles's absolutism: it is no coincidence that the most spectacular masques, such as Carew's *Coelum Britannicum* (1634), effecting an apotheosis of the King, are contemporary with Charles's 'Personal Rule' – the years, 1629–40, when he ruled without Parliament. The introduction of the antimasque, beginning with the witches in *The Masque of Queens* (1609; colour plate 10), could also serve a philosophical and political function: as in *Oberon*, the movement from wild and untamed nature to elegant palaces, or the dismissal of grotesque and unruly creatures by noble and virtuous masquers, affirmed the Kings as the source of order and the controller of earthly and cosmic harmony. Jonson never lost sight of this strictly thematic function of the antimasque; and we can see it as deeply thematic in Milton's rather more literary masque of *Comus* (1634). But, once he had left the partnership with Jones, antimasques were allowed to proliferate because of their entertainment value, and Davenant's *Salmacida Spolia* has no less than twenty several 'entries' of grotesques.

Inigo Jones, scene of architecture, Salmacida Spolia.

Inigo Jones, a masquer, possibly the King, Salmacida Spolia.

By the time *Salmacida Spolia* was performed, affirming Charles's 'kingly patience to outlast /Those storms the people's giddy fury raise', on 21 January 1640 – and, ironically, not in Inigo Jones's Banqueting Hall, since the insertion into its ceiling of Rubens's Apotheosis of James I would have been damaged by the smoke from masquers' torches – the first rumblings of the Civil War were already being heard in the country. The gap between Court and country had widened disastrously; and, as in *The Tempest*, though more fatally, the real world was about to break in on the 'cloud-capp'd towers' of the princely fiction. This was the last court masque (unless the very last was the 'memorable scene' of Charles's execution in front of the Whitehall Banqueting House, on 30 January 1649). Spectacular masques found their ways into Commonwealth proto-operas and into Restoration shows like the operatic version of *The Tempest* (1674). But the Court Masque died when there was nothing left for it to symbolise.

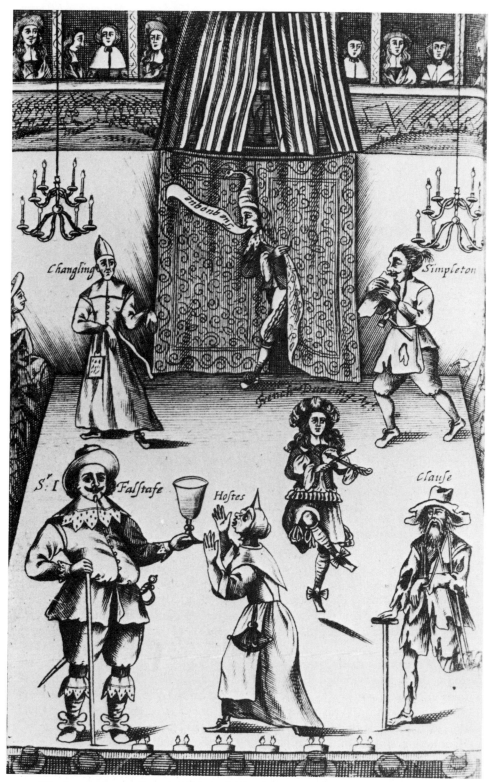

The frontispiece to Francis Kirkman's The Wits *(1662).*

4 Literature and Drama

GEORGE PARFITT

Introduction

It would be an oversimplification to say that Elizabethan literature was dominated by the court, but there is no denying that much of it is court-focussed. In the seventeenth century the court of Charles I exerted considerable influence on lyric and drama, while that of Charles II controlled theatre and produced the lyrics of such courtiers as John Wilmot, Earl of Rochester (1647–80) and Sir Charles Sedley (1639–1701).

Yet the major figures of seventeenth-century literature were neither courtiers nor dominated by court culture. In drama Shakespeare (1564–1616), Ben Jonson (1573–1637) and Thomas Middleton (*c.*1570–1627) were all of relatively humble backgrounds and none of them became primarily a court spokesman (although Jonson did sometimes play this role). The greatest English poet of the century, John Milton (1608–74), was the son of a scrivener and became an obdurate opponent of monarchy, while some of the finest prose of the period was written by John Bunyan (1628–88), tinker son of a tinker father. Courtly coteries existed throughout the century, but the variety and richness of English literature at this time take us far beyond courts, into urban contexts, mercantile careers and the protests of the underprivileged. Much of what was produced was no longer the product of leisure: the professional writer comes to overshadow, though not to exclude, the amateur. By 'professional' I mean not only those writers who earned their livings mainly by writing, but also those who were urged into print by the pressure of what they had to say, rather than by the impulse to create beautiful objects.

This change of emphasis (and it is no more than that) makes the theatre a good place to begin, while another reason for starting with drama is that its seventeenth-century history stresses the importance of the decades of the Civil War and Commonwealth (1642–60) in any account of the century's writing. For one of the best-known pseudo-facts about English seventeenth-century writing is the break in drama caused by the closing of the theatres in 1642. The tendency to see this as an absolute break and to regard Restoration

drama as almost wholly unlike drama before 1642 is misleading and inaccurate. The closures of January and September 1642 were said to be 'for a season'; drama continued to be produced between 1642 and 1660; and Caroline drama has much in common with Restoration. But there is a break in continuity, even if not an absolute one, and this is well indicated by material changes in the nature of theatre, changes particularly worth emphasising since drama is essentially designed for performance.

These changes can be summarised quite easily. The Restoration quickly saw the establishment of scenery on public stages and the introduction of actresses (although both features were anticipated in Jacobean and Caroline court masque), while the last quarter of the century saw the emergence of women dramatists. It is also important to remember that, between 1660 and 1700, there were very few theatres. Finally, although the claim that only a very restricted social range was represented in Restoration theatre audiences has been overstressed (and while such restriction began before 1660), there can be little doubt that theatre was a less popular medium in 1680 than it had been in 1610.

Theatre in England between 1600 and 1642 was, if the masque is excluded, almost entirely dominated by professionals. Its texts were provided by male dramatists whose livelihoods depended upon their being both versatile and speedy. Plays had very short runs and theatres kept large repertoires in active circulation, so that actors had to be adaptable, quick of memory and highly efficient. The dramatists were, on the whole, educated men, who had often been to university, but they were rarely of genteel birth – Jonson's stepfather was a bricklayer, and the father of John Webster (*c*.1580–*c*.1634) seems to have been a tailor – and their profession had little social standing. The dramatists were involved with theatre in varying degrees: there was Thomas Heywood (*c*.1574–1641), with his alleged hand in some 220 plays over almost fifty years, and there was Ben Jonson, who wrote for the stage intermittently and, it seems, with some reluctance. The lack of status is clear when one thinks of Shakespeare seemingly anxious to cleanse his hands and retire to become a Warwickshire gentleman; or of the genteel John Fletcher (1579–1625), a prolific writer for the stage for some years who left it completely when he found his rich widow.

An overview also notices the variety in English drama before 1642. Very little dramatic criticism exists before 1660 and what there is tends to be moral and practical rather than theoretical. This is not surprising, given the professional pressures mentioned above, but the dramatists do comment on each other's practices through parody, as can be seen with the running mockery directed at that great Elizabethan hit, Thomas Kyd's *The Spanish Tragedy*, or with such directly parodic plays as Francis Beaumont's *The Knight of the Burning Pestle* (1607?). But relative neglect of theory encouraged casualness about genre, and both this and the love of parody can be seen in the striking growth of city-based comedy after 1600 and in the strong element of satire which came into tragedy in the early seventeenth century. The former derided the conventions of romantic comedies like *As You Like It*, while the latter mocked ideas of tragic dignity and reconstruction. As comedy and tragedy infected each other tragi-comedy was

produced, but also tragedies which were marked with black humour and comedies which were amusingly serious.

After 1660 public drama becomes, paradoxically, both more respectable and more disreputable. Monarchic patronage and a restricted audience made it easier for the genteel to write for the public theatre without losing face. The Restoration saw drama turn both inwards and outwards. Comedy tended to be set in contemporary London and to concentrate on the interests and milieux of the genteel, creating a striking mirroring. The play's reflection of its audience constituted a distortion which could be viewed either complacently or critically. Meanwhile tragedy located itself abroad (this being nothing new in itself), largely purged comedy from within itself, and stressed themes and conflicts between moral absolutes rather than the detailed presentation of individual circumstances.

This emphasis in tragedy, together with comedy's interest in the satirical inspection of moral values, has led to a view of Restoration theatre as aesthetic rather than socio-political. Yet Restoration comedy can be seen as offering an oblique critique of its world rather than a complacent endorsement of it. Tragedy, distanced in setting and performance-style, operating under controls which preclude direct discussion of contemporary politics, does nevertheless articulate comment upon such matters. The value-worlds of *Venice Preserved* (1682; by Thomas Otway, 1652–85) and *Aureng-Zebe* (1676; by John Dryden, 1631–1700) are far from simple; while the frequent use of contemporary costumes and the stylisation of sets, together with the ambiguous placing of the acting space in front of the proscenium, allowed for complex tension between play and audience.

John Milton's *Paradise Lost* (1667) is an epic and the greatest poem of the seventeenth century, but epic was not the chief mode of that century's poetry. Much attention has been given in our time to the work of John Donne (1572–1631), yet so-called metaphysical verse was not the most characteristic kind of seventeenth-century verse. It is satire, in fact, which provides the best starting point, and Dryden's *Absalom and Architophel* (1681) may be seen as the focal poem. *Absalom* is concerned with Achitophel/Lord Shaftesbury's attempt to draw Absalom/Monmouth (the bastard son of David/Charles II) into rebellion against his father and, as satire, it reminds us of other satirical poets of the period – Jonson, John Cleveland (1613–58), Andrew Marvell (1621–78), John Oldham (1653–83), Samuel Butler (1612–80) and John Wilmot, second Earl of Rochester. It reminds us also of how much seventeenth century verse was satirical without being formal satire. *Absalom* is itself an example, while Jonson never called a poem of his a satire. Marvell and Rochester (like Donne before them) injected lyric with satire and Milton is often satirical in epic.

But *Absalom* is an heroic poem as well as a satirical one, and as heroic it reminds us that the seventeenth century is an age of public poetry. It is also a mock-heroic poem which links the heroic and the satiric to construct a debate which is found everywhere in the verse of the period – in the cynicism of much lyric, in the ambiguities of Marvell, in the ways in which Charles Cotton (1630–87) and Rochester undercut the pastoral tradition. Even Milton's epics can be seen as satirically subverting ideas of the heroic. His

epic critique of the heroic asks '*Who* is heroic?' and 'Is heroic behaviour really possible?' Such questions draw other matters in. Milton's Puritanism calls him to redefine heroism. Adam is no Hector, but he is the ancestor of John Bunyan's Christian and Daniel Defoe's Robinson Crusoe, while, before Milton, Calvinism's awareness of human depravity had already questioned courtly confidence.

Calvinism changed the nature of religious poetry in the seventeenth century. Such poetry was marked more by its variety than by any common concern with being of the School of Donne. It includes the egocentric doubts of Donne himself, the high Anglicanism of George Herbert (1593–1633), the extreme sectarian emphasis of Henry Vaughan (1622–95) and the Counter-Reformation manner of Richard Crashaw (*c*.1613–49). It was the extraordinary variety of religious opinion in the century which drove Milton to examine the origins of belief in epic, yet this necessarily involved a link with the development of public verse of compliment. In such verse possibilities of heroic behaviour were explored, and its use of classical allusion explicitly associated such possibilities with the heroes of classical history and legend. In the course of the century the emphasis changed from native heroic history to the presentation of contemporaries in heroic terms. This, though, brings us back to the tension between heroic and satiric. *Absalom* is a poem of conflict, between David and Achitophel but also within these figures. David is both godlike and a rake, while Achitophel has both demonic qualities and considerable integrity. Milton's heroic figures are similarly riven (except for Christ in *Paradise Regained*, 1671). John Donne figures the arrogance of the male lover, but also his fears of impotence and humiliation (themes sharpened by Rochester). Even Thomas Carew (1594/5–1640) writes smooth Caroline lyrics with surfaces which are often disturbed, and Marvell carried such tension to extremes.

But if it is useful to see much seventeenth-century verse as bound together by such tension, it is also important to notice how various is the material which tension unites, for the period was one of refinements and formal experiments. The heroic couplet was tightened in the service of satire and compliment. Burlesque was developed as a satiric mode. Variety of love lyric replaced the sonnet sequence and Milton provided the first great English non-dramatic blank verse. At the same time there are interesting developments in the decorum of the language of verse. Milton's famous Latinisms heightened the distancing of epic, even while his matter insisted on its urgent contemporaneity, and Edmund Waller and Abraham Cowley (respectively 1606–87; 1618–67) constructed the diction of polite love-making. Jonson developed a plain style which gave poetry a flexible version of ordinary language, while mock-heroic insisted upon juxtaposing different linguistic registers to critical effect. Important things happened also in the special area of allusion. Thus Roman legend and history were stressed, while pastoral was retained, and aspects of 'new' knowledge were made familiar. During the century, too, the vocabulary of puritanism was drawn into verse, bringing with it new political meanings.

If drama was the most obviously professional medium of literature in the seventeenth century, and if poetry remained the most prestigious, it may be

argued that prose became the most democratic, although this has not been the usual emphasis of discussions of English prose in the period, for such discussions have tended to operate in terms of the history of style or in relation to the Whiggish concept of the rise of the novel. The former concentrates upon aesthetic issues, stressing balance, rhetorical patterning and the elevation of diction away from the idiomatic towards Augustan lucidity. The approach by way of the rise of the novel places more stress upon the fitting of prose for the novel's eighteenth-century preoccupation with the ordinary concerns of ordinary people.

But, at least within seventeenth-century terms, it is more important to relate its prose to the spread of the medium. Living as we do in an age of (modest) mass literacy, where prose is the normal medium of written communication, it is easy for us to underestimate the significance of this spread. During the seventeenth century English prose built on Tudor developments to the point where prose rather than verse became, as never before, the usual medium for writing. Hobbes and Locke made English prose a serviceable style for philosophy, while it was also developed as a vehicle for criticism, was used for various kinds of fiction and became the proper medium for history. But, above all, there were the developments in the sheer amount of writing in the related forms of the diary, the memoir and the letter. Quantity is as important here as quality. Accident plays its part and more survives partly because the seventeenth century is closer to us than earlier times. But the century was also interested in preserving memorials of itself, including the writings of people who had hitherto been largely silent.

By this account, the most important factor in the history of English prose in the seventeenth century is neither to be seen in the aesthetics of style nor by working back from the experiments of Defoe and Richardson in the novel. It lies instead in the pamphleteering of the period between 1642 and 1660. Such writing was inextricably bound up with the politics and religious controversies of that period and, as such, has repelled critics and scholars who, for example, deny any connection between Milton's epics and the world of 'telegrams and anger'. But the extraordinary outpouring of pamphlets is of great importance to anyone who is aware of the necessary impurity of art. Although the Civil War did not create the pamphlet and although the pamphlet did not die with the Restoration, the two decades between the latter and the outbreak of war accelerated and compressed the development of pamphleteering prose and the involvement in this of ordinary men and women. What was created was a medium which could do most things and which most could use, by writing, reading or listening.

Some sixteenth-century prose had reached large audiences as drama and through the pulpit. By 1600 there was already a tradition of popular prose in the hands of such as Nashe (1567–1601) and Deloney (c.1550–1600), and there was also a tradition of prose controversy, largely a product of the Reformation, which had a fine flourish with the satirico-religious pamphlets of 'Martin Marprelate' near the century's end. And, of course, learned prose was well developed. But what is not readily to be found is a serviceable prose for memoir, diary, familiar letter or multifunctional pamphleteering. Seventeenth-century prose saw changes in learned writing, with style

becoming broadly less ornate. There are connections between the fictional manner of Nashe and that of Defoe (1660–1731).

The most significant gains were, however, democratic. The social strains, separations and demands of the period between 1642 and 1660 encouraged the type of direct and flexible letter-writing which we find, for example, in the records of the Verney family, while the relative collapse of censorship and the socio-political opportunities of the period made it both urgent and possible for voices to be heard which had been largely silent before 1642. Prose is the dominant medium of these voices, which may be largely orthodox in expression (as with Gerard Winstanley), while others are both strange and challenging (the prophet Eleanor Davies, for example, or the Ranters). There was also that increased confidence over self-expression which grew with Puritanism and which is best known in relation to John Bunyan; but the Romanticism which sees Bunyan as solitary genius is almost wholly false, for Bunyan's prose is firmly rooted in the achievements of non-learned prose in the mid-century. It can even be argued that the most significant aspect of seventeenth-century English prose is the testimonies of non-conformist women, not because they magically speak as with the tongues of angels (though they may speak in tongues) but because they speak at all. This may not be what it usually thought of as Literature, but it is certainly literary.

A theatre of satire and revenge

Shakespeare's *Hamlet* (1603) was first played at the beginning of the seventeenth century, and although the title-figure is probably the most famous in English drama, Hamlet is basically a stock character, acted on a long open-air stage without scenery, by a busy actor working in a tradition of short runs, little rehearsal time and a high degree of acting formality. Hamlet is given a revenge task and the play is 'about' the difficulties which this entails. Both task and difficulties are parts of the conventional material of revenge drama.

Towards the end of the century, in 1682, Thomas Otway's *Venice Preserved* was produced for the first time. Its central character, Jaffeir, struggles with the conflicting demands of friendship, married love and politics. His play, acted on a covered stage and with scenery, is 'about' the difficulties of moral and emotional choice. A brief history of English drama in the seventeenth century might be written with these two plays as markers.

Hamlet includes characters who reflect upon experience and what it might signify. Polonius *has* reflected; Hamlet himself is notorious for having a reflective disposition; and Ophelia's madness reflects on the Danish court and Hamlet's brutish rejections of her. But *Hamlet* is also a play of violent action, whether staged within the play proper (the theatricals which Hamlet hopes will trap Claudius), reported (Hamlet's treatment of Rosencrantz and Guildernstern), or enacted on stage (Hamlet's killing of Polonius; the final murders). It is also a tragedy full of satiric comedy – the mockery of Polonius, the shivery near-farce of the second ghost scene, Hamlet's obscene

jokes at Ophelia's expense, the graveyard humour, and even the 'horrid laughter', of a botched denouement.

In *Venice Preserved* reflection is ubiquitous in the sense that the vocabulary of moral conflict and behaviour is so prominent that we are fully conscious of themes and our attention is drawn to the clash of moral values. Violent action remains important, notably in the report of the attempted rape of Jaffeir's wife and in the closing torture scene, while satiric comedy is brilliantly represented in the sub-plot, involving Antonio and Aquilina. Yet *Hamlet* is commonly seen as perhaps the greatest tragedy in a period of fine tragic drama, while *Venice Preserved* is usually seen as one of the very few Restoration tragedies of any value.

Shakespeare was a professional dramatist who, by the time *Hamlet* was written, was thoroughly experienced. Given the prevailing theatrical conditions (sketched earlier) the best way of writing drama was usually to take an existing story, and to turn it into dramatic form along lines already established, bearing in mind the strengths and the specialisms of the expected performers and the interests of the likely audience. Innovation was mainly a matter of extending or parodying that which was already established, and anything more obviously radical was likely to cause difficulties, as the career of Ben Jonson makes very clear. Working at high speed and needing to develop expertise in a number of styles and modes, a professional dramatist had little time for theory or generic purity. Work for the public theatre called for flexibility, large gestures, bold effects and striking language. The dramatists are at times keen to be seen as poets, but the strength of Elizabethan and Jacobean theatre lies in its theatricality. The burning crown of Henry Chettle's *Hoffman* (1602) and the ghastly stomping of the duke in *The Revenger's Tragedy* (1608; usually ascribed to Cyril Tourneur) have their analogues in *Hamlet*, while a self-consciously gestural style stresses the theatricality of the plays and their insistence on seeing life as drama.

Such theatricality makes the point that drama draws on and depends upon the material factors which go to make it up. Drama can never be pure and seventeenth-century drama is very impure indeed, not least in its attitude to genre. Where it is tragic the tragedy is often, as in *Hamlet*, shot through with satire, to the extent that the reductive nature of the latter almost overturns Aristotelian definitions of the genre. Such central figures as Vittoria in Webster's *The White Devil* (1612) and Beatrice Joanna in Middleton's *The Changeling* (1622) are morally highly ambiguous and lend themselves to satiric treatment. Comedy is often as impure, to the extent that quite drastic redefinition of generic categories may be called for. In what sense is *The Merchant of Venice* a comedy for Shylock (and perhaps Antonio)? Jonson's *Volpone* (1607) is a very funny play, but so savage as to make the laughter it elicits disturbing. The themes and conventions of Romantic comedy are revised in city-based comedies, such as Middleton's *A Chaste Maid in Cheapside* (1630) – and in such plays the laughter may be as uneasy as the 'horrid laughter' of satiric tragedy.

Being revenge tragedy *Hamlet* is concerned with vengeance, but it is striking how deeply revenge is written into this drama (reflecting in part the litigiousness of the period). In tragedy the achieving or thwarting of revenge

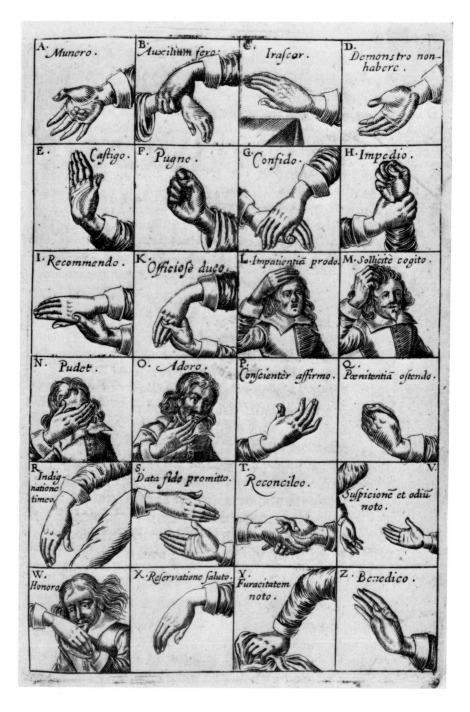

Gestures for miming in John Bulwer, Chirologia, or the Naturall Language of the Hand *(1644).*

is everywhere, although revenge cannot formally be allowed to triumph unless it is that of the rightful and righteous ruler. Hamlet, a sensitive and brutal botcher, dies in carnage he could neither engineer nor control. Vindice, in *The Revenger's Tragedy*, a much more accomplished fixer, has the creative ability of one of Jonson's comic plotters and, like Volpone, can only be brought down through ironic exposure and self-revelation: ''Twas we two murdered him'. Mockery marks the masques of such tragedies as Middleton's *Women Beware Women* (1621), with the mockery touching both the idea that revenge defeats itself and the comic illusion of harmony which the masque form asserts. But when revenge is enacted as a public function by a legitimate ruler we are not asked to condemn it. We are not, I think, asked to see revenge upon the Macbeths as dubious, and yet tragedies of the early seventeenth century find it difficult either to affirm the operations of state revenge without irony or to find alternatives to private vengeance in social relations. Theories about social harmony weaken under the pressures of the detailed reality in which this drama deals: hence the weakness of the note of reconstruction at the end of *King Lear* (1605) and the implied undercutting of Antonio's position as the new duke in the conclusion of *The Revenger's Tragedy*.

But revenge is not confined to tragedy. In *Measure for Measure* (1604) the duke takes mild revenge on Angelo and more severe vengeance on Lucio, while in the Thomas Dekker and Thomas Middleton comedy *The Roaring Girl* (1608) the central figure, Moll, takes revenge upon the male sex (with, however, only limited final success). Figures like Volpone and Shylock are savagely punished by societies bent on avenging the challenges they represent. In city-based comedy comic revenge is taken on the folly of the gentry, the pretensions of citizens and the idiocies of romantic conventions – hence the brutal mockery of Malvolio, the madness of Sir Giles Overreach, the land-grasping merchant in *A New Way to Pay Old Debts* (1633; by Philip Massinger, 1583–1640), and that motif whereby romantic love issues as marriage to a whore.

Two aspects of revenge drama, however, prevent vengeance and the satire involved with its presentation from being purely pessimistic. One is verbal and, being commonplace, needs only brief mention here. Plays of the period are linguistically very lively. Even plays which show relatively little literary sophistication are full of energetic language – listings, images, namings of objects – and this creates textures which may be rough but are seldom thin. Such specificity – Middleton's famous realism, Jonson's fascination with dialect and argot, Shakespeare's figurative obsession and fecundity, the nervous density of the style of *The Revenger's Tragedy* – relates to the second aspect I want to stress: that, for reasons indicated above, this is very much a drama of story. The stories may be historical, as in the tragedies of Webster and George Chapman (1558–1634), or fictional, or a mixture of both as with Dekker's *The Shoemakers' Holiday* (1600); but while this is a drama which is alert both to the telling juxtaposition of motifs and their thematic implications, it is not theme-based drama but rooted in particular stories, locations and dilemmas. So *Hamlet* is less a play about Revenge than one about the Danish court; and Jonson's comedy *Bartholomew Fair* (1614) is about Bartholomew Fair.

It is almost a cliché to speak of the energy of Jacobean drama, but this energy is neither primitive nor facile, being instead a sign of resilence in face of a properly pessimistic view of experience. The famous optimism of humanism is severely damaged by Calvinism's awful sensitivity to human depravity and a terribly just deity, and Hamlet lives in a depression between these contrary visions. But even while the dramatists are creating corrupt and depraved worlds (as in *King Lear* and *Troilus and Cressida*) they are also articulating energy, ingenuity and resilience. Socially these qualities may come from almost anywhere, from Webster's duchess of Malfi, with her resolute sense of self, from the plebian Moll in *The Roaring Girl*, or from the shoemaker Simon Eyre in *The Shoemakers' Holiday*, from Jonson's tricksters or Middleton's villains. It would be silly to call Jacobean drama democratic, but it is to the point to notice that its energies come from a full social range and to relate this, if only tentatively, to the size and accessibility of the theatres and the intimacy of Jacobean society.

A stock account of English drama in the seventeenth century would stress the Jacobean achievement and go on to claim another flourishing in Restoration comedy. It would almost certainly speak of this latter flourishing as a more limited and more sophisticated achievement than the Jacobean, and it might well play upon the organic nature of the image, with its intimations of decay and death between periods of flowering.

If, for the moment, we accept this pattern, the first thing we should notice is that the term 'Restoration comedy' defines something quite precise, a type of comedy usually set in the rooms and pleasure haunts of the genteel, with a cast of characters dominated by the gentry (at the expense of the aristocracy, merchants, tradespeople and peasants). These characters do not work and do not need to, and they show little sense of service to the state or society. These comedies stress love, intrigue and wit.

Intrigue is what characters live for. It is manifest in assignations, plots, letters and disguises, and is located in a world of dancing, singing, play-going and social intercourse in parks and drawing rooms. These characters aspire to epigram and impervious social disguises, even while they operate in a context of brutal deceit and appetitite. It is also, it seems, a closed world: servants are agents rather than people, foreigners are funny. It is comic to ape foreigners and backward to adhere to rural values. Work is a mark of social inferiority and so any representative of trade is to be rebuffed as a pretender to gentility. Only at the margins and by implication are the major political and religious concerns of the second half of the century recognised. It is comic to be Puritan and unstylish to seem seriously committed to a Cavalier past or even an overtly royalist present. In fact, it is unstylish to be committed to anything except style, and a character who finds himself or herself committed to anything else does well to disguise this in stylishness. If, however, the stylishness is affected in a blatant way humiliation is seldom far off, whether you are aping the French, painting to defy age, pretending to wit you really lack, or claiming to be a civilised, urban product without adequate urban experience to justify the claims.

It is important not to misread the social significance of Restoration comedy. Its authors tended to be gentry or gentry-aspirants, and were seldom

professional dramatists in the Jacobean sense (although both John Dryden and Aphra Behn, *c*.1640–88, were exceptions). They tended, instead, to be participants in the worlds they write about and it is easy to see their drama as mimetic, especially given the contemporary settings and costumes of the comedies and the ways in which prologues and epilogues blur the lines between play and audience, in the same manner as the chief acting space, on the forestage, exists in an ambiguous relationship to scenery and auditors.

But Restoration comedy offers a mirror only of a fraction of Restoration society and is cool about what it does mirror. The concentration upon a part of the totality of Restoration society suggests in itself a social fraction turned in upon itself. It is a fraction which is specialised to London and largely reduced to the pleasure principle. Its world is broadly that of Thomas Hobbes (1588–1679), a world of appetite, and even though the best of the dramatists are aware that this is a world of severely restricted values they seem to feel that no better exists.

Restoration comedy was largely the product of the gentry in the aftermath of the period of the Civil War, Commonwealth and Protectorate, and it was written primarily for gentry consumption. The period which led to this comedy saw the acting out in politics and warfare of splits in the genteel class which were evident before 1642, and it also saw the active and literary participation of the non-genteel on a new scale. That broad phenomenon we try to net as 'Puritanism' exacerbated fissures in the theoretically monolithic concept of social hierarchy (one good example being how the gentry's preserve of military leadership was shattered by the New Model Army), while Catholicism continued to cause socio-religious divisions and suspicions. But although the effects of 1642–60 are complex there can be little doubt that they worked to make Restoration comedy culturally isolated. T. S. Eliot's idea that a 'dissociation of sensibility', whereby intellect and emotion became progressively more separated after the middle of the seventeenth century, is a dangerous toy and the flexible energy of William Congreve (1670–1729) and George Etherege (?1635–91), together with the rougher and dirtier edge of Dryden and William Wycherley (*c*.1641–1716), should not be underestimated or made to seem more refined than it is.

This is a comedy which aspires to polished, sophisticated surfaces:

> *Miss Prue* Why, must I tell a lie then?
> *Tattle* Yes, if you would be well-bred. All well-bred persons lie. Besides, you
> are a woman: you must never speak what you think.
> (Congreve, *Love For Love* II, 1.545f.)

But style and staging nevertheless remind us of an essentially tough world of disease, graceless aging, disloyalty and sexual violence. It is a world in which Wycherley's Horner feigns castration to ease access to married women (*The Country Wife*). Regardless of how knowingly this is presented, the world of Restoration comedy looks cut off from sources of renewal. Cynicism within seems to deny the possibility of renewal from within and the chance of renewal from without. The terminus of its Hobbesian emphasis on sensation is the verse of Rochester, while avoiding the logic produces a retreat into the sentimental comedy of Sir Richard Steele (1672–1729). By definition,

Restoration comedy cannot be enriched by Puritanism – being written for
and acted on stages under tight monarchic control – but it was Puritanism
which was to enrich culture for decades to come.

Restoration comedy concentrates upon the social fraction it represents with
such intimacy that it can be seen as having a critical dimension almost
irrespective of intention. The very fact that it is so selective makes a point
about the society it drew on and entertained. But Restoration theatre was not
just a matter of the kind of comedy written by Congreve and Etherege.
Dryden and Wycherley retain something of the roughness of Jacobean
comedy, while, towards the end of the century, Aphra Behn, significantly
both a sexual and a social outsider, exploited the conventions of the genre in
ways which draw out the grossness and inequalities of its world.

There is also Restoration tragedy which is, on the surface, the antithesis of
Restoration comedy. It is almost always set abroad, while the comedies are
usually London-based. It is usually set back in time, against the comedies'
use of time present. It uses verse intead of prose and it offers serious and
direct discussion of major moral issues in place of comedy's emphasis on
cynical behaviour and a lack of moral commitment. Seen in this way,
Restoration tragedy presents the heroic aspect of culture in the second half of
the century, and, taken with the nature of the comedy, this would indicate a
split culture, one in which the heroic is divorced from the comic, the ideal
from the actual, verse from prose. Yet, granted that the dramatists and
audiences are much the same, can the reality be as paranoid as this account
would suggest?

Restoration society was certainly deeply fissured and the reign of Charles I,
together with its aftermath, had necessitated this fissuring. One feature of a
split society may be the desire to find and follow high moral standards, and
this is not incompatible with a defensive fear – product of experience – that
such standards may be delusive. Restoration comedy, located in the
contemporary, concentrated upon the defensive analysis of moral behaviour,
while tragedy was driven, because of censorship, away from direct discussion
of major moral and political issues in a specifically native and contemporary
situation. Tragedy was directed into exotic locations and comedy into almost
exclusive preoccupation with social manners. But these divisions are
simultaneously true and misleading.

In the first place, Restoration tragedy's divorce from the native and the
contemporary can be overstated. There is an important formal division,
whereby political issues can only be presented in exotic locations, and
accepting this was a prerequisite of production. But the dramatists were
capable of suggesting connexions. Dryden's *Aureng-Zebe* (1675) is typical
enough in its presentation of issues of loyalty to monarchs and he writes
about theories of rule. His play is safely set abroad and its theoretical
views are, on the surface, orthodox enough, but his interest in loyalty among
blood relatives of a monarch could scarcely have lacked contemporary
significance, given how long James had to wait to rule. The temptation to be
disloyal, to rebel, was too much for Charles's bastard son, Monmouth.
Moreover, Dryden's play-text claims the action takes place in 1660 when
issues of the right to rule could hardly have been more urgent to the English.

The conditions under which the dramatists worked made formally
orthodox conclusions a necessity (and the banning of Nathaniel Lee's tragedy
Lucius Junius Brutus in December 1680 showed how difficult it was to write
about republicanism under any circumstances), but Elizabethan history
drama had suggested how orthodox conclusons could co-exist with other
possibilities. Costume, with its broadly ahistorical mixture of styles and
period, could readily suggest connexions between the exotic and the
contemporary/local, and the same is true of sets, which tend to be typical
rather than particular. Moreover, a writing style which emphasises theme and
generalisation of character leaves much space for application to more than
one set of circumstances:

> Swear then, my Titus, swear you'll never upbraid me,
> Swear that your love shall last like mine forever;
> No turn of state or empire, no misfortune,
> Shall e'er estrange you from me. Swear, I say,
> That if you should prove false, I may at least
> Have something still to answer to my fate.
>
> > (Teraminta; *Lucius Junius Brutus*, I, 1.51f.)

Indeed, it could be suggested that the heroic style took the form it did to
allow discussion of issues of contemporary importance without the dangers of
particular application. Even so ubiquitous a theme as that of the conflicting
demands of political duty and sexual appetite hardly lacked contemporary
point when the monarch was as promiscuous as Charles II (this being a
theme which Rochester used with privileged obscenity). Towards the end of
the period *Venice Preserved* showed how tragedy could balance very finely
between political orthodoxy and heresy. That play concerns a plot against a
republican government, and the plot fails, with the plotters being executed
for their treason. But the play makes much of governmental corruption, gives
real force to the arguments of the rebels, and the ending leads,
simultaneously, to sympathy with Jaffeir and the sense that nothing has
happened to produce betterment in the state. A variety of conclusions can be
drawn from Otway's play – and the links which the prologue and epilogues
make with native and contemporary events serve to increase the enigmatic
quality of the whole.

This leaves a point which should be obvious – that it is vital not to divorce
the texts of Restoration tragedy from the contexts and conditions of their
performance. And if it is important to notice the toughness beneath the
surface of Restoration comedy, it is as important to register how a satirical
element in some Restoration tragedy can draw its seemingly idealised worlds
back into close contact with harsh reality. The sub-plot of *Venice Preserved* is
a good example of how satire can work in this drama, while Dryden's use of
juxtapositions of style and action in *Aureng-Zebe* is an effective instance of
how presentation can cast an ironic light on orthodox sentiments.

It remains true, however, that Restoration drama is more specialised than
Jacobean. Its comedy is more severely segregated from its tragedy, its verse
from its prose. Decorum plays its part here, and this reminds us that,
particularly through Dryden, theory became more influential and more fully
developed after 1660. But there were analogous divisions within the material

of drama, as the gentry became more distant from the aristocracy, and both distant from the citizen and peasant. Town becomes more distinct from country. It also seems that there was a change whereby tragedy stressed the general rather than the particular, while in comedy a more limited particularity came to dominate. Drama was now theme-orientated rather than story-based. Caroline drama can be seen as providing a link which is more than chronological.

Caroline drama has had a bad press, and cannot be properly rescued here. It is conventionally associated with ideas of decay and degeneracy, and there is an interesting coincidence between this view and the stock account of the court of Charles I as being sterile and complacent. 'Caroline' is seen as the period of the dotage of Ben Jonson and of pale, thinned versions of Jacobean tragic and tragi-comic styles in the hands of such as Massinger, John Ford (c.1586–c.1640) and James Shirley (1596–1666). Richard Brome (c.1590–c.1663) is seen as a minor Jonson, while such court-based dramatists as Thomas Randolph (1605–35) and Sir John Suckling (1609–41) are dismissed as amateurs and sycophants. The popularity of drama in court circles is admitted. It has been estimated that some 400 performances took place at court between 1625 and 1640, but it is the received view that this is an élitist drama, pandering to narrow courtly tastes, co-operating with and feeding courtly complacency, having lost touch with the broad social base of Elizabethan and Jacobean theatre.

This view illustrates the dangers of Darwinian criticism and of pervasive metaphors from the organic world. It depends upon the idea that there must be evolution in art and that where you have had a 'flourishing' there must then be decay and death. It also arises, I suspect, because of a superficial feeling that a reign which ended in disaster could only have produced an etiolate culture.

It is broadly true that Caroline tragedy does look thinner than Jacobean, and more obsessively sensational, extending the Jacobean interest in horrors into more specialised areas, as in Ford's *The Broken Heart* and Shirley's *The Traitor* (1633; 1631), and showing an emphasis upon moral ideals and moral conflict at the expense of Jacobean specificity. *The Traitor*, formally based on an incident in Italian history, lacks historical anchorage and Webster's feeling for rich textures. It anticipates Restoration tragedy in its concern with intricate but generalised moral dilemmas, and it may be that proper consideration of such tragedy depends upon seeing it as pre-Restoration rather than post-Jacobean, this, of course, violating the thesis of an absolute break brought about by the closure of the theatres in 1642. But there is a particular sense in which *The Traitor* can be said to reach both backwards and forwards. Shirley uses a foreign setting to articulate patterns which bear on his own period, but in his play the ruler is blatantly corrupt and his overthrow is endorsed, this being something which both casts doubt on the thesis of Caroline sycophancy and could scarcely have been dramatised at the Restoration. Caroline tragedy has its own characteristics and need not be seen as a pallid version of something else.

Caroline comedy is easier to defend straightforwardly. It is often derivative of earlier models (Jacobean drama is also parasitic in this respect) but there is

A vignette probably depicting the indoor playhouse, the Cockpit, from the title-page of
Roxana *(1632) by William Alabaster.*

little to suggest a marked thinning out. Even William Davenant (1606–68), so disastrous as a would-be epic poet, can write quite richly-textured verse in *The Wits* (1636), while Massinger, Shirley and Brome all maintain a Jacobean feeling for idiom which suggests a far broader social range than that of Restoration comedy. There is a courtly emphasis in Caroline comedy, but citizens are not yet peripheral and the dramatists develop some interestingly critical patterns. To call plays like Massinger's *The City Madam*, Shirley's *The Lady of Pleasure* and Brome's *Mad Couple Well Matched* (1632; 1637; 1639) decadent is to miss their particular quality. If Caroline drama is seen more in terms of the patterns it makes and less as a drama of character it can be argued that it amounts to an intelligent and alert drama and includes some substantial achievements which involve social debates that are neither complacent nor trivial. Davenant reworks Jonson's great comedy *The Alchemist* in *The Wits*, but make his own stimulating points about female wittiness; while Shirley, in *The Lady of Pleasure*, produces a pattern which sets rural decency against citizen pretence and the arrogance of urban gentry in a manner which is perceptive, intelligent and quite tense.

It should be clear that there is a great deal of variety in English drama of the seventeenth century, but it is more important to recognise that this variety can only be appreciated if the idea that it is all to be understood in terms of what Shakespeare did is resisted. Seventeenth-century drama does many different things in the course of one hundred years, and it does a number of them rather well. Often it is our ability to understand which is deficient rather than the plays which we are watching or reading.

Public poetry from Jonson to Dryden

Earlier in the present century the bulk of critical attention to the poetry of the seventeenth century was devoted to what is called metaphysical verse. Dryden had identified 'metaphysical' poetry as a category and, in his *Life of Cowley*, Samuel Johnson discussed 'a race of writers that may be termed the metaphysical poets' who, he said, appeared 'About the beginning of the seventeenth century'. John Donne is usually seen as the pioneer of the style in English, which is closely associated with the lyric, with the individuality and privateness of some poetry, and with the concept of 'wit' as the central tool of such verse ('wit' being one of Johnson's key terms in discussing the style). Yet the major poetic achievement of the seventeenth century, it may be argued, was in a kind of public verse which was not primarily lyrical, highly individualised, or witty in the intricate and intellectual way associated with Donne. Such public verse may use some features of the metaphysical but is not dominated by such features, and in this connection it is useful to see Ben Jonson and John Donne as complementary poets, who together develop the ways of writing verse which dominated their century's poetry.

Even in the lyric, as we shall see, the strongly individual voices found in Donne's *Songs and Sonets* (1633) are modified into the more social tones of Carew and Cowley, while Rochester sets his sceptical personae roaming in Restoration social contexts. Dryden and Milton, who were influenced by

Donne early in their careers, both distance themselves as they grow older. In religious verse the same happens, with Donne's striking example being modified. Donne writes religious verse which represents duels between God and persona, the focus being very intense, marked by first person pronouns; but although these private duels can be responded to by many there is little sign that Donne was interested in the exemplary aspect of his work. By contrast, Milton, when he came to write his major religious poems, widens the scope to the ultimate, seeking to explain all of God's plan and purpose, across all time and space. There is the same sense of duel, between God and Satan, God and Adam, God and Samson, Eve and Adam, Eve and Satan, but the individuality and the infinity of application occur at the same time.

The century also saw the development of a lucid verse which could react intelligently to a great range of social stimuli, which is to say that verse responds to the challenge of the century, becoming socially flexible in a period of major public crises. The great poets of the social voice are Jonson, Marvell, Dryden and Milton.

Ben Jonson provided the chief model for seventeenth-century public poetry. He is perhaps the first major English poet (except for William Langland) whose output is dominated by poems of direct social and moral content. At the technical level, and confining our attention to non-dramatic verse, Jonson left the legacy of a large output marked by substantial achievement in almost every poetic mode he touched, but also by a strong preference for the couplet, for neat rather than intricate verse forms and by a use of language which stresses clarity and consistency rather than complexity and ambiguity. Jonson was sensitive to the demands of genre, to the attitudes and language appropriate to the various kinds of verse he wrote, across a range from scabrous satirical epigrams to the high diction of the ode.

The major result, however, of Jonson's feeling for genre has been to raise doubts about his 'sincerity'. The poet who can excoriate irresponsibility among the gentry ('A Speech According to Horace') is the same who writes flatteringly about such genteel families as the Sidneys ('To Penshurst'). The satirist of female sexuality ('An Epistle to a Friend, to Persuade Him to the Wars') is also the laureate of great ladies ('Epistle to Elizabeth Countess of Rutland'). Jonson has been seen as a sycophant and a blind supporter of the social *status quo*. He is the writer who glorifies the power of the country gentry, while suppressing the conditions of those whose labour sustains that power ('To Penshurst'). He is seen as a conservative poet who is at times reactionary, and a poet who fears social change. So the well-known Jonsonian emphasis on individual and social responsibility is seen as a decorous version of how the powerful maintain their power, by using propaganda to impress their ideology upon the exploited.

As description little of this is wholly inaccurate. Jonson was a conservative poet and there seems no doubt that his commitment was to monarchy and to gentry rule. The only social model which Jonson could contemplate with equanimity was hierarchical and, for him, social responsibility meant the benevolent exercise of power by those who had it by birth and/or merit and the diligent acquiescence in this by the disprivileged. In Jonson's view the poet's role in this was as a person of wisdom and learning, who should serve

as ethical adviser to those who apply the power. A man of humble birth and upbringing, Jonson could not convincingly claim to be of the social élite, but he could define a role for the poet which, stressing merit above birth, would give him professional status. The poet thus becomes a cultural civil servant (a Cecil) rather than a courtier.

Jonson was a social poet whose ethics were idealistic, and it is here that the inadequacy of hostile accounts begins to emerge. Jonson was a myth-maker. Having a strong sense of what human beings should aspire to be, he worked both to convey what the actualisation of human potential would feel like and the horrors of individuals and societies which have abandoned the positive vision, or are in danger of doing so. Jonson is thus drawn to write 'To Penshurst', with its vision of a genteel harmony under threat, this being represented by the language of building in the opening lines:

> Thou art not, Penshurst, built to envious show,
> Of touch, or marble; nor canst boast a row
> Of polished pillars, or a roof of gold:
> Thou hast no lanthern, whereof tales are told;
> Or stair, or courts; but stand'st an ancient pile,
> And these grudged at, art reverenced the while.

But he also writes 'A Speech According to Horace', with its felt horror at gentry irresponsibility. So he presents young gentry as saying:

> Our blood is now become
> Past any need of virtue. Let them care,
> That in the cradle of their gentry are,
> To serve the state by councils, and by arms:
> We neither love the troubles, nor the harms.

Jonson was certainly not a revolutionary poet masked as a reactionary. What he was, however, was a conservative poet deeply aware, both consciously and subconsciously, that his society was crumbling. The fact that he could only react to this perception by seeking to renovate old models made him similar to almost every other major writer of his time. More importantly, this says something about how hard change can be – but Jonson's art could not conceal his awareness that change was to be away from the models he endorsed. His development of a style which could render his sensitivity was his major contribution to seventeenth-century public poetry.

Jonson's style stresses lucidity and precise definition, but in drawing attention to how his example affected seventeenth-century poetry at large it is also important to refer to his authority, which owed less to birth or social position than to the weight which he gave to the artist's role in society and to the conviction with which he acted out the defined role. This is most movingly expressed in the brief poem 'To the right Honourable, the Lord High Treasurer of England. An Epistle Mendicant', where the interplay of the personal figure of the ill poet with the presentation of the muse provides a fine instance of how Jonson can stress the importance of role at the expense of the role-bearer:

The frontispiece to The Works of Benjamin Jonson *(1616).*

> The muse not peeps out, one of hundred days;
> But lies blocked up, and straitened, narrowed in,
> Fixed to the bed, and boards, unlike to win
> Health, or scarce breath, as she had never bin.

The advisory role for the poet spoken of above is an important part of the stance of almost any public poet and it influenced the careers of Marvell, Milton and Dryden. But it is important to recognise how this role – and the whole Jonsonian formulation of it – affected the course of seventeenth-century poetry at large, rather than simply the careers of particular poets. It was Jonson's example which gave body to the intelligent work of the 'Cavalier' Thomas Carew, who was capable of something like Jonson's own sensibility. The confidence of both Abraham Cowley and Edmund Waller – although both were more inclined than Jonson to shade into complacency – owed a lot to Jonson's creation of a supple, socially-directed style. John Denham (1615–69) and John Cleveland were very different poets, but they were both willing to comment at length on social change, with Denham, in *Cooper's Hill*, utilising the perspectives of a poem like 'To Penshurst' and a flexible couplet to comment upon the upheavals of the mid-century in an impressively subtle manner. In the Restoration period there was also Charles Cotton, with his Jonsonian sense of social divisions and his refusal to allow hedonism to be dismissed as amoral. And there is the example of Jonson's satire. Although Jonson did not write formal satire, many of his poems blend satire with advice and compliment and this, together with the clarity with which the satirical analysis is made specific, does much to create a climate for the major achievements of later satirists.

All poetry is finally public in the sense that it belongs inextricably to the world from which it comes, but there is still a difference between poetry which is directly engaged with the social and political world of its origin and poetry which seeks to escape or transcend that world. One of the striking facts of seventeenth-century verse is how much of it is directly engaged. The Jonsonian model of the poet as a professional was conducive to giving the artist social confidence and, although this could easily deteriorate into playing the role of cosy flatterer of social fraction, it is remarkable how often the public poetry of the seventeenth century avoids such deterioration. A little-known poem such as Cotton's 'On the Lord Derby' shows how valuable Jonson's example had been. Something like Ted Hughes' 'The Honey Bee and the Thistle' shows how much of that example has been lost.

Andrew Marvell was a poet of much smaller output than Jonson, and his individual poems tend to be brief (although 'Upon Appleton House' is a long poem, as are various formal satires which Marvell may have written). His life had a public dimension, as long-time Member of Parliament for Hull, as assistant for a while to Milton as Latin Secretary to the state, and as a consistent Parliamentary loyalist; but his verse is usually ostensibly so private that we seldom know just when a particular poem was written. It is also often private in the sense of being cryptic, although there is a clear public dimension to some of the poems – in satires and in the complimentary verse, especially to Oliver Cromwell. Although Marvell lived until 1678 he seems

never to have reconciled himself to the restored monarchy. He certainly never endorsed it as Dryden did.

Marvell favoured short couplets and tight lyric forms, and he drew persistently on poetic traditions and emblematic language, as in 'The Nymph Complaining for the Death of her Faun'. He rewrote the Jonsonian country house poem and drew on the erotic conventions of classical and Elizabethan poetry. He shared with Richard Lovelace (1618–57) an interest in the miniature, but also dealt with major figures and occasions. He sometimes followed Donne in making the 'I' figure prominent, but his versions are evasive, sometimes insubstantial, often merged with poet-figures projected as distinct from the poet himself, 'Bermudas' being a good example of this.

Things seldom stay still for long in the world of Marvell's verse and they are often not what they at first seem. This shiftiness comes about for more than one reason. At times we are mainly aware of how changes of perspective challenge us, as with the play of the gigantic and the diminutive in 'Upon Appleton House', whereby 'Things greater are in less contain'd' (l. 44). At other times we are struck by the complications introduced by framing devices ('Bermudas') or by syntactical ambiguities and intricate combinations of tone ('An Horatian Ode . . .', 'The Garden'). The poet-figure also shows a marked desire to dissolve into the ideal or to be annihilated ('. . . shatter . . . with him my curious frame' – 'The Coronet'). There is a concern for patterns of passivity and violence, to be seen most clearly in, for example, 'The Coronet' and 'To His Coy Mistress'. A variation is the theme of innocence and experience (as in 'The Nymph Complaining . . .', with its strange blend of ignorance and knowingness), and this is all connected with Marvell's interest in the respective calls of the public and private lives.

This brings in the interest in Cromwell, who is seen in 'An Horatian Ode' as issuing from his garden to save the state. But the poem is also concerned with Charles I as actor ('That thence the Royal Actor born / The Tragick Scaffold might adorn') and with involving the 'forward youth' as a figure which is multiple rather than single. In 'The Garden' the poet-figure mocks the public life of laurels, oaks and bays:

> How vainly men themselves amaze
> To win the palm, the oak, or bays,
> And their incessant labours see
> Crowned from some single herb or tree

but having permitted the withdrawal of 'the Mind' into transcendentalism, the poem returns to the mundane world of sundials:

> How well the skilful gardener drew
> Of flowers and herbs this dial new,
> Where from above the milder sun
> Does through a fragrant zodiac run.

'Upon Appleton House' is concerned to praise Fairfax, but is teasing about Fairfax's decision to retire from public life – and for some Fairfax had been the great moderate hope, whose retirement could mean either a dignified

perpetuation of loyalty to the Commonwealth (although without further active support) or a betrayal of the cause and a commitment to a policy of continued negotiation with the King and maintenance of the monarchy.

How appropriate is it, then, to see this evasive and cryptic poet as 'public'? Does Marvell really belong in this section? The answer lies, I think, in the very nature of Marvell's poetry and in the responses it elicits. There is considerable intelligence and sensitivity in his writing, and these are directed at realities which lie alongside imagined ideals. So the use of words like 'Levellers' in 'Upon Appleton House' and the use of military language when writing of flowers in the same poem link the ideal and the actual, the permanent and the present. The shiftiness, the famous Marvellian poise, of the final section of 'An Horatian Ode' demonstrates how difficult were the social, religious and political choices to be made in the decades between the accession of Charles I in 1625 and the restoration of his son in 1660. Marvell, on the surviving evidence, seems to have remained consistently loyal to the Parliamentary cause and yet his finest public poem, 'An Horatian Ode', was sufficiently poised to be printed in both a parliamentary and a royalist collection in his own century.

This, however, is perfectly consistent with the careers of such men as Roger Boyle (1621–79; first earl of Orrery) and the enigmatic George Monck (1608–70; first duke of Albemarle). It can also be understood in relation to the tense pull of loyalties in families like the Verneys. The career of John Lilburne (c.1614–57) indicates how, under the pressure of trying to maintain a leftwing polity as your former partners move to the right, you may find yourself willing to negotiate with those you started out opposing. The Lilburne family also indicates the tensions of loyalty, as Henry Lilburne broke ranks and crossed to the King's side. Then, there are figures such as Lucius Cary (1610–43; viscount Falkland) and Edward Hyde (1609–74; first earl of Clarendon) who were strong critics of Charles I, but who came out for the King when war threatened. Yet Cary seems to have, in effect, committed suicide as a result of deep depression in face of Civil War. So it may be argued that Marvell's tentativeness in verse reflects exactly those pressures of loyalty which are most characteristic of his period.

The career of John Milton, which overlapped those of Marvell and Dryden, shows devotion to the state (as he understood that), to his religious faith and to the muse.

Milton's long silence as a poet after the publication of *Lycidas* in 1637 is well known. After that date, apart from the *Miscellaneous Poems* of 1645, there was nothing until the publication of *Paradise Lost* in 1667. The latter did not get written overnight and there is no reason to believe that Milton ever gave up poetry. But is clear that, between his return from Europe in 1639 and the Restoration, Milton's life was dominated by pamphleteering and other work arising from his religio-political beliefs. Some commentators regret this activity, dwelling plaintively on the poems which might have been, rather than on the prose that was. Yet even if one takes the view that verse is somehow the superior medium it seems clear that it was the period from the outbreak of war to the Restoration which made Milton's epics possible in the form in which we have them. The point cannot be argued out here, but it can

be suggested that one of the keys to beginning to understand *Paradise Lost* is to read 'The Ready and Easy Way' (1660), a pamphlet in which Milton argues the urgent need for the rejection of monarchy to be sustained.

Lycidas is a great poem about faith and loss and living in a tough world:

> I come to pluck your berries harsh and crude,
> And with forced fingers rude
> Shatter your leaves before the mellowing year.
> Bitter constraint, and sad occasion dear,
> Compels me to disturb your season due;
> For Lycidas is dead . . .

and it is obviously in part a poem about how the individual copes with death in a world which seems indifferent or drained of meaning by the death of young promise. The epics can be seen as developing such themes on a greater scale, but it is the period between 1642 and 1660 which made belief, death and loyalty major public issues.

Milton's style for epic is necessarily one which distances, working to create a world beyond the immediate contexts of the author:

> Thus Eve with Countnance blithe her story told,
> But in her Cheek distemper flushing glowd.
> On the other side, Adam, soon as he heard
> The fatal Trespass don by Even, amaz'd,
> Astonied stood and Blank . . .

<div align="right">(Paradise Lost, IX. 886–890)</div>

But this does not mean that the world created for the epic has nothing to do with that in which the poet lived. Classical epic was impregnated with moral valuings and could not operate in later ages without its world being tested against the worlds in which it was received, as is perhaps most obvious if one looks at how translations of Homer differ in what they register across centuries and languages. Milton, moreover, was writing Christian epic and was thus intricately involved with the stories and style of the Bible – and therefore with its values and their significance for Milton's own period.

This is not so much a matter of noticing the ubiquity of biblical reference in the seventeenth century as of responding to what this meant in a world in which the allusions were vital truths for religious and social life. The gods to whom Charles I, Cromwell and Lilburne appealed were not metaphors and the texts in which these gods revealed themselves, their instructions and intentions, were repositories of essential truth. To take a single example, Gerard Winstanley, Robert Filmer and John Locke, among others, discussed whether Adam was the first King or rather the first custodian of God's bequest to humankind at large. No one who reads thse discussions should be in any doubt that the writers were interested in more than scholarly exegesis of the Bible. For them, scholarship served to help the examination of an issue of primary social and political importance, one which defined their various loyalties.

The function, then, of Milton's epic style is to make the theological point that the pattern of Fall and Redemption is ubiquitous through time and space. It would be more accurate to say that this pattern, outside time and

space from God's perspective, is one which will only be complete and fully comprehensible from a human viewpoint when there has been the Second Coming and Last Judgment. Since any contemporary world is part of this incomplete pattern it is vital for a believer to read the whole pattern, as revealed in the scriptures, in relation to her or his contemporary world, and also to read the latter for what it may suggest of the former, since it is vital for the believer to be ready for the Second Coming. Since theology was political and social in the seventeenth century, and politics theological, Milton could not avoid being a political poet, even if such a situation were possible and even if Milton had shown signs of wanting to be apolitical, which he did not. The patterns with which he was involved and remade were tied up with the debate about Adam as first King (or not), but also with such matters as the status of women and the wrongs and rights of rebelling against authority. The matter of Eve's rights and obligations (especially in *Paradise Lost* IX, X) bears directly on those discussions by seventeenth-century women which are only now being rediscovered. As for rebellion, the patterns say that Adam, Eve and Satan all rebelled; and that Samson (*Samson Agonistes*), having rebelled, learnt to await God's signal. Against this there is the example of Abdiel's obedience in *Paradise Lost* and of Christ's in that poem and in *Paradise Regained*. Milton could scarcely have chosen more relevant themes, and to read his accounts without seeing how his pamphlets complement and are complemented by his epics is to cripple his achievement. Milton contemplates God's pattern to make sense of his own strange world.

John Dryden published verse from 1649 ('Upon the death of the Lord Hastings') until his death in 1700, while verse published posthumously makes the link with the eighteenth century more marked. His achievement covers drama and criticism, as well as a variety of types of verse. Dryden was at the opposite extreme from someone like Suckling, a talented versifier whose ethos encouraged him to tolerate his own carelessness and technical inconsistency. By contrast, from the beginning Dryden was a conscious and careful artist, and there have been few greater stylists in English poetry. This is perhaps most obvious in the openings of *Absalom and Achitophel* and *Mac Flecknoe* (1681; 1682), where his feeling for the precise placing and choice of words and his sensitivity to rhythm and rhyme work to create effects which are devastatingly exact and wonderfully suggestive:

> Sh____alone, of all my sons, is he
> Who stands confirmed in full stupidity.
> The rest to some faint meaning make pretence,
> But Sh____never deviates into sense.
>
> (*Mac Flecknoe*, 11.17–20)

But Dryden's style is at the same time the perfect embodiment of his concerns, so that the opening of *Absalom and Achitophel* catches both the slyness of Charles II and the subtlety of response to him which was necessary if the Restoration was to endure.

There is similar stylistic assurance in, for example, the 'Song for St Cecilia's Day' (1687), with its outstanding architectonics, in the solutions to the problems of decorum in 'To the Pious Memory Of . . . Anne Killigrew'

(1686), and in the tensely intelligent synthesis of religious faction in *The Hind and the Panther* (1687). But Dryden's verse has a consistent objective, to define material and render it fully comprehensible. His writing can be resonant with intelligence and feeling for language, but he is not a mysterious, let alone a mystical poet. He writes of the mysteries of majesty and faith, but his worlds are always corporeal. The debate in *The Hind and the Panther* may be inconclusive, but the significant point is that it is a debate, an attempt to resolve differences by discourse (which is not to say that the debate is fairly staged!). And it is typical of Dryden that his David/Charles resolves the turmoil at the end of *Absalom and Achitophel* (part one) with reasoned speech.

Dryden has been seen as a time-server, and the evidence includes 'Heroic Stanzas' (1659) and 'Astraea Redux' (1660), written within a few months of each other and commemorating, respectively, the death of Oliver Cromwell and the accession of Charles II. But what is sometimes missed is the consistency of Dryden's position – his concern for settled and peaceful government. So, in 'Threnodia Augustalis' (1685), the attempt is to ease the transition from Charles II to his brother James by reducing the complexities of the political situation, while stressing the (alleged) heroic capacities of the dead monarch and his successor. Similarly, David/Charles in *Absalom and Achitophel* is given a majestic reasonableness because this is seen as the best means to ensure continuity of rule:

> He said. Th'Almighty-nodding, gave, consent;
> And peals of thunder shook the firmament.
> Henceforth a series of new time began,
> The mighty years in long procession ran:
> Once more the Godlike David was restored,
> And willing nations knew their lawful lord.

Dryden's hatred of extremes produced some of the greatest satire in the language, but it is hatred at the service of a positive aim – to render conservatism as conducive to stability. So while *The Hind and the Panther* is vicious about sectarianism—

> The bloudy bear an Independent beast,
> Unlicked to form, in groans her hate expressed.
> Among the timorous kind the Quaking hare
> Professed neutrality, but would not swear

– it is concerned to emphasise the common ground between Catholicism and Anglicanism.

Like Jonson, Dryden is in the business of making myths. His versions of recent history in *Absalom and Achitophel*, and even at the start of 'Astraea Redux', are not contemptible as history, but they are clearly intelligent party history. They belong to the tradition of Jonson's 'To Penshurst', in that they seek to render their material into a coercive vision which might encourage society to make the potential of the vision into the actual. Similar attempts occur elsewhere. In the 'Song for St Cecilia's Day' Dryden uses language and rhythm to make harmony desirable and chaos terrifying, and so the poem

has a political dimension. The Killigrew ode, typically for a seventeenth-century elegy, has little to say about the individual nature of Anne Killigrew, but it memorialises her by making her a model of moral goodness, her service on earth being rewarded by early translation to heaven. Thus Anne Killigrew is valued because of the example she is:

> There Thou, Sweet Saint, before the Quire shalt go,
> As Harbinger of Heaven, the Way to show,
> The Way which thou so well has learned below.

Dryden's art was at the call of the state more often than not, but it cannot be fairly said that it was servile. Dryden had the sense of serving something beyond the contingent and this links him with John Milton. In terms of literary history, Dryden is also the link between the Elizabethan and Jacobean Ben Jonson and the manner of Alexander Pope.

Love, God and the metaphysical lyric

It is necessary, when considering lyric in the seventeenth century, to take into account the tyranny of periodisation. Elizabethan poetry is not neatly divided from Jacobean by the death of the Queen in 1603, nor is Caroline verse divorced from that of the Restoration by the execution of Charles I in 1649. The majesty of monarchy has its limits: style, formal preferences and preferred materials do not conveniently reflect either such deaths or the labels of literary historians. Poets live across reign-endings and century-turns; they refuse to be one abstraction or another.

Seeing change in early seventeenth-century poetry in terms of the work of Ben Jonson and John Donne is commonplace; but difficulties arise at once if we try to pin such change to the turn of the century or the death of Elizabeth. Donne's early verse is chronologically Elizabethan; he was largely unknown as a lyric poet in the early part of the seventeenth century; and his poems, with few exceptions, were unprinted until 1633. Much of Jonson's non-dramatic verse was written well into the new century, but the poetic world he stressed in his *Conversations* (with the Scot William Drummond in 1618–19) featured Edmund Spenser, Michael Drayton and Samuel Daniel. This world seems Elizabethan rather than Jacobean, and the great Elizabethan lyric anthologies were popular long after 1600. The 'Elizabethan' Drayton died in the same year as Donne (1631), while many of the fine lyrics of the 'Elizabethan' Thomas Campion were products of the seventeenth century. Donne did not wipe out Elizabethanism, while Jonson can be seen as a revivalist rather than an innovator.

There was much that was Elizabethan in the Stuart period and much of what was Elizabethan was connected with Elizabeth's court. It can be argued that the creation of a strong sense of court was among the most important achievements of Elizabeth's reign, and that this achievement had much to do with Elizabeth being able to reign in relative security until the end of her life, managing, with her court, to act as a unifying focus for the nation even as time ravaged her and realities undercut images. It was no accident that the

cult of Elizabeth was strong in the Jacobean period: the success of the image-makers in promoting positive impressions of the Queen and her court inevitably pointed up the deficiencies of the Stuart versions. Nor is it mere coincidence that Elizabethan poetry is still usually thought of as the verse of Spenser and Sir Philip Sidney. Sidney was seen, even in his short lifetime, as a paradigm of the Elizabethan courtier. Spenser, a court dependent rather than a courtier, was no sycophant, but he was a key figure in the creation of the Elizabethan courtly myth.

From the beginning, so far as we can see, John Donne was something different. In the 1590s he was associated with the young men of the Inns of Court who assailed the worlds of *The Faerie Queene* and *Astrophel and Stella* with wit and parody. Donne was the poet who best sustained this attack.

Much of what has been written about Donne's challenge to established modes concentrates upon style, and much of this is largely an elaboration upon Thomas Carew's remarks in his fine elegy for Donne:

> Thou hast redeemed, and opened us a mine
> Of rich and pregnant fancy, drawn a line
> Of masculine expression . . .

Such commentary emphasises Donne's variety of rhythm and form, the range and shock value of his images, and the complex ingenuity of his arguments. As Carew's poem bears witness, there is no doubt that stylistic features of Donne's verse were of great interest to a number of his contemporaries and followers, but rather than repeat such commentaries I shall concentrate upon other features of Donne's work.

In Spenser's *Faerie Queene* everything proceeds from and returns to the court and its queen, just as the monarch's chair was focal in seating arrangements for masques and state trials. In sonnet sequences everything leads to and proceeds from the lady, while Ralegh's love poems and letters show how far these two patterns overlap. But in his *Songs and Sonets* Donne breaks with such patterns. There are no sonnets, as we understand the term, and there is no narrative sequence. The court is no longer central and no constant theme of subservience, service or devotion to the mistress can be traced. Locations are rarely described and there are no catalogues of ladies' charms. Instead of all this there is a focus upon the minds and emotions of the poet-figures, while locations are suggested by a language of intellectual and mercantile worlds. The poet-figure can be scornful about almost everything, including religion, courts and monarchs:

> Sawcy pedantique wretch, goe chide
> Late school boyes, and sowre prentices,
> Goe tell Court-huntsmen, that the King will ride,
> Call countrey ants to harvest offices . . .

<div align="right">('The Sunne Rising')</div>

Such poet-figures claim their independence and articulate the masked male power of the Elizabethan sequences as an arrogance which threatens to dominate the female even as it registers her potential resistance:

> She is all States, and all Princes, I . . .

<div align="right">('The Sunne Rising')</div>

Donne's early career can be seen as a classic example of an outsider devoting himself to the task of becoming an insider. He nearly succeeded, only to fail decisively when he married Ann More in 1601. Before and after this marriage Donne seems to have been working to enter the world of court and government service, and the secular poetry, including the *Songs and Sonets,* can be seen as part of a campaign to this effect. But it was also part of an attempt to assert independence of the world and service. There is no necessary paradox here, for the pose of tough-mindedness and independence might be just what would attract a courtly/governmental patron. But the effort to project autonomy remained a challenge to a society which stressed dependence and interdependence. The social effort of the period, as since the coming of the Tudors, was towards conformity, while Donne's poetry is strongly individual.

Yet while Donne brilliantly articulated the loneliness of the independent and the integrity of the ego, he was at the same time representing a development which was more than personal, and here the religious sense of 'conformity' is important. The ego's integrity is most astonishingly dramatised in Donne's religious verse, in which the mediaeval traditions of how Everyman learns to contemplate Christ's birth and crucifixion with trust give way to an inability to dissolve the ego. Resentment, anger and doubt struggle with faith, fear and the desire to be absorbed:

> . . . my ever-waking part shall see that face,
> Whose feare already shakes my every joint . . .
>
> ('This is my playes last scene')

> Take mee to you, imprison mee, for I
> Except you enthrall mee, never shall be free,
> Nor ever chast, except you ravish mee.
>
> ('Batter my heart . . .')

There is the knowledge that humility is a prerequisite of salvation, but the psyche of these poems has a terrible obstinacy:

> . . . grace, if thou repent, thou canst not lacke;
> But who shall give thee that grace to beginne?
>
> ('Oh my blacke Soule . . .')

What this reflects is Calvinism, and it signifies more than narrowly religious change. The Calvinist emphasis upon the individuality of salvation and upon the urgency of seeking for signs that the individual is one of the elect, together with the broader 'Puritan' rejection of the importance of intermediaries between God and the individual, is ultimately subversive of State and established Church. Slowly, and then more rapidly, the Reformation loosened the tongues of those whom hierarchy said should be silent. Donne consistently sought to conform to social expectations and he finally achieved the kingly lap as Dean of St Paul's, but his work remains a startling example of that seventeenth-century phenomenon – voices saying subversive things.

Donne's writing was deeply revolutionary in style and attitude, even while his career was conservative and much of his work shows deep traditional roots and reactionary elements. By contrast, many of the poets in an

anthology like Helen Gardner's *The Metaphysical Poets* are only superficially revolutionary. With these poets there is evident conservatism: Carew stayed loyal to the declining Caroline court; Suckling took arms for the King against the Scots, at a time when his countrymen were decidedly reluctant to take the field for Charles, and he died in exile from Parliamentary power. Henry King became bishop of Chichester, was deprived for loyalty to the crown and reinstated after the Restoration. George Herbert represents the best of Laudianism, which is closely monarchic; Henry Vaughan seems to have fought for Charles; and Richard Lovelace ruined himself in the monarchic cause. Moreover, several of these men seem, stylistically, to be reach-me-down revolutionaries, carrying Donne's development into courtly Stuart worlds, taming them (Carew), or coarsening them (Suckling). Exceptions to this metaphysical/loyalist nexus are few: Marvell, the Parliamentarian, Milton and Rochester (but this last was royalist in his own strange way).

It is necessary at this point to remember Jonson who, as we have seen, was a professional writer (as Donne never was) and who purported to operate as an independent moral critic of society. Donne can be called a metaphysical poet in the philosophical sense, in that his verse is often directed towards some point beyond the material – deity or some infinity of love:

> Since shee enjoyes her long nights festivall,
> Let mee prepare towards her, and let mee call
> This houre her Vigill . . .

<div align="right">('A Nocturnall upon S. Lucies day . . .')</div>

Donne's style may also usefully be called metaphysical in its restless speculation, the compressed relating of disparate materials, and even the abrupt, elliptical syntax and unpredictable rhythms. Little of this fits Jonson, whose concerns were mainly social and ethical and whose style stressed lucidity.

The histories of many seventeenth-century poets can be written between the lines of Donne and Jonson. Thomas Carew wrote perceptive poems about both men, and he provides a good example of how the dual influences can be profitably combined, but it is significant that Carew was a courtly poet, for, if Donne and Jonson were both outsiders, the history of English lyric between, say, 1630 and 1700, was largely of the court regaining control of the secular division of the lyric.

This can be seen most clearly in the three poets who are most often held to represent 'Cavalier' – Carew, Suckling and Lovelace. Carew's father was a knight, he lived mainly in the Caroline court, and he died before the Civil War broke out. Suckling's father was also a knight, he inherited land, fought for the King and was banished by the King's opponents. Lovelace, of a landed Kentish family, was twice imprisoned for supporting Charles and spent his fortune for the King's cause. On the surface these three represent orthodox loyalisms, and yet they are less simple than they seem.

Carew, for example, stands with Van Dyck as evidence that to be of the Caroline court need not mean being amateur or careless. Carew was a craftsman. His lyrics present attitudes of ease and Donne-like insolence, but they blend with these Jonson's careful example of polished craft in ways which render both the beauty and the final insubstantiality of the court:

> Now that the winter's gone, the earth hath lost
> Her snow-white robes, and now no more the frost
> Candies the grasse, or castes an ycie creame
> Upon the silver Lake, or Chrystall streame . . .

('The Spring')

Carew's epistles, elegies and country house poems show that he was not unaware of values other than the narrowly courtly, and the intelligence of his writing involves a critical dimension (as, notably, in his poem for Jonson).

Suckling had little of Carew's range and his style epitomises Cavalier carelessness. His casual manner reflects his pose of insolent reductiveness in the face of ideas of constancy and spirituality in love. Suckling learnt from the more obviously outrageous of Donne's lyrics, while thinning out the complex texture of Donne's style:

> This present morning early she
> Forsooth came to my bed,
> And gratis there she offered me
> Her high-priz'd maidenhead.
>
> I told her that I thought it then
> Far dearer then I did,
> When I at first the Forty crowns
> For one nights lodging bid.

('Profer'd Love rejected')

But it is striking how easily Suckling rendered the darker side of Donne's world. The stereotype of the Cavalier stresses lightness of tone and the refusal to value anything very much, but Suckling's verse conveys a sense of horrid laughter which stands oddly beside the stereotype. It seems likely that Suckling killed himself and, even if this was not the case, his verse suggests a lack of commitment to the values of the courtly world in which he lived. In that sense Suckling's feeling for the disease beneath the skin undercuts the world he is often seen to represent:

> A quick corse me-thinks I spy
> In ev'ry woman; and mine eye,
> At passing by,
> Checks, and is troubled, just
> As if it rose from Dust.

('Farewel to Love')

Richard Lovelace survived the Civil War and lived until quite close to the Restoration. He attempted at times the insolence and superficial insouciance of Suckling, while at other times he wrote soft-core libertine lyrics (of the kind perfected by Thomas Randolph). These aspects, together with his technical inconsistency, fit well enough with the Cavalier stereotype, but the significant point about Lovelace is that he is seldom at his best in the insolent or libertine lyric. His best poem is 'The Grasshopper' and the most satisfying of his other poems are those on animals and insects, his prison lyrics and his few complementary poems.

The court which Henrietta Maria, the Queen of Charles I, tried to

establish was drawn to neo-platonism, this taking the form of an idealised high seriousness and elevation of the Lady reminiscent of the Elizabethan sonnets. Lovelace's verse perhaps best represents this ideal of court, emerging in the stress upon innocence and honour in lyrics like 'To Althea, from Prison' and 'To Lucasta, Going to the Wars'. But the circumstances of the social and political breakdown which led to the Civil War called for something tougher, and Lovelace achieved this in 'The Grasshopper', a poem which is a critique of the whole idea of 'Cavalier' and which, in its careful evaluation of Cavalier defeat, carries an heightened moralistic element which occurs elsewhere in Lovelace's verse and which is at odds with the Cavalier image. Indeed, it recognises some of the errors the King had made. The poem responds to defeat with a Jonsonian falling-back upon the integrity of the knowing self and it has the firmness necessary for survival in adversity:

> . . . we will create
> A genuine summer in each other's breast,
> And spite of this cold time and frozen fate,
> Thaw us a warm seat to our rest.
>
> Thus richer than untempted kings are we,
> That asking nothing, nothing need:
> Though lord of all what seas embrace, yet he
> That wants himself is poor indeed.

Although Lovelace was court-centered his poem is country based – and it was the country gentry who finally triumphed at the Restoration.

But there were more truly conservative lyric poets than these; such poets as Robert Herrick (1691–74), Abraham Cowley and Edmund Waller. All show something of how the examples of Donne and Jonson could be made safe. Herrick was an outstanding craftsman, but essentially a trivialiser whose small indiscretions are neatly masked by his decorous style. Minor frissons of eroticism are made acceptable. Cowley was more intelligent. His version of *Songs and Sonets*, 'The Mistress' (1647), looks pallid if it is directly compared with Donne, screening out the latter's offensiveness and his disturbing mixture of confidence and doubt. Cowley's collection seems safer because more generalised, more directly involved with values than with bodies, but Cowley can think in verse and is technically adroit, whereby his work is seldom dull or insipid. Finally, Waller's poetic courtship of Sacharissa and other poetic mistresses with more or less biographical reality is skilful and intelligent, if rather bland. Both poets were better technicians than either Suckling or Lovelace, and both depend for their interest upon technique and precision of effect, rather than upon the tensions which made the Cavaliers variously subversive.

Marvell has already been discussed, but it can be reiterated here that his lyrics are revealing of the social conditions from which they come. Even where dating is uncertain, and even where the connections are most indirect, this claim is true in that the evasions and hesitations which characterise the poems mirror the tensions of the mid-century. A combination of the desire to commit oneself and an acute sense of the difficulties of so doing was

something which Marvell's poetry shares with the experience of many of the poet's contemporaries.

There is, finally, Rochester, whose verse is something like that of a more calculating Suckling. Rochester's poems are technically more consistent and adroit than Suckling's and the darkness of response more evident and more pervasive, as the poet extends implications of Donne's lyrics with more stress upon direct representation of genital activity. Rochester, as was mentioned in the 'Overview', often locates poems in named social locations and his lyrics overlap with his satires to provide a cynical commentary on Restoration society. But it is revealing that Rochester's verse lacks the reformist drive of much satire. His poems concentrate upon the sexual itch as standing for overwhelming human appetitiveness – but there seems to be no alternative room for satisfaction, and the poems are clear that sensual fulfilment is finally no fulfilment at all. The Jonsonian sense that humans have choices has gone and it seems that there is nothing to do about the frenzy. In that sense Rochester is about as subversive as could be.

It is commonplace to notice similarities between Donne's secular poems and his religious ones. But it is less often remarked that there is nothing surprising or idiosyncratic in this, given the interpenetration of the religious and the secular in the seventeenth century. Nor, granted this, should we be surprised that other poets have both religious and secular concerns which overlap. Carew's poem to George Sandys expresses the importance of working out relationships between the divine and the secular. George Herbert wrote secular poems (which he destroyed) and his religious verse is marked by secular imagery; Vaughan and Crashaw both published secular poems; Herrick wrote religious lyrics; Cowley has a religious epic; Jonson and Marvell both produced religious lyrics.

But it is worth noticing that the major religious lyricists of the century are not courtiers. Donne took orders partly because a court career did not materialise, and his religious lyrics come from the period of 'exile' before ordination. There is evidence that Herbert had his eyes on a courtly career, but he retired to Bemerton and became the Country Parson. His poems represent Laudian Anglicanism, but he was a courtly poet who operated outside the court and away from its main areas of interest. Richard Crashaw was an academic until deprived of his fellowship, and he effectively banished himself by becoming a Catholic, although it could be said that his verse presents the outlook of a court Catholic. Vaughan, politically a royalist, was nonetheless a poetic separatist. John Norris was a country priest (Bemerton again), while George Wither supported the Commonwealth and Thomas Traherne was the son of a shoemaker and a priest in Hertfordshire.

In Donne's religious verse the prominent features include the emphasis on first person singular pronouns and the sense of struggle. There is little feeling for Church as place and little sign of interest in making the persona of a poem typical of the Christian believer. The poet-figures seem desperate to believe in their individual salvation and although, at times, there may be some sense of relief and conviction, even in what seem among the latest poems there remains marked qualification:

> But sweare by thy selfe, that at my death thy sonne
> Shall shine as he shines now, and heretofore;
> And, having done that, Thou hast done,
> I feare no more.

> ('A Hymne to God the Father')

The firmness of that last line is qualified by the conditional nature of the quotation's syntax. The dominant impression these poems create is of uncertainty, together with the fear that the true god may be the awesome, just, but hardly merciful deity of the Old Testament. Donne was born of a Catholic family which included martyrs and his own brother died in prison, having been arrested for harbouring a Jesuit priest. Donne seems to have remained a Catholic until sometime between 1596 and 1600, and he ended his life in the Anglican communion, as dean of St Paul's and under the influence of Archbishop Laud. But before the rise of Laud, the Anglican settlement was basically Calvinist, with predestination as official doctrine, and so the Calvinism of Donne's religious poems, largely written before he was ordained, is not incompatible with a career in the state church.

It is slightly misleading to call Donne's religious lyrics Calvinist without adding that they also have echoes of Catholicism (in, for instance, their attitude to the Virgin Mary). But a reader is most struck by the sense of a just, but hard and rigorous God and of doubt about the poet-figure's belief in the possibility of salvation. There is the strong feeling of a search for some sign of grace, but mixed with marked reserve about accepting seeming signs, and the outcome is an extraordinary mixture of threats, appeals, petitions and anguish, presented in broken rhythms, listings, exclamations and intricate arguments:

> Batter my heart, three person'd God; for, you
> As yet but knocke, breathe, shine, and seeke to mend . . .

> (*Holy Sonnets* XIV)

> Thy lawes abridgement, and thy last command
> Is all but love; Oh let this last Will stand!

> (*Holy Sonnets* XVI)

The poems feel very individual and, in their egotism, so they are; but at the same time, the struggle they articulate illustrates the choices other people also had to make. English Catholics were constantly faced with decisions about how far to remain loyal to their faith, while non-Catholics had decisions to make about their positions as doctrinal emphasis changed within the state and its church. Even the presence of impurities in Donne's Calvinism and the move towards the High Anglicanism of Arminianism (to be seen in the last sermons) are unsurprising if it is remembered that the Reformation began as a movement to reform within Catholicism.

George Herbert's poetry has technical similarities to Donne's, but he was a very different poet. Any reader of *The Temple* (1633) is made aware of the physical manifestation of the church as never in Donne; and this sense of the church as building, central to the organisation of Herbert's collection, gives his poems a congregational quality which Donne's lack. Herbert's church is

seemly and clean, with the trappings of ceremony, music and the robed priest ('Church-musick', 'Church-floore', 'Aaron'). The priest is the leader of the 'flock', concerned with its spiritual welfare. This is a concern which fits in well with Herbert's own genteel birth and it accepts the importance of an intermediary betweeen God and the lay believer. Herbert's personae are rarely innocent and he can write movingly about sterility and rebellion, but in his lyrics rebellion is finally childish. The poet is aware of the gap between what the human has to offer and what this God deserves, and so he writes 'a verse or two, is all the praise, /That I can raise'. This sense of inevitable gap can lead to rebellion: 'I struck the board, and cry'd, No more. /I will abroad' ('The Collar'), but rebellion collapses: 'Me thoughts I heard one calling Child: /And I replied My Lord' ('The Collar'). There is no doubting God's power, but this is informed with a feeling of a God who loves humankind (as powerfully in 'The Sacrifice'), to the point where, as in 'Love V', God becomes Love. This loving God embraces, while Donne, in one of his *Holy Sonnets*, calls on God to 'ravish mee'.

Herbert's poems also suggest a faith rooted in the past. He conveys the impression of church buildings which have been on their sites for a long time, while his use of emblems and his strongly proverbial elements work to convey the idea of traditional wisdom refined by time into comforting forms. He was usually too precise a technician and had too sharp a poetic tongue to seem complacent, but the association with Donne is misleading if it disguises the degree to which, in his care for simple forms and lucidity of diction, Herbert is reminiscent of Jonson. *The Temple* offers reassurance through the transformation of the mess which is ordinary human experience into something hopeful. Like Jonson, Herbert tidies the quotidian, making myths which give humankind something to aspire towards. And although he was a religious poet, like Jonson he was primarily concerned with the living of life on this earth.

Henry Vaughan said that the example of Herbert made him a poet – but it did not make him a poet like Herbert. Vaughan used Herbert's titles, sometimes adapted the older man's phrasing and occasionally matched his neatness of structure, but the differences are more striking. Locations are very different, for Vaughan shows no interest in buildings at all: his poems are set in the natural world and that is his church. But even the world of nature is only to be tolerated insofar as it is 'signed' by God's presence, and Vaughan's personae long to escape from the world into the divine presence. Vaughan was a nature mystic in the sense that, for him, it was in nature that the divine penetration of mundane life might be sensed. This animism is denied by urban, mercantile experience, which, for Vaughan, represented a turning away from God. But this did not make him a nature poet if that is taken to mean a poet who rested content in Nature's lap, for the personae are always driving to transcend the material world completely, to be absorbed in the divine radiance which is Vaughan's conception of God. The awesome justice of Donne's deity and the loving figure of Herbert's are equally alien to Vaughan, whose God is a spirit manifest in light and fire. The distaste for the material is matched by a poetic articulation which is looser than those of Donne and Herbert. Vaughan lacks Donne's strenuous arguments and

Herbert's capacity to use mundane material to convey something of religious experience.

To this extent it is simply unhelpful to read Vaughan with these other poets in mind: the numinous quality of his writing is the result of his particular vision. The world of Vaughan's poetry is one of isolated figures seeking union with God-as-light and looking for the breaking up of sin-clouds:

> . . . when shall that crie
> The Bridegroome's Comming! fil the sky?
> Shall it in the Evening run
> When our words and works are done?
> Or wil thy all-surprizing light
> Break at midnight?

<div align="right">('The Dawning')</div>

Vaughan's strong sense of human depravity, his rejection of church as institution, his lack of interest in doctrinal niceties, his drive to transcend the mundane, and his feeling for the scriptures as signs rather than texts to be glossed exegetically make him a figure with much in common with the separatists.

In this light Vaughan could scarcely be further from Richard Crashaw, but there are in fact some interesting links. Crashaw would seem to owe to Donne his interest in the extravagant development of the conceit, but Crashaw was the most European of these poets. His links with the Baroque have been written about quite extensively and he is the only one of these men who converted to Catholicism. Donne offered elaborate patterns of argument and Herbert provided carefully logical constructs, but Crashaw, like Vaughan, was no thinker in verse. He was instead a poet of image and association whose poems are weak in structure (at least if we use Donne or Herbert as examples), seeming to be of indeterminate length and to proceed by the use of associative links: one image suggests another, which suggests another:

> Hail sister springs,
> Parents of silver-forded rills!
> Ever-bubbling things!
> Thawing crystal, snowy hills!
> Still spending, never spent: I mean
> Thy fair eyes, sweet Magdalene.

<div align="right">('The Weeper')</div>

The associations result in a sense of listing modified by one of circling, of the same points being made over and again. Moreover, Crashaw's poems have almost nothing of the strong ego of Donne's. Here again there are links with Vaughan, although the method is very different. Crashaw created swirling, sensuous worlds which are, by Herbert's standards, unstable and imprecise. Words are repeated and overlap, sense impressions are exploited to convey an ecstatic experience, and the result does indeed recall the sculptures of Bernini. Crashaw, moreover, seems to have had no sense of the controversial, no feeling that the type of religious experience he tried to

articulate might seem objectionable or ludicrous to others. As with Vaughan, there is little sense in stressing the deficiencies. Crashaw's methods produced some of the worst writing of the time in English by the standards of Donne or Herbert, but they also produced some quite extraordinary verse, mainly in his late writing. The particular qualities which make Crashaw's best work memorable are best studied in poems like 'To the name above every name, the name of Jesus'.

It is the variety represented by these major religious poets which should be stressed, rather than any artificial union under a label like 'metaphysical'. The variety reflects the range of religious experience and faith which was characteristic of the seventeenth century, and it may not be fanciful to suggest that the irreconcilability of these poets, in terms of interests and techniques, reflects the degree to which any search for unity within Christianity rapidly became hopeless in that century. More could be said and other poets mentioned. There is work to be done on the tradition of restrained Anglican puritanism which was represented by Wither and Quarles, while efforts have been made to claim that, near to the end of the century, Norris and Traherene produced work which shows that the impulse to write religious lyric had not died. The fact of their work perhaps makes that point, but what would be most revealing would be to discover why it is so uninteresting. Norris was bland; Traherne dull and undisciplined.

Finding voices in prose

It was suggested in the Introduction that prose in the seventeenth century might be considered with reference to how various types of people found their voices in that period; and it was also suggested that this was perhaps more important than to study such prose in purely stylistic terms or with reference mainly to the 'rise of the novel'. This is not to disparage such approaches, for the finding of voices must clearly include consideration of style, while the importance of the novel in English literature from 1700 clearly makes examination of its pre-history significant. A list of those writers of the seventeenth century who are usually considered important producers of prose would not include many novelists, but this hides the fact that a good deal of fiction was created or translated, although its importance has yet to be adequately studied. Even so, seventeenth-century prose is not primarily imaginative in the obvious sense, and this immediately suggests a different situation from those of poetry and drama in the period: in the seventeenth century prose is the medium for non-imaginative discourse. This may seem obvious, but it had not been true in the Middle Ages, nor even entirely so in the sixteenth century.

In the first forty years of the century several monuments of Anglical prose were published. The *Revised Prayer Book* of 1604 and the *Authorised Version of the Bible* (1611) are impressive attempts to establish Anglican authority through style, and both are usefully to be seen as documents in the struggle to define an English state church in the aftermath of the break with Rome and in relation to attempts to reconcile a variety of doctrinal and nationalistic

demands and pressures. As is well known, the *Authorised Version of the Bible* was the work of a committee (not all of the same doctrinal views) and it was published while the Church of England was still clearly Calvinist. It is famous for the dignity and sonority of its rhythms, features which have more than stylistic significance. The Elizabethan church had struggled to outflank both Catholicism and separatism, and James I's church inherited that struggle. James himself was strongly Protestant and something of an expert in theology, but he was no advocate of toleration. The *Authorised Version of the Bible* represents the concern of the state church to incorporate as wide a range of beliefs as possible, but its authority is finally coercive. Whether consciously or not, the very confidence of the prose works to encourage assent and to discourage discussion.

In 1629 the *XCVI Sermons* of Lancelot Andrewes (1555–1626) was published and in 1640 John Donne's *LXXX Sermons*. Andrewes, having been dean of Westminster and bishop of Chichester, Ely and Winchester, had reached considerable eminence in the Anglican church by the time of his death and he is associated with the high Anglicanism of George Herbert. Andrewes' sermons and prayers have the same sort of eloquent authority as Herbert's poems, and he conveys the same calm assurance:

> Thou which givest evening to be the end of day,
> whereby we bring to our mind the evening of life:
> grant me alway to consider that; like as the day, so life
> flieth past . . .

<div align="right">('Evening Thoughts')</div>

Donne's sermons are more obviously exciting and more evidently rhetorical:

> There remaines yet another House, a fourth House, a poore and wretched Cottage; worse then our Statute Cottages; for to them the Statute layes out certaine Acres; but for these Cottages, wee measure not by Acres, but by Feete; and five or sixe foote serves any Cottager . . .

<div align="right">('The first Sermon Preached to King Charles . . .')</div>

But Donne's sermons are concerned to establish the force of the Anglican position (or positions, for there is a movement to a more strongly Laudian stress in the latter sermons). Negatively, this can be seen in the attacks on Catholics and separatists alike; positively, in the recurrent emphasis on the union of Church and State, Bishop and King, as well as in the persuasive, sometimes bullying force of the style.

For the last years of his life Donne was dean of St Paul's, while Andrewes, as we have seen, held several senior posts in the Anglican communion. As prose writers both are best known for their sermons; and it is important to remember that the sermon was seen in the seventeenth century, as earlier, as a major vehicle for the transmission of social, as well as religious, teaching. The Puritan attempt to gain control of pulpits, which so infuriated Laud, was important because the preacher was an influential former of opinion in religious and political life. The published sermons of such figures of the established church as Donne and Andrewes are statements about orthodoxy, and both the volumes mentioned above were published when authority was

under some pressure. Charles I dissolved Parliament in 1629, the year in which Andrewes's sermons came out and the same year in which the Three Resolutions of Parliament included condemnation of the Arminianism (or High Anglicanism) which the King supported. Donne's *LXXX Sermons* appeared in 1640 and their emphasis on loyalty to the crown and the established faith is interesting in the context of a year which saw the impeachment of Laud, the triumphant release from prison of the Puritan oppositionists Burton, Bastwick and Prynne, the second Bishops' War with Scotland, as well as the summoning and dissolution of the Short Parliament and the calling of the Long.

Towards the end of the seventeenth century, however, the major author of religious prose was a very different figure, John Bunyan. Bunyan was plebian, born and educated far from the centres of privilege, carrying out his ministry beyond the bounds of the established church. In terms of the struggle for control of that church (or for its abolition) the future of Anglicanism had been most at threat with the moderate Presbyterian settlement under the Commonwealth and with the peaking of Leveller strength in the late 1640s. But with the Restoration Anglicanism re-emerged and of a kind which put heavy emphasis on non-resistance and opposition to toleration. From that point of view Bunyan was of the defeated, for he was a sectarian, and the history of the sects, at least in the short term, is one of decline after 1660. Donne and Andrewes both include autobiographical material in their sermons, but both men preach as figures of authority in the state church. Bunyan tells and retells the story of his spiritual life as that of the individual's search for salvation. The example may, and should, encourage others, but the individual figure no longer represents an established institution. The prose which Bunyan writes utilises scriptural rhythms, but the images are domestic, often humble. The dignity and authority of Andrewes have given way to the struggles of the homely:

I often, when these temptations have been with force upon me, did compare my self in the case of such a Child whom some Gypsie hath by force took up under her apron, and is carrying from Friend and Country; kick sometimes I did, and also scream and cry . . .

(*Grace Abounding*, 1666)

Donne is among the most egotistical of English writers, but he never wrote a formal autobiography, his effort instead being to project aspects of his strong sense of self in a variety of transformed or 'fictional' forms. Bunyan wrote spiritual autobiography, which requires him also to project his life in the shapings of that genre. This suggests some kind of link with Donne, but, more importantly, it associates his prose with the development of history, diary and memoir in the seventeenth century.

Sir Walter Raleigh (1552–1618) began his *History of the World* in 1606 and, although it was never completed, what was written was published in 1614. The project's scale recalls both the ambitions of the medieval encyclopedists and the designs of Francis Bacon for the writing down of all knowledge in a systematic form. But Raleigh's attempt at universal history is both strongly nationalistic and strongly marked by his own sense of self.

Universality may be the aim, but not objectivity, and Raleigh's flexible, fluent prose (which can achieve passages of remarkable descriptive power) is signed by personal opinion:

> To pass over the rest, till we come to *Edward* the Second; it is certain that after the Murder of that King, the issue of blood then made, though it had some times of stay and stopping, did again break out; and that so often, and in such abundance, as all our Princes of the Masculine race (very few excepted) died of the same disease. And although the young years of *Edward* the Third, made his knowledge of that horrible fact no more than suspicious: yet in that he afterwards caused his own Uncle the Earl of *Kent* to die, for no other offence than the desire of his Brother's redemption, whom the earl as then supposed to be living; (the King making that to be treason in his Uncle, which was indeed treason in himself, had his Uncle's intelligence been true) this I say made it manifest, that he was not ignorant of what had passed, nor greatly desirous to have had it otherwise; though he caused *Mortimer* to die for the same.
>
> This cruelty the secret and unsearchable judgment of God revenged, on the Grandchild of *Edward* the Third: and so it fell out, even to the last of that Line, that in the second or third descent they were all buried under the ruins of those buildings, of which the Mortar had been tempered with innocent blood.

This element of egotism connects Raleigh with the main strand of historical writing in the seventeenth century: the concern to write the history of the author's own times or of the immediate past. So William Camden (1551–1623) writes of the reign of Elizabeth, Thomas May (1594–1650) of the recent history of Parliament, Clarendon (1609–74) of the Civil War, and Gilbert Burnet (1643–1715) of his own lifetime. This emphasis on contemporary history should not be exaggerated, for the seventeenth century also saw important developments in a more 'scientific' approach to the collection, editing and interpreting of source materials from the distant past; but it is the history written by such as Clarendon which is of most importance here. Clarendon was a major political figure, while Burnet liked to think himself important. Both were participants in the events they narrate and Clarendon, especially, contributes to the establishment of a style-conscious tradition in English writing of history. It might be added that Clarendon's prose is a model of lucid and confident patrician style:

> When the loss of Reading was well digested, and the king understood the declining condition of the Earl of Essex's army, and that he would either not be able to advance or not in such a manner as would give him much trouble at Oxford, and hearing in what prosperous state his hopeful party in Cornwall stood . . .

Although the events of which Clarendon writes are clearly at times difficult for him to comprehend (so that even when he is considering the King's greatest follies the underlying theme seems to be 'How *can* anyone rebel against monarchic authority?') his style retains its poise, keeping anarchy at bay with its considered periods.

The obtrusiveness of the author-figure in Burnet's *History of My Own Time* (1724–34) ties his work in with more obviously biographical and autobiographical writing, and here several women are of great interest. Lucy Hutchinson (1620–c.75), for example, wrote the life of her husband – the *Memoirs of the Life of Colonel Hutchinson* – between 1664 and 1671 (although

they were not published until 1806). The framework is the life of the
husband, but the fact that he had a public career of some importance means
that the account is a valuable source for the history of the period, while the
author's moderate puritanism, strong commonsense and ability to organise
evidence make the life an impressive piece of work. Lucy Hutchinson formally
accepts the subordinate role of the woman (although she did produce a
fragmentary life of herself), but that itself is questioned by the quality of
what she does as a writer, since her husband exists in history largely as a
result of her creation.

Ann Fanshawe (1625–80), wife to Sir Richard, wrote memoirs for her son
of 'the most remarkable actions and accidents of your family; as well as those
of more eminent ones of your father and my life'. This is not formally a life
of the husband, but the woman clearly sees herself as functioning to support
and memorialise the man. Fanshawe seems a chronicler beside the more
analytic and reflective Hutchinson, but although the style of the memoirs is
sometimes naive it is nevertheless clear and usually controlled. The desire to
commemorate a husband is found again in Margaret Cavendish (1624–74),
who, among much else, wrote the life of her husband, William duke of
Newcastle, who was for a time Charles I's senior general in the north of
England early in the Civil War, and one of the nation's greatest landowners.
Like Lucy Hutchinson, Margaret Cavendish also wrote a brief account of her
own life, while her large output of poems, plays and essays includes material
which gives a striking sense of a powerful personality partly constrained by
sex and social position. All three women had husbands of some social
standing and historical importance and, as memorialists, the wives
subordinate themselves. Yet all three have a sense that they are more than
scribes for husbandly glory. None is an anonymous writer and each makes a
contribution to the development of a clear English narrative style. It should
also be mentioned that the mixing of biography and autobiography which
they reveal is repeated, at a more humble social level, in the writings of a
number of other women, especially Quakers.

A reader of Ann Fanshawe is struck at times by her particularity:

I failed not constantly to go, when the clock struck four in the morning, with a dark
lantern in my hand, all alone and on foot, from my lodging in Chancery Lane, at my
cousin Young's, to Whitehall, at the entry that went out of King's Street into the
bowling ground'.

The sense that such details matter can be connected with a movement away
from the platonic emphasis of earlier biographical writing (as seen, for
example, in Fulke Greville's life of Philip Sidney). Such particular recording
even occurs at quite modest social levels, as in the memoirs of the Derbyshire
yeoman, Leonard Wheatcroft, but it is best known in the diaries of John
Evelyn (1620–1706) and Samuel Pepys (1633–1703).

The diary can take some very humble forms. It may simply be a bare
record of appointments and events, but from such modest shapes it can be
developed towards history, autobiography, even fiction. Like the memoir, the
diary depends upon a sense of ego, a feeling that the personality of the
diarist, interacting with events, has importance. Samuel Pepys became an

important state official of the second rank, but even before he reached this level his diary assumed that his reflections on the great and small would be of interest. The good diary is also likely to be intimate, if not indiscreet. Pepys had recourse to code and his diary, like Evelyn's, was not published until long after his death, while a number of seventeenth-century diaries have never been published. Pepys has special qualities, but it would be an error to see him and Evelyn in isolation, for their diaries are major examples of the seventeenth-century's interest in all forms of biographical writing.

John Evelyn seems to see the diary as closely related to the autobiography. He begins with an account of his family, birth and upbringing, while the early entries are brief summaries of years in his life. Thus, the entry for 1626 reads 'My picture was drawn in oil by one Chanterell, no ill painter'. Gradually the entries are tied to day and month, becoming quite regular by 1641. The final entry is for 3 February 1706, about three weeks before Evelyn's death. Part of his importance is immediately clear: Evelyn wrote during and about a period from before the outbreak of Civil War until after the accession of Anne, and he wrote as a man of some social standing who was yet fairly free of the corruptive pressures of office. Since he was interested both in recording his thoughts and movements and in national events, his diary provides perceptions about the interaction of the personal and the general. Since he concentrated upon recording events and reactions rather than, it seems, upon style in itself, his diary provides another example of the establishment of a functional, all-purpose type of prose.

By the standard of Samuel Pepys, John Evelyn's work seems constrained and discreet. Evelyn has wide interests and emerges from the diary as cultured, well-rounded and rather dully respectable whereas Pepys's writing seems more unbuttoned. Obviously, the seemingly candid diary may well be as calculated in its candour as the careful self-projections of a Clarendon or a Burnet. Pepys became an experienced writer as his diary proceeded and his official duties meant that he was probably never a naive one. Whereas the diary conveys a shrewd sense of the conscious creation of effects – Pepys seems candid, and is far more intimate and indiscreet than Evelyn – much of the fascination lies in a self-revelation which looks unconscious, even though it may not be so.

Like Evelyn, Pepys was in frequent contact with the great, but he was much more of a careerist and had much more to tell about the business of administration and the dealings (and fixings) which this involved in the world of the Restoration. Such things fascinated Pepys, but his diary is simultaneously concerned to record his own role in this public life and the more private aspects of his world. Indeed, one of the most significant aspects of Pepys' diary is that he used the form to create a private complement to, and commentary upon, the public world in which he functioned. It is unnecessary here to elaborate the claim that Pepys was a natural writer. He loved detail, had a sharp pen and considerable self-confidence. If he reveals more than he realises, that is our gain and also a tribute both to his curiosity and his involvement in living.

The recordings – of aspects of lives – with which we have been concerned vary considerably in scope and perspective. Clarendon, a critic of the King

before the Civil War, became Charles I's most important adviser and later, for a time, the chief minister to his son. He wrote a very full account of a period through which he lived and which he influenced, and he is thus deeply concerned in some of the most significant events of our history. Ann Fanshawe, Margaret Cavendish and John Evelyn were also royalists (as is Pepys in his way), while Lucy Hutchinson was Puritan and parliamentarian. Clarendon and, to a lesser extent, Burnet were decision-makers in affairs of state; while Evelyn is interested in such matters, without being deeply involved; and the three women are condemned, because of sexual and social prejudice, to supporting roles (which seems to have irked Margaret Cavendish particularly). But of these writers only Pepys was of humble birth (his father was a tailor, although the family had connexions with the socially great) and he is also the only one who could properly be said to have lived a professional life. Even Pepys, however, was much in the company of the socially distinguished, and he was an educated man (St Paul's and Oxford) who had, from early on, influential connexions. None of these voices could reasonably be called plebian.

Up to this point we have been concerned with theological writing, histories and various sorts of biography. These concerns, however, merge in the extensive pamphleteering of the seventeenth century, and most especially of the period from 1640 to 1660. 'Extensive' seems scarcely an adequate word for the vast territory covered by the pamphlet. It includes political theory (shading into Utopian fiction with James Harrington's *Oceana*, 1656), ranges across the political and religious prose of Milton, Lilburne (*c*.1614–57) and Winstanley (?1609–*c*.60) to the more extreme religious writings of such as Eleanor Davies (or Douglas) and the Ranters, while it also includes the very important spiritual autobiographies of Quaker men and women. Such prose – involved, often embittered and highly partisan – draws in the plebian and challenges purely literary definitions of literature.

The great bulk and variety of this material make it difficult to write about in a survey of this kind. An idea of its extent can be gained by looking at the Short Title Catalogue, which gives details of authors and titles of books and pamphlets published in the seventeenth century, and if it has any common characteristic it must lie in the involvement of the material in the affairs of its time. At one extreme it may seem quite theoretical, as in Filmer, Hobbes and Locke, but its concerns are always with theory as bearing on, and shaped by, contemporary actuality. The point could itself be made in terms of style, because all of these writers make use of the powerful, sometimes coarse and abusive, rhetoric of controversy in their writings, as well as the seemingly-dispassionate language of philosophy. Milton, a master of elaborate and Latinate prose, incorporates a directness which is often coarse – and Milton could scarcely be more involved with contemporary events. At the other extreme, the variety of the material is shown in styles which are at times hardly coherent at all, by orthodox standards. Rational discourse melts under the pressure of vision, anger and despair: association, biblical reference, the overlapping of images, create, in writers like Davies and the Ranter Abiezer Coppe, a prose which can be bafflingly impressive. The range of education and background of these writers is also considerable. John Lilburne was

Christ Church Coll: Ox: Canterbury Minster Trinn: Colledge Camb:

MERCURIUS RUSTICUS

Countess of Rivers plundered pag:11

St John Lucas house plundered pag:5.

Sr Rich Mynshuls hous plundered pag:31.

A Bonfire for the voting downe Episcopacy pag.26.

THE COUNTRYS COMPLAINT Recovnting the sad Events of the late unparalleld REBELLION

Mr Jones a Minr: carried on a Beare pag:81.

Edge hill Battle

Warder Castle defended by a Lady. pag:41.

The cover of a political news sheet in the year of James II's accession (1685).

genteel; Gerard Winstanley's father was a mercer. John Milton held office in the state; James Naylor was brutally punished by the state; and many Quaker women of humble origins who have left spiritual autobiographies were whipped and imprisoned.

The very fact that in the seventeenth century there was an accumulation of women making their voices heard is significant in ways which are only now being explored. The prose which survives, from the prophecies of Eleanor Davies to Quaker spiritual autobiographies, and from the biographies touched on earlier to the women's petitions to Parliament, is only one aspect of the struggle of women in the seventeenth century, and that struggle associates an aristocrat like Margaret Cavendish with the Quaker Mary Anderson, sister to a Bridgwater goldsmith. In Cavendish there is the moving prose of a woman who sees the gap between her social role and her ambitions and abilities. This prose, usually lucid and controlled, has frustration and ambition in common with that of Eleanor Davies, who is commonly dismissed as an hysteric and/or lunatic; and these features in turn associate the struggles of women with those of men who also felt that their voices were undervalued and disprivileged.

The style of Milton's pamphlets was, as mentioned above, learned. In 'A Treatise of Civil Power . . .' (1659) Milton argues for the separation of the civil and the ecclesiastical in the state by drawing upon a range of allusions and quotations, deploying a formidable variety of rhetorical devices and rhythms. Milton's prose is usually in the service of popular causes, but it is not itself popular prose. Winstanley, however, was a writer who, urgently committed to the Digger cause, evolved a style which is accessible and expressive, informed and shrewd, unpatronising and unpedantic:

And truly I'll tell you plain, your two acts of Parliament are excellent and righteous: the one to cast out kingly power, the other to make England a free commonwealth. Build upon these two, it is a firm foundation, and your house will be the glory of the world; and I am confident, the righteous spirit will love you.

('A New-year's gift . . .')

It is clear that Winstanley believes in reasoned persuasion (though it did him little good) and in that sense he may be seen as taking over an orthodox, educated prose in a radical cause. Something similar can be said of John Lilburne. Lilburne characterises God as Reason, and both his life and his writings are testimony to his obstinate belief in the persuasiveness of argument and righteousness (for which he spent much time in prison).

Elsewhere, however, the effort to utilise traditional educated prose for radical causes is modified or abandoned. In its place there is a style developed from the apocalyptic books of the Bible, a style which seems to restrict communication to initiates, but which has striking moments of clarity and often considerable rhythmical power. A moment of Joseph Salmon will show how this prose unites the visionary and the autobiographical impulses:

Thus was I led into paths that I had not known, and turned from a King to become a Beast, and fed upon huskes for a season. After a while posting most furiously in a burning zeal towards an unattainable end: my manner of walking being adjudged by those in power contrary to the peace and civill order of the Commonwealth I was justly apprehended an offender . . .

('An Apologeticall Hint to . . . Heights in Depths . . .')

Salmon introduces his pamphlet by referring to himself as a 'poore Pilgrim' and claims that he has 'dressed' his remarks 'in a homely Language'. He is writing in the middle of the century (1651) but both the pilgrim image and the comment on style point forward to Bunyan. The comment on homely language is also interesting in that it is accurate (Salmon's language *is* homely) and yet the messages this language conveys are both radical and, by the usual standards of reasoned discourse, often disjunctive, even fragmented.

There are other types of prose in the seventeenth century. Robert Burton's *Anatomy of Melancholy* (final version 1651/2) and the writings of Thomas Browne (1605–82) provide examples of styles which are highly idiosyncratic, rich and enjoyable, but of limited influence. It is perhaps more important to notice the development of the prose of speculation and criticism. By the end of the century the English language had a prose which could handle philosophical enquiry (with Locke stressing the need for precise verbal definition and resisting numinous abstractions) and literary criticism (Dryden being the first English critic to leave a substantial body of critical prose, in which a concern with clarity, precision and methodical description is very evident).

I have, however, emphasised achievements in the prose of women and radical men. This is partly because it is in prose that these are particularly important. During the seventeenth century there is drama and poetry produced by women, and the extent to which this involves taking over styles traditionally dominated by men is only beginning to be explored. During the century, too, there is radical drama and poetry, written by men like Middleton and Milton. But it is in prose that we come closest to articulations by women and radical men which threaten or promise to take over control of a literary medium from the privileged. There is a perspective on literature which would suggest that this is the most important development in seventeenth-century writing.

It may seem perverse to end a chapter on seventeenth-century literature by discussing prose rather than drama or poetry, and especially to conclude with stress upon the prose written by women and radicals. But it can be argued that the future of English literature lay with prose of a broadly radical kind, in the hands of such as Defoe and Richardson (not to mention Dickens later). When drama next became significant in English culture it was to be in the radical form of melodrama; while although the immediate future of poetry was to be with Pope, it is the achievements of Crabbe, Clare, Blake, the early Wordsworth and Shelley, who in their various ways sustain a radical tradition, that are most deeply important in the life of Western culture.

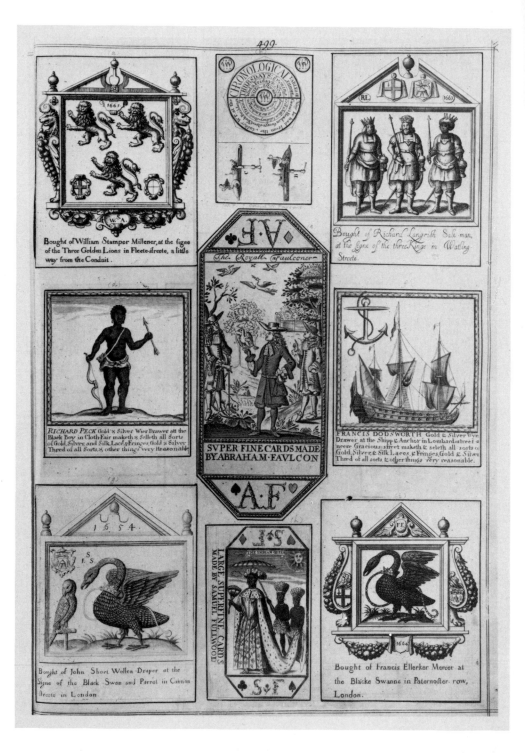

London trade cards from Samuel Pepys's collection of printed ephemera. Tradesmen often wrote their bills on the reverse.

5 The City of London

PHILIPPA GLANVILLE

On May Day in the morning every man would walk into the sweet meadows and green woods, but now the countryside is much pestered with building, and with enclosures so that by the closing in the common grounds, our archers for want of room to shoot abroad, creep into bowling alleys and ordinary dicing houses nearer home.

(John Stow, *Survey of London*, 1593)

This vast city is like the head of a ricketty child which . . . becomes so overcharged that frenzy and death unavoidably result.

(Fletcher of Saltoun, 1703)

London's growth, both in area and in population, was a phenomenon of the early modern age. Stow's lament for the loss of the old innocent pastimes, written in the early 1590s, hints also at the simple pleasures of urban life – the excitement and stimulation possible in a metropolis of some 200,000 people. This figure represents a fourfold increase in its population from about 1500 to 1600. At the accession of James I about one-twentieth of England's population lived in London, but it was to swell even more rapidly and by 1660 about one in every twelve Englishmen called himself a Londoner.

By the end of the Stuart era London's inhabitants numbered nearly three-quarters of a million, despite attempts by the government to regulate its size and the natural brake of recurrent epidemics and an exceptionally high mortality rate for London-born infants. The new Londoners came both from overseas and from the provinces; it is estimated that the rural counties sent about two per cent of their people every decade to the capital as apprentices, as maidservants, to the Inns of Court, or to join trading companies. London offered a unique range of opportunities for talented and energetic youths; Robert Hooke, son of a curate in the Isle of Wight, spent much of his life in the metropolis as architect, scientist and curator to the Royal Society.

This was a cosmopolitan city; aliens or 'strangers' with special skills, whether dancing masters or silk-weavers, continued to flood across the Channel, as they had in the sixteenth century, attracted by the possibilities inherent in a rapidly emerging consumer society with underdeveloped native industries. The arrival of thousands of Huguenot refugees in the 1680s is the

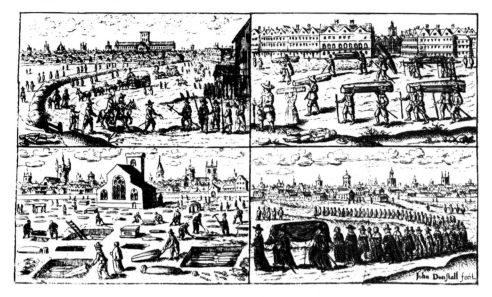

John Dunstall, The Great Plague of London *(1665); detail of a popular broadside.*

best-documented and publicised of these waves of immigration. A return of aliens resident in London in 1635 shows that there were then several hundred, running workshops and employing outworkers in London, Southwark and Westminster. Many were engaged in the silk industry, making accessories such as ribbons, spangles and upholstery trimmings, skills much in demand for which there was no native tradition. A typical figure is the Utrecht-born goldsmith, Christian Van Vianen, whose Westminster workshop employed 11 journeymen, both native-born and aliens.

This burgeoning population could not be contained in the old built-up area of London which, in 1600, extended beyond the walls westward only to St Giles and St Martin's, still virtually 'in the fields', with Westminster a separate community and administrative unit (as it remains today). Kensington, Paddington or Hackney were still villages several miles outside the town where Londoners sent their daughters to be educated and themselves retreated in times of plague. The extension of buildings in the out-parishes fringeing the City and the suburbs beyond alarmed both the Crown and the City, and in 1633 the Council asked the City 'whether they woulde accept of parte of the suburbs into their jurisdiction and liberty for better government', but the City rejected the offer. However, lists prepared in 1638 of the 1300 or so new houses built in the out-parishes since 1603 enable us to plot the areas of expansion. Over 600 new houses had been compounded for to the west of the city in Drury Lane, Long Acre and elsewhere, and 400 to the north around Clerkenwell. A return of communicants made in the same year reveals the contrast in size and overcrowding between some of the tiny city parishes and those beyond the walls; St Matthew Friday Street had 24 houses and 140 communicants, whereas All Hallows Barking contained 300 houses and well over 1000 communicants.

A vivid snapshot of the inexorable westward push of London's limits appears in Wenceslaus Hollar's isometric view, *West Central London,* which was prepared about 1658. In 1623 the number of houses rated in St Giles' parish was 897, of which 136 had been recently erected in Bloomsbury, formerly open country. Covent Garden, St Paul's Church and the surrounding streets were a commercial development of the 1630s by Francis, 4th Earl of Bedford. The church, designed by Inigo Jones, was aligned with four-storey brick terraces designed by Isaac de Caus and modelled on the Place des Vosges in Paris. These were intended for the more affluent; Bow Street was described as 'large and open with good houses well inhabited and resorted to by gentry for lodgings'.

Within a generation the great noblemen were to transfer their London mansions further westwards, away from London's festering multitudes, to new sites along Piccadilly and in north Bloomsbury. Already in 1640 the Earl of Southampton had received a licence to demolish his Holborn house and build tenements on the site. The 1680s were to see the site of Arundel House, the medieval town palace of the Dukes of Norfolk south of the Strand, laid out by the developer Nicholas Barbon as streets.

Thanks to the townscapes and long views of Norden, Hollar, Cornelis Bol and Danckerts, the London of the Stuarts, particularly London after 1660, can be reconstructed with considerably more detail than any earlier period. Claud de Jongh first came to London in 1615; his masterpiece, *Old London*

Wenceslaus Hollar, view of West Central London (c.1658).

Bridge (1630) is at Kenwood House. Wenceslaus Hollar, the greatest of all London's topographical artists, who came to England under the patronage of the Earl of Arundel, left an extraordinary body of exact and detailed engravings and drawings of London buildings and London scenes between the 1630s and the 1660s. The cartographic tradition which flourished in seventeenth-century Amsterdam had its counterpart in England; the first true map of the City, as opposed to the bird's eye views of Norden, Hollar or Faithorne, was published by the indefatigible John Ogilby and William Morgan in 1676; in this, the blank unbuilt areas reveal the devastation wrought by the Fire ten years earlier.

Thanks to the diaries of John Evelyn, Samuel Pepys and Robert Hooke, the structure of Restoration intellectual, cultural and scientific society is generally familiar. Add to these the maps, engravings and guidebooks in English and French published between the 1660s and the 1690s and the accounts by travellers such as the Florentine Count Magalotti, and de Monconys in the 1660s, and another Frenchman, Monsieur de Misson, in the 1690s, and late Stuart London has few dark corners. However, rather less is understood about the London of Charles I. The season is often described as a post-Restoration development but it should rather be seen as a flowering of a well-established tendency. Already in Elizabeth's time, the Inns of Court had emerged as combined finishing schools and law academies for the sons of gentry and wealthy yeomen. In their maturity men came to London to attend Parliament, to follow up a law suit, to buy luxuries and to see the fashion. Increasingly their wives came too, for part of the year at least, and much of the West End housing built between 1630 and 1680 was occupied as lodgings

London merchant's wife (left) from Theatrum Mulierum *(1643); (right)* Summer *(1644), showing St James's Park with the Banqueting House and old St Paul's in the distance; by Wenceslaus Hollar.*

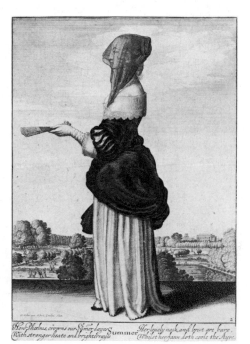

by these country gentry. In 1632 a quarter of the peerage was resident in London.

Retail shops, as opposed to markets and fairs, were an urban creation which rapidly spread to provincial towns in the seventeenth century. For London they were no novelty, but an innovation was the cluster of luxury shops in a purpose-built building. The New Exchange or 'Britain's Bourse', a two-storey commercial development financed by the Earl of Salisbury and opened by James I in 1609 in the Strand, was a West End rival to the booths on the upper floor of Gresham's Royal Exchange; here customers could buy jewelled fans and watches, silk gloves, silver-bound books and curiosities. Even a sophisticated foreign visitor, such as the Florentine Lorenzo Magalotti could describe it in 1669 as 'a very rich shop of drapers and mercers, filled with goods of every kind and with manufactures of the most beautiful description . . . under the care of well-dressed women'! Another fashionable place of resort, with little shops selling fancy goods, stationery and lace was Westminster Hall, one of the most important public spaces for Pepys and his contemporaries. Here too the law courts held their proceedings, a popular entertainment for visitors to Westminster.

As fashionable life shifted westward, so did the shops; the opening of the New Exchange was to be followed by a steady flow of goldsmiths, cutlers,

Part of the frontispiece to William Badcock's The Touchstone for Gold and Silver Wares *(1677), illustrating the work of the Assay Master and his assistants.*

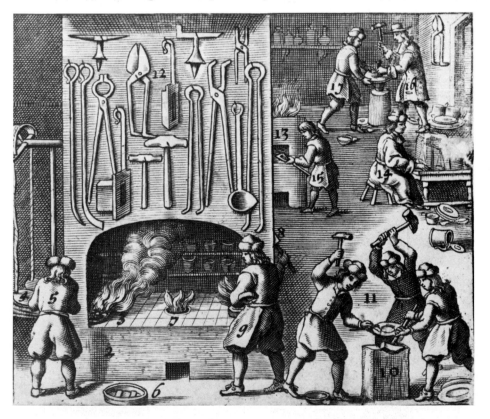

swordsmiths, hatmakers and others supplying the gentry. Unpopular with both Crown and City, because the traders in the new locations were outside the strict trading and craft restrictions of the Common Council and the livery companies, which restricted the right to run a retail shop to freemen, this tendency was attacked in the 1630s. St Paul's Churchyard remained the centre of the book trade; there were 23 booksellers there until the Fire of 1666, when the stocks stored by the members of the Stationers Company in St Faith's church were largely destroyed.

London offered also the opportunity to order special items such as a new coach, tailor-made garments (although ready-made clothes shops were beginning to appear, as Pepys's diary records), tapestries, flock-printed wallpaper or upholstered furniture. London's influence was felt in the provinces too. In Yorkshire some 280 gentlemen rebuilt or refurbished their houses between 1580 and 1640, and their inventories reveal the novel and luxurious furnishings now considered necessary, from mirrors and clocks to Indian cotton bed hangings. Since a man's surroundings, from his plate to his upholstery, were taken as an index of his status, to be fashionable was not only an obligation but a pleasure, and in this process the habit of visiting London played a crucial role in stimulating awareness and emulation.

The streets were noisy, cluttered and congested with traffic: carts, chariots, drays and coaches. That essential of urban life, public transport, was well established. Because there was only one bridge over the Thames (Westminster Bridge was not begun until 1737) water transport was an essential element in London's life. In 1676 there were said to be some two thousand watermen plying for hire; single or double sculls were the taxis and wherries, seating 10 or 14 people, the buses of the time, with regular routes

A London carter and meat porter (1614–15). The bales on the cart carry a merchant's mark.

and calling points down river as far as Woolwich. Innovations were the sedan chair and the hackney coach, which had become a regular form of transport plying for hire from the 1630s. A stand for hackney carriages at the Maypole in the Strand is shown in Hollar's view of West Central London, and by the 1660s, as Monconys commented, they were to be found everywhere. Pepys took one almost every day, even in the early years of his career as civil servant. Private coaches added to the congestion; Pepys, realising in 1668 that he was the only principal officer of the navy without his own coach, bought one which was delivered for his use on May Day 1669. Pavements and rails are both Restoration innovations, enforced to protect foot passengers from the hazards and dirt of wheeled traffic.

To disseminate fashion and stimulate consumer demand, a network of regional carrier services was essential. By 1637 there were over 200 carrier services and by 1690 over 300 wagons carrying both goods and passengers. Newsletters, books and more perishable commodities were carried to the furthest corners of the kingdom. For wealthier customers, coaches ran on the main roads, travelling about 25 miles a day. In 1690 a hundred and eighty operators were running long-distance coaches. Travelling for pleasure and information, or tourism was already a feature of English life, as the tours of Sir William Brereton (1634–5) or Celia Fiennes (c.1682–c.1712) show and London was where all roads led, as in John Ogilby's roadbook *Britannia . . . Principal Roads Thereof* (1675). In the later seventeenth century a new discovery of England was in progress.

Fashion, too, travelled the roads from London; by 1700 it becomes more difficult to distinguish regional styles in traditional status symbols formerly made in provincial capitals, such as silver or funerary monuments. Provincial customers increasingly demanded 'the newest fashion' and provincial craftsmen had to invest in up-to-date pattern books or employ London-trained journeymen to satisfy them. Such was the appeal of London-made goods that John Elston, an Exeter silversmith, could build up the basis of a flourishing business by offering to supply his fellow-goldsmiths in Devon with fashionable silver wares, undercutting London rates.

At a lower social and economic level too, London increasingly dominated the market. Wholesale warehouses like the Red Lion in Bishopsgate Street supplied low-grade silverware, accessories and textiles to pedlars and chapmen, who then carried them around the regional fairs and markets, a process which in the long run was virtually to destroy locally-based industries.

The Great Fire is a milestone in London's history; it raged for four days from 2 September 1666 and destroyed an estimated 13,200 houses, 87 churches and 44 livery halls as well as the City's administrative and commercial centres, the Guildhall and the Royal Exchange and apparently offered an opportunity to rebuild London wholesale to an ideal plan, and on the most admired contemporary town-planning principles. Within a few days of the Fire two men with the entrée to Charles II, Wren and Evelyn, had presented plans to the King, although the virtuoso John Evelyn had an advantage in that he had travelled extensively in the 1640s and 1650s and had been thinking and writing about London improvements for several years.

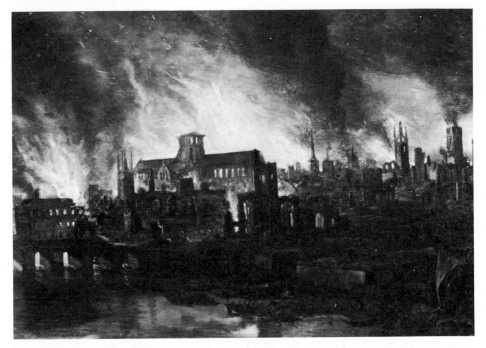

The Great Fire of London *(detail); by an unknown Dutch artist.*

None of these planners' dreams could be realised; the cost both in money and time was too great for the City, lacking the credit resources offered by sophisticated banking and without effective financial support from the Crown, apart from the coal dues. As it was, the most notorious streets such as Thames Street and Threadneedle Street, both major roads which were only 11 feet wide between their house-fronts, were widened. Steep approach roads were eased, particularly Ludgate Hill, and New Queen Street laid out as a fine, 24-foot wide, thoroughfare from the river to the Guildhall. London had within its walls 'a multitude of bye-lanes, walks and alleys, huddled one upon the neck of another so that some houses scarce ever saw the sun and the inhabitants lived comfortless and unwholesome'; the post-Fire Building Acts, which had their precursors in the 1630s, established four house-types and sizes, all to be built in brick, laid down minimum safety requirements about party walls, and forbade overhanging jetties.

The result was a uniform and, in its main streets at least, handsome city; the market stalls were removed from the thoroughfares such as Newgate and set up in purpose-built structures, and the Fleet River was transformed from a ditch 'very stinking and noisome' into a fine canal lined with broad quays, reminiscent of those in Amsterdam, as a mooring point for lighters. Unfortunately, the City's limited authority stopped above Holborn Bridge and the Middlesex Justices of the Peace were not fastidious about dredging the river and keeping it free of debris. The consequent silting-up of the Fleet drove industrial traffic away. The Thames Quay, which was also intended as a commercial gain for the City, emulating the waterfronts of Genoa and Amsterdam, replaced the muddy, smelly foreshore recorded in Hollar's

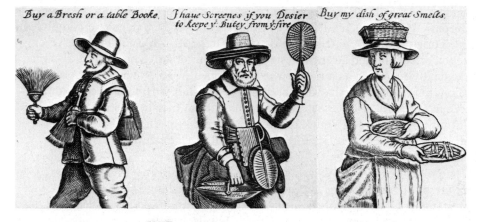

Some Cryes of the City of London *(c.1640), from a series of thirty-two plates.*

drawings. The first dock, Howland Dock, was to be developed at Rotherhithe by the energetic Russells in the late 1690s. Despite later re-development and the destruction of wartime bombing, the city still retains some handsome post-Fire buildings, such as the Apothecaries' Hall and the College of Arms, not to speak of St Paul's Cathedral, a handful of Wren's churches and the Monument, whose design, often attributed to Wren, was actually the work of Robert Hooke in his capacity as City Surveyor.

Rather more of both pre- and post-Restoration London survives scattered through the suburbs; in Westminster stands the Watergate to York House (1630s), now stranded some hundred yards from the water's edge in the Embankment Gardens, which has been attributed both to Nicholas Stone and Balthazar Gerbier, and the Banqueting House (completed 1622) which is undisputably the work of Inigo Jones. This was intended as a setting for masques – Jonson's *Masque of Angels* was the first to be performed, but Rubens's magnificent ceiling painting, showing the Apotheosis of James I, was completed in 1635 and Charles banned masques there because of the damage from candle smoke. It was the backdrop for the execution of Charles on 30 January 1649. As a setting for state ceremonial it was much admired, particularly since the rest of Whitehall Palace was a rambling mass of some 2000 rooms in early Tudor brick buildings (the work of Wolsey and Henry VIII, mostly). They were of different heights connected by corridors, gatehouses and staircases, quite unlike the Versailles of Louis XIV: 'the rest of the Palace is ill-built and nothing but a heap of houses, erected at divers times and of different models'.

Further west, Kensington Palace was built for William III and Mary by Christopher Wren on the site of a Jacobean house in 1689–92; the King's distaste for Whitehall (the coal smoke and its damp situation aggravated his asthma) was reinforced by fires in 1691 and 1698, the latter virtually destroying the Tudor palace. Further afield Ham House, the Thameside home of the Tollemache family, Earls of Dysart, retains the atmosphere, appearance and many of the furnishings of the Duke and Duchess of Lauderdale's time, and neatly expresses the French-inspired ornament characteristic of the English aristocracy in the 1670s. To the south-east of

London the royal park and buildings at Greenwich are a unique assemblage; the centre is the Queen's House (begun for Anne of Denmark and completed for Henrietta Maria) which again demonstrates the Caroline dependence on French ornament and French design, at court level at least. Charles II's plan to extend Greenwich as a palace was abandoned in 1669 when funds ran out, although he moved the Royal Observatory and the Astronomer Royal out there in 1675. In 1692 Queen Mary dedicated the half-built structure, with additions by Wren and Hawksmoor, as a hospital for disabled seamen in counterpoint to Charles II's military hospital at Chelsea built by Wren between 1682 and 1689.

The pleasures of the town, both under cover and in the streets, included already by the early seventeenth century, an astonishing range of paid entertainment, whether plays, bear-baiting, visiting museums or seeing the historic arms and armour and the Crown Jewels at the Tower, which also maintained the only permanent menagerie. Exotic animals were popular with showmen and public alike; James I kept a small menagerie of 'Indian' animals and birds in St James's Park with an Indian as keeper (crocodiles, beaver, deer and turkey and quails), a precursor of Charles II's large aviary. The much-travelled and sophisticated John Evelyn took the opportunity to inspect London's first rhinoceros, which was put on show at the Belle Sauvage Inn, Ludgate Hill, in October 1684, since he was uncertain whether it really could be the origin of the unicorn myth as traditionally claimed.

London had its share of the private museums or, rather, cabinets of curiosities which were so marked an expression of European intellectual life in the seventeenth century; these collections, to a modern eye extraordinarily miscellaneous, brought within their scope 'whatsoever the hand of man by exquisite art of engine has made rare', as Francis Bacon recommended, a scope which drew in ethnographic objects from South America or the East Indies, antiquities, Chinese porcelain, shells carved and mounted and natural wonders such as stuffed crocodiles or ostrich eggs. These collections were indeed the germ of the modern museum system, which now separates decorative art from natural history or ethnography.

Until the 1650s the Earl of Arundel's London house in the Strand was the setting not only for his famous collection of paintings, and for the antique marbles which were later to form the nucleus of the Ashmolean Museum, but also for a characteristic assemblage of exotica and antiquities – rhinoceros horn cups, the ivory comb of the Saxon queen Bertha, worked coral, petrified wood and Limoges enamels. Arundel's collection, like John Selden's, was not formally open to the public, although informed and cultivated people could obtain tickets to visit parts of his house and garden, but the Tradescant Collection in Lambeth was set out as a public attraction. It was dominated by exotic and curious objects gathered on their travels, rather than by intrinsically valuable items. Many of John Tradescant's rarities are still to be seen in the Ashmolean Museum, such as an Indian feather cloak, Russian snow shoes or the lantern used by Guy Fawkes. At Westminster Abbey there was a rather different range of attractions; the tombs and the wax effigies of English kings and queens which were on show as they are today.

Periodically, expressions of civic and royal pageantry brought glitter and

excitement to London's streets. Every year the new Lord Mayor made a procession by river to Westminster in a flotilla of gilded livery company barges hung with banners, and there was a great procession of floats on allegorical themes through the City. In 1616 the Lord Mayor, John Leman, came from the Fishmongers Company, and the motifs that year included his device of a lemon tree, fishing boats, dolphins and mermaids. There were occasional royal entries; the most spectacular was at the Restoration of Charles II. When Marie de Medici visited England in 1637, the splendour of her reception and the size of the processions was considered sufficiently interesting for a series of etchings to be prepared to record it. Folk-festivals were fewer than before the Reformation; the most important was May Day, when the milkmaids dressed in their best and set on their heads towering frames of silver tankards and plates, interwoven with ribbons and flowers. They then danced in front of their customers' houses in the hope of collecting tips.

Londoners also seized the opportunity offered by the occasional freezing-over of the Thames to transfer their customary amusements onto the ice, with some additional features, such as whirling in a sledge around a pole or riding in a coach on the ice; the watermen charged those coming down the steps onto the ice in recompense for their loss of occupation (colour pl. 1). At these fairs on the ice, held in the 1680s, it was possible to buy fire insurance, hot food, punch and souvenirs. The annual Bartholomew Cloth Fair, held at Smithfield for three days, was, by the seventeenth century, more significant as a centre for entertainment, as Ben Jonson's play demonstrates.

The Lord Mayor's Procession, from the album of Michael van Meer of Hamburg (1614–15).

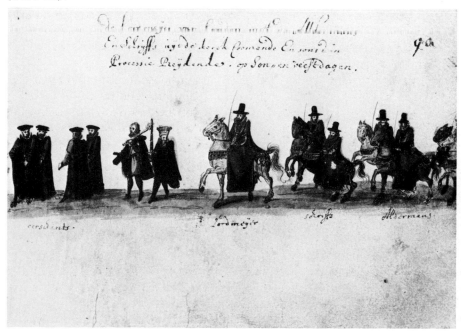

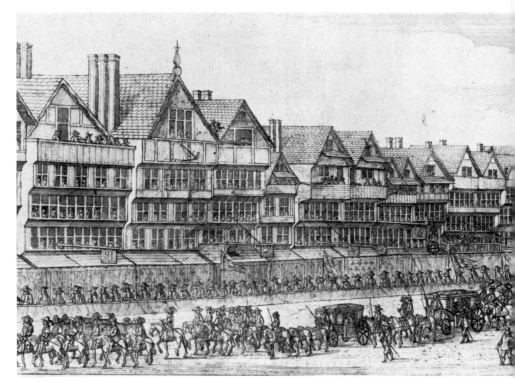

Marie de Medici's procession (1637), by the Eleanor Cross, Cheapside (above). The street is sho

Interior of a London coffee house (c.1705).

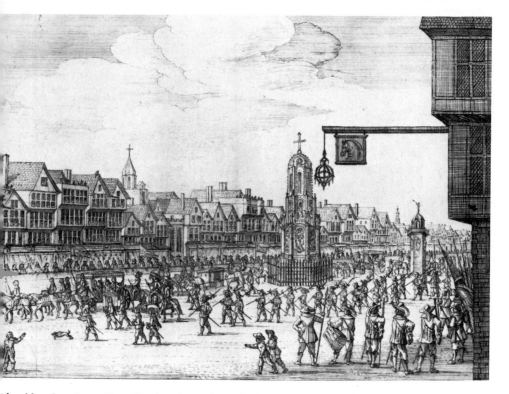

...h wider than in reality, allowing the artist to include as many details as possible.

As London grew larger, so it became essential for men to have meeting places which were more formal than the tavern, and less intimate than a private house; the arrival in the mid-seventeenth century of the new beverages, coffee pre-eminently, chocolate, tea and punch, created an entirely new form of social environment, the coffee-house. As is well known, these became the meeting places for men of a particular class, commercial group or intellectual bent, each clustering at one favoured house; they were the genesis of the London club. In the 1680s Robert Hooke can be seen visiting Garraway's coffee-house near the Exchange to discuss the sheets of the map of London then in production, later in the day meeting Wren at another coffee-house to discuss some aspect of the re-building programme for the City, and visiting a third to find another group of friends or colleagues towards the evening. The first coffee-house had been opened in Oxford in 1650; by 1663 there were eighty-two in the City. The proprietors supplied newspapers and displayed advertisements, here political and court gossip was exchanged and coteries formed, to the occasional unease of the State.

To experience London was to love it or hate it; despite the thousands who were drawn every year to it as to a magnet, it was also seen as corrupt, stinking and a canker that was eating not only the young men but also the prosperity of the rest of the kingdom, particularly the smaller ports.

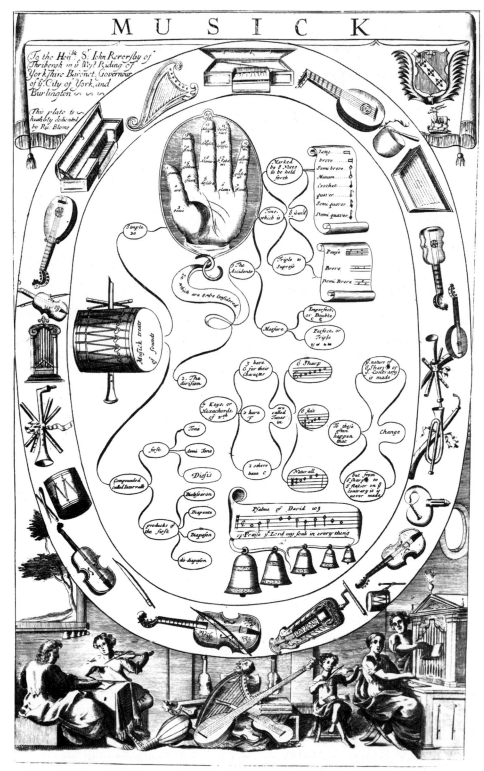

Richard Blome, 'Musick', from The Gentleman's Recreation *(c.1686).*

6 Music: Paradise and Paradox in the Seventeenth Century

WILFRID MELLERS

Prelude: the forgotten garden

It is not an accident that the major long poem of England's seventeenth century should be called *Paradise Lost*. According to the medieval cosmological view the world, having been made by God, appeared, 'in prospect from his throne', to be 'good and faire, According to his great Idea'. Music was allied to this idea, being an art that echoed the 'undisturbed song of pure Concent' such as is sung in heaven, and was sung on earth in our prelapsarian state. In *At a Solemn Musick* Milton says that we need to be reminded of the music of the spheres in order that

> we on earth with undiscording voyce
> May rightly answer that melodious Noyse;
> As once we did, till disproportion'd sin
> Jarred against Nature's chime, and with harsh din
> Broke the fair musick that all creatures made
> To their great Lord, whose love their motion sway'd
> In Perfect Diapason, whilst they stood
> In first obedience, and their state of good.

He ends with a prayer:

> O may we soon again renew that Song,
> And keep in tune with Heav'n, till God ere long
> To his celestial Consort us unite
> To live with him, and sing in endless morn of Light.

The lingering rhythm of the final line reinforces the wistfulness of the passage: which remains, whether we think of the lines in personal terms (we will be fulfilled only when dead), or whether we think of them as a prophecy about the destiny of the human race. The whole of Milton's work proves that he knew that, if ever the prophecy were fulfilled, it could not be in the form of a return to the past. Paradise, once Lost, can be Regained only by becoming something different.

Milton's dubiety, as epic poet of the seventeenth century, balances the

optimism of Spenser, bard of the first Elizabeth; and the relationship between the poets is paralleled, in a smaller way, by that between the two finest miniaturists of the Elizabethan and Jacobean periods. Hilliard's 'limning' is pristine, the likeness merging into Platonically symbolic attributes. Oliver's portraiture is more naturalistic, while symbolic dimensions dissolve into what we would call psychological insight. His God, like Milton's, works in a more mysterious way to perform whatever wonders may be feasible. Yet although the winds of change blew decisively only in the seventeenth century, the breach in man's nature harks back as far as the Renaissance itself, when man became potentially the arbiter of his destiny. In the Elizabethan age there is evidence of this in the very notion of a Reformed Church. God as absolutist monarch and the New Man as Protestant redefined the alignment of Church and State; the English Prayer Book, though not subversive, offered a vernacular liturgy to which 'all sorts and conditions of men' could respond. Human protest might, *in extremis*, threaten traditional religious sanctions. At no earlier period could an intrepid spiritual adventurer and probable athiest like Christopher Marlowe have attained such renown. Shakespeare's supremacy may lie in the fact that he alone achieved a reintegration of Christian ideas of order with the psychologically humanist impulses that were moulding the modern world.

The story of English music during the seventeenth century stems from this ambiguity. In the Jacobean age traditional vocal polyphony balances between the 'Divine' music of the Anglican rites (with infusions from Catholic recusants), and the 'Civic' music of the secular madrigal, with stronger impulse from the corporeal rhythms of dance and with more humanly introspective, and dissonant, harmony. These 'progressive' elements were more potently explored in instrumental music for keyboards and lute; in the lute ayre for solo voice, intimately dependent on the relationship between music and poetry; and in polyphony and dance music for strings, rooted in vocal tradition, yet garnering more physical animation. Solo ayre, in fusion with string dance music, led into a potentially theatrical development, encouraged by cross-currents between England and Italy – original home of the Renaissance and of a dramatically humanist view of music's nature and function.

This coherent evolution was frustrated when the division within English culture became explicit in the Civil War. During the War and interregnum division became bifurcation: symbolically represented in the careers of two immensely long-lived composers, Angelo Notari and John Jenkins. Notari, born in Padua in 1566, worked in Venice in youth but settled in England in 1610, as composer-performer in the retinue of Prince Henry. After the Prince's lamented early death, he served Charles I, survived through the War and interregnum, and was again a court musician, for Charles II, at the age of 93! His only published collection of songs, duets and madrigals, issued in 1613, is ornate and Italianate, including astonishing virtuoso pieces for two tenors, and still more for a bass of phenomenal range and agility. Though having no direct connection with English tradition, this Monteverdian music appealed to the esoteric tastes of Charles I's court, and encouraged composers of the middle years of the century to their own similarly exotic experimentalism.

John Jenkins, born in 1592, also lived from the age of Elizabeth into the Restoration of the monarchy under Charles II, dying in 1678. Though still a court musician, he did not sever his spiritual and technical roots in Anglican vocal polyphony and was, as an instrumental composer for strings, as soberly English as Notari was Italianately eccentric. Yet the English and Italian veins ran parallel; interchange between them was still possible, as it was between Court and Country, Catholic and Puritan, and the religious and 'scientific' camps thrown up in those turbulent years. Nor was the apparent triumph of the secular age at the Restoration unqualified: as the music of its most distinguished creative talent, Henry Purcell, eloquently testifies.

From motet to madrigal

Our exploration of English music during the seventeenth century must start a little earlier, with Thomas Tallis (*c*.1505–85), who also embraced three (earlier) reigns and the Reformation. Already, in the thick of turmoil, he was racked by divisiveness which he resolved into serenity: especially in his (probably late) *Lamentations* wherein, combining traditional incantations on letters of the Hebrew alphabet with polyphonic settings of verses from Jeremiah, he called fallen man to repentence. In Part I the archaically severe phrygian modality – crudely imitated by playing the white notes on a piano from E up an octave – is swept from its moorings as it 'weeps' in the humanly passionate 'Plorans ploravit', attaining climax when the modality arrives at B flat, as far as possible from the initial E, since the two tones are a devilish tritone apart. In Part II the peoples' groans (*gementes*) and the bursting of the city's gates are enacted in harsh dissonances accruing from the simultaneous sounding of the minor and major third: a phenomenon (appropriately termed false relation) that itself sprang from a clash between two worlds – the old modal unity of plainchant and the new consciousness of harmony as alternating degrees of tension and relaxation existing in time. Even so, Tallis's anguish is not insupportable: the repeated note figure on 'convertere' does effect conversion, stabilising what had threatened to disrupt.

English sixteenth-century composers owed their progressiveness to the fact that they worked for a Reformed Church which modified Roman hegemony. Protestant creeds related the humanity of Christ to that of the common man; not surprisingly, Tallis and most composers of his generation sought for instant intelligibility and composed, alongside polyphonic masses and motets to Latin texts, anthems in English, in four-part homophony with a tune at the top: music appealing as directly to the heart of common humanity as did the New English Prayer Book itself.

William Byrd (1543–1623), the greatest composer of Shakespeare's day, was a pupil of Tallis, for whom he composed a noble threnody. Although he belongs chronologically more to the sixteenth than to the seventeenth century, it is impossible to differentiate sharply between the Elizabethan and the Jacobean ethos; and perhaps because he was the greatest composer of his time, it is Byrd more than anyone who looks forward as well as back. Unlike Tallis, he embraced every genre of music then conceivable: liturgical music to Latin and English texts, solo songs for voice and viols, madrigals, string

fancies, keyboard music for organs and virginals. There is dualism and conflict in both his life and art. Responsive to the multiplicity of modern life and occasionally litigious over material possessions, he none the less created music of which the heart is mystically serene. Ambiguity was inherent even in his religion, for although honoured by a Protestant Queen for his exceptional talents, he was a Catholic recusant who composed Latin ecclesiastical music for private chapels. Yet this music for the Old Faith is, paradoxically, often some of the most 'humanistically' expressive he created, as is manifest in its dense melodic-harmonic texture. In his own words:

> There is a certain hidden power in the thoughts underlaying the words themselves: so that as one meditates on the sacred words and constantly and seriously considers them, the right notes, in some inexplicable way, suggest themselves quite spontaneously, framed to the life of the words.

Though inspiration is God-given, this is an avowedly expressionist creed, which conditions both the details of the texture and the structural relationship of the parts to the whole.

Consider the Agnus Dei of the five-voiced Mass, which is the musical peak of the work, as it is of the Eucharist. This music is indubitably Elizabethan in that it was composed in the 1590s for a Catholic chapel; and its technical conception is Elizabethan in deriving from the kind of polyphony practised by Tallis. Even so, its effect is far from identical; and differs because the linear and harmonic, horizontal and vertical, relationships are more highly charged. The words are sung three (trinitarian) times, scored, respectively, for three, four and five voices; each statement rises in an arch, and subsides. Each added voice imparts a deeper plangency: melodic freedom generates density of harmony. In the setting of the words 'miserere nobis' acute suspended sevenths cadence, with a chromatic inflexion, in what we would call a chord of the dominant seventh. One could not pay Byrd higher tribute than to say that such effects of tragic pathos complement those in Shakespeare's final plays, such as the reanimation of Hermione's 'statue' in *The Winter's Tale*. Both deal with the peace that passeth understanding precisely because it is wrested from man's joys *and* sorrows, pleasure and pain. Whether or not one considers this prophetically Jacobean rather than Elizabethan in feeling is unimportant; what matters is that the alignment with Shakespeare discussed above implies a quality that is not evident in Tallis or any music of his generation. Byrd's temporal sense – his awareness of beginning, middle and end – allies him to the future, even from the heart of his conservatism.

Byrd's range of activity provides a link to younger Jacobean composers, notably Orlando Gibbons (1583–1625) who, although born forty years later than Byrd, outlived him by only two years. An anthem like 'O Lord, increase my faith' is texturally richer than the comparably 'chordal' Reformed Church pieces by Tallis or Tye, but it serves no less to make the human import of the words apprehensible to folk 'gathered together' throughout the parish churches of England. Powerfully impressive is the way in which the prevailingly homophonic texture, disturbed by only a few imitative 'points', blossoms at the multifold Amen into canonic inexorability. Traditional

modality is in abeyance, as it is in the more densely polyphonic but no less harmonically expressive anthem 'O Lord in thy wrath', penitentially concerned with the plight of us 'miserable offenders' rather than with the unknowable nature of God.

Modern man is, however, courageous enough not to be crippled by his awareness of human anguish; many English anthems celebrate a confidence inherited from Elizabethan days. Gibbons's seven-voiced 'Hosanna to the Son of David' uses counterpoint as a source of physical energy rather than of metaphysical grace. Although the consistently diatonic entries are independent, overlapping in stretto, they are harmonically organised in a simple oscillation of tonic and dominant. The upward thrusting fugal theme is borne on the metrical pulse of an earth-pounding dance, in 'modern' tonality, the occasional false relations at the climax serving to enhance excitation. By the time we reach the final cadence, after a stretto introduced by fortissimo basses, we recognise this as a paean to God's glory but no less as an act of homage to Man and to the beauty of the physical world.

Gibbons's Reformed Church music, being humanistic rather than mystical in bias, is not sharply differentiated from his secular vocal music, especially in a 'spiritual madrigal' such as his setting, in the 1612 collection, of Raleigh's 'What is our life?'. This fine poem, if philosophical rather than religious, is far removed from madrigalian convention. For two-thirds of its length Gibbons treats it in severely contrapuntal style, mirroring Raleigh's punning conceits on play acting and playing music, which seem illusorily to outwit death. But the text's reference to 'the graves that hide us from the searching sun' prompts Gibbons to a series of false related concords in block harmony – startling both because they bring us face to face with the dark inevitability of the grave, and because the word 'searching' imbues the sun (the source of life) with the attributes of a stern taskmaster and Last Judge. This emotive effect is not entirely effaced when, as the verse refers in another musical pun to 'our latest rest', Gibbons reinstates fugal order, for in context the implacably metrical fugato sounds stoic rather than spiritual: a tribute to human fortitude rather than a manifestation of God's grace.

One might say that English music during the seventeenth century was sparked between two opposite yet complementary poles: on the dexterous hand Elizabethan Exuberance, an optimistic awareness of human potential; on the sinister hand Jacobean Melancholy, an encroaching consciousness that man, without God's succour, must be, in Sir John Davies's phrase, 'a proud, and yet a wretched, thing'. Chronologically, the distinction is evident in the courts of Elizabeth and of James I: the former Reformist, expansive, forward-looking; the latter self-involved, intellectually tortuous, emotionally and sexually ambivalent, religiously confused by James's flirtings with the Old Faith and with occultism, and by his gloomy disaffection over the murder (as he saw it) of his Catholic mother. But 'exuberance' and 'melancholy' are not merely chronological distinctions; the two states, coexistent, were alike – reflections of the century's psychological cross-road. This is palpable in secular music: for if the madrigal – the secular complement to the motet – naturally stressed Elizabethan Exuberance as incarnate in dancing bodies, this was balanced by a deepening awareness of Jacobean Melancholy as

evident in harmonic tensions that – since a suspension needs a strong and a weak beat on which to be 'prepared' and 'resolved' – is itself dependent on the pendulum of Time. We cannot be vitally alive in nerves and sinews without also admitting to our pitiful ephemerality.

Queen Elizabeth claimed that she was half Italian, and 'sunny Italy' had long been the source of Renaissance man's celebration of his humanity. It was therefore natural that Italian influence should have conditioned the secularisation of Elizabethan music: a process encouraged by the dissemination in London of a collection of Italian madrigals under the title of *Musica Transalpina*, issued in 1588. Chiefly responsible for the vogue was the eupeptic Thomas Morley (1557–1602), most of whose music consists of light-weight, 'exuberantly' optimistic canzonets, dance-like balletts and other 'little-slight songes'. Yet is is typical of the age that this delight-affording composer could on occasion produce madrigals, such as the chromatic 'Deep Lamenting', of tender pathos, and that he should have composed some incipiently tragic penetential music for the Anglican Church.

A similar duality distinguishes the work of Thomas Weelkes (1576–1623), a more substantial composer, most of whose music was also written in the Elizabethan age. Yet if we remember that 'Elizabethan Exuberance' and 'Jacobean Melancholy' are complementary psychological states rather than chronological distinctions, we may find in Weelkes a composer who straddles the two eras. This is evident even in the fine – sometimes vigorously energetic, sometimes painfully pathetic – church music he composed for the Anglican rites when he was organist of Chichester Cathedral. Still more is it manifest in the secular music he published between 1598 and 1608, as we may see if we pair one very optimistic madrigal with another very melancholic madrigal. 'As Vesta was from Latmos Hill descending' pays tribute to a Queen both human and humane, if 'divine' in virginity. Pictorialism becomes action as the lines bound, with no trace of archaic modality, in cross rhythms. The piece begins as fun; we revel in the illustrative devices, which are stylised musical rhetoric parallel to the intellectual rhetoric savoured in the Bible of Renaissance courtiers, Sidney's *Astrophel and Stella*. Rhetoric and wit distance experience, which at the same time exists physically, in the musical moment. So fun is metamorphosed into Majesty – a homage to the monarch that suggests that the delight we take in being alive is due in part to the society she has fashioned and represents.

For such brave reliance on human resourcefulness there is a price to pay, audible in those madrigals of Weelkes which explore Jacobean Melancholy. In 'O Care, though wilt despatch me', especially its second part, the old fugal unity is scarcely operative; instead Weelkes exploits violent fluctuations between a series of chords, often connected by only a single chromatic alteration. Instead of flowing lines we have wailing fragments interlaced in alternating degrees of consonance and dissonance. Such dramatic startlement is, like the fun in Elizabethan Exuberance, in part a game, though gamesomeness does not diminish intensity. The vocal lament of the main line could be accompanied by instruments playing the other parts, as it was in the later madrigals of Monteverdi; the music's extravagant passion seems to demand bodily gestures, even mimed enactment on a stage. As passion is

thus 'bodied forth', a changed import is given to the cult of the Wailing Lover which Italian sonneteers and madrigalists had adapted from the medieval troubadour. Whereas the troubadour had identified his unattainable mistress with an Eternal Beloved often barely distinguishable from the Virgin Mary, the Renaissance lover wails the more wildly because his yearning is less fortified by religious sanctions. Of its nature earthly love hurts if rejected or, if accepted, disappoints. Mutable love and immutable death are the opposite sides of the same coin: hence the desperation which, in the crucible of art, may be momentarily if melancholically annealed.

The supreme achievements of the English madrigal occur when Elizabethan Exuberance and Jacobean Melancholy coalesce. Weelkes's 'Thule, the period of cosmography' is a six-voiced madrigal in two sections the verses of which deal with (geographical) exploration in the physical world, related to (psychological) discovery within the mind. Traditional imitative points make flying fishes audibly fly; to evoke more outrageous marvels of the physical world, such as volcanic eruption, contrary motion chromatics, sundering tonal roots, make the music blow itself up. Yet the refrain, centring this whirligig on the sex-death paradox of the Petrarchan frying and freezing lover, comes through to a major apotheosis; the music, at once scary and hilarious, acts therapeutically in reconciling opposite poles of experience. Similarly, 'Hark, all ye lovely saints above' is merrily blasphemous in using traditional counterpoint to equate sex and death – our – alpha and omega – with love and war. The 'saints' gambol in cross-rhythms between 3/2 and 6/4; the more conventional counterpoint for the 'fa la la' refrain is gentle, since it doesn't debunk sexual delight but merely admits that it must be transitory.

The feeling here, however jolly, is stoic rather than Christian. Passion and sobriety meet in a way we may relate to the elegiac poetry of Ben Jonson – to which both words and music of Gibbons's famous choral ayre 'The silver swan' are akin: 'more geese than swans now live, more fools than wise'. The two greatest late Jacobean madrigalists, John Ward (1571–1638) and John Wilbye (1574–1638), likewise incline to be valetudinarian, excelling in dark-hued madrigals in five or six parts. Both lived retired lives on country estates, Ward in the service of Sir Henry Fanshawe, where he mingled with Italian-speaking poets, Wilbye as household musician to the Kitson family at Hengrave Hall, near Bury St Edmunds. Neither composer wrote, or at least published, much music, and that mostly vocal and secular. Their manner is rich and grave, as they seek stability, even peace, in the very act of parrying the slings and arrows of a fortune that can be relied upon to be outrageous. Ward's 'Hope of my heart' explores the conceit of a hope that is hopeless yet becomes, as ripely scored polyphony 'thunders forth disdain' in dotted rhythm, a paradoxical affirmation. In the even finer 'Out from the vale of deep despair' anguish intensifies until, on the word 'cruelty', chords of C minor and B flat major are dissonantly telescoped, sounding six degrees of the scale simultaneously. Again the ripe texture, like that of seventeenth century string music, becomes a positive value.

In setting Arcadian poets like Sidney and Drayton, Ward thus darkened the pastoral paradise with retrospection and tautened it with introspection.

Rhetorical devices acquire purely musical momentum: as when, in 'There's not a grove', falling scales, overlapping, metamorphose tears into 'showres', effecting an earth-watering consummation that inverts or, rather, reveals the deeper implications of the verbal meaning. A comparable equilibrium between old and new distinguishes Ward's fine, mostly unpublished music for string consort and his few but remarkable works for the Anglican church. Only his contemporary John Wilbye can rival him in thus rendering regression progressive. Wilbye's output is even more exiguous – two books of madrigals, plus a little discreet string music for domestic use and two hymns for his patron's private chapel. Yet despite or because of his insularity, Wilbye developed traditional polyphony to untraditional ends, as is evident in his most famous piece, the six-voiced 'Draw on, sweet night'.

The core of this madrigal is no longer the continuous growth of line in all the voices; rather it falls into three sections grouped according to key relationships, our modern major and minor scales being precipitated out of vocal modality. The first section ends with a modulation to the dominant, as in an eighteenth century sonata: an excitation prompted by piled up dissonant suspensions that aurally enact the words 'pain and melancholy'. An abrupt change from major to minor occurs when the text shifts from contemplation of night and nature to self-dramatizing awareness of the self: '*my* life so ill for want of comfort fares'; the sequential passages that follow have something in common with a sonata development. A modified recapitulation revives the D major serenity of the opening, though triple suspensions now remind us of the painful dichotomy between the self and the natural world. The final cadence envelops us in night, which is also death as release from the pain of consciousness. The modernity of Wilbye's technique is thus his way of dealing with human isolation – we would call it alienation – and with the possibility of *developing* experience: whence his vestigial sonata form. Working at a time when values were increasingly threatened and confused, Wilbye anticipated crises of belief and unbelief under which we still labour. His is the serenity of disillusion; the resolution this madrigal wins through to seeks no succour from God or the gods.

Jacobean music for organ and virginals

Both Ward and Wilbye lived until 1638, though Wilbye's madrigals were published in 1598 and 1609, and Ward's collection no later than 1613. None the less, composers of paradox in a paradoxical world, they were forward-looking in their very retrospection; and we have noted that in 'Draw on, sweet night' Wilbye created a remarkable harbinger of future musical and psychological events. The most *ostensibly* progressive composers of the first half of the seventeenth century, however, tended to specialise not in vocal music but in instrumental music for keyboards, which of their nature encourage both harmonic experiment and figurative excitation. The organ, though an ecclesiastical instrument well adapted to polyphony, can sustain dissonances more easily than can voices. The virginals – an English version of the mechanised lute which all instruments of the harpsichord family

amount to – can define percussive dance rhythms, sustain harmoniC textures
in broken chords, and revel in acrobatic passage-work. Its exhibitionistic
qualities accord with music's secularisation; it is not surprising therefore that
the Jacobeans produced a school of keyboard composers not notably inferior
to their vocal masters.

The two major figures, Byrd and Gibbons, were equally skilled in vocal
and instrumental fields, and their keyboard music showed the closest links
with traditional vocal practice. They excelled in fancies (in English) or
fantasias (in Italian), the term implying that the form wanders where the
fancy lists, as though the player-composer were dealing in free fugato with
successive phrases of an unstated text. Both form and idiom were rooted in
vocal models, though instrumentation provoked a higher proportion of
dissonance and livelier figuration, through which fleet fingers capered at the
behest of sprightly wits and overburdened hearts. Gibbons's noble aeolian
'Fantazia of foure parts', especially if played on organ, remains vocally
orientated even in its false relations, while the liltingly syncopated entries of
the penultimate section give way to a canonic peroration on the ecclesiastical
cliché of rising fourth followed by descending scale in dotted rhythm. A
powerful 'Fancy in Gamut Flatt' (G minor), on the other hand, opens with a
theme based on a tense diminished fourth and translates traditional modality
into cadence-punctuated diatonicism, with animated rhythms and jazzily
elliptical imitative points. Ecclesiastical polyphony has been discreetly
theatricalised.

A technical manifestation of the 'between worlds' status of Jacobean music
is the ambiguity of its tonality. Fancies, pavanes, galliards and other dances
were often described as being 'in A minor', D minor, or G minor or, rather
less frequently, in C, G or D major. Those in A minor were in fact in the
aeolian mode compromised, especially in cadences, by 'modern' harmonic
processes; D and G minor survived as flat modal transpositions such as
occurred in sixteenth century polyphony. Pieces that seem to be in our
modern C major were really in the Ionian mode: which appeared rather more
frequently transposed up a fifth to G major, the most favoured 'optimistic'
key, or more rarely up a further fifth to D major. Gibbons in his keyboard
music adhered consistently to this tonal hierarchy.

As we might expect from his fantasias, he favoured dance forms capable of
spacious evolution. His pavanes and galliards no longer pretend to have
functional purpose as music for moving to. With him, these most important
of Renaissance dances, one in slow duple time, the other in more vigorous
triple measure, become 'absolute' instrumental forms in three strains, the
second usually in what we would call the relative major to the initial modal
minor, each strain being repeated with 'divisions' (or ornamental
elaborations) in shorter note values. Pavanes and galliards, usually in
thematically related pairs, may amount to substantial, often great, music; and
this is no accident in view of the Renaissance philosophy of dance, which
found in the art a vision of order man-made. The finest pieces tend to be
melancholic, the communal ceremony of dance controlling personal passion
that might otherwise be destructive. Gibbons's well-known 'Pavane for the
Earle of Salisbury' is a magnificent example, combining traditional polyphony

(especially in the stretto canons at the end) with richly spaced harmony and, in the repeats, incipiently polyphonic ornamentation.

Even when Gibbons adopted the popular rather than courtly convention of variations on rural folk songs or urban popular tunes he created music which – in for instance his 'Hunts up' variations – is a marvel of contrapuntal ingenuity, harmonic subtlety and decorative excitation. Byrd, in his great 'Walsingham' variations on a love song that is also a song of religious pilgrimage, likewise sundered barriers between the popular and the esoteric. Even Giles Farnaby, in his lengthy and difficult variations on 'Woodycock', found in popular rural and urban music occasion for adventures in harmony, metrical proportion, sonority and figuration of some sophistication; while in his brief set on the urban 'Pawles Wharfe' he dignified the low with scraps of ecclesiastical fugato and intensified it with vocally derived false relations.

Giles Farnaby (1563?–1640), a minor composer whose music is as lovely as his name, is a fascinating figure in the Jacobean scene. It is to the point that little should be known of him except that he was buried in London in 1640; the unreliable Anthony à Wood's report that he came of Cornish stock is not substantiated. Though he had degrees in music from 'both the Universities', he made only a slight contribution to the central traditions of English vocal music. As a technically able amateur musician (by trade a joiner), he favoured his own instrument the virginals, composing for it brief autobiographical character-pieces that have distinctive personality. 'His dreame', 'His rest' and 'His conceite' suggest a man of child-like simplicity, though 'His Humour' (the term being used in its seventeenth century sense) reveals a mind of mercurial complexity, now rhythmically witty, now chromatically melancholy, now canonically devotional. Such subtlety beguiles; yet the music still recalls the folk songs to which Farnaby spontaneously responded.

When he employed the old form of the keyboard fancy, counterpoint proved little more than a gesture. With him more than any composer the fancy has become fanciful: an open form responsive to whim or dream. His mixolydian G major Fancy (no. 5 in the Musica Britannica edition) has a smiling, diatonic major theme which is gradually enveloped in impressionistic decoration, flows through passing notes in tingling false relation; is trans-formed into a triple rhythmed dance; and ends in slightly tipsy rapture a fifth higher, in or on D major. If Farnaby is by origin a West Country man we may detect an analogy with the poet Herrick, who likewise combined a folk-like, even child-like, rurality with courtly sophistication. Significantly enough, when Farnaby produced little dances which he called Masque, presumably implying a reference to court entertainment, they were still characterised by a folk-song-like fragrance.

Ambiguities between worlds old and new, manifest in the keyboard music of Byrd, Gibbons and Farnaby, are more extravagantly evident in the work of John Bull (1563–1628), whose character and music belie his name, for nothing could be more remote from the stocky, rubicund John Bull of eighteenth-century convention. The Jacobean Bull – to judge from the portrait in the Oxford Faculty of Music – was long, lean, pale, fiery-eyed, on familiar terms with the skull and hourglass in the background: which have

Robert Hatley, virginal, in Fenton House, Hampstead, London (1664).

hermetic as well as mortuary import. During his youth he composed
Anglican church music in fulfilment of ecclesiastical duties, but he owed his
later celebrity to his keyboard music. On the continent he acquired a
reputation legendary alike for learning and for virtuosity. There are
apocryphal stories about his adding forty new parts to a motet at sight
(thereby outbidding Tallis's notorious forty-part *Spem in alium*); and about
congregations in foreign churches falling to their knees as one man,
exclaiming, as he improvised incognito, 'it must be the Devil or John Bull'.

The mystery surrounding Bull was not restricted to his musical prowess.
Though honoured by the Queen as first Gresham Professor of Music, he was
a Catholic recusant who in 1613 fled the country to live in the Low
Countries, dying in Antwerp in 1628. According to his own account he was
self-exiled because of his religion; but the Establishment's view was that he
was obliged to abscond because of his 'incontinence, fornication, adultery and
other grievous crimes'; the Archbishop, in punning indecorum, considered
that he had 'more music than honesty' and was 'as famous for marring of
virginities as for fingering of Organs and Virginals'. The parallel with the
poet Donne is striking. Both were half rake and half divine, men of profound
traditional learning who were also empiricists and adventurers. The oft-
quoted lines of Donne are as pertinent to the composer as to the poet:

> And new Philosophy calls all in doubt,
> The Element of Fire is quite put out;
> The Sun is lost, and th'Earth, and no man's wit
> Can well direct him where to looke for it . . .
> 'Tis all in peeces, all cohaerance gone. 'The First Anniversary'

Yet the collapse of traditional values did not, with Bull any more than with Donne, lead to despair. Unlike inactive Hamlet, or the villain-heroes of John Webster who die 'in a mist', their souls driven they 'know not whither', Bull takes arms against his sea of troubles. This is audible in the extravagance of his music.

Extravagance is patent no less in organ pieces that may have ecclesiastical associations than in secular works for harpsichord. The famous aeolian *In Nomine* 'in 11 4 time' is one of the most astonishing keyboard works in history. It has an archaic basis in starting from the plainchant *In Nomine* as cantus firmus: over which flow long imitative lines deriving from the ecclesiastical formula of rising fourth or fifth succeeded by a declining scale. At first the cantus firmus acts as a drone, and the modal lines sound unmeasured. Gradually, keyboard figuration floats into sensuous coruscations of parallel thirds; 'scholastically' inspired cross-metres turn into physical excitement; chromatic inner parts and flickering false relations impart a flush. Tonality shifts bodily to keys a tone or a third apart, until the liturgical solemnity of the *In Nomine* has been alchemised into an earthy, elaborately syncopated dance in triple rhythm. The piece's fusion of funerary grandeur with mordant fantasticality resembles the prose of Donne's sermons.

That reference to alchemy is pointed, for Bull was interested in Paracelsian chemistry as well as astrology and other hermetic arts. One might also say that Bull's late, *Art of Fugue*-like canons amount to a *demonstratio* of the acoustical-alchemical 'microcosm of the World' of the Rosicrucian Robert Fludd, whose mind-boggling treatises (many published in the Low Countries after Bull had settled there) overrode distinctions not only between Catholic, Protestant and Calvinist, but also between these creeds and Persian and Cabbalistic cults: along with numerology, astrology, palmistry, alchemy, medicine, and more modern sciences. Bull's puzzle-canon labelled *Sphera Mundi* closely resembles Fludd's emblematic illustrations to his books, and musically, as well as intellectually, Bull's canons must have bolstered his reputation for superhuman powers. Clearly the man who made them might presumptively be the New Messiah, Elias Artifax, 'the Renewer of all Arts and Sciences and the Renovator of the World' who metamorphosed the Christian redeemer into then modern scientific terms. The artist-magician-scientist-priest was to become the arbitrator of a new, humanistically biassed society: as Fludd demonstrated in his theoretical writings about everything under and beyond the sun, and as Bull manifested in his music – sometimes sublimely, as in the 'A minor' *In Nomine*, and more commonly weirdly, as in his Hexachord fancies. These experiments, not merely in chromaticism but also in enharmony and possibly in equal temperament, hint at necromancy in that the 'tempering' (an alchemical metaphor) of *just* intonation is a Fall from tonal grace into dis-grace. But for this Fall the history of Western harmonic music would have been inconceivable: so there is a parallel between this musical phenomenon and Milton's fallen angel Satan, who is villain but also hero, and his Eve, a sinful apple-plucking female who is also a redeemer.

The effect of this paradox on Bull's music is understandably violent. Tonal adventure cannot be readily adjusted to the mathematically pre-ordained order of the medieval *cantus firmus*. Within the ecclesiastically rigorous

frame of the six-note rising scale or Hexachord, harmony, modulating through each chromatic degree, becomes licentious and form amorphous. When Bull puns on the melodic and harmonic identity of two tones, 'unjustly' equating F sharp with G flat, we may compare the effect to the puns in Donne's devotional poetry. Blasphemous wit and tragic passion coexist; as they also may in pieces that are mainly rhythmic rather than harmonic in impetus, such as the ninth *In Nomine*, which plays games with metrical puzzles, originally scholastic, but alchemised into corporeal physicality. The syncopation is patently jazzy, while on occasion the reiterated patterns sound like today's 'process' music.

Bull's large-scale pavanes and galliards call for the harpsichord rather than the smaller virginals. Those written after he'd left England may have been conceived for such an instrument, though one cannot assume that such is the case, since the superb *Pavana Dolorosa* by another Antwerp-exiled English recusant, Peter Philips (1560–1628), was certainly composed during his youth, while languishing in an English prison. Bull's pavanes are the equals of Philips', alike in passion and in dolour; one might even claim that his *Queen Elizabeth's Pavane*, composed as a funerary tribute, is the greatest instrumental example of synthesis between Elizabethan Exuberance and Jacobean Melancholy, as befits the subject. The span of the melody is grand, the chromatic harmony of the second strain thrilling, the metrical intricacies of the third stimulating, the notated ornamentation in the repeats richly sustained.

As a composer of variations Bull could on occasion produce works as touching in their simplicity as Farnaby's: for instance, 'Why aske you', in which he allows the tune to speak for itself. On the other hand he may more or less dispense with a tune, as in the celebrated 'King's Hunt', an exercise in advanced keyboard technique, with broken chords, whirring scales and jazzy syncopations. This piece is in diatonic G major, and although written for James I is a supreme example of Elizabethan exuberance. But the greatest of Bull's variations fuse, as do his noblest pavanes and galliards, old modality with new tonality – most notably in his immense set on 'Walsingham' which, even more than Byrd's set on this sacred-profane tune, is a locus classicus of early seventeenth century keyboard technique. The melody is aeolian, and Bull equivocates between its linear modality and the major triad apotheosis in the cadences. Survivals of contrapuntal practice lurk in canonic inner parts, interchanging with batteries of broken chords, scales in contrary motion, hammered repeated notes and whirling arpeggios. Spirit and flesh coexist, in Bull's sophisticated composition no less than in the folk song itself. As Sir Thomas Browne put it:

> Man is an Amphibian, living in distinguished and divided worlds.
> The secret and symbolicall unit is the Harmonicall nature of the Soul.

There is a sociological as well as philosophical aspect of this in that Bull's 'Walsingham' is a learned, even hermetic piece performable only by experts, though the tune would have been recognised by the man in the street or on the village green. Allied to this is the fact that Bull, despite his abstruse intellect and complex passions, was also capable of a tender or humorous

intimacy. His short dances sometimes have the memorability of Farnaby's: as we may hear in *his* autobiographical group, 'Me Selfe,' 'My Jewel', 'My Griefe', and 'Bull's Goodnight'. The simple, balanced melody of the Goodnight is unforgettable, in the composer's radiant G major. Most of the tunes are diatonic major, though sometimes Bull, like Farnaby and the Beatles, exploits primitive shifts between keys a tone apart, with an effect at once innocent and startling.

In these technically rudimentary little pieces the formidable Dr Bull seems insular, even provincial. Yet he consorted with the great ones of the world, wrote courtly music of majestic sweep, and produced intellectual puzzle-pieces way beyond the common touch – quite apart from the fact that his most typical music is removed from 'the people' by reason of its extreme (whether thrilling or tiresome) virtuosity. Though not the greatest composer of the first half of our seventeenth century, Bull might claim to be, in his amorphousness, the most prophetic of the (confused) shape of things to come.

Lute, ayre, and consort music for strings

Folk song variations testify to the stability of a society, for the tunes are the people's, while their treatment may be sophisticated. Such parity between classes of people and levels of experience perhaps couldn't be long sustained, any more than could Byrd's equilibrium between the Divine and the Civic. Soon man, dressed in a little brief authority, would prove subject to the vagaries of whim and caprice; and the daydreams in which a Farnaby delighted might turn – as some of Bull's music demonstrates – into night-mares. Shakespeare's Hamlet, veering between Renaissance reason and real or assumed lunacy, is an archetypal figure: a hero-villain whose problems hinge on conflict between an inherited Christian ethic and the individual's need to take the law into his own hands, arrogating to himself duties that properly belong to God. Hamlet does not resolve the dilemma; but Shakespeare does, in the sequence of his plays from *King Lear* onwards. I hinted that something similar might be said of the mature church music of Byrd. Certainly there is another composer who in this respect parallels Shakespeare; by coincidence he was for some years court musician at Hamlet's court at Elsinore.

John Dowland's dates (1563–1626) are close to those of Bull. He too was a Renaissance loner, not because as player-composer on keyboards he operated a one-man band, but because he carried his lute with him, and sang to its accompaniment. Though a popular instrument because it was portable, the Renaissance lute was also capable of the utmost refinement since its strings were beneath the player's fingers, which were controlled by his agile mind and sensitive heart. Lute composers explored every genre, from short dances to monumental pavanes and galliards, from folk song variations to polyphonic fantasies. Such were Dowland's arts of persuasion, through haunting melody, expressive harmony and virtuosic figuration, that he was known as 'the English Orpheus'. Even his little dances, 'Nothings' or 'Puffes' dedicated to noble or merely rich ladies, are domestic music distinguished by a wit that

John Dowland, signature and 'musical point' from Johannes Cellarius's Album Amicorum.

transcends function; while his large-scale dances, such as the 'Mellancholly Galliard' or the autobiographical 'Semper Dowland, semper dolens', are as majestic as they are passionate.

Personally, Dowland seems to have been a sanguine, even happy man; if we none the less think of his music as prevailingly melancholic, we must define melancholy in its seventeenth century connotations. Robert Burton's *Anatomy of Melancholy* – first published in 1621 and reissued several times during the century – may seem a gallimaufry of primitive magic, outmoded theological lore and modern pseudo-science. Yet is was intended as a serious study in social psychology: for melancholy was regarded as a medical condition, an imbalance of the humours, astrologically ordered by the planets but aggravated by pernicious social factors. From the academic fastness of Oxford Burton wrote his enthralling book to suggest practical alleviations of the consequences of the criminal imbecilities of which man, since the Fall, was guilty. However quirky, his book was Baconian in intent: an attempt to leaven man's irrationality with common sense, his credulity with sceptical open-mindedness, especially in matters of religion. Of all man's criminal imbecilities war – especially war provoked by theological dissension over matters that, in the light of reason, can only be deemed trivial – is the most flagrant. Writing while storm-clouds gathered, Burton did what he could to promote decency; and had no doubt that the 'chiefest aid' to that end was 'musick, instrumental, vocal, with strings etc. . . . so powerful a thing that it ravisheth the soul, helps, elevates, extends it'.

Nothing reveals the therapeutic powers of music more wondrously than Dowland's twin polyphonic fantasies, 'Forlorne hope' and 'Farewell'. Both are harmonically plangent, for the theme contrapuntally imitated is a chromatic scale, descending in the former, ascending in the latter. The chromatic descent droops through a fourth: an inversion of God's interval of the perfect fifth, which had acquired its divine connotations by way of medieval and Renaissance Platonism. The falling fourth 'represents' man's declension from kinship with God to Shakespeare's 'muddy vesture of decay'; because the descent is chromatic, it effects painful dissonances, obliterating the lucidity of quasi-vocal modality, the more so as the range lowers. At the unlucky thirteenth entry the music slows to crotchets, each a chromatic wail, sinking to tenebrous depths. Having reached bottom, battered man desperately rallies, for the final stretch of the fancy explodes in virtuosity, the chromatics flickering in scales and roulades. The extreme difficulty of the music is part of the point, exhibitionistically mirroring the follies and foibles of the world while paying homage to human courage. The piece's chromaticism proves not totally destructive of order, while its arcane number symbolism Platonically places man's ephemeral fallibility in the context of God's eternal infallibility.

If 'Forlorne hope' is 'about' submission to the mire and the desperation that induces, 'Farewell' concerns the possibility of redemption. Since the theme is still a chromatic scale, it too is harmonically emotive; but since the scale in this case rises, it balances the 'forlorne' hope with hope that is purgatorial. There are fourteen statements of the motif, in number symbolism a double spiral that signifies rebirth; the imitative points finally

find rest, after dissonantly grinding suspensions, in mellifluous warmth and profound calm. The piece is called 'Farewell' not in melancholy valediction but in a literal sense. Saying goodbye to the world, Dowland musically demonstrates how man – the more so when aware of the contagion of world, flesh and devil – must lose himself to find himself. This is *how* we may Fare Well.

Supreme as lutanist-composer, Dowland was no less esteemed as a composer of solo songs with lute accompaniment, such as had proliferated throughout the sixteenth century in France, Italy, Germany and Spain. Since as a young man he travelled widely in Europe, he must have had direct contact with these musics; several European traditions meet and are anglicised in the four volumes of ayres to the lute which Dowland published between 1597 and 1612. All the volumes – except the second which seems (fortuitously?) to have garnered an extra song – contain twenty-one numbers, twenty-one being three times seven, both magic numbers, and seven the omega of existence, the 'divine seal' upon earthly things, manifest in the seven days of the week, the seven planets, the seven sacraments of the Church, even the seven deadly sins which, since the Fall, are a gateway to rebirth. At once human and divine, Dowland's ayres justify Castiglione's comparison of the singer-composer to Orpheus, servant of 'a higher authority and power'. A Jacobean ayre sublimates speech into song, words into music. The text – often by good, sometimes by great, poets – offers a complex intellectual argument whereby the distresses of the flesh may be disciplined; mind and body reach equipoise, often in the communal rhythm of a dance.

Three stages in the dance-song may be identified with numbers from the first book. 'If my complaints could passions move' was originally an instrumental dance dedicated to the piratical Captain Digory Piper. The words describe the lover's conventional distress, which is annealed in the swinging rhythm and soaring tune; social song and dance assuage the state of fallen man. In 'Can she excuse my wrongs?' the ego more consciously hits back at grief, for animated cross-rhythms typical of a danced galliard – the piece exists in instrumental form as the Earl of Essex's Galliard – seem to spring from, and to wrest affirmation out of, the words' apparent negation. Then in 'Now, O now we needs must part' we have a song of true love, maimed by inevitable separation – the lovers will eventually be parted by death, if not prematurely by fortune's malice – yet creating out of pain one of the most heart-easing tunes even Dowland ever wrote.

Dowland's second book of ayres, published in 1600, turns inward to face the grief inherent not merely in loving a mortal woman, but in being humanly mutable. In this volume we encounter Dowland's most famous song, 'Flow my teares'. The melody is based on the same falling fourth as characterises 'Forlorne hope', though it is not chromaticised. The phrase audibly incarnates the tear, which droops through the fourth, swells through an aspiring sixth, bursts, and descends with the weight of human sorrow, the effect being at once passion-rent and majestic. Complementarily, the plangent lute harmony is stabilised in the rhythm of a dance, for the song is a pavane in three strains, each with ornamented repeat. No wonder the song, under the generic title of *Lacrimae*, became a synonym for the quasi-religious

transcendence of the private grief to which man, facing the dark alone, had committed himself; it was arranged for every resource then conceivable, and is copiously referred to throughout contemporary literature, both élitist and popular.

Dowland's third volume, published in 1603, is not so much about the anguish of specific lovers as about the relationship between grief and time. 'Time can abate the terror of every common pain', sings one of the beautiful fountain songs, 'But common grief is error, true grief will still remain'. Accepting this, tears become wellsprings of consolation, and the exquisite 'dropping' refrain seems – like the (contemporary) fountain in Trinity Great Court, Cambridge – to annihilate time itself. This purgatorial theme becomes explicit in Dowland's fourth book, published in 1612 under the significant title of *A Pilgrimes Solace*. Here songs of love and time merge into religious themes, as 'In sin sore wounded'. These ayres differ from orthodox Jacobean devotional music in that in them a solo voice – an I – sings of belief and unbelief, lacerated by guilt. Religious experience has turned inwards; though the vocal line moves traditionally by step, it is often agitated by repeated notes, while the lute part, more polyphonically independent than in earlier books, none the less groans in false related thirds. A divine and a human view of the world are locked in tension, as they are in Donne's devotional sonnets.

Post-Renaissance eroticism, Platonic transcendence, and Christian abnegation meet in Dowland's mature work, and nowhere more powerfully than in the single song that consummates his achievement. 'In darkness let me dwelle' was not published by Dowland himself but as a contribution to an anthology collated in 1610 by his son Robert, under the title of *A Musicall Banquet*. No longer strophic but through-composed, 'In darknesse' rivals the *Lacrimae* in introspective ardour and in its climactic use of the interval of falling fourth. Slowly the vocal line emerges from a long sustained tone, *de profundis*, its arch being pointed by expressive dissonances in the polyphonically conceived lute part. Augmented fifths, chromatics and false relations intimate, perhaps imitate, 'hell's jarring sounds', until at its apex the melody topples down in fourths, perfect and imperfect (C to G sharp). Yet although human fortitude may seem to triumph, in this Italianate declamation, over a religious heritage, the song is also Orphically purgatorial. In music that complements the melancholy of Hamlet and the personal love poetry of Donne, the tomb becomes a womb; accepting darkness, being half in love with easeful death, proving a paradoxical gateway to life. After the (unusual) lute postlude has returned us to the depths we started from, the voice whispers its opening phrase, its penultimate note still more lovingly sustained over the dissonant major seventh until it fades into silence, awaiting the release of death. The frustrated resolution is a kind of realism: the song ends, dramatically, on an unanswered question – when will the cadence be completed, the axe fall?

'In darknesse let me dwelle' is a Platonic-Christian threnody on fallen man, and as such is the most distinguished contribution to a Jacobean genre: the song of mourning which, though usually addressed to a specific Great Person, was also of universal significance. The finest examples are Coperario's (1575?–1626) *Funeral Teares* of 1606, and his *Songes of Mourning*, composed

in 1612 in memory of Henry Frederick, Prince of Wales, son of James I and
Queen Anne: an apple of his parents' and everyone's eye who expired at the
age of eighteen. In the earlier, more personalised songs vocal line is
intimately 'framed to the life of the words'; as the experience is universalised,
declamation expands into more impassioned melody, climaxing in the
magnificent penultimate song, 'To the most Disconsolate Great Britain'.
Tears become emblems of purgation, in quasi-liturgical lament.

Giovanni Coperario – really John Cooper, Italianised at the behest of
fashion – naturally embraced a magical seven songs in each of his funeral
cycles. Such emblematical concepts bear on English conservatism, which
in turn relates to our partiality for 'old-fashioned' string music for viols,
usually in the retrospective form of the polyphonic fantasy. The basic
consort of viols (treble, alto, tenor, bass) approximated to the ranges of the
human voice, and Jacobean madrigals were often described as being 'apt for
voices or violes'. The voices could be instrumentally doubled, or viols could
be substituted for voices; if this happened in all the parts an instrumental
fancy resulted. More commonly instrumental polyphony was created *sui
generis*, modifying vocal principles. Gibbons, Ward and Wilbye, whose
weightier madrigals are especially effective with instrumental doubling, all
composed purely instrumental fancies, and Ward and Wilbye played in string
consorts for and with their aristocratic patrons. Coperario himself concentrated
mainly on consort music for strings; Ferrabosco 'the younger' (1575?–1628)
produced a fair crop of motets and madrigals in the tradition of his father,
but found his most congenial medium in the string fantasia, which evolved
from imitative points in fugato, like a wordless motet.

This string tradition is our music's unbroken lifeline throughout the
tormented century. Even when Coperario, as in 'Chi pure miravi',
instrumentally reworks an Italian madrigal, he handles polyphonically
induced dissonance with a mastery that sounds idiomatically instrumental –
and English. Ferrabosco was, unlike Coperario, of genuine Italian stock,
though born in London; his big five- and six-part fancies seem genuinely to
transcend vocal technique, freeing the spirit as they liberate the lines from the
burden of words. The effect of such music is described by Thomas Mace
who in 1676, after the War, nostalgically offered his book, *Musick's
Monument: a Remembrancer of the best Practicall Musick, Divine and Civill,
that has ever been known to have been in the World*. In those golden old days

[we] had for our grave Musick Fancies of 3, 4, 5 and 6 parts to the Organs,
interposed now and then with some pavans, Allmaines, solemn and sweet-delightfull
aires, all of which were, as it were, so many Patheticall Stories, rhetoricall and
sublime Discourses, subtle and acute Argumentations, so suitable and agreeing to the
Inward, secret and intellectual Faculties of the Soul and mind that to sett them forth
according to their true praise there are no words sufficient in Language; yet what I
can best speak of them shall be to say that they have been to myself, and many others,
as Divine Raptures, powerfully captivating all our unruly Faculties and Affections for
the time, and disposing us to solidity, Gravity, and a Good Temper, making us
capable of Heavenly and Divine Influences.

Since the essence of sixteenth- and seventeenth-century compositional
technique is an equilibrium between voice and dance, related to, if not
identified with, spirit and flesh, it is not surprising that Jacobean composers

WHILE I lay bathed in my natiue blood,
 And yeelded nought faue harfh, & hellifh foundes :
And faue from Heauen, I had no hope of good,
Thou pittiedft (Dread Soueraigne) my woundes,
 Repair'dft my ruine, and with Ivorie key,
 Didft tune my ftringes, that flackt or broken lay.

Now fince I breathed by thy Roiall hand,
And found my concord, by fo fmooth a tuch,
I giue the world abroade to vnderftand,
Ne're was the mufick of old Orpheus fuch,
 As that I make, by meane (Deare Lord) of thee,
 From difcord drawne, to fweeteft vnitie.

Harp emblem, from Henry Peacham's emblem book Minerva Britanna *(1612).*

should have produced 'civic' dance music hardly less 'divine' than their polyphony; Ferrabosco's 'Dove house Pavan' and 'Four note Pavan' are superb instances. Polyphony and dance likewise coexist in Dowland's consort work, *Lacrimae*, or 'Seaven Teares figured in Seaven Passsionate Pavans, sett forth for the lute, viols, or Violons, in five parts', and published in 1604. This is based on the famous 'Flow my teares', the descending fourth of which introduces each number. There are (of course) seven magical movements, and the work is both emblematic and metamorphosic since the pavanes effect a spiritual evolution. The first, *Lacrimae Antiquae*, is a fairly straightforward transcription of the song, sounding yet more elegiac on the dark-hued viols and twanging lute, which has an independent part. *Lacrimae Antiquae Novae* dissolves the song into more flowing polyphony, proving that spent tears may, phoenix-like, be renewed and renewing. *Lacrimae Gementes* reveals latent drama by turning the broken phrases of the song's second strain into audible groans. *Lacrimae Tristes*, the centre- piece, is more homophonic, fluctuating triads suggesting the human pathos of love's tears. The last three pavanes enact a purgatorial process. *Lacrimae Coactae* is rhythmically more animated, its harmonic tension accruing *from* its more complex polyphony; *Lacrimae Amantis* initiates the sublimation of pain and passion, sometimes inverting the falling fourth into upward aspiration. This inversion is consumated in the final *Lacrimae Verae*, which reveals Truth as we enter the metaphysical seventh heaven; tears 'burst smilingly', as they do in *King Lear*. Dowland points out in his Preface that

although the title doth promise teares, yet pleasant are the teares that musick weepes, neither are teares always shed in sorrow, but sometimes in joy and gladnesse.

Dowland's pavanes and Ferrabosco's string fancies are instrumental music that remains domestic and, in a Platonic sense, religious. Later, such retrospective music will prove unexpectedly progressive; in the first half of the century, however, string consort music represented the old guard, while another kind of instrumental music stood for fashionable modernity. Associated with dance as a formalising principle, this had manifestations both high and low, the levels being interconnected, as they were in the keyboard music of Farnaby or Bull.

Masque and the post-Renaissance philosophy of dance

People have always danced, and did so vigorously in the Middle Ages. Then, however, 'serious' music was almost exclusively associated with worship, whether of God or of an Eternal Beloved, while dance music was merely functional, a racket for moving to. So much was this the case that dance tunes, usually monophonic, were seldom written down, being 'occasional' music, here today and gone tomorrow. With the Renaissance, dance music became relevant to 'serious' music because it was a social and artistic principle. At the 'low' level the growing importance of dance had social causes and economic consequences; the music was notated and published because it answered the needs of a prospering urban middle class, affording

pleasure at home and enlivenment at civic junketings. Sometimes the music consisted of 'easy' arrangements – comfortable to play and simple to dance to – of chansons or madrigals that had become popular hits; more frequently dances were composed especially for the collections. Often the tunes were modal, consciously or unconsciously recalling real rural tunes. Gradually, however, tunes in tHe Ionian mode, identical with our diatonic major scale, prevailed because of their cadential possibilities. Instruments were seldom specified, though viols, violins and lutes formed a basic choir, often used antiphonally (in separate groups) or in interaction with choirs of recorders, crumhorns and dulcians; lacking instruments, the tunes could be sung. Brass was used by waits, in civic contexts; improvised percussion appeared as occasion offered.

Although these dances were usually frivolous since their purpose was to while away empty time, they may still – 'art' and 'entertainment' not yet being separate categories – gravitate to solemnity, even profundity. Popular urban tunes such as 'Pawles Wharfe', 'Tower Hill' and 'Gray's Inn' exist in many versions for viols, violins, lutes, citterns and recorders; Farnaby's settings of them for keyboard were 'short scores' convenient to use at home. Rural dances like 'Woodycock' melded with ballads like 'Callino Casturame', 'Fortune my foe' and the ubiquitous 'Greensleeves', and were vigorous enough to survive through the Puritan interregnum. Robert Burton, in his *Anatomy of Melancholy* (1621), paints an idyllic picture of 'yong Lasses' who

. . . after evensong, meet their sweet-heartes, and dance about a Maypole, or in a Town-green under a shady Elm . . . Yes, many times this love will make old men and women that have more toes than teeth dance, John come kisse me now, mask and mum; for Comus and Hymen love masks, and all such merriment above measure will allow men to put on women's apparel in some cases, and promiscuously to dance, yong and old, rich and poor, generous and base, of all sortes.

And although Puritan Richard Baxter, in his *Reliquiae* of 1664, frowned on such capers, they were still going on:

In the village where I lived the Reader read the Common Prayer briefly, and the rest of the Day even until Night was spent in Dancing under a May-pole and a Great Tree, not far from my Father's Door, where all the Town did meet together.

The 'high' manifestion of dance, which complemented the low in a manner hinted at by Burton's reference to Comus and Hymen, was the masque: an enactment of Renaissance philosophy in corporeal movement, reinforced by poetry, song and visual spectacle. Back in Elizabeth's day Sir John Davies, in his poem *Orchestra* (1596), had called dancing 'this new Art', which it wasn't, though it seemed so to modern folk who found in it a new social philosophy, almost a substitute for traditional religious belief. The discussion in Davies's poem may take place in classical antiquity, but the point lies in the concluding prophecy: the ultimate realisation of love's order (dance) will occur two thousand years hence, in 'our glorious English Court's Divine Image, as it should be in this our Golden Age'. So the masque was essentially contemporary; when the masquers were unmasked they proved to be, not legendary creatures from classical mythology, but the King and nobility, and by inference ourselves.

The finest makers of masques for the Jacobean court were Thomas Campion (1567–1620), an exquisite lyric poet versed in classical prosody and a composer of ayres artful in their artlessness; and Ben Jonson (1573–1637), whose tough intellect classically allied poetic to terpsichorean grace, refusing to countenance the mindless euphoria whereby mortal masquers pretended that in their earthly paradise Time might be immobilised. They could imagine it might only if too high on self-esteem and fermented liquor to notice it; effects of bathos were not uncommon, the grandiose ceremony being in more than one sense dissipated in the collapse of the monarch himself, or at least in a fit of the giggles from the fine ladies. 'Charity came to the King's feet', wrote Sir John Harrington, describing a masque presented at Whitehall in 1606; 'she then returned to Faith and Hope, who were sick and spewing in the Lower Hall'.

Theoretically, the masque did allow for human fallibility in the anti-masque, a rout of satyrs representing the libidinous undercurrents to our fallen selves, and often linking the high ritual to low and ancient traditions of mumming and morrissing. But such things that go bump in the night are admitted only to be laughed away. In our pretend-paradise they pose no real threat, as they did in historical fact and do in those supreme adaptations of masque conventions, Shakespeare's *The Tempest* and, in the next generation, Milton's *Comus*. The best authentic masques of Shakespeare's day, such as Campion's piece for the marriage of Lord Hayes presented at Whitehall in 1607, are still, however beautiful as poetry, 'art at an emergent stage', a cross between entertainment and a ritual of humanism.

Our notion of masque must remain hazy because, although we usually have a printed verbal text, masque music survives only fragmentarily, while antimasque music was often deemed too trivial to be written down at all. Moreover, although we have handsome drawings and engravings of masque decor, and vestigial choreographic notations, we cannot adequately recreate the spectacle; like Shakespeare's 'cloud-capped palaces', masque spectacle has gone with the wind, leaving scarcely a wrack behind. It is interesting that Jonson's masques often merge classical mythology into old English fairy lore, which is superhuman not in being divinely larger than life, but in being indigenous illusion. In *Oberon*, devised for Prince Henry in 1611, antimasque horrors become quaint hobgoblins whose music, in so far as it survives, is not horrid but perfunctory, even when the grotesques have satirically contemporary relevance. Complementarily, the elegance of much masque music seems unremittingly bland, valid only if one is participating in the social and spiritual harmony it venerates. If masque were to be adequate to a changing world, it needed to grow up into opera, confronting the antimasque as the nasty negation it was, rather than dismissing it as a rout of fey fairies or boisterous buffoons. Later, at the Caroline court, buffoonery became significantly naturalistic, as is evident in the profligately expensive *The Triumph of Peace* which James Shirley, in collaboration with William Lawes and Simon East, produced in Inigo Jones's noble Whitehall in 1633, in honour of one of Charles's recurrent 'returns'.

As was conventional, the antimasque – in hierarchically inverse order – entered first, consisting of low human types hardly distinguishable from the

brute beasts who worked for them, as they worked for their human if not always humane lords and masters. They are banished by the entry, '*like Priests and Sybils*', of the Musicians, 'Sons and Daughters of Harmony' who in turn usher in the Grand Masquers (the nobility), sumptuously seated in chariots, 'in the Roman manner'. Masques and antimasques proceed 'as was wont', confirming in their conformity religion and obedience; though a modern touch is added by the appearance of some dotty Projectors, whose 'scientific' enterprises satirise the way of the newly emergent World. Particularly remarkable is what happens *after* the Triumphs, when anti-masquers enter who, far from being legendary, prove to be a gang of real workmen and their wives. The downtrodden proletariat no longer grovels like the beast he may be mistaken for. Having built the Masque's Engines and painted the scenery, the workmen claim – speaking in low prose, not verse – a right to share in the fun: 'the masquers will do no feats *so long as we are here* . . . 'tis our best Course to dance a Figgary [figure] ourselves, and then they'll think it a Piece of the Plot'. Whereas in Jacobean fiesta high masque and low antimasque were mutally absorbent, in Shirley's Caroline fiesta class distinction rears its head: 'a Piece of the Plot' more significant than might at first appear.

Interlude: 'The Dishonour of the Kingdom'

So was the Civil War described by Lucy Hutchinson, in her noble memoir of her colonel husband John: who although of high birth and a graduate of the Arminian college of Peterhouse, Cambridge, espoused the Parliamentarian cause and died, after the Restoration, in prison. At bottom, the Civil War was not a war of religion; at least the struggle between Catholicism and Protestantism was only one strand of a deeper tension between absolutism and democratic government, King and Parliament, Court and Country, Religion and Science. Charles I adhered to his father's tenet that 'the state of monarchy is the supremest thing on earth', and had no doubt that his Divine Right overrode Bishop Selden's utilitarian view that 'a King is a Thing men make for their own sakes, for quietness' sake: just as in a family one man is appointed to buy the Meate'. But although Charles's Church was the Catholic-tinged Anglican institution of his father, when he married a French Catholic queen his monarchical obsession went rampant. Religion then encouraged an absolutist view of the state; rich favourites acquired disproportionate power as the King's minions at court; Archbishop Laud steered the Church towards monarchical autocracy, claiming that his calling came 'immediately from the Lord Jesus Christ, which is against the Laws of this Kingdom'.

Gradually the court of Charles and Henrietta Maria became a bastion remote not merely from 'the people' but also from the Country of the landed gentry, notwithstanding their innate conservatism. Paradox was the heart of the matter. Henrietta Maria's French, Catholic, hyper-sophisticated court attracted to it men of learning and culture as well as social climbers; but the instigation of a Court as distinct from the Country carried a threat

epitomised by George Wither in his *Britain's Remembrancer*: 'Nor will this Island better days behold So long as offices are bought and sold'. Such corruption was of course not new; what was new was that, the Court having become an entity unto itself, the gentry could be estranged from it. Living on their country estates, upholding the agrarian values of Old England and adhering to parliamentary democracy rather than absolutism, they justifiably regarded themselves as the Country's backbone. Charles's error lay in failing to realise how impotent he was, without either their support or a standing army. Ironically, the gentry became sturdier as an opposition party than the Dissenters who, under economic pressure, allied themselves ambiguously with Country, City and Crown. In the society in the melting pot, aristocratic tradition had to come to terms with Puritan ethical fervour, with the commercial interests of the City, and with the encroaching strength of the common man.

There could be no clearly defined 'sides'. The Laudian High Church embraced the near-Puritanical Quietism of a George Herbert or Nicholas Ferrar; on the other hand the baroquely Arminian Crashaw came of middle-class stock and was Puritan in unbringing. Milton himself, a Puritan reared as Renaissance Platonist and Latinist, saw that the paradoxical problem of the century was that 'liberty hath a double edge, fit only to be handled by just and virtuous men' who were, and perhaps always had been, in short supply. When Milton supported Cromwell it was because he thought *absolutist* monarchy threatened freedom, the more crucial option. But he believed that Cromwell's cause was 'too good to have been fought for'; and at bottom this was the attitude of Cromwell himself.

Descending from the small gentry, but with affiliations to 'trade', he can be interpreted in many contradictory guises – as regicide, revolutionary, Christian zealot, hypocritical man of ambition and – most persuasively – as moulder and preserver of middle-class values in a middle-class state. Yet at least in his early years his ideal was a revivification of the Golden Age of Elizabeth I: a Protestant Queen who governed through a democratically elected Parliament, in harness with the 'sweet and noble' Ecclesiasticall Polity of Hooker. Charles had to fall because he usurped parliamentary rights; Cromwell's attempts to reestablish them foundered because, in contrast to Elizabeth whose genius was for parliamentarian accommodation, he was both gullible and politically inept. Cromwell's successive parliaments all sold out, and for Milton the Restoration of Charles II as a king modelled on the Stuarts, rather than Tudors, was the beginning of the end. After 1660 Milton abnegated politics in favour of 'a Paradise within thee, happier far'.

Yet morally Milton still hoped for a new, international world in which patriotism was a recognition of the rights of all sorts and conditions of men (if not women!). And although Parliament lost the peace, the causes it espoused did, in time, win through to mould 'a Nation not slow and dull, but of a quick, Ingenious, and Piercing spirit: a noble and puissant Nation rousing herself like a strong man after sleep, and shaking his invincible locks'. Donne, brooding over contemporary alienation, had deplored that 'every man hath got To be a Phoenix', believing that there could be 'none of his kind, but Hee'. Milton, after the purgation of war, renovates the phoenix,

in the guise of his Samson Agonistes, a destroyer who is also a symbol of resurrection.

The creative ambiguity of England's seventeenth century is summed up in Marvell's *Horatian Ode*, which balances positive and negative forces in assessing both King and Protector. It is 'madness to resist' Cromwell's 'industrious Valour', which must of necessity 'cast the Kingdom old Into another Mold'. None the less the process has served to '*ruine* the great Work of Time'. Both the protagonists are presented as tragic heroes. The 'Royall Actor' on his 'Tragick Scaffold' may be a player on a stage, but his martyrdom, when he 'bow'd his comely Head Down as upon a Bed', was for real. Complementarily, victorious Cromwell 'his Sword and Spoyles ungirt To lay them at the *Publick*' skirt'. The poem closes on an open question: 'Besides the force it has to fight The Spirits of the shady night The same Arts that did *gain* A Pow'r, must it *maintain*.' The taut, uneasy rhythm indicates how difficult, and precarious, that task must be.

Roundhead and Cavalier in the music of the interregnum

The War was the palpable cause of the failure of continuity in English musical tradition; in particular it frustrated the growth of court masque into a mature heroic opera such as flourished in France. Bafflement and bemusement are not, however, restricted to theatrical fields: as is demonstrated in *A Sad Pavan for these Distracted Times*, composed in the year of the King's execution (1649) by the long-lived Thomas Tomkins (1572–1656). The grandeur of the large-scale dances of Gibbons or Bull is here burnished to a mortuary gravity parallel to that of Sir Thomas Browne's *Urne-Buriall* which, published in 1659, rang the knell on English agrarian civilisation even as it tolled its universal threnody on human mortality, enshrined in those prehistoric receptacles for ashes. The old-style linearity of Tomkins's *Pavan*, with its canonic inner parts, is fused with harmony and oramentation as richly sombre as the Latinate convolutions of Browne's prose. Distraction may be evident in the way in which the slow pulse occasionally drops or adds a beat.

Latent rather than patent religious music during these distracted years equivocates between a 'spiritually' polyphonic heritage and the fevered excitations of Italian-influenced, neo-baroque harmony and figuration. There are significant harbingers of this during the first Caroline age: for instance in the work of Martin Peerson (1572?–1651) who was born into ecclesiastical tradition, and occupied the august position of choirmaster at St Paul's. His most significant music, however, is in the form of 'spiritual madrigals' and verse anthems for solo voices with organ and strings, suitable not so much for public ecclesiastical usage as for the private chapels that became increasingly significant as the Establishment foundered. Especially pertinent in this context is Peerson's setting, published in his 1630 collection of 'Motetts or Grave Chamber Musique', of Fulke Greville's philosophical but anti-metaphysical poem 'Man, feare no more': which admits that there are mysteries beyond our ken, while relinquishing hope of mystical experience. The anthem's opening, discouraging metaphysical speculation, is homophonic

in texture, dramatic in its equivocations between modality and modern major-minor. But when Peerson reaches the final couplet – 'for God's workes are, like him, all infinite, And curious search but craftie sin's delight' – an odd thing happens: for the words about God's incomprehensible infinity are set to the same chromatic phrase that, early in the piece, had been associated with the pains of hell, only it is now inverted. The wavering texture grows from Peerson's human passion, presenting man as potentially divine yet fearfully frail. The point of the verse is the opposite of what the music tells us, since Greville maintains that spiritual presumption is the work of the Devil.

Peerson's waywardly dramatic, even melodramatic, 'chamber' style flirts with Italian operatic technique without quite embracing it. His contemporary Walter Porter (?–1659), though also an Establishment man at Westminster Abbey and the Chapel Royal, was the only English composer actually to study under Monteverdi, and published the only English madrigals in concertato style in 1632, followed by two-voiced 'Mottets' (really arioso dialogues with continuo bass and even the Italianate *trillo*) in 1659. It was during the interregnum that a mating of the English and Italian traditions was consummated: notably in the work of a mid-century composer rehabilitated only during the last decade or so, George Jeffreys (*c*.1610–85). A missing link in the story of English music between the Jacobeans and Purcell, he is no 'interesting historical figure' piously resurrected but a composer of considerable imaginative force, living through an age of religious and political strife, yet potent enough to assimilate – perhaps by way of Notari and Porter – Italian Monteverdi, and to anticipate Purcell. At the same time he established an English identity, at once fraught and valedictory: as is evident in his ornate devotional songs for three or four male voices, and in the verse anthems written in 1669, such as the darkly introspective 'Whisper it easily', or the appropriately titled 'A Musick Strange'. Still more remarkable is the wildly chromatic and dissonant funeral anthem 'In the midst of life we are in death', composed in 1657 when Jeffreys believed he was terminally ill. Autobiography merges into a threnody on a sick world, 'amphibiously' divided and distracted. It is pertinent to note that in his early days at court, before he went with Charles I into retreat at Oxford, Jeffreys composed mainly sensuously subtle, incipiently erotic songs, dialogues, and music for masques and plays. Only after the siege of Oxford and his retirement to the Northamptonshire village of Weldon, where he was steward to the Hatton family at Kirby Hall, did Jeffreys turn to the devotional music in which he discovered his, and perhaps his country's, slightly manic heart and soul.

Another gentleman composer John Gamble (d.1687) calls for mention because although not a composer of even incipient genius, he published volumes of ayres for voice and baroque lute as late as 1659. He wrote in a convention halfway between Dowland's and the later opera-derived style that notated only a bass line, with harmonies to be filled in continuo-wise. In his adaptation of traditional Petrarchan themes (as manifest in 'When I lie burning') there's a touch of the hyper-sophisticated martyrology and Mariolatry of Henrietta Maria's court, and a more tenuous link with the self-indulgent nostalgia of the plays of John Ford. Yet Gamble was a man of the City rather than the Court, and also wrote low songs about the delights of

rural life hinting – in 'Men and maids at time of year' – at the popular
bucolicism of the Restoration. Complementarily, another late composer of
ayres, John Wilson, born as early as 1595 but active until near his death in
1674, was a professional theatre musician who sometimes favoured a courtly
esotericism. His extraordinary theorbo-accompanied 'Beauty, which all men
desire', published in 1640, is about the agony of sexual desire, which it
renders audibly incarnate by screwing up (to use an appropriately indelicate
metaphor) its first two G major bars to a repeat in A flat major-minor, and
adds further semitonal twists in the next four bars. The artfulness of the
device counteracts the apparent randomness: so that the final eight bars may
return to G major as the singer-composer-actor dismisses erotic disturbance
as unnecessary, if not undesirable.

But it is in the vocal music of the brothers Lawes that we discover how, in
the course of time, seventeenth century confusion became con-fusion. As a
writer of secular songs, Henry Lawes (1596–1662) is the truly progressive heir
to Dowland. He became a member of the Chapel Royal in 1626, belonged to
the Court circle, was admired by the King, and was a friend of Cavalier
poets, among them Herrick, Carew and Cartwright, whom he set. Yet he was
also praised by the Puritan Milton for being the 'first to span words with just
note and accent' (he meant setting words with an arioso-like attention to the
inflections of speech). Some of his ayres with lute or theorbo are within
Jacobean tradition; 'Sweet, stay a while' and 'I prithee send me back my
heart' are symmetrical and sweetly tuneful, almost in the manner of
Campion. Other lyrical songs move towards Cavalier artifice and affection.
'This mossy bank' – an aubade by Carew, sung by a shepherd and
shepherdess who are both female – deliciously confounds soulful paradise
with nests of spices, the voices twining in parallel thirds. Sometimes Cavalier
affectation merges into popular pastoralism, as in Lawes's ornate lark song,
which Pepys taught to his (clever) chambermaid.

Of deeper substance than these then-modern pieces are songs deriving
from but modifying the valedictory manner of Dowland: such as a darkly
introspective Wailing Lover song, 'Farewell, despairing hopes', and a
purgatorial water-song liquidly ornamented, 'Slide on, you silver floods'.
Lawes's response to words is more than illustrative. In the line 'in heavy
murmurs through broad shores tell', the weeping suspensions on 'heavy' and
the undulations for the 'murmurs' are balanced by the long, highish note on
'broad', so that meaning conditions musical shape. This is what Milton
admired, as a poet might; and it is still more obvious in a narrative song like
'I laid me down upon a pillow soft'. As he dreams, the vocal line reflects
keywords such as cried, prayed, bold, cold, flame; but the mini-drama the
song enacts *is* the musical form, which is on the way to opera. In his Orphic
hymn 'O King of Heaven and Hell' Lawes has arrived at a fully developed
English-Italianate arioso (or song-like recitative). Music's power to summon
heaven and hell, to thunder, fry, freeze, melt are active in melodic contours,
rhythmic gestures, and discreet harmonic progressions. Rhetorically acquiring
Orpheus's powers, the composer assumes some of the properties assigned to
God.

Yet Henry Lawes's reverence for Man was still dependent on his respect

for a Divine Being: who is celebrated in Psalm settings remote from aristocratic elegance. They are rather in direct continuity with Anglican homophony of the previous generation, with the verse anthems of an Anglican composer such as Gibbons, and with the simple devotional songs for voice and lute of Thomas Campion – who early in the century had published 'A New Way of making Counterpoint in foure parts', anticipating the nineteenth-century conversion of a tune at the top, a bass at the bottom, with two inner parts 'filled in'.

Henry Lawes's Psalm settings are in this Quietist tradition: which appealed alike to genteel poets like Carew and Sandys and to Puritan divines who approved of the style because it encouraged men and even women to address God in humility. Lawes's settings of Carew's versions of Psalms 104 and 137, published in 1638, could belong either to the High Anglican camp of Herbert or to the Puritan but not puritanical sobriety of Bunyan. 'Operatic' elements in the solo sections are discreet, and when the five soloists combine in 'chorus' the homophony is hymnic; the soloists themselves generate the devotionally communal ensembles. To us the manner seems elegiac, harking back to a Paradise Lost. No doubt it seemed elegiac to Lawes's audience also, since the willow-weeping by the waters of Babylon was construed as a lament for exiled Royalists.

This music combines Roundhead austerity with Cavalier grace: a fusion evident too in what survives of the music Henry Lawes wrote for Milton's *Comus*, the one masque that attains poetic sublimity because it allows the forces of darkness – Comus and his myrmidons – their vigorous veracity. Lawes's music does not pretend to be adequate to evil, and we may put this in technical terms in saying that his arioso, being narrative rather than dramatic, does not help the masque to grow up into opera. His arioso works best in passages that are purely sensuous; the music describing 'young Adonis' on his bed of hyacinths touches the heart of the matter, while Sabrina's song about the rushy-fringed bank momently redeems Eden.

There's a link here with the pastoral ayres and dialogues of Henry Lawes's younger brother William (1602–45), who was killed at the siege of Chester, fighting for the King. Henry wrote a moving elegy on his brother's death which, as its title of 'Cease, O cease ye jolly shepherds' indicates, is cast in pastoral vein. 'Willy' is presented as an Orpheus whose song could 'allay the murmurs of the wind, appease the sullen seas, and calm the furious mind'; the music descends, in dissonant suspensions, to cavernous depths. William's own secular vocal music, written for Henrietta Maria's court, celebrates a *lost* Arcadia, fervently believed in until the harsh times belied it. The salons of France and Italy naturally influenced William's style, though his nervous fervour may, at this time of division, be peculiarly English. Significant is Lawes's partiality for the dialogue between Love and Death, when a presumptively dying love-lorn swain confronts Charon, guardian of Lethe. William's two Charon dialogues, and still more a dialogue recounting Orpheus's descent into Hades, are affecting despite or because of their esotericism. Again a personal predicament is related to times that are out of joint. Orpheus's harp, however 'out of tune', may still 'Harmonize the Stygian choir' and 'make a heaven' of the hell from which he cannot and

perhaps – since for Caroline courtiers pain and pleasure are masochistically inseparable – does not want to escape.

Occasionally Lawes's lament is on the verge of hysteria, as in 'Musick, the Master of thy Art is dead', a threnody for John Tomkins. The ungrammatical dissonances for the 'sad griefe' and the ululations that 'howle sad notes' are even more vehement than those in the music of the clinically lunatic Gesualdo. 'The Catts as other Creature doe' is a comic complement to this, for although a court song with satirical references to particular people, its presentation of them as caterwauling felines is as much scary as risible. The particular and general are likewise mated in an impassioned lament for two sopranos, 'How like a widow', since this draws a parallel between war-ravaged Britain and the biblical City of Desolation.

In such pieces William Lawes is not merely a somewhat outrageous composer dependent on the odd milieu he lived in, but almost a great one. He is a more forward as well as backward looking composer than his brother, though Henry survived him into the Restoration. William's theatre music for masques and verse plays by Cavaliers like Suckling is ostensibly progressive. Far more 'modern', however, is his apparently retrospective church music which, like that of George Jeffreys, combines spiritual dignity with emotional fervour, and still more his polyphonic music for strings. Before entering court service the Lawes family had been associated with Salisbury Cathedral and William, apprenticed to John Coperario, had been rigorously trained in the Italianate-English conventions of the string consort. William's string music continues this noble tradition, with enhanced animation and emotionalism: as is evident in the 'setts' of Royall Consorts published by Henry after William's death. This is four-part music for the Caroline court, mostly in dance forms – paven, almain, courant, saraband, each dance slightly faster than the preceding. Interspersed among the dances are a few tuneful 'aires'. A fine six-part fantasia introduces the D minor sett, and the dances themselves, even when sprightly, cultivate the physical-metaphysical compromise of the Caroline court.

Nobility and spirituality are mainsprings of the larger polyphonic fancies, not published by Henry, but also probably composed for the court in the thirties. They too are grouped in 'setts', substantial fugued movements being separated or followed by pavanes or by 'sweet-delightfull ayres' with a tune at the top, affording emotional relief. A prototype is the first G minor Consort Suite of five parts: strenuously contrapuntal in texture, but with themes that incorporate declamatory repeated notes and with cross-rhythms that impart a dancing animation. The music comes out as ambivalent, having the dignity of the polyphonic heritage yet sounding, in its relatively short-spanned phrases and fluctuating textures, wistfully vulnerable, aware of the shifting sands the composer lived on.

Lawes's finest music tends to be his shiftiest, as in the C minor Consort Suite, with its weird, chromatically altered theme and 'horrendous' diminished seventh. The closely imitative part writing is continually in metamorphosis, so that the music is always in flux, like life – especially seventeenth century life – itself. Even wilder are Lawes's works for 'broken' consorts, mixing viols with violins, lutes, harps and keyboards. The so-called

eighth Sonata, in D major, begins with a fantasia which is not a contrapuntal fancy in the old sense, though emotionally it is highly fantastic. The erratic theme is first stated by the organ, divided between the hands, and is answered by the strings, which wildly or comically bandy the notes between them. In place of sustained polyphony we have perky or vehement exchanges, separated by silences; the undermining of conservative pedagogy technically parallels the undermining of traditional values in an insecure world: a licence which extends to the ostensibly 'social' almain and galliard. The former has an extraordinary jokey theme consisting of repeated notes punctured by silences, later hotted up in free diminution.

Given its premises, William Lawes's sonata is brilliantly re-creative, as well as recreational; and that he was capable of envisaging a new world which, founded on the old, could heal the paradoxes of the present is revealed in his 'Pavens' with Divisions, usually scored for a broken consort of violin, bass viol, theorbo and harp. One of the loveliest is based on a theme of his old teacher John Coperario, wherein modernity and traditionalism meet. Another Paven and Divisions, this time on an original theme, is in radiant G major, beginning in serene nobility. Gradually the 'Divisions' (or variations), emotive dissonances, irregular rhythms, assymetrical phrases, virtuosic figuration and mellifluous tone-colours impart an outward flush and inner excitation. Significantly, this may be the last piece to incorporate a reference to the famous *Lacrimae*; Dowland's philosophical melancholy is transmuted in a world in turmoil. Even more than Dowland, Lawes approximates to the romantic notion of the artist as social misfit. In the seventeenth century such men were called malcontents, though if they were disillusioned, this is not because they indulged in self-commiseration but rather because they were aware of the fallibility of human hopes. Lawes's sociability and personal grace were indeed crudely annulled by fate, for the War's cannonball destroyed his fulfilment, as it did that of the world he inhabited.

A rougher instance of malcontent is offered by Captain Tobias Hume, who died in the same year (1645) as William Lawes, though his only published music appeared in the Jacobean age. A soldier by profession, he complained of unjustified lack of advancement, and responded to disappointment in solo viol music of elegiac gravity (in his Pavane and Galliard grandly entitled *Death and Life*) or of gruff irascability (in *A Soldier's Resolution*). Though an amateur musician, Hume was able enough to bolster waning self-esteem with technically grateful virtuosity.

Hume, however, is eccentric in the literal as well as colloquial sense; more revealing, in considering the evolution of English music during the century, is the long career of John Jenkins, who survived three reigns. During the interregnum he was household musician at several estates, notably Kirtling Hall, Cambridge. On the Restoration he was recalled to court, though he was hardly active in it, not only because of his great age but also because he had remained faithful to the English tradition of string polyphony, which the new monarch abominated. Although the chronology of his prolific output is obscure, we may hazard that his earlier music is domestic in function and devotional in feeling, bearing a relationship to English musical tradition

similar to that of the Anglican nature-mystic Henry Vaughan to our poetic tradition. Jenkins even wrote an old-fashioned plainchant *In Nomine*; more commonly – as in the noble six-part A minor fancy – he mated a fully worked fugal exposition to a 'pathetick' middle section, and a more animated fugato which in this case culminates in chiming bells. Some fancies – a lovely F major piece for violins rather than viols, and a weirdly modulating virtuoso fancy in D major – are modern in diatonic tonality and secular in feeling, though they are not necessarily late in date.

By the Restoration the violin family was ousting the viols, though the bass viol still flourished as a solo instrument adept at playing virtuoso divisions over another string bass, with or without continuo. The violins triumphed because their bright tone and crisp accentuation suited the new, dance-dominated music, as well as the larger halls in which it was performed; the nature of violin bowing favoured dance as much as viol bowing encouraged the malleable rhythms of quasi-vocal polyphony. Returned to Court, Jenkins was not totally unaffected by the zeitgeist, since he produced, in his seventies, a series of 'Fantasy Suites' for two violins, one or two bass viols and organ, the keyboard instrument sometimes acting as continuo, sometimes being alloted an independent part. Though some of these pieces amount to trio sonatas anticipating the Italianate Purcell, it would seem that Jenkins was a *reluctant* modernist; one can understand why the music historian Roger North, writing in 1720, in his *Memoires of Musick*, should have thought with benevolent condescension that Jenkins's music, though more 'airy' (he meant tuneful) than some, was still not airy enough:

> He was a great Reformer of Musick in his Time, for he got the better of the dulnesse of the old Fancyes, and introduced a Pleasing Ayre in everything he composed . . . But to do right in showing what was Amisse in the manner of Mr. Jenkins, It was wholly devoid of Fire and Fury, such as the Italian Musick affects, In their Stabbs and Stoccatas, which Defect is excusable only on the Humour of the Times, which These will not bear.

Interlude: monarchy restored, in a new peruke

Indeed they could not, for the Restoration was not a restoration of old values. Politically, the brilliant Halifax summed matters up when he wrote in his wry prose: 'When people contend for liberty, they seldom get anything by their victory but new masters'. Culturally, Bishop Sprat, in his history of the Royal Society of Science which, founded in 1667, was to be the artifactor of the scientifically orientated future, remarked that 'if our Church should be enemy to Commerce, intelligence, discovery, Navigation, and any sort of Mechanicks, how could it be fit for the present Genius of the Nation?' Of course it couldn't; the pristine world of the early Caroline court, obliterated by the War, was not recoverable. Neither Court nor Country won the War. If anyone did, it was the City, since with the growth of scientific enquiry, England was becoming 'a nation of shopkeepers'. By 1640 Britain already produced three times as much coal as the rest of Europe put together; thirty years later mercantile adventure (and sometimes misadventure) had become

unstoppable. Moral standards were similar to our own, being those of the smart alec.

It is not therefore surprising that Charles II should have wanted to emulate the Sun King across the Channel, and sent some of his more favoured artists to study in Europe. One musician, the brilliantly talented Pelham Humfrey, was able to profit from this. His magnificent arioso setting of Donne's *Hymne to God the Father* proves how a deeply traditional awareness of the English paradox – the poem is about death and a desperately wavering faith – can be transmuted into an English vocal idiom which potently absorbs Italian virtuosity; similarly, the astonishing verse anthem 'O Lord my God, why hast thou forsaken me?' – also dealing with a crisis of faith – adapts a sober English ecclesiastical convention into convincing Italianate rhetoric. But Humfrey was an exception; most British artists of the Restoration period who aped the French and Italians were unable to inform grandiosity of manner with grandeur of spirit, since both the moral core and the sense of stylisation were lacking. This is why when Dryden, superb as satirist, assayed the Heroic as tragic dramatist it was with disillusioned wishful thinking rather than conviction. The conflict between the veracities of private passion and the necessities of public duty – the heart of Corneille and Racine – was abandoned; what mattered was the display of simulated emotions that the characters, faced with synthetic moral choices, could exhibit. A tragedy of simulation and dissimulation is a contradiction in terms. Since comedy could and did flourish on deceit, it worked more effectively in the Restoration theatre, though apart from Congreve none of the dramatists achieved, or even attempted, anything like Molière's comedy of manners *and* morals.

The implications of this are quite deeply illuminated by Valentine's dialogue when, in Congreve's *Love for Love* (1695), he feigns madness to evade the consequences of amorous and financial intrigue:

Valentine It's a Question that would puzzle an Arithmetician, if you should ask him, whether the Bible saves more Souls in *Westerminster-Abby*, or damns more in *Westminster-Hall:* for my part, I am *Truth*, and can't tell; I have very few Acquaintances . . .

Forefight Pray what will be done at Court?
Valentine *Scandal* will tell you; – I am Truth, I never come there.
Forefight In the City?
Valentine Oh, Prayers will be said in empty Churches, at the usual Hours. Yet you will see such Zealous Faces behind Counters, as if Religion were to be sold in every Shop. Oh things will go methodically in the City, the Clocks will strike Twelve at Noon, and the Horn'd Herd Buz in the Exchange at Two. Wives and Husbands will drive distinct Trades, and Care and Pleasure separately Occupy the Family. Coffee-Houses will be full of Smoak and Stratagems.

(Act IV)

Charles II was himself the arch-representative of Congreve's *Way of the World*: some of the musical consequences of which are evident when, in *Love for Love*, the servant Jeremy, asked whether he likes music, replies 'Yes, I

have a reasonable good Ear, Sir, as to Jiggs and Country Dances; and the
Like; I don't much matter your *Solo's* and *Sonata's*, they give me the
Spleen'. This expression of the plain man's taste accords with that of the
monarch himself, for Roger North tells us that whereas Charles I and
Cromwell alike loved, Charles II had an 'utter Detestation' of, fancies and

never could endure any Musick that he could not Act by keeping the time, which
made the common Andante or else the step Tripla ye only musicall Styles at Court in
his time . . . He was a lover of slight songes, and endured the accompanying very
well, providing he could beat the time. Once he was invited by Sir J.W. to hear some
English musick, who was not a little rediculed for his paines, and as to Skill he used
to despise it & say Have I not Eares, to Judge as well as anyone?

The sardonic Halifax documented the Character of this King 'Who Knew
What He Liked' in remarking that

The Familiarity of his Wit must needs have the Effect of *lessening* the Distance fit to
be kept to him . . . Formality is sufficiently revenged upon the World for being so
unreasonably laughed at; it is destroyed, it is true, but it hath the spiteful Satisfaction
of seeing everything destroyed with it.

Since *l'Etat c'est Moi*, that might be a portrait of the society as well as of the
King; and of course the shift from old world to new is not all loss. Although
North's reference to the 'common Andante' and the 'Step Tripla' quoted in
the previous paragraph is meant to be disparaging, such technical
developments had a positive aspect, reflecting the necessary triumph of the
humanist's 'corporeal' metre at the expense of the churchman's 'spiritual'
rhythm. Charles II's partiality for the new Italian and French music was
genuine as well as modish; but the equilibrium between positive and negative
forces that characterises the 'mind of England' in the closing decades of the
century is most deeply revealed where one might most expect to find it – in
the music of the Restoration composer most endowed with genius.
Notwithstanding that Henry Purcell (1659–95) was in the vanguard of
progress, his greatness cannot be separated from the fact that he reveals
realities his age preferred to ignore or evade.

Masque and opera, autocracy and democracy in the Restoration theatre

Born on the eve of the Restoration, Purcell produced at the age of twenty a
series of works written as exercises in an archaic style – that of the string
fancy, which we have seen to be profoundly representative of the mind of
seventeenth-century England. Like those of Gibbons, Ferrabosco and
Jenkins, Purcell's fancies start as instrumentalised vocal fugato. Indeed the
last of them, the five-part Fantasia on one note, is the swan-song of the old
convention, for the technique of the *In Nomine*, in turn derived from
medieval *cantus firmus*, is carried to its ultimate: the 'firm song' has become
one continuous note. At the same time the augmented intervals and
cumulating false relations in this piece, and still more in the fourth four-part
fancy in C minor, resemble the more melancholic passages in Purcell's

Mrs ARABELLA HUNT Dyed December 26th 1705.
Were there on Earth another Voice like thine, | The late afflicted World some hopes might have,
Another Hand, so Blest with skill Divine; | And Harmony recall thee from the Grave.
G. Kneller S.R.Imp. et Angl. Eques Aur Pinx. I. Smith fec. et ex. 1706.
R GODFREY KNELLER JOHN SMITH C S 137 I

'While She Sings 'tis Heav'n Here'; mezzotint of Godfrey Kneller's portrait of Mrs
Arabella Hunt.

operas; and although the rhythmic independence of the parts is a legacy from vocal polyphony, the physical animation of the quick section anticipates Purcell's music for the Restoration theatre.

For despite his roots in England's past, Purcell was a passionate modernist. Our music, he wrote in the Preface to his *Sonatas of II Parts*,

is yet in its Nonage, a forward Child, which gives hope of what it may be hereafter in England, when the Masters of it shall find more Encouragement. 'Tis now learning Italian, which is its best Master, and studying a little of the French Air, to give it more of Gayety and Fashion. Thus being further from the Sun, we are of later Growth than our Neighbour Countries, and must be content to shake off our Barbarity by degrees.

Purcell was quick to follow his precepts, for he soon embarked on the composition of trio sonatas for two violins and continuo, on the model of the 'famed Corelli', who had codified the formula into a microcosm of the techniques of Italian baroque opera. The prototype – there are many variants, and French and even English dances are often interpolated into the Italian formula – has a first movement that derives distantly from ceremonial pavane and the slow section of a French operatic overture. The second movement is an Italianate fugue that dances; the third movement is a quasi-vocal operatic aria, often in sarabande rhythm; the fourth is another, slighter and lighter fugued dance. In Purcell's trio sonatas 'English' false relations, augmented intervals and sobbing appoggiaturas generate an ardour earthier than that of Italian Corelli or French Couperin, and in apparent paradox the modernity of the music springs from its being, as Roger North put it, 'Clogg'd with somewhat of an English Vein'. Though Purcell is indeed heroic, his heroism, being that of a man of the English Restoration, has a touch of brash animality and sexual swagger.

This one can detect in his treatment of the *notes inégales* which English music borrowed from French. In France unequal durations were not written out because they were too subtle for notation. The English version, with sharply pointed dots, is more frequently notated and sounds more aggressive: the plain man's conscious assertion of superiority – whereas Couperin simply knew he was superior. Purcell's two-part counterpoint, in the violin parts of his trio sonatas, maintains what Hopkins called the 'thew and sinew' of English string polyphony; the dance music prances in physical gestures; and he offers his own, very English version of the rhetoric of the Italian voice, riddled with Roger North's 'Stabbs and Stoccatas'.

An opera, or at least a theatre, composer was thus already latent in Purcell's early instrumental works. Theatrical ambition must have been fuelled by his acquaintance with the stage music of his immediate predecessors, notably Matthew Locke and his own teacher John Blow. Locke (1621/2–77) had started as an ecclesiastical musician at Exeter Cathedral. At Exeter he met Henrietta Maria, seeking a haven of quiet with her son, later to be Charles II: under whose protection Locke eventually went to the Low Countries, became a Catholic and returned home in anticipation of Charles's return. Henceforth he was a prevailingly secular musician to a secular age. In 1653 he produced a harbinger of the Royal Restoration in the form of a masque concocted to a book by James Shirley, with musical assistance from

Orlando Gibbons's second son Christopher (1615–76). This piece, *Cupid and Death*, modifies courtly convention in a manner even more curious than that of Shirley's *The Triumph of Peace*: for although resolutely monarchical even during the interregnum, its mode is, at least until its apotheosis, not grand but low – closer to pantomime and music-hall than to opera.

The story, adapted from Aesop, offers a pawky commentary on the obsessive seventeenth century theme of sex and death, love and war; for the protagonists, lodging at the same inn, have their bows and arrows exchanged by a Chamberlain who is a representative 'political' modern man in that he narcissistically thinks he can play ducks and drakes with Nature. The interchange of weapons between two forces often considered near-identical results in a series of japes between senior citizens caprinely gallumphing and military heroes sentimentally or sensually embracing, who were both, then as now, good for an easy guffaw. Much of the piece is *spoken* in prosy verse; until the apotheosis the only serious singing role is that of Nature, who passionately protests against the threat she's exposed to by man's cynicism. She strikingly anticipates our situation in the twentieth century, being a conservationist who wants to conserve herself. Her ecological eloquence rouses the chorus – us the People – to poignantly harmonic lament. Even Death has had enough, and shoots the Chamberlain, who had started all the trouble. Of course the effect of the shooting is not to kill the Chamberlain but to make him besotted on two court apes he'd been exhibiting around the fairs. In playing tricks with Nature, Love and Death man has reduced himself to apeish stature; the antimasque has become the heart of the matter.

That the piece as a whole seems short-winded is part of the point: it shifts through cinematic 'clips' because modern life is 'one damn thing after another'. Throughout, the often piquantly chromatic, irregularly rhythmed dance music says what is to be said on behalf of the New Age: which comes into its own when Mercury descends as *deus ex machina* to save the Chamberlain from suicide, banish the antimasque, restore Love and Death to their proper selves, and regenerate Nature. He, mightier even than she, will soon tidy up the mess left by War and Protectorate; and by the time of the repeat performance in 1659 the identification of this Mercury with Charles II was patent. Just as the communal music of choral lament is truly pathetic, so Mercury-Charles, a figure larger than life, sings an arioso as long, grand and more ornately spacious than that of Nature herself; and although he admits that not even he can bring the arbitrarily slain lovers – victims of the crossed arrows of that arbitrary war – back to life, he can inspire music wherein the Renaissance dream of an Arcadian Paradise on earth may seem, refashioned in the most modish French style, momently to have come true. This is at once a vision of the Elysian Fields and a prophecy about the New Society. 'If this place be not Heaven', sing the chorus, 'one thought can make it, And gods by their own wonder led mistake it.'

Whereas Locke was a man of the theatre, John Blow (1649–1708) – born a decade before his most illustrious pupil but surviving him by thirteen years – was an Establishment figure at both the Royal Chapel and Westminster Abbey. None the less he owes his place in history to the fact that, making 'a masque for the King's entertainment', he fortuitously effected that crucial

transition from masque into opera. Two thirds of his *Venus and Adonis* celebrate the Arcadian revels of lovers who, in those blissful Elysian Fields, pretend they 'haven't a care in the world'. What brings them to *life* is again, in English paradox, the fact of *death*: for only when Adonis has been slain by the boar who may be his own 'blind' lust does Venus apprehend the reality of love. *Cupid and Death*, shuffling around the theme, had defused it in satire; Blow, when his Venus sings 'Alas, Death's sleep thou art too young to take', attains tragic awareness. Her ululations – sobs that become almost screams – are emotional torment that finds relief in physical gesture without ceasing to be music. She is really heart-broken – by what she had intended to be a jape. Her mental state is marvellously reflected in the string postlude, with its hesitant, limping rhythm, like a bird with a broken wing.

Blow's *Venus and Adonis*, produced in 1683, must have been in Purcell's mind when in 1689 he received an invitation to write a theatre piece for his friend Josias Priest's school for young ladies. He could not have realised how significant an event this was to prove: for whereas Blow's *Venus* was conceived as a masque and turned into an opera accidentally, *Dido and Aeneas* was designed by Nahum Tate as a spoken heroic tragedy which, musicked by Purcell, became more not less dramatic, since the music revealed the true passions beneath the rhetorical gestures. *Dido* is Purcell's only real opera on the traditional heroic theme of the clash between public and private morality. That it is not a grandiloquent court ritual but a miniature affair lasting about an hour, intended for performance by adolescent girls, is not the frustration it might seem: for the intimate scale of the piece is the condition of its truth. *Because* Purcell lived in a community unable to encompass the Heroic as exemplified in Louis XIV's France, he was able to invert conventional values and to equate Dido's instinctive nature – her 'love' – with her heroism, while patriarchal Aeneas's 'Empire' is a deceit. He has a 'poor' part, with no aria, not because he was a man smuggled into a girls' school but because, in Nahum Tate's and Purcell's conception, he is a poor thing – whereas Dido discovers, in the savagely farcical scene in which she upbraids him as a 'Deceitful Crocodile', that it is more heroic to be a woman than a queen. Significantly, the only important characters apart from Dido are Belinda, a 'common' serving girl who is close enough to her mistress lightly to emulate her heroic music; and the Sorceress, who darkly emulates Dido's king of arioso because she is the alter ego of Dido herself. In this sense Dido has both masque and antimasque within her, as to a degree we all have. The real negation within her psyche reveals the antimasque naturalistically presented on stage for the sham it is.

All this is anticipated in the overture: which sets Dido's private heroism in the context of unheroic public life. The opening slow (pavane-derived) section is Dido-music, its grandeur contained in the arching sweep of the melody and the gravity of the rhythm, its personal passion in the dissonantly sobbing and sighing harmony. The quick section embodies the public world, as it did in Lullian convention: only instead of being a triple-rhythmed graciously fugued round-dance, it is now in duple time, fast and perfunctory. Though still conventionally in fugato, it is low in manner: a communal get-together of those middle-class Restoration gossips and harridans whom

Nahum Tate and Purcell call witches, and of those raucous sailors who, like
imperious Aeneas, take a 'boozy short leave of their nymphs on the shore,
while never intending to visit them more'. Their evil is their triviality, which
would destroy Dido because it fears her truth. In more than one sense they
are *common* men and women: the bingo-playing multitude, the social
climbers, the wide-boys and instant tycoons who, in Restoration Britain as in
ours, had come to represent the public world.

The tragic grandeur of *Dido and Aeneas* is thus not in the public music but
in the creation, in arioso, of Dido's ongoing psychological life. In her two
arias, in the first and third acts, each on an endlessly repeating ground bass,
her passion itself becomes ceremonial, the ostinato pattern standing for both
the social Law, against which she rebels, and Fate, which she has no choice
but to accept. Her sublime final lament, 'When I am laid in earth', is a
chaconne – a triple-rhythmed marriage dance such as still graced the
weddings of important persons. Dido, having renounced Aeneas and a
Congrevean Way of the World incommensurate with her truth, commits
herself to marriage with Death, though it is unclear whether she stabs herself
or dies of a broken heart – a seventeenth-century malady discussed in
Burton's *Anatomy of Melancholy*. During her lament the chromatic ground
promotes dissonances that sob and throb through the string texture, while
her vocal line stabs and jabs as it rises in proud arches, culminating in a
sustained high G on the words 'Remember me'. She asks us to remember her
in so far as she is humanity's scapegoat; but to 'forget' her pain because that
has been not only suffered but transcended. Purgation is aurally incarnate
when, as Dido dies, the bass's chromatic descent spreads through the string
orchestra, dissolving into the final chorus in which Cupids – at once plump
fruits of sexual love and cherubic angels of the old world – chant over her an
archaic 'canon four in one'.

In thus honouring private experience and spiritual values at the expense of
the public life, *Dido and Aeneas* discovers the heroism inherent in every man,
and especially woman, according to his or her capacity. So the opera is
prophetically both democratic and feminist, and could have occurred only in
a society that had *failed* to attain its patriarchally autocratic ideal. This is the
ultimate link between the seventeenth century and us.

One's first instinct is to say that *Dido* is a flash in the pan, a creation of
genius greater than the Restoration warranted. And it is true that the super-
ficiality of the Restoration comedy of (mostly bad) manners as compared with
Molière's, and the pasteboard heroics of Dryden's, let alone Shadwell's,
attempts to emulate Racine, have a still crasser complement in the
Restoration's refurbishing of old plays by out of date dramatists like
Shakespeare. The relation of Purcell's *The Fairy Queen* (1692) to
Shakespeare's *Midsummer Night's Dream* parallels that of a twentieth century
movie musical to 'the book of the film', being a series of shows introduced,
for commercial appeal rather than as ritual ceremony, into a spoken play.

On reflection, however, this account seems too simple. Purcell's Fairy
Queen is a candyfloss figure compared with his Carthiginian one, yet her
relatively demotic spirit, allied to the fecundity of Purcell's invention,
becomes a kind of virtue. And even Shadwell's rehash of Dryden and

Davenant's rehash of Shakespeare's *The Tempest* (1695), grotesquely though it distorts Shakespeare, prompts Purcell to music which, in melodic span and harmonic momentum, foreshadows the 'reasonable' control of wayward Nature typical of English Augustanism. The *da capo* aria 'Halcyon days' suggests that at the time of his premature death Purcell was about to effect a crucial synthesis of Shakespearean prodigality with Handelian (Augustan) order.

In this context we may compare two of Purcell's St Cecilian odes, composed, respectively, in 1683 and 1692. Many Restoration poets from laureate Dryden downwards turned out Odes to St Cecilia, patron saint of music, to be set for soli, chorus and orchestra and performed at monarch-and-state-glorifying festivities. Dryden's own two odes, in artfully intricate classical baroque stanzas designed to display man's triumphant artifice, are fine examples of public rhetorical poetry. They present Cecilia as a female Orpheus whose music affects the order implicit not merely in an abstract godhead, but in the mechanical view of Nature. Music is the force whereby the 'Jarring Atoms' cohere to make the Newtonian universe. Her order is a social analogy, for the fluctuating tensions of harmony must (literally) bow to the public ceremony of dance and to a scheme of tonality linked to dance metre. But music's function is Orphic too in the sense that a properly ordered whole promotes the fullest expression of the parts. Indeed the universal order is dedicated to the fulfilment of man's sensual nature. Though 'From Harmony, from Heav'nly Harmony, this Universal Frame began', it runs through 'all the Compass of the Notes' in order that the Diapason may 'close full in MAN'. Milton, in *At a Solemn Musick*, had deplored the loss of the Perfect Diapason that symbolises man's oneness with God. For Dryden the octave is synonymous with Man himself, the apex of creation. If Paradise is Lost, the sacrifice is justified, since Man has been Found.

Purcell's 1683 ode, *Welcome to all the Pleasures*, has a text by a versifier following Dryden's prescription. Ostensibly it celebrates the hedonist's paradise – those endless sensual gratifications which, since orgasm is a-dying, seem to be independent of Time. Yet the music qualifies the buoyant message, being scored for slight forces in the manner of a verse anthem, and starting with a French overture that, in linear and harmonic density, sounds like operatic *tragedy*. The climax of the work is a gentle but heart-rending tenor air that yearns, through painful upward appoggiaturas, for Eden; while the final chorus – in E major, traditionally the key of heaven – seems to refer to a world beyond the hedonist's here and now, since it dissipates into thin air. For Purcell, the hedonist's paradise proves insubstantial as a masque decor – or a dream.

By the time of the bigger, more fully scored 1692 ode, Purcell's humanistic New World has garnered substance. Here the overture displays greater sustaining power in handling architectural tonality, which relates musical to political organisation. The basic key relationships of tonic, dominant, subdominant and relative are enriched with sequential modulations; fugato becomes a principle of unity fitting into, rather than conditioning, the key scheme, for the public weal is the arbiter of individual destiny. The

seventeenth century had been driven by what Hobbes called 'the perpetual and restless desire of power after power, that ceaseth only in death'. In personal terms this was the force behind Restoration sexuality, which had its public manifestation in authoritarian political organisation. In Purcell's late music energy and order are related much as they are in Dryden's tense equilibrium between speech rhythms and the metrical beat of his heroic couplet. The musical 'bar' (a prison) and the poetic 'beat' (a military domination) join forces to promulgate order.

Even so, Purcell's greatness still lies in the fact that his musical planned society allows scope for the personal life, especially in recitative and arioso which, for Purcell as for his Dido, is man's unaccommodated state. The famous alto arioso 'Tis Nature's voice' begins with Nature's acoustic fact of the triad which flowers, through sobbing suspensions and caressing roulades, into a consummation of personal feeling. The music creates, before our ears and eyes, the heart of human nature, as distinct from the Nature we come from, and to which we return when, in the monumental, near-Handelian chorus 'Soul of the World', the 'Jarring Atoms' of Newtonian physics are marshalled by man's will and intellect. Man has learned, through the two falls of Satan and of Eve, to *impose* order on time and space; and although Purcell did not live to fashion a classical heroic opera and his failure is the paradoxical measure of his success, he superbly deploys in this ode most of the techniques that will typify opera *seria* as practised by Handel: who himself set Dryden's original St Cecilian ode in a manner indebted to Purcell but more classically, even complacently, assured.

Having said that, one wonders whether Purcell may not have died at the right, if chronologically premature, time. Like his Dido, he had to expire because the 'world' wasn't ready for his kind of heroism. In this context it may be significant that 'the last song Mr Purcell set, in his sickness' should have been a Mad Song – contributed to his incidental music for D'Urfey's typically cynical burlesque of Cervantes' *Don Quixote*, a tale itself turning on madness and illusion. Attempting to seduce the Don from his idealistic addiction to his Eternal Beloved, Altisidora – as sexually predatory as a Restoration buck – sings an arioso-scena, 'From rosy bowers'. In it she tries herself out in all the degrees of seventeenth-century madness, specified in the score as Sullenly Mad, Mirthfully Mad, Mellancholly Mad, Fantastically Mad, to the ultimate Stark Mad: which alone can match her desperation. Technically, she alternates arioso with dance-formalised airs, though the latter don't last long since the discipline of social dance cannot deal with such 'outrageous' sexual passion. That it is sexual is patent in the invocation to the God of Love and attendant cupids, the 'rosy bowers' being incarnate in undulating chromatics, the cupids in tripping arabesques. She is using music to 'win dear Strephon whom my soul enjoys', the sexual metaphor being more to the point than the reference to her soul, unless that's a euphuism like seventeenth century 'dying'. When she passes from Sullen into Mirthful Madness she briefly frisks in a gavotte, tripping 'like any fairy'. She's indulging in a hopeful game: deflated by Melancholly Madness, leading to 'death, cold Despair, and fateful Pain', audible in sobbing appoggiaturas and in syncopations that act out mental agony in corporeal gestures. 'Tempests'

of passion whirl in scales, only to be effaced when her pulse slows to a dismal thumping, drooping flatwards through a Dead March.

That Altisidora's madness is feigned, like Valentine's in *Love for Love*, doesn't make it less frenzied, nor much less crazy in its implications. She's frantic because for her, even more than for the protagonists in *Cupid and Death*, life is without rhyme or reason because without sanctions religious or social. This bears on the fact that even Purcell – not merely the hack composers of his age – tends to be a bit short-winded. His prodigal invention compensates for his movements' brevity; they're soon spent unless buoyed on the law of ground bass, which implies habituation, whether to social convention or to the necessities of fate. In 'From rosy bowers' Purcell compensates by making the last, stark-maddest section the most sustained. Having made the sex-death paradox of the frying-freezing lover basic to everything we do or fail to do, he survives by finding life *within* lunacy: an anticipation of the normalcy-lunacy inversion of our century's R. D. Laing. After the wildest arioso ('No, no, no, I'll straight run mad'), Purcell's final section becomes almost an aria, in stable C major, very fast, but metrically regular, and with orderly sequences moving through the conventional tonal relationships. The Way of the World being itself crazy, there's hope in the fact that the Sauvage man is come again, metamorphosed into a sexually predatory woman: a maenad or Bacchic Terrible Mother, inverting the 'normal' male image in the same way as Dido, as Heroine, had ousted the macho Restoration Hero. Altisidora is the dark Sorceress within Dido herself, now taking the centre of the stage.

This is an apex to the lunacy that goes back to the beginning of the century and earlier. In the early years melancholy and malcontent were more than a fashion, while in Purcell's time, at the dawn of the age of Reason, a remarkable number of talented men went crazy, the Earl of Rochester being merely the wildest and woolliest. Although there is a streak of fearful farce in 'From rosy bowers', Purcell's 'last song' is, in total effect, far from a laughing matter. It may be hyperbole when Altisidora yells that her torments are such that she is prepared to die 'a thousand deaths', for one death, after all, would suffice. Remembering the seventeenth century pun on the literal and sexual meanings of dying, however, we may take this as her madness's ultimate desperation. We in the twentieth century, likewise obsessed with sex and death as we confront *our* scientific (electronic) revolution, must find Purcell's encapsulation of his and our predicament even more forceful, and no less bewildering.

Postlude: the Old Age out

Neurasthenia is not, of course, the immediate impression given by the art of Purcell's age. It was a period of material prosperity, which nurtured a vigorous crop of native – and foreign – talents to sing and dance in its praise. But whereas they celebrated the gaudy façade, Purcell's genius saw behind it. Without being priggish about his jaunty age – he was a master of the low music from beer-garden caper to bawdy-house catch in which it revelled –

he foresaw, having created his Dido, an alternative destiny, more hopeful, though undeniably tragic. His own strength he discovered in a Dido-like acceptance, not evasion, of 'the pain of consciousness'; and in this there is no peer-composer to warrant comparison with him. Nor is there a worthy literary parallel, for Dryden as public poet and Congreve as socially satirical dramatist lack the tragic sense and the spiritual dimension that in Purcell were allied to, though not a product of, the traditions of Anglican vocal polyphony and our domestic consort music for strings.

Perhaps the only valid comparison with Purcell is offered by Christopher Wren, whose greatness is classical and baroque in a way as odd as Purcell's. The Great Fire was an end that might also have been a beginning, for Dryden in *A Secular Masque* wrote off the Restoration with the words:

> The Wars brought nothing about;
> > The Lovers were all untrue.
> 'Tis well an Old Age is out,
> > And time to begin a New.

The poem was published in 1700, the year of Dryden's death, and of the turn into the new century. When Wren rebuilt London after the Fire he achieved a British compromise – between Court and Country, Church and Parliament, Religion and Science – such as the tormented century had been painfully seeking. He lived to establish a great, ongoing architectural tradition, which Purcell had not done for English music. Even so, the British compromise that Purcell effected is still the key to our future, should we have one. Non-racist, non-sexist democracy, though an unrealisable ideal, remains the best that we have.

Portrait of Margaret Brownlow by Henry Tilson (1689–90), framed by carvings attributed to Grinling Gibbons, over the west chimneypiece in the Great Parlour of Belton House.

7 Belton House, Grantham

ANDOR GOMME

There has always been good money to be made at law; and the development
of the English country house owes much to investment in building made by
shrewd but not over-ambitious lawyers, who made fortunes in the courts and
then moved out to establish or enhance their families' standing in the
country. Richard Brownlow, who bought the Belton estate (near Grantham,
Lincolnshire) between 1609 and 1619, was a bencher in the Temple and for
forty-seven years Prothonotary to the Court of Common Pleas, a position
then paid at £6000 per annum (say £¾m today). His two surviving sons, John
and William, were both made baronets in 1641, but, after the Roundhead
victory at Grantham, maintained a cautiously Parliamentarian position. Sir
John had no children but late in life adopted his great-niece Alice Sherard
and 'educated and maintained' his brother's grandson, another John, who
had in 1668 inherited the second baronetcy. To old Sir John's delight these
two 'affected one another' and were married in 1676. In 1679 they jointly
inherited Belton and set about making visible use of the family fortune. They
bought a London house in the newly built Southampton Square and in 1684
began to rebuild the old manor at Belton on a scale appropriate to the richest
family in Lincolnshire.

But Belton House, at once noble and domestic, unostentatious yet
sumptuous, is not a palace, and in the 1680s was in no way revolutionary.
Neither was it old-fashioned, and the use of sash windows shows a designer
in touch with the latest technology. Belton – especially now that so little of
Roger Pratt's work survives – stands out as the apotheosis of the opulent but
seemly and reticent style of the Caroline gentry, to which Pratt (for whom see
pp. 80–82) had given the perfect architectural form. It is indeed a smaller and
quieter version of Pratt's short-lived but influential Clarendon House,
Piccadilly, pulled down the year before Belton was begun; the architecture of
Belton is well within Pratt's range (though it was certainly not by him),
simply adding hipped wings to a reduced replica of the façade of Horseheath
Hall, Cambridgeshire, where, as at Coleshill, the principal rooms at the
centre of the house were given outward expression by widelier spaced
windows but in addition the middle bays projected and were crowned with a

Belton House.

broad pediment. This is the Clarendon formula, but Belton is much simpler
in its detailing; and the projecting hipped wings, and surprisingly the
pediment also, give its façades a genial and relaxed air missing in the austere
dignity of Coleshill. Curiously, symmetry is disrupted on the secondary
façades to east and west, for – presumably to allow adequate space for the
chapel – the wings project further to the north than the south, and the
crowning balustrade consequently appears off-centre.

The plan, therefore, is an H. Its centre is a six-room double-pile rectangle,
all of whose internal walls are structural, thus imposing a formally identical
plan on both floors; unlike Coleshill, Belton has a single continuous spine and
hence no corridor: the principal rooms are entered sequentially one from
another. Only the very centre of Coleshill was fully public – hall, great
parlour and great chamber – and each corner of the house, on each floor, was
designed as an apartment of one chamber and two subsidiary rooms. Belton
seems originally to have had two, or possibly three, apartments on the ground
floor, but all were in the wings, leaving the whole of the seven-bay centre free
for public rooms – hall and great parlour in the middle, separate great
staircase (secondary staircases are in the wings), and three further rooms, one
of which was probably a library. As at Coleshill, the great dining chamber
was on the first floor, and here there may have been two more withdrawing
rooms.

A plan of such character and scale points to an elaborate and fairly formal
social life as would befit the High Sheriff of the county: once William III
dined at Belton, where he invited Lady Brownlow to sit with him, while Sir
John waited on them: the King is reported to have been highly gratified and
to have somewhat over-indulged himself. But there can't ever have been a

question of his staying: Belton is not a courtier house, and its formal design
and layout indicate rather the stately style in which the Brownlows
themselves lived. Internal arrangements have been altered several times, and
it isn't possible now to identify all the rooms referred to in inventories, made
in 1688 when they moved into their new house and again ten years later. It is
clear, however, that the Brownlows, with their large family, including five
daughters and at least two Sherard relations in residence permanent enough
to have rooms named after them, used the house to the full. Though the 'best
bedroom', with a drawing room attached, was presumably kept for
distinguished guests and though the great parlour and dining room may not
have been used every day, there was no state suite in the sense of rooms
reserved for state occasions. But the arrangement of the rooms ensuite
enabled Belton to be used as what was later called a 'circuit house', in which,
when company was present, circuits of more or fewer rooms could be opened
simply by opening or closing connecting doors. Service rooms were all in the
basement or in a free-standing office range, though the kitchen (in the north-
west wing) may have been two-storeyed like the chapel. The main body of
the chapel, where the household would gather, is at basement level; its simple
wainscot contrasts with the lavish family gallery above: a formalised version
of the medieval family's segregated pew. There may have been thirty or more
staff living in, with bedrooms in the basement, attic or office wing.

The Queen's Bedroom, so named since Queen Adelaide slept there.

Belton's sober, golden exterior, whose elegance is achieved solely by good proportion, finely crafted stone and restrained ornament, is matched inside by rooms where originally a darkish wainscot prevailed, laid out in conventional bolection-framed panels. Surprisingly oak seems to have been little used: the great parlour is of red cedar, and the other surviving rooms of deal, formerly grained to resemble oak. Apart from an increasing collection of pictures and sculpture (most is now neo-classical), the chief decorative features were elaborate plaster ceilings, carved limewood overmantels, tapestries, and in two rooms 'marbling' – wainscot painted to imitate coloured marble.

Visitors should, however, beware: in addition to the easily recognisable recasting of rooms by James Wyatt in 1776–7 and Jeffry Wyatville in about 1810, the third Earl Brownlow carried out a conservative but extensive scheme of restoration in the 1870s, which included some remarkably convincing seventeenth-century pastiche. The ceiling of the great parlour is too coarse and repetitive to be mistaken for the real thing, but the tapestry

The Tyrconnel Room, with 18th century Dutch painted floor depicting the family coat of arms.

room ceiling (1879) is scintillating. The chimneypieces in their present form
are obviously made up, of marble and slate that do not always match. Most
deceptive of all is the carving: two hands were almost certainly at work in the
1680s, but much was added by W. G. Rogers, whose experience as a restorer
enabled him to make uncannily convincing imitations, some of which may
actually be inserted among original work.

Belton was built by William Stanton (1639–1705), one of several
generations of a family of London-based masons. He received £5091, which
paid not only for the main structural work but specifically for carved
chimneypieces and decorative cornices: Stanton combined the business of a
mason-contractor with work as a carver and statuary, whose numerous
monuments include sensitive portraits with delicately cut drapery. One, not
among his best, is in Belton church, to 'old' Sir John and his wife – demi-
figures rising from a tomb within an architectural frame, whose form, an
aedicule topped by a broken segmental pediment, was repeatedly used by
Stanton and appears with coupled columns in the colossal marbled wooden
reredos – much too big for its place – in the chapel. Nothing of this suggests
that Stanton was capable of designing Belton. John Sturges, also in the
accounts, no doubt designed the stable block, closely similar to his larger
group at Milton Hall, Peterborough, but he too was not in the Belton league.
Pratt seems to have given up designing by 1670 and is nowhere mentioned in
connexion with Belton. So the best name seems to be that of William Winde
(d.1722), gentleman architect involved in several aristocratic houses in the
later seventeenth century, including Combe Abbey, Warwickshire, which
bore a striking resemblance to Belton. Winde certainly knew Belton well by
1690, though it has to be said that no other house in which he is known to
have been engaged has anything like the structural coherence and social
fluency of the Belton plan.

In 1690 Winde called Edward Goudge 'the best master in England in his
profession'. His work is the climax of the native tradition in seventeenth-
century plasterwork, in which geometrical patterns, originally expressing the
layout of ceiling beams, are enriched by deeply undercut rolls, wreaths and
festoons of fruit and foliage, sometimes populated by animals or cupids, and
alternating with lower-relief swirls in which acanthus leaves predominate.
Laurence Turner identified the chapel ceiling at Belton as the finest example
of its kind, 'a liberal education in the art of modelling' in which 'crispness is
obtained without hardness and shadow without instability'. The plain central
panel floats within its deeply moulded frame whose undulating profile is
defined by alternating concave and convex segments enclosed within dense
wreaths of fruit – at once breathtakingly light and rich. The staircase ceiling
is almost as good, just a little harder in outline, but the silky sinuousness of
its acanthus moulding is unmatched.

The best of the carving is of the same quality – undercutting of amazing
virtuosity, detail of unsurpassed fineness, an unending fertility of invention.
The west overmantels in the hall and great parlour and the centrepiece in the
chapel gallery are worthy of Grinling Gibbons and may indeed be by him,
though his name does not appear in the (incomplete) accounts, and the
remarkable skill of several provincial carvers in the same tradition is now

acknowledged. The otherwise unknown Edward Carpenter made at least three overmantels at Belton. A 'very rich chimneypiece . . . done with a variety of fish and shells with birds, foliage, fruit and flowers' – once in a drawing room – is identifiable as that now over the east fireplace in the hall. Its rather pedantic symmetry noticed by David Green may have been exaggerated by additional trios of fish presumably inserted by Rogers to make it correspond in size to the 'Gibbons' overmantel to the west. The crowning double acanthus scroll, a hallmark of Gibbons's art, is stunningly fine, but the rest of Carpenter's work is a little more ponderous and stodgy.

The presence of London craftsmen at Belton prompts brief comparison with Sudbury, Derbyshire, a house of similar social standing, begun by Sir George Vernon in 1660 but not finished till thirty years later. Its architecture – almost certainly by Vernon himself – is a rather cranky mixture of the conservative and the idiosyncratically different; the plan incorporates a vestigial screens passage with off-centre great hall, and the main rooms are simply stacked back to back with a partially coherent circulation only in the more public half; upstairs is perhaps the last of the genuine long galleries. Yet in the 1670s Vernon brought in London craftsmen – Edward Pierce and Gibbons for the main carving, Bradbury and Pettifer for plasterwork nearly as elegant as Goudge's though far less inventive. By adding ceiling paintings by Louis Laguerre, Vernon overleapt Belton into the baroque: Sudbury is a curious case of an old-fashioned provincial house forced by weight of decoration into a modern metropolitan world; Belton is the unified expression of a settled civilisation, even though one which turned out to be on the point of passing.

The 1688 inventory reveals that almost no furniture was kept from the previous house: everything was new and in the current taste, with a special liking for japanning and gilt and many 'seeing glasses'. Many pieces are still in the house; but it is part of Belton's charm that the Caroline atmosphere has been able to absorb changes of taste which nevertheless found space to leave their mark: the sense of a continuing family house, respectful of tradition but awake to contemporary movements, is very strong. In 1691 Sir John commissioned two large tapestries from John Vanderbank, at the top of his craft as chief arras-worker of the Great Wardrobe: they are designed 'after the Indian manner' and show oriental vignettes arranged like wallpaper without spatial relation – not at all sombre but in accord with a taste for black oriental lacquer which Sir John's nephew and son-in-law, Viscount Tyrconnel probably did not share. Still, he left them in place and had another set woven in a newly fashionable vein – huge colourful scenes after moralistic paintings by Le Brun telling the story of Alexander and Diogenes the Cynic: the wealthy have always enjoyed fictional displays of disdain for the vanity of worldly greatness. Furniture likewise changed only gradually, and enough remains to show that the early Brownlows went for quality without ostentation, but liked variety and novelty: the large set of late seventeenth-century chairs (now gilded and their backs partly upholstered) is characteristic – intricately carved with openwork panels of acanthus among which amorini nestle. The state bed, a half-tester eighteen feet high with a headboard of damask organ-pipes, is a more flamboyant gesture in the same

Belton House chapel ceiling, by Edward Goudge.

Walnut bureau-cabinet (c.1715) in the Blue Bedroom.

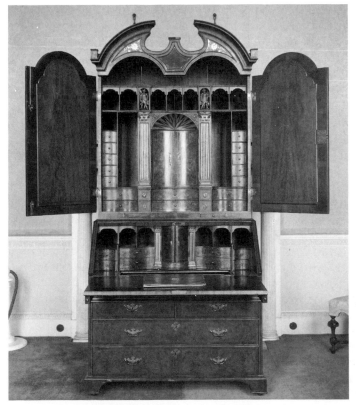

spirit. Going round the house gives a sense of superlative workmanship in furniture which looks simultaneously sturdy and elegant, intelligently designed for use but with a rich patina of marquetry or other inlay which looks much more than skin-deep and inspires confidence that each was designed also to last. There are one or two Boulle pieces (and, later, Louis XV), but most are English. Surprisingly the inventories include no musical instruments, and none from before 1800 is now at Belton, though a William Hill organ was installed in the chapel in 1826.

The Brownlows have never been short of pictures: the first inventory mentions forty-three on one staircase alone. They were probably family or royal portraits, and a tradition of family portraiture was kept up, culminating in Lord Leighton's hauntingly wistful evocation of the last Countess. Young Sir John and his wife were painted by John Riley with another pair of his brother and sister-in-law. Like the coy overmantel portraits of two of his daughters by Henry Tilson, they have always formed part of the furnishing of the great parlour, nearly filling the large wainscot panels, but are much more than family background – imbued with the resigned penetrating melancholy well known in Riley's portraits of servants in the royal household. Godfrey Kneller later also painted Lady Alice, an unusually thoughtful study perhaps influenced by Riley's.

As well as being duly displayed in full robes by Charles Jervas, Lord Tyrconnel, a characteristic Georgian dilettante, began collecting: books, oriental ceramics and what were then thought of as the best works of the old masters – typically, mannerist Italian and Dutch paintings of the seventeenth century. But the Guercinos and Marattis and van Dycks were never more than attributions. Reynolds painted a brooding portrait of Sir John Cust, the luckless Speaker of the House of Commons who died of fatigue induced by the strain of office during the reign of John Wilkes. In 1879 very different pictures transformed the one-time library into the Hondecoeter room, lined with enormous idyllic garden scenes by the seventeenth-century Dutch master in which nature and all activity seem petrified into eternal stillness as on the grecian urn. But the most fascinating picture in the house is its own portrait done soon after completion in an engagingly naïve but anatomically accurate manner, apparently by Henry Bugg, the house porter. Behind a hunt with Noah's ark animals stands Bugg himself, proprietorially with his staff of office. He looks about twelve feet tall, but the careful painting of the house makes the picture historically most valuable.

Lord Tyrconnel was the last Brownlow of Belton to bear the family surname: when he died in 1754 the estate passed to his widowed sister, mother of the Speaker, whose son revived the old name when, in honour of his father's services, he was created Baron Brownlow. The barony was raised to an earldom in 1815, but after the third earl, who did so much to safeguard and foster the house, the direct line again failed and the title reverted.

In 1776 James Wyatt removed the balustrade, cupola and belvedere (later replaced by the third earl) and trimmed the south front in the interests of neo-classical purity. Inside he redesigned several rooms, most strikingly the dining chamber, transformed into a grand drawing room (since 1879 the library), and Lady Brownlow's boudoir, whose flat trompe-l'œil ceiling suggests

Belton House, painted in 1689 by its porter, Henry Bugg, soon after the house was completed.

from some angles a shallow saucer-dome and from some a strange curved sheet suspended at the corners to reveal glimpses of a circle of fat green books. The drawing room ceiling is equally fastidious – an elliptical vault of super-low-relief panels staked out with aetiolated classical arabesques: the Etruscan style reduced to a filigree diagram. Wyatt's nephew Jeffry Wyatville invented the white and gilt decoration of the staircase and the red drawing room, a mechanical exercise in the direst neo-classical mode. His also is the orangery whose severely rectangular façade reduces classicism to its bare structural bones.

To complement the house Belton was surrounded by formal gardens. A paved court to the south was divided into four squares each with a statue in the middle; to the north intricate parterres centred on an obelisk in the middle of a small round pond; to the east a long rectangular canal divided an elaborate formal 'wilderness' of straight walks between miniature plantations. Lord Tyrconnel smoothed two parterres into lawns, filled in the canal, built garden buildings including a dinky Palladian summer-house and a tower (later known as Lord Brownlow's breeches) from which to view seven counties, added a wilder picturesque widerness complete with 'awful' rock-faced cascade, and extended the entrance court into a large oval. This meant moving the superb wrought-iron gates attributed to John Warren, with their wonderfully daring overthrow incorporating the Brownlow crest – perhaps those now leading into the office court, though traditionally the Lion gate at the park entrance was once by the house. The formal gardens

Bird's-eye view of the gardens at Belton, from Vitruvius Britannicus.

The west forecourt, seen through gates by John Warren.

gradually disappeared, until the third Countess recreated some formality by planting geometrically trimmed Dutch and Italian gardens where the old parterres had been.

These separate the house from the village church, which has through two and a half centuries become a Brownlow mausoleum, so crammed is it with their monuments – a visual history of English sculpture from the mid-seventeenth century to the late nineteenth, with examples from all styles – artisan mannerism, baroque, the serious rococo, neo-classical and gothic revival. Some, like the wall tablets by Edward Stanton and Christopher Horsnaile, are variations on a standard pattern; other, including Henry Cheere's to Lord Tyrconnel and most especially William Tyler's to Speaker Cust, are moving and pathetic works of art. The church, packed with marble aides-memoire of the long sequence of a family's life, should be the solemn conclusion to any visit to Belton.

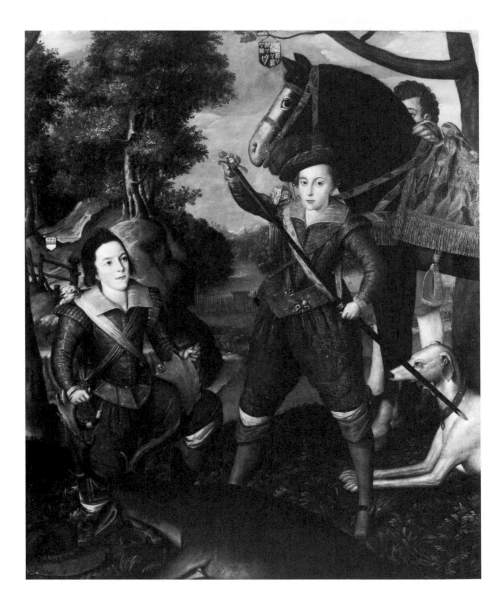

Robert Peake, Henry, Prince of Wales and Robert Devereaux, 3rd Earl of Essex, in the Hunting Field *(c.1606)*.

8 Painting: from Astraea to Augustus

JOHN MURDOCH

The Protestant problem with images

The word of Moses was clear and the penalty for breaking the Second Commandment terrifying:

> Thou shalt not make unto thee any graven image, or any likeness of any thing that is in heaven above, or that is in the earth beneath, or that is in the water under the earth; Thou shalt not bow down thyself to them, nor serve them: for the Lord thy God am a jealous God, visiting the iniquity of the fathers upon the children unto the third and fourth generation of them that hate me.
>
> (Exodus XX, vv. 4–5)

These were the words of the King James Bible, the text authorised for use throughout the kingdom. As the Dedication of this Authorised Version makes clear, the decision to press forward the great work of translation had been a priority for the new government, an essential statement that the polity established under Elizabeth would be maintained and strengthened. The Bible, a text to be read out publicly in churches in a language intelligible to all, was thus a foundation for that common sense of belonging in a state possessed of a spiritual and ideological purpose.

The Dedication referred to Britain as 'our Sion', and Protestant Englishmen could thus think of themselves as children of Israel, having a direct relation to God as the chosen people, and having direct access to God's word through the Bible unmediated by a priesthood which owed a separate allegiance to a foreign power. For them especially the Bible was an inescapable text and Englishmen loyal to Church and State had therefore to think hard about the meaning of the Second Commandment, an ordinance ranked second only to that enforcing God's primacy.

Pictures therefore were not an easy subject for the English; those that were not demonstrably idolatrous were at best indifferent, empty or vain, and might be purged. It was only because certain sorts of image were discovered to be useful and provided the only or most viable means of articulating certain aspects of ruling class ideology, that they exist at all in the period we have to consider.

The story of Protestant iconoclasm in Britain is often referred to and has been told as a sort of spasm, a profoundly destructive and anti-cultural movement, an episode of reaction against the progress otherwise represented in our island story. The destruction of religious sculpture in churches and the partial dispersal of the pictures collected by Charles I seemed shocking in the nineteenth century, in a social climate of Catholic Emancipation and of One Nation politics. And still, when presented within the rhetorical context of the National Heritage, the destruction has power to embarrass discussion of the forces that actually produced in those years a distinctively British visual culture.

For the debates about images in the sixteenth and seventeenth centuries defined the basis on which images could be permitted and on which they could be recognised as playing a central role in the life of the state. In synthesis, they led to the secularisation of art, to its removal from churches to palaces and great houses, and from the realm of faith to that of the élite intellect. Almost at once in the sixteenth century the debates on images led to the massive preponderance of portraiture over other forms of art, and their terminology leads on in the longer run to the pietistical naturalism of the Romantics. Even the tougher iconoclasts like Bishop John Hooper of Gloucester had proclaimed a reverential attitude to the natural world because it could be read, as it were typologically, as a register of the spiritual. He allowed, for example, that the Resurrection could be figured, not by man-made images, but 'by the grain of the field that is risen out of the earth and cometh of the dead corn that he sowed in the winter'.

The Puritan dislike of art because it circumscribed reality and put a limitation on the tangible miracle of God's abundance, had its corollary in

Peter Lely, Elizabeth Hamilton, Countess of Gramont *(c.1663)*.

Cornelius Jonson, Sir Robert Dormer *(1642)*.

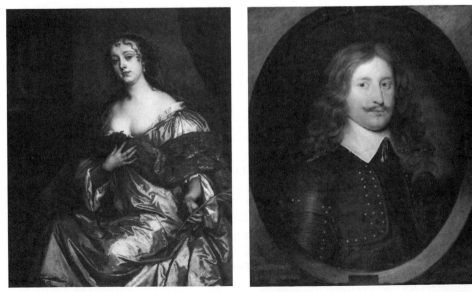

support for an art that celebrated this miracle, and took worship finally out of the Church altogether and into the mountains and fields. Of course there were many elements to that cultural synthesis – the idea of mountains and fields as in the realm of intellect and culture at all depends on the educated Englishman's long meditation on the Virgilan tradition – and it can be helpful to remember also that the period we are discussing, as part of the British Renaissance, exists for us palpably only through the formal language of Classicism.

The image of the monarch

Renaissance and Reformation: at times it seems as though the crises of social transformation in the sixteenth and seventeenth centuries are contained in elisions like that of the Virgin Mary, her image removed from churches, into Elizabeth, who had a half sister called Mary (whom she succeeded); but here Elizabeth was the Virgin, and she appeared to her subjects as Astraea, the Goddess of Justice. There seems to have been a beauty and an aptitude in this transformation of Elizabeth into a Roman Goddess, whose persona had a clear authority and association with a fundamental royal virtue. The extreme confusion, on the other hand, that was possible in the general perception of Authority when its image was muddled with that of the pre-Reformation Marian cults was obvious:

So there are two excellent women, one that bare Christ and another that blessed Christ; to these may we join a third that bare and blessed him both. Elisabeth bore him in her heart as a womb, she conceived him in faith, she brought him forth in abundance of good works . . .

Unsurprisingly, Elizabeth had moved to control her image, mindful that a large element of her support came from those, like Bishop Jewel, who were wary of pretensions to divinity in the image of the Monarch. So the Queen's iconography at its most coherent was based on classical typology, her virginity celebrated by reference to the sieve, the attribute of the Vestal Tuccia (who proved her virginity by carrying a sieve of water to the Temple of Vesta without spilling a drop); by reference to the crescent moon (attribute of the queen and huntress chaste and fair, Cynthia or Diana); to the Eglantine, Phoenix or Ermine.

James of course was a different matter: hailed as the sun who rose on the setting of 'that bright Occidental Star, Queen Elisabeth, of most happy memory', he was greeted on his entry into London in 1604 with a series of triumphal arches erected throughout the City, as Caesar Imperator. The early Jamesian iconography, like that of Henry VII and VIII, stresses the element of the blood line, both as conveying legitimate descent and as offering hope for the future. The line is set forth at length in the great *Baziliwlogia A Booke of Kings . . . from the Conquest untill this present* (1618), and the specifically Protestant construction of the history that he fulfills and presides over is told in the *Herwologia* (1620), a visual compendium of the makers and martyrs of the Anglican Settlement equivalent to Foxe's *Actes and Monuments* (1563).

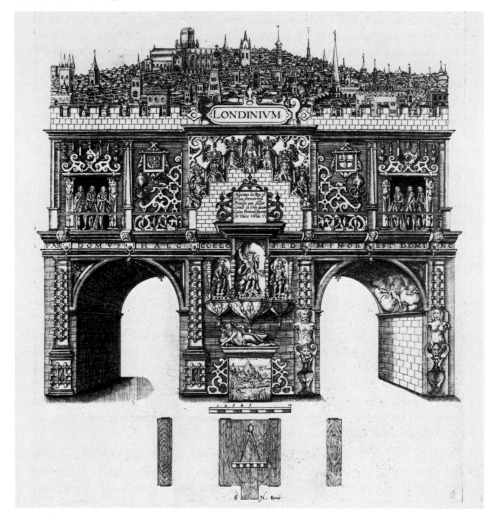

From Stephen Harrison, The Archs of Triumph . . . *(1604). One of seven temporary triumphal arches erected to honour James I on his arrival in London.*

The image of Prince Henry, the marvellous boy, *uomo universale* of his generation, is the famous one of him exercising with the pike. It is followed poignantly by the image of his hearse. There are Thomas More, Wolsey and Thomas Cromwell after Holbein, Essex and Sidney, Tyndale, Cranmer, Latimer and Ridley, Drake and Frobisher. They make up the true line of secular and spiritual legitimacy, real heroes rather than plaster saints. Elizabeth herself is there as Sovereign, framed by a niche, carrying her orb and sceptre, an old woman with the light falling across her sunken cheek and temple, mortal rather than divine. English reformers were acutely aware of the example of the Byzantine emperors who had promulgated iconoclasm as a defence against idolatry, but who had then substituted their own images for those which had been abused. Both the *Baziliωlogia* and the *Herωologia* seem framed to avoid this risk.

For James inherited the kingdom from a monarch whose magnificent utterance on being confronted by the Marian Abbot and Chapter of Westminster, bearing torches, incense and holy water at the state opening of Parliament in 1560, had been: 'Away with those torches, for we see very well.' And this was the same Elizabeth who told her court limner Nicholas Hilliard (1537–1619) to take her likeness in the 'open alley of a goodly garden', so that the bright light of heaven could show her features without the obscurity or exaggeration of chiaroscuro.

This her Majestie's curious demand hath greatly bettered my judgement, besides divers other like questions in art by her most excellent Majestie.

Elizabeth was not, as her father may have been, soft on images, sentimentally attracted to the accoutrements of the old liturgy. No, here we see the sovereign at the head of her élite, beginning to see a use for painting in its capacity to tell the simple truth: 'For Beauty and good favour is like clear Truth, which is not shamed with the light, nor needs to be obscured.'

Now, in the historical moment of 1600, this was an idea that 'belonged' to Puritans, and tended to separate them from high churchmen with their greater interest in the imaginative power of mystery and symbol. So, as in the case of images of the natural world, one is beginning to see how puritan intellectuals, instead of at best despising painting as a waste of human effort, could see in it a powerful means towards useful knowledge. If painting were freed from its service to idolatry – if painters unmistakeably abjured – in the words of the 1559 Articles – all kind of expressing God invisible in the form of an old man, or the Holy Ghost in the form of a dove, then it could take its place amongst the ordinary secular activities of intelligent men, like those addressed in Peacham's *Compleat Gentleman* (1622).

So iconoclasm, if I am right, was the means not to the destruction of painting but to its re-habilitation and inclusion within the high-caste activities of the Renaissance-Reformation state. Capable of endowing the government with the visible mantle of Roman legitimacy, painting could also make an address *in plain language*. It could concentrate the powerful rhetoric of verisimilitude, of exactness, accuracy and Truth to Nature, in the discourse of government to its citizens. In the effort to present political authority as natural, to show it, as James and Charles I wished, as an emanation of God's power on the same level of inevitability as any other ordinance of the Creation; or to show it (in Hobbes's famous image of the sovereign as Leviathan) as the fulfilment of the Laws of Nature, the capacity of the painter to project the image of the monarch and the political élite in this guise of Truth and Nature was of fundamental utility.

The royal family

When James, an immensely intelligent man, was offered a Triumph on his entry to his new capital in 1604, he knew that the most brilliant triumph of his accession was the unification of the two ancient enemies, England and Scotland. He saw himself as a peacemaker, as judge, and we shall see later

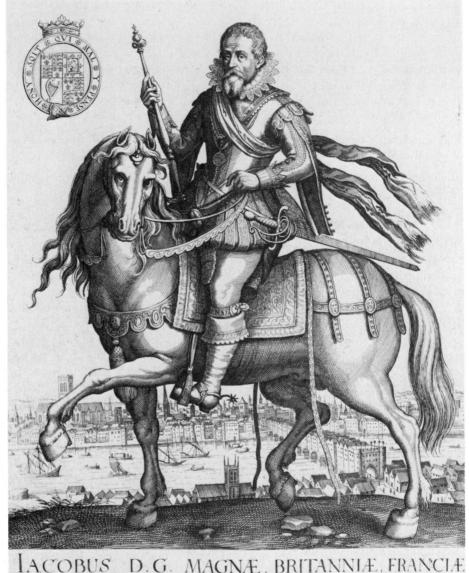

Anon, James I as Marcus Aurelius *(1621)*.

how these themes, which his iconographers began to develop on his behalf as
soon as he arrived in London, issued in the great images of him as the new
Solomon in the Palace of Whitehall after his death.

Meanwhile we need to distinguish another aspect of his public persona
which differed from that of his Virgin predecessor and which impressed itself
on contemporaries. With James, his domestic life and pastimes, his off-duty
self, become part of the publicly visible 'style' of monarchy. A scholar and
(perhaps) a Magus by ambition,

William van de Passe, James I as Solomon, *title page to* A Thankfull Remembrance of Gods Mercie, *by George Carleton (1624).*

those formalities of state which set a lustre upon Princes in people's eyes, were but so many burthens to him: for his private recreations at home, and his hunting exercises abroad, both with the least disturbance, were his delights.

For the first time in English history it is probably right to think of an entity called 'the royal family', the means of enlisting into the ideology of monarchy a set of parallel notions, profoundly established in religious and secular culture, concerning Patriarchy. Patriarchy naturalises monarchy, as it were, by likening it to fatherhood, naturalising political hegemony by analogy with the biological predominance of the male, and making dynastic pretensions concrete in the image of real children. Part of its persuasiveness, its power as an instrument of political imposition, was its acceptability among the great families, whose own social authority was in turn legitimated by its image.

So the 'royal family', made up of parents and children, all separately valued as individuals in a personal as well as a political dimension, was an important invention of the Stuart monarchy: James and his queen, the gifted Anne of Denmark, the precocious Henry Prince of Wales, and Charles the slow developer overshadowed by the brilliance of his elder brother and sister Elizabeth, the future Queen of Bohemia. The rise of 'affective' relations between parents and children, the tendency for parents to increase the 'investment' of love and care in individual children, was related to improved life expectancy in the seventeenth century.

From the 1590s portraits probably by painters such as Robert Peake (*c*.1551–1619) and Isaac Oliver (*c*.1565–1617; colour plate 3), who both became close to Anne of Denmark, record the faces of children, the scions of grand families, as real little people to care about. Gheeraerts the Younger (1561/2–1636) paints the Countess of Leicester with six of her children in 1596, the same year as Lady Wentworth appears with three of hers and

Isaac Oliver (l to r), Henry, Prince of Wales *(miniature, c.1612?)*; Charles as Prince of Wales *(miniature, c.1613?)*.

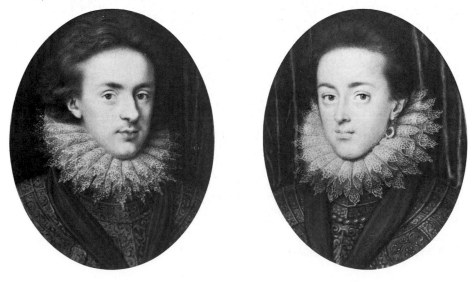

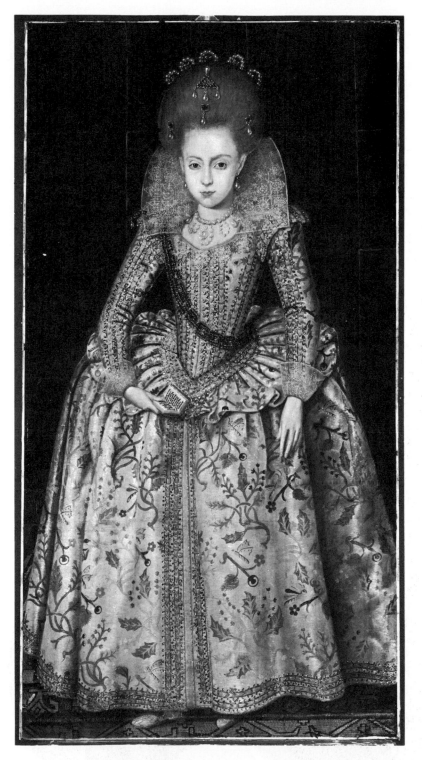

Robert Peake, the Elder, Princess Elizabeth *(c.1600–5)*.

perhaps a fourth on the way. The images of the Princes Henry and Charles and of Princess Elizabeth by Peake, from 1603 to about 1605, fit easily into this context and lead on to such famous images of Henry as a vigorous eleven year old *c.*1605, out hunting with a companion and about to give the *coup de grâce* to a stag lying at his feet. Henry's sudden death in 1612 was not only a political catastrophe but a genuine family tragedy. Charles took on his brother's dynastic role as heir apparent, Prince of Wales, slipping into the same costumes and poses virtually unchanged until, in the early 1620s, he began to impose his own strong character on the making of his image.

Pictures in the seventeenth century were not part of a closed apolitical discourse of Culture. For monarchs especially the distinction between public and private was either non-existent or indefinite, and it is possible to see in some of the uses of pictures in court circles a movement towards the public advertisement of areas of the great man's life previously concealed. The admission to the visual record of infant members of the family marks, as I have suggested, one of the great sociological changes of the years around 1600. But with Charles's family, when the time came, what had been a fairly cautious promotion of the Royal Family became a virtual epithalamion, a hymn in celebration of marriage and fertility.

Daniel Mytens (*c.*1590–1647) and Anthony van Dyck (1599–1641; colour pls. 7 and 11) both celebrate the great festivals of family life, from the nuptials of Charles and Henrietta Maria, their idyllic outings as a happy couple to the chase, to the birth and childhood of the second prince Charles with his four siblings, James, Mary, Elizabeth and Anne. Not probably until the cult of the royal children in the present century has the face of every

Anthony van Dyck, Five eldest children of Charles I *(1638)*.

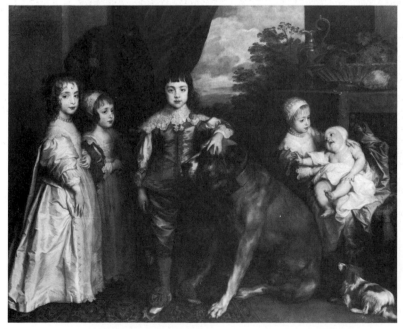

Anon, The Betrothal of Charles I and Henrietta Maria *from George Marcelline's*
Epithalamium Gallo-Britannicum.

member of the royal family been so thoroughly published, been made collectively so much an icon of virtuous fecundity for the edification of the subjects. It remains a puzzle that James I, unlike his favourite Buckingham, availed himself relatively little of this potent form of dynastic self-protection: perhaps a technical answer may have some force, that simply the compositional problems of the great group portrait were beyond the skills of the painters available to the court until Mytens was hired. By the 1630s the idea of memorialising the family on the walls of the state rooms of the house had currency also amongst the great aristocrats. There is no more breath-taking nor instantaneously convincing image of courtly and civic virtue than that by van Dyck of William Herbert Earl of Pembroke surrounded by his family in the Double Cube Room at Wilton House in Wiltshire (colour pl. 11).

Immigrant painters

After 1617, with the death of Isaac Oliver and Nicholas Hilliard, the painters of the Jacobean court who had been members also of a wider community of musicians, jewellers and other court artificers were replaced by a group of experienced court painters from the Netherlands, Abraham van Blijenbergh (1617–22), Paul van Somer (c.1576–1621/2) and Daniel Mytens (c.1590–1647). In spite of the Dutch origins of the painters brought over during the lifetime of the Queen and their connexions with the Orange court at The Hague, van Somer's portrait of the Queen (1617), pausing from the chase within sight of her palace of Oatlands as her greyhounds leap excitedly up at her, simply provides an extra, brilliant dimension to the familiar Jacobean ethos. With its Italian motto 'La Mia Grandezza dal Eccelso' ('my greatness comes from the All-Highest'), and the view of the gateway recently completed for her by Inigo Jones, it seems to predict the Arcadian imagery of the 1630s. It is a natural sequel to Peake's great image of her dead son at the chase.

Mytens's first employment was to paint a series of the King's Scottish and English forbears, and on him Charles was clearly an increasingly strong influence. What we instantly recognise as a distinctly Caroline iconography dates from c.1622–3, when Mytens began a regular production typified by the magnificent full-length of the Prince of Wales dated 1623, still in the Royal Collection.

What had happened in 1623 was the visit of Charles and the Duke of Buckingham to Spain in order to seek an alliance of marriage with the Infanta. This journey, though in a sense a natural continuation of James's vision of his role as peacemaker, was a shock to the British polity, more especially to British Puritans. In Spain Charles was exposed to the sight of the Hapsburg Catholic autocracy at its most intoxicating. He experienced an image of monarchy rendered absolute by Titian, Velasquez and Rubens.

In Madrid, word reached him that certain great pieces from the hand of Raphael were on the market, cartoons for a series of tapestries commissioned by the Medici pope Leo X in about 1514 for the Sistine Chapel. Decorated with borders celebrating the spiritual and secular accomplishments of the Medici, the tapestries showed the Acts of St Peter and St Paul, the two fathers of

Paul van Somer, Anne of Denmark *(1617)*.

Christendom. For a Prince concerned to establish a framework of legitimacy for his own prospective headship of Church and State, the Raphael Cartoons were of immense potential significance. Reproduced again as tapestries under the supervision of Francis Cleyn (1582–1657/8) at the new Mortlake Works, they would spread their message throughout the kingdom.

In Spain also, Charles saw how a monarchy gained power and prestige by presenting itself in a setting of the great defining myths of the civilisation. 'History' paintings, single unified images that made mythology into a tangible

Daniel Mytens, Charles I as Prince of Wales *(1623)*.

Raphael's influential Beautiful Gate of the Temple *(1515)*.

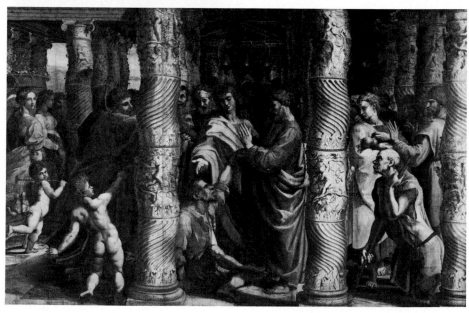

commodity, made it available also for ownership by the great and apt as a display of wealth and power. Like his brother, his master . . .

Charles, with his brother, his mother and a considerable circle of courtiers, was already what we now call a connoisseur and a collector and had been well aware from childhood that Art was part of the aura of kingship. But his experience in Spain transformed a relatively private scholarly activity into a

major initiative of public policy. From the moment of his return, when he must have been briefing Mytens on what he wanted, his imagery of himself was calculated to state over and over again both his personal authority and his membership of the European élite. Hence his tall, suave, black-clad figure in the version of the 1623 portrait intended for Don Carlos de Colona, the new Spanish Ambassador in London. And hence, as the portrait idiom developed and freed itself from the instantaneous effect of the Spanish experience, the Caroline iconography expressed an increasingly formidable and generalised image of the aspirations of European princes in the Age of Absolutism.

Rubens's Whitehall ceiling

Without doubt the supreme statement of Jacobean-Caroline aspirations was the ceiling painted in the Banqueting House of Whitehall Palace (colour pl. 2). The artist was Peter Paul Rubens (1577–1640), and the first reference to it comes in a letter of 1621 he wrote to Prince Charles's agent in Brussels: 'regarding the hall in the new palace, I confess that I am, by natural instinct, better fitted to execute very large works than small curiosities'. In Rubens, Charles found an instrument of very much greater potential than Mytens, greater even, it must have seemed, than van Dyck, because Rubens had been van Dyck's master.

Rubens was from Antwerp, living there in preference to Brussels which was the capital city of the Spanish Netherlands. He was a Catholic, court painter to the Archdukes Albert and Isabella, and widely regarded around 1620 as the most grandiloquent painterly apologist of counter reformation theology in Europe. Rubens can have had no easy sympathy for the requirements of an English Protestant monarchy. Though a subtle diplomat, probably coached by Inigo Jones, Ben Jonson or William Davenant, he would have found it difficult even to learn the peculiar iconographic language of the English court. On the face of it he was a curious choice, politically provocative, and expensive beyond the means of the Stuart monarchy to pay. The commissioning of the Whitehall ceiling has usually been treated, therefore, as a brilliant anomaly, an event to be explained almost purely in terms of Prince Charles's personal connoisseurship and love of Art. But like his purchase of the Mantua pictures, of the Raphael and of the Mantegna Cartoons, like his patronage of the masque and of the theatre and his planned re-construction of Whitehall, the commissioning of the Banqueting House ceiling was a central part of Charles's political project; not a compensation for his general ineptitude but, if ineptitude it was, one of its most forceful manifestations.

There are three major panels in the ceiling. The first, visible from the throne, shows the heroic figure of James I, cast as Solomon, giving judgement between two women who appear before him, as it were in contention over the infant between them. These women are England and Scotland, and James's wisdom exceeds that of Solomon in that he achieves resolution of the conflict not through division but through unification and

peace, as the Child triumphantly tramples down the heap of redundant armour piled up to fill the chasm that separates the kingdoms; on the heap a *putto*, a small child, extinguishes the light of battle. Behind the women, placing a crown on the head of the Child is a Goddess in the role we have become accustomed to consider as that of Astraea, whose arrival precedes that of the Child. The Child is of course Prince Charles, but the Astraean virgin in Rubens's ceiling is not quite her familar self, but is the other virgin, Minerva or Athena, goddess of Wisdom, who armed Hercules for his Labours but who also, as patroness of the Arts of Peace, made the olive tree grow on the Acropolis and adopted its branch as her sign. For James the scholar, the association with Minerva was especially appropriate. On each side of the central panel, subsidiary canvases have Hercules battering Envy with his Club, and Minerva, accompanied by her owl bearing an olive crown, driving Ignorance into the depths with a long stick.

Visible to those approaching the throne from the other end of the Banqueting House, the principal panel shows James seated on a throne, set between spiral Solomonic pillars (modelled on the supposed relic of the Temple of Solomon held at St Peter's in Rome). Solomon as the teacher and judge was an Old Testament ante-type of Christ, and his Temple was the ante-type of Christ's Church on earth. James in this image, with breath-taking hubris, is presented as the modern Solomon-Christ; below the throne Minerva with her *aegis* or shield drives a torch-bearing figure of War into the abyss, and Mercury or Hermes, a god associated especially with commerce, prods at the defeated with his *caduceus* (a wand, with two serpents twined round it). On the ledge of the throne, under the King's sceptre and subject to a powerfully discriminatory gesture of protection, the ample figure of Peace embraces Plenty, with a Cornucopia spilling over between them. The subsidiary oval panels show Temperance holding her bridle, squashing Intemperance underfoot, and Liberality, her head aglow, pouring out riches as Avarice looks up hungrily from below. Temperance, a function of wisdom, and Liberality by which the Prince rewards virtue, are the characteristic accompaniments of the Plenty brought by good government.

The great central oval, more easily visible from the end of the Hall away from the throne, is ambiguously an Apotheosis or Ascension, casting James as the emperor-god Augustus, or as the Christ returning to his father in heaven. At the base of the composition, the eagle of Jupiter, clasping the thunderbolts, lifts James heavenward – the Augustan emperors regarded themselves as the incarnation of Jupiter. On James's right is Religion with her altar and Faith with the Bible (Authorised Version!). On his left, guiding him with a Roman grasp, is Justice carrying scales: she is Astraea, and James stares at her with anxious but not abject adoration. Above him *putti* hold his crown and a palm of victory; above again floats Minerva-Athena with her *aegis*, accompanied by a figure perhaps of Truth, for she carries the *caduceus* of Mercury, promising accurate prophecy: between them they bear the King's laurel crown, the emblem of his triumph, and of his death as victory.

On either side of the central oval *putti* gambol in a frieze: they serve as emblems of peace and concord as they ride on sheep and wolves harnessed together, and as they bridle the lion or draw its fangs. Like the rest of the

ceiling, the image is poised between the biblical vision of the second coming, when the lion shall lie down with the Lamb, and that of the returned Golden Age predicted in Virgil's *Fourth Eclogue*.

It was of course sublimely right that it should have been from under that ceiling, with the image of himself as the promised Child and of his father, guided heavenward by Astraea, printed on his mind's eye, that Charles stepped out onto the scaffold. Perhaps that severe tableau of the People's justice, writing *consummatus est* at the close of the Stuart absolutism, has upstaged forever the rhetoric of the ceiling. But that ceiling remains the most eloquent revelation of the ambivalently classical and Biblical forms of state authority, the prize which competing elements across most of the political spectrum were still struggling to secure a hundred years later.

The image of an aristocracy

The decade of the 1630s was that of the Tyranny, 1629–40, when Parliament did not meet and when a highly centralised monarchy, recognising no constitutional limitations on its power, governed the kingdoms of Britain in an aura characterised by its great apologist Clarendon as 'the greatest measure of felicity it had ever known'. Van Dyck died at the end of 1641 and was succeeded as a servant of the court in arms in London and Oxford by William Dobson (1610/11–46). The world of Dobson's most famous painting, *Prince Rupert and the Colonels Murray and Russell* (c.1645), is one of tension and anxiety; the picture is about loyalty and the experience of a society at war with itself, rather than the calm face of unquestioned class hegemony.

More significantly for the future, the successor of van Dyck in the patronage of the Pembrokes and of their ramifying family connections – Dormers, Capels, Percys – was a new immigrant painter Peter Lely (1618–80). Through Northumberland he was commissioned in 1647 to paint one of the last portraits of the King, in captivity under Northumberland's charge at Hampton Court, with James Duke of York looking sidelong at him, as though the mark of destiny were already visible on his pale elongated countenance.

In this period and throughout the interregnum, many of the former governing class, typified by the Noble Defectors, Northumberland, Pembroke and others, lived on their estates, in Horatian retirement from the dangers and perplexities of court and city. Among them and among the concentric circles of interrelated Royalist families poised around London at Syon, Ham at Ascott in Buckinghamshire and so on, we can begin to discern an early flowering of an enduring British myth, that of the independent Enlightenment aristocracy. Its formative site and imagery may be that of Wilton, where the conjunction of Palladian architecture and the rural *genius loci* construct a prototype for the Burlingtonian country house of the next century. The idea that the great landowners constitute an aristocracy, that is a group of men who govern because they are best fitted to govern, and in government to resist corruption and guarantee the liberties of the subject, is

posited on the wealth which guarantees civic integrity and on the leisure which provides time for the direction of industry and art in others.

Inigo Jones (1573–1652), whose genius is (but to an uncertain extent) evident at Wilton, initiated the architectural realisation of this social project; and just as Inigo Jones was a recurrent part of the vocabulary of classicism for the next hundred and fifty years, so was van Dyck. From Gainsborough in the 1770s to Sargent around 1900, the painters of the British aristocracy turned repeatedly back to the van Dycks at Wilton for the means to express their clients' class identity and aspirations. That exterior dignity, solemnity, calm and authority of the van Dyckian cavaliers (colour pl. 7) represents the public face of self-righteous hegemony, almost exactly parallelled in the rhetoric of Jones's classicism:

For as outwardly every wyse man carrieth a gravity in Public Places, where there is nothing else to be looked for, yet inwardly had his imaginacy set on fire . . . to delight . . . to laughter, sometimes to contemplation and horror, so in architecture the outward ornaments [ought] to be solid, proportionable to the rules, masculine and unaffected'

It is the image of that wise gravity that the painter is increasingly concerned with from the 1640s well into the mid-eighteenth century.

Richard Gibson, Arthur Cappell, Earl of Essex *(miniature, c.1657).*

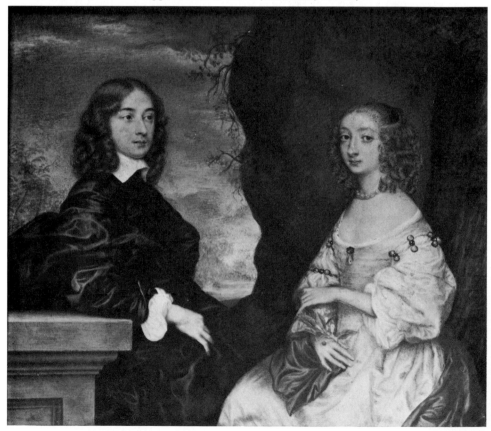

Samuel Cooper, Sir Samuel Morland *(miniature, 1660);* Elizabeth Claypole *(miniature in oils, 1653).*

A uniform for the times

There used to be a tendency to simplify the cultural polarities of the Civil War around the stereotypes of the Roundhead, severe and self-denying, and the Cavalier, gorgeous and self-indulgent. There was indeed truth in this. Yet the portraits of the Herberts and their cousins through the 1640s and 1650s show the prevalence of sad-coloured costume as the attribute of stern, dedicated men and women. These aristocratic images are if anything more self-denying than the Cromwellian family images of the 1650s, since the Protector himself clearly recognised the need in government to project himself as a family man, with images of himself by Peter Lely (1618–80) and Samuel Cooper (*c.*1609–72), and of his sons and daughters, by Michael Wright (1617–1700) for example, in a style often recalling Petitot and the vanities of French court portraiture. In fact the cult of public severity was as profoundly cavalier as it was puritanical – the 1623 Mytens image of Prince Charles (see p. 248) makes the point well that the sad-colouring of silks and soutanes was part of the counter-reformation glamour of Spain. Clearly there was more involved in the sad-colouring of clothes than now meets the eye.

There was a large complex of ideas involved in the early seventeenth century usage of the word 'sad': steadfast, firm, constant, trustworthy, judicious, grave, serious, mature, as well as mournful. The primary meaning of sad-coloured was dark or deeply coloured, implicitly, as in the Lely-Gibson portraiture, having a predominance of earth colours; and all these associations would have acted to recall the Renaissance cult of Melancholy. Melancholics were subject to the influences of the planet Saturn; they were withdrawn, often solitary, often to be found in a classic Arcadian setting of woods, water and hills. They were especially gifted with wisdom in philosophy and politics,

Peter Lely (l to r); Oliver Cromwell *(c.1653)*; Admiral Sir Jeremy Smith *(1666–7)*.

and were active in the arts. Their Melancholy was often caused by exile from the court or rejection by the beloved, and they bore their disappointment with steadfastness. There was a large Latin and Italian Renaissance literature of the subject, and in England it was pervasive at least from the 1580s to the Civil War, and in a range from Shakespeare's *Loves Labours Lost* (1598) to Milton's *Il Penseroso* (1631).

Melancholy was by no means a cult for Puritans as such. It was rather a cultural mode available to the whole 'educated' class, one which probably deepened the receptiveness of the whole culture to specifically puritan ideas. In fact, after the Grand Remonstrance from the Commons to the King in November 1641, Melancholy was probably more widespread among the King's supporters than among Puritans. Indeed the portraiture of the King through the 1640s, culminating in the terrible image of him at his trial by Edward Bower (d.1667), shows him in what must have been instantly recognisable as the uniform of Melancholy, the black coat and floppy wide-brimmed hat, rejected but steadfast.

Portraits for merchants and professionals

The cult of Melancholy, with its rejection of the vanities of worldly pleasures in favour of contemplation and the eternal verities, provided an important means to the acceptance of image-making in what was still a profoundly Protestant culture. A visual idiom that was intrinsically moral and which was conventional for politicians, philosophers, poets and scholars, provided for the members of these metiers an iconography that alluded to their gifts, pre-occupations, problems and achievements. Portraits of the non-court classes, the mercantile and professional élites, had existed for a long time, but the

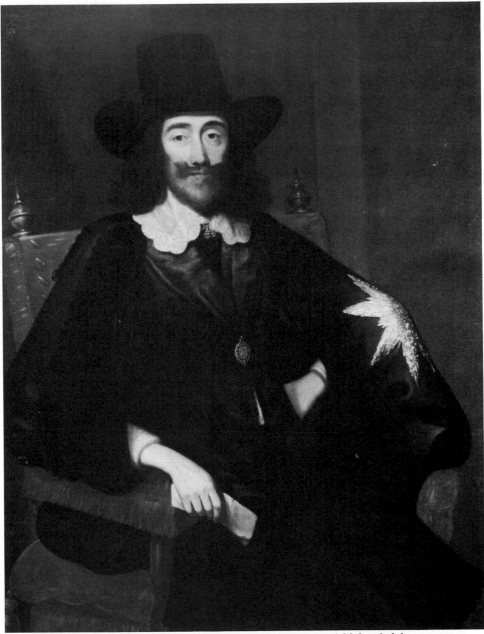

Edward Bower, Charles I *(1649); at his trial in 'the uniform of Melancholy'.*

most obvious examples of such portraiture in the north, such as Holbein's portraits of the Stele Yard merchants in the early 1530s, were already rarities, images that were bought and sold between princes rather than remaining as exempla of city culture.

In the middle of the seventeenth century in England, however, the merchants and professionals of the West End élite more or less suddenly started commissioning portraits on a fairly large scale. Personal prosperity,

political self-confidence, and the collapse of court patronage for the painters after the King left London in 1642, all help to explain the increase in numbers of non-court sitters at this time. After 1660 a sophisticated 'urbane' culture of painters and their clients seemed to ensure a reasonable cash-flow, as between men who belong in the same civilisation and who share the same class-based understanding of contracts and mutual obligations. It would be wrong to forget that the great bulk of production in the reign of Charles II was for the court, but there is a sense in which the flow of images by 'minor' painters such as Mary Beale (1633–99) or Thomas Flatman (1637–99; colour pl. 9) represents a different social and cultural dispensation.

The sitters are the members and officers of the city companies, of the colleges of Oxford and Cambridge, of Gresham's College in London, of the

Mary Beale, Thomas Sydenham, MD *(1688)*.

Physicians and Surgeons, senior ecclesiastics, barristers, judges and Members of Parliament. They are the men for whom the uniform of Melancholy provides an iconography of their intellectual and civic excellence, stressing the soldier values of the City which was constructed not on the model of exile from the court, but in distinction from it, as its moral and economic equal or opposite.

Flatman was himself a member of this élite, an intellectual and wit, and certainly was not in any practical manner an exile. For with Thomas Flatman and his class the sense is increasingly of cultural centrality, of a fairly small group of clever and powerful people, great magnates or poor scribblers, who lived on an axis between Whitehall and the City, in the Strand and Covent Garden, who all knew one another and whose high valuation of the urban virtues went along with a Melancholic tendency to cynicism and wit. The Melancholic powers that brought eminence to these philosophers, these lovers of wisdom in whatever field, brought scepticism too, based on a clear-sighted awareness that courtly pretensions to immortality or to any kind of superhuman significance were less hubristic than ludicrous. For them, there was another way of discussing human greatness, which is in funerary ode or memorist portrait: with a sense of due proportion in the light of day, describing the subject as a mortal man, dying as in nature he must, and mourned for his achievement with due measure of human grief and gratitude.

The Royal Society and the face of the natural world

Flatman was a Fellow of the Royal Society, and in the intellectual ambit of the Royal Society one can see, I think, a point of arrival for certain impulses from the English Puritan tradition and a connexion to that side of the Elizabethan court, represented by Bacon, Sidney, Essex and even Hilliard, which was, in an almost literal sense, enlightened – in Hilliard's words, 'for beauty and good favour is like clear Truth, which is not shamed with the light, nor needs to be obscured'.

The Society disliked inflated discourse and sought to prohibit the 'swellings of style' characteristic of baroque eulogy in either poetry or painting.

They have exacted from all their members a close, naked, natural way of speaking; positive expressions, clear senses, a native easiness, bringing all things as near the mathematical plainness as they can; and preferring the language of Artisans, Countrymen and Merchants before that of Wits or Scholars.

With this dictum of Thomas Sprat (1635–1713), Bishop of Rochester and the first historian of the Royal Society, that whole impulse towards the simplified and enlightened can be seen in the context of a new form of social consciousness, possessed óf its distinctive philosophy and manner:

Thus they have formed that Society, which intends a Philosophy, for the use of Cities, and not for the retirements of Schools; to resemble the Cities themselves, which are compounded of all sorts of men, of the Gown, of the Sword, of the Shop, of the Field, of the Court, of the Sea; all mutually assisting each other.

Sprat's is an image of society made up of a narrow, virtually self-electing élite of intellectuals, contained within the court or in that part of London which, when Inigo Jones began the development of Covent Garden in the 1630s, could already be distinguished as the West End. It is the civilisation of a formidable political and financial nexus, at home in the theatres, coffee houses, inns of court and the other locales of male society; of an easy confraternity of acquaintances, riven occasionally by bitter animosity, political quarrels and professional jealousies, but in no doubt of its centrality in the life of the nation state.

If Puritans in the early seventeenth century had a problem with images, those guardians of the Elizabethan Settlement, the Anglican bishops of the original Royal Society group, had a problem with Man as a subject for study in the 1660s. Not quite a religious problem, more perhaps an ambiguity arising from the re-construction of the old religious view that Man was special, in a different category from the other parts of the natural creation, which provided the proper subjects for scientific enquiry. It was in the context of such beliefs that the use of painting, above all the use of draughtsmanship, to record the physical appearance of places, of their flora and fauna, began to be an important part of British culture. The need among thoughtful members of the ruling élite to 'map' the country and establish a precise sense of its physical and economic geography, had manifestations in the cult of travel, of writing accounts of travels and of illustrating such accounts with views of significant locations.

The most absolutely beautiful landscapes produced in this idiom in England in the seventeenth century were certainly those by van Dyck, made as he travelled through Rye probably in 1634 on his way to Antwerp. They lead on directly to the work of the Bohemian draughtsman Wenceslaus Hollar (1607–77), who arrived in London late in 1636 in the suite of Lord Arundel. At about the same date and in the same cultural milieu, Isaac de Caus, the hydraulic engineer and associate of Inigo Jones, was at work on the gardens at Wilton, producing drawings which express a different function of scientific rationalism: the use of knowledge in order to control and exploit the disorders of nature. House portraits, 'bird's-eye views', most of the publications in which authors and painters communicated knowledge about the face and resources of the country, increased in production after the Restoration, and most of the best known view painters – Hendrick Danckerts, Jan Siberechts, Jan Griffier or Leonard Knyff – were actually figures of the last quarter of the century. Their drawings, especially those by Siberechts, show a descriptive or delineative technique that relates easily to the contemporary studies of draughtsmen such as Francis Barlow (1626–1702), whose decorative and sporting subjects have a similar basis in direct empirical studies of fauna: a nearly explicit scientific impulse is evident in the eighteen engravings of the *Multae et diversae avium species multifariis formis et pernaturalibus figuris* published in London in 1671.

An occasional collaborator with Barlow on such projects was Francis Place (1647–1728), whose technique was profoundly influenced by contact with Hollar in London. Primarily an intellectual, a lawyer manqué, he lived from about 1670 in York in one of the most dynamic regional centres of 'advanced'

scientific and philosophical enquiry. He was, like Thomas Flatman, one of those who realised the power of drawing as a tool of empiricism, but rather than human portraiture, his subject was the face of the country. In his work that clear, simplifying discourse, that 'mathematical plainness', finds technical expression in a sharp pen line, even lighting and clear washes of colour. The pandemonium of London, the mystery or taint of superstition clinging to the ruined aisle of an abbey, the Medusa-like power of the Knaresborough Dropping Well, became accessible to the light of reason when presented with such calm and analytical intelligence.

Drawing: the mother of art

For the traditional art historian it is possible to characterise the difference between Elizabethan and Caroline painting in terms of line and colour. The importance in the formation of an English school of the example of Holbein meant that it was difficult to conceive of anything recognisably belonging to the category of painting that was not constructed from clear outlines and bright, barely modulated colours, 'filling in' the contours of surface visibility. Elizabeth's instruction to Hilliard to take her likeness in the 'open alley of a goodly garden' was thus profoundly typical of the culture she presided over and against which the younger generation at court in the early seventeenth century to some extent reacted.

Simply, the reaction has been presented as one in favour of chiaroscuro, of the representation of forms by the differentiation of perceived colour rather than by line; a preference for Venice as against Florence, for Antwerp as against The Hague. The preference of Anne of Denmark for Isaac Oliver over Hilliard is seen as typical and isolated pieces of evidence concerning for example Oliver's trip to Venice in 1596, his putative journeys to Flanders and his knowledge of the Haarlem Mannerists, are supported by the evidence of a different graphic technique underlying his work in colour. For Oliver was arguably the first English artist seriously interested in drawing as such, and proficient in the art on the same scale of competence as the European draughtsmen.

So why were intelligent and progressive people like Isaac Oliver in the early seventeenth century becoming interested in drawing? The answers to this question are to do with the science of knowledge, with perception, with developing the means of recording observations and communicating information about the world. The real difference between Tudor and Stuart culture lay in realising that *science* in the broadest sense depended on the ability to form and transmit images that possessed referential exactitude. 'Drawing', wrote William Gore in 1674, 'is the bearing mother of all the arts', because drawing was the product of both observation and description.

The problem was to make drawing a more effective tool and to spread the ability to use it more widely. Hence the multiplicity of technical treatises published during the century. Illustrated with engravings, they recommend the study of prints to achieve the semblance of three-dimensional form and teach the systematic contour hatching of Goltzius and the Northern Mannerists,

which achieved a Michelangelesque sculpturality within the rigorous disciplines of line engraving. At this level, the ability to render differences of tone in black and white depended almost entirely on variations in the density of line and was technically very demanding. This was why most professional draughtsmen in the seventeenth century used the naturally subtle media of black or red chalk, or what is sometimes confusingly referred to as pastel. The literature indicates that there was by the Restoration a thriving output of portrait studies in this media, but their fragility has meant that few survive. And that in turn is probably why the opening up of a more plentiful supply of 'black lead', the graphite mined at Borrowdale, was such an exciting development of the 1660s. The portrait draughtsman could now manipulate a soft lustrous substance across the full tonal range, using the medium transparently to create lights from a white support, and allowing, in the blacker passages, the natural reflectiveness of the polished graphite to give back light to the eye of the beholder.

These brilliant drawings, known as plumbagoes, by draughtsmen such as Robert White (1645–1703), David Paton (fl.1660–95), David Loggan (1635–92) and Thomas Forster (fl.1690–1717), are among the most distinctive creations of the late seventeenth-century graphic culture. They are evidence of a serious effort by workers in black and white to 'catch up' with the representational power of painting. In this they relate directly to the other great invention in the graphic arts of the period, the mezzotint. Attributed to Prince Rupert, the son of that doyenne of progressive intellectuals Elizabeth of Bohemia, mezzotint was the sort of invention that Renaissance princes hoped to stimulate by filling their palaces with enterprising craftsmen. By raising a burr evenly across a whole printing plate, so that when inked it would print a deep velvety blackness onto the paper, the artist could burnish down progressively those areas that he wished to be lighter, thus achieving the effect of a smoothly modulated tonal range. Though expensive and laborious (until the development of specialised grounding tools), the technology was obviously superior to that of stipple engraving, at this date the only seriously competitive tone process. John Evelyn (1620–1706), the diarist and a Freemason and Fellow of the Royal Society, who announced the invention of mezzotint, had been most firmly insistent that there were among the crafts and trades great resources of unformulated science, capable of bringing great benefit to humanity and of transforming the civilisation.

The study of Man

Analytical studies of the face of nature were capable of yielding results important for human progress, and were untroubling to the Protestant conscience since they were liable to produce in those who undertook them, whether in London or the provinces, an intensification of reverence 'for the admirable order and workmanship of God's creatures'. In contrast, God was not a fit subject for the empirically based studies of the Royal Society. Pope's remark 'presume not God to scan' echoes perfectly this belief that man's rational faculty could only be brought up sharply at the impenetrable mystery of God.

The objection to the study of Man was based on the inaccessibility of the subject to empirical study, because, Sprat tells us, 'the Reason, the Understanding, the Tempers, the Will, the Passions of Men, were so hard to be reduced to any certain observation of the senses'. Sprat's use of the word 'observation' itself shows that he thought of the problem primarily as visual, of achieving a record of human phenomena that would be accessible to visual examination. There must have been members present at the Society meetings who did not share Sprat's despondency about the power of observation and careful record to succeed in the study of Man, and who felt that there was an answer. As a practical problem, the study of Man could be solved by practical means, by the application of skills, as Sprat was himself usually among the first to recognise, existing already among artisans and other non-scholastic people. Abraham Cowley clearly thought of the empirical method of science as modelled on the activity of the draughtsman, whose study had to be taken directly from the specimen. And in his verse introduction to Sprat's *History of the Royal Society*, he pointed the way firmly to portraiture as the pattern of exactitude, in which there could be no help from other masters nor reliance on invention to supply the want of observation:

> Who to the life an exact Piece would make,
> Must not from others work a copy take;
> No, not from Rubens or Vandike;
> Much less content himself to make it like
> Th'ideas and the images which lie
> In his own Fancy, or his Memory.
> No, he before his sight must place
> The natural and living face;
> The real object must command
> Each judgement of his eye, and motion of his hand.

It is a prescription that demands a relationship of direct access and study between the author of the image and the subject, one which begins to establish the concept of *authenticity* as an essential constituent of Art. Authenticity is constructed precisely in that moment of confrontation between the artist and subject, which cannot be negotiated through intermediaries nor diverted into homage for an old master. Authenticity, guaranteeing Truth on terms susceptible of a simple visual check on likeness, was more important than the creative furor of Genius.

From the last quarter of the seventeenth century the artist and his subject assume a common form and belong to the same urban milieu. The 'wise gravity' identified by Inigo Jones as the visible mark of inner virtue and civic consequence, is worn by all, great Whig aristocrats or scurrilous Tory poets, Duke of Marlborough or Alexander Pope, in Kneller's portraits of the members of the Kit-Cat Club.

The Augustan élite

With Sir Godfrey Kneller (1646–1723) and the Kit-Cats (the members of the Whig dining and discussion club named after Christopher Cat's tavern in which it originally used to meet), we are recognisably in the Augustan Age.

His 48 Kit-Cat portraits are those of the members of the West End élite, as individuals, dressed for the street and social round, or undressed and wigless for the private, domestic circle. They update the prints of van Dyck's *Iconographia* as images of artists and intellectuals in the painter's own circle, but they have that essential Augustan quality of close association with the political power structure, perhaps best personified in the career of Sir Richard Steele (1672–1729).

The sitters are the aristocratic beneficiaries and negotiators of the Revolution Settlement, 'that group of politicians, writers and soldiers aptly described as "the Whig party in its social aspect"'. To the Tory pamphleteers they were a galère of literary pretension and political disloyalty. Steele, the most sea-green incorruptible of the Whig promoters of the Protestant Hannoverian succession was, when the Tories came in in 1711, asssociated with the movement to establish in London an Academy for Drawing and Painting. It is significant of the pride, as opposed to the guilt, now felt by his class in the production and possession of pictures that he could write:

No nation in the world delights so much in having their own, or Friends or Relations pictures: whether from their National good-nature, or having a love to Painting; and not being encouraged in that great Article of Religious Pictures, which the Purity of our Worship refuses the free use of, or from whatever other cause . . . we have the greatest number of the Works of the best masters in that kind [that is, portraiture], of any people. . . .

And accordingly in fact, Face Painting is no where so well performed as in England . . . if Foreigners have often times, even for the most part, excelled our Natives, it ought to be imputed to the advantages they have met with here, joined to their own ingenuity and industry.

(*Spectator*, 1712)

A national school

Steele's evident anxiety about the relative excellence of foreigners introduces effectively one of the major themes of the new century, the question of nationality. In the Jacobean and first Caroline courts it had not been seen as a matter of great importance that a piece of work should be executed by a native artist. Painters, like musicians after all, used an almost perfectly international (or European) language and, as we have seen, for the supreme act of state patronage in the century, the commissioning of the Whitehall ceiling, a foreign artist, a Catholic, had been chosen. For Charles I, the very foreignness of Mytens, Rubens, van Dyck, was a pledge that he was King in a European dimension, and not just the usurper of a minor off-shore principality. For Charles II and James II, with a whole long succession of immigrant painters – Gerard Soest, Jacob Huysmans, Henri Gascars, Willem Wissing, John Closterman, the Verelst family and Michael Dahl – the same was probably true. When Antonio Verrio (*c.*1640–1707) came to England in about 1672 it was under the aegis of Ralph, later first Duke of Montagu, recently Ambassador in Paris and architect of the secret Treaty of Dover

Godfrey Kneller, Sir Richard Steele *(1711), one of the forty-eight Kit-Cat Club portraits.*

(1670). Verrio's arrival could be taken as marking the conviction of the regime that its most important relationships were external (colour pl. 8).

While Verrio, Laguerre (1663–1721), Pellegrini, Sebastiano and Marco Ricci were employed in England variously between about 1672 and 1708 – Verrio, for instance, undertook the decorations of Windsor Castle and Hampton Court, and Laguerre carried out elaborate, allegorical decorations at Chatsworth, Petworth, Blenheim, etc. – there seemed very little sense even of suspicion that foreigners might take the bread out of the mouths of British artists. But as early as 1658 William Sanderson had published lists of native talent, of specialities and peculiar excellencies. His scathing references to foreigners – characterising lubricity as 'Italian-mindedness' – were set in a

text aimed at a very specifically British, Protestant public, promoting British art both on the production and on the demand side. It partly prescribed and partly described a culture in which pictures could be commissioned from native tradesmen on much the same terms as other commodities, and in which pictures were the subject of rational critical discourse between men whose capacity for such discourse was the mark of their élite status.

The beginnings of a distinctively British art history are located in these years, and historians or compilers of biographical information such as George Vertue, looking back from the next generation, had no difficulty in filling out the story told by their predecessors Peacham or Sanderson. To them there had certainly been a vigorous continuity of native painters, existing in close and fruitful relations with the dominant foreigners. Apart from the miniature painters, who anyway constituted a polite élite among image-makers, a genuine seventeenth-century succession could be constructed: Cornelius Jonson (arguably, since he was at least born in Britain), Sir Nathaniel Bacon (a gentleman like Flatman or Place), the Scot George Jamesone (c.1588–1644), Edward Bower, William Dobson – the latter called by Aubrey the most excellent painter that England hath yet bred' – Robert Walker, Isaac Fuller, John Greenhill, John Riley – who squeezed into the office of Principal Painter when Verrio was sacked in 1688, but only in effect as the junior partner to Kneller.

It was the scholar, antiquary and connoisseur Michael Wright (1617–1700) who had been trained in Rome at the Academy of St Luke beside the great masters of the Roman Baroque, who seems now to have transformed the line from the subsidiary to the dominant. He came back from Rome in the last years of the Protectorate, worked for the Cromwells and then managed to consolidate a reputation among the Restoration courtiers before beating a shortlist of Lely, Huysmans and John Hayls to an important City commission for a series of judicial portraits. The fact that the decision in his favour was made by City men, aldermen sitting in official committee, was significant for the new century.

When in 1708 James Thornhill (1675–1734), after a carefully orchestrated campaign of self-promotion, gained the commission to paint the Great Hall in Sir Christopher Wren's Royal Hospital at Greenwich, it could probably be sensed among the Governors as a contradiction of prevailing values that the triumphs of the monarch should be celebrated by an alien. For with Thornhill's nationalism the art of painting reached that Augustan state which literature in the reign of Queen Anne had always claimed. It is perhaps not unimportant that the Painted Hall, the first and greatest specifically British state painting, should have been commissioned less by the sovereign than by the Governors. It is undoubtedly important that the building itself was a hospital, a benevolent institution of a kind which reflected the philanthropic activities of the urban élite, and which became later in the eighteenth century the locus in which Painting proved its civic value.

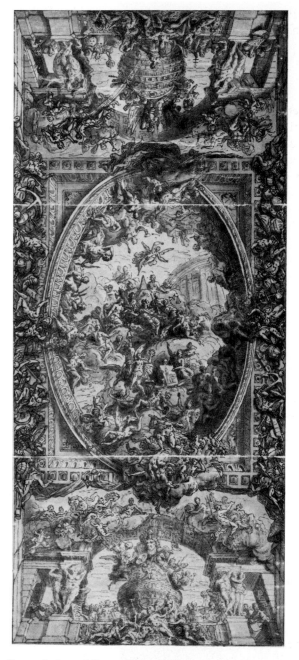

General view of James Thornhill's Painted Hall (1708–12), at the Royal Hospital, Greenwich.

Nicholas Stone's monument to John Donne (1631–2), in St Paul's Cathedral.

9 Nicholas Stone and Early Stuart Sculpture

ADAM WHITE

In a period of British sculpture on which we are poorly informed from contemporary records, it is fortunate that there is one major artist whose career can be followed in detail. The Note Book and Account Book of Nicholas Stone the Elder (1586/7–1647), preserved in Sir John Soane's Museum, London, between them cover his career from 1614–42 revealing much of what he did, when, where and for whom, what he was paid for it and, in some cases, who assisted him with it, a wealth of information which cannot remotely be matched for any of his contemporaries. Because of this imbalance in the facts available it is easy to exaggerate Stone's importance, yet it is clear from the commissions he received that, when active in adult life, he was at all times an important figure and that by the 1630s, if not earlier, his workshop had become the most important centre of stone and marble carving north or south of the Scottish border.

Stone grew up at a time of opportunity when the renewal of cultural ties with the Catholic countries of Europe made a wider range of source material available to British artists and demand for sculpture was greatly on the increase. The rise in patronage was particularly in evidence with church monuments which were being erected in large numbers as the fashion for them spread down the social scale, helping at the same time to assuage a fever for ostentatious spending which held the richest sections of society in its grip. A vogue for commemorating wives and children gave a further stimulus to an already busy trade.

In this booming market Nicholas Stone appeared with the advantage of a prestigious international training. He was born in Devon but must have left his native county when still young, for by his own account his first master was the London tomb sculptor Isaac James under whom he served for two years as an apprentice and one year as a journeyman. It was probably in 1607 that he had the good fortune to meet the distinguished Dutch architect, master mason and sculptor Hendrik de Keyser who was on a visit to London and is likely to have taken him back to Amsterdam to improve his skills in the family workshop. In 1613 Stone married de Keyser's daughter Mayken (Mary) and returned with her to England where he established himself as an

independent artist in the parish of St Martin in the Fields, Westminster. Important commissions came to him, first with remarkable speed and thereafter with impressive regularity.

Stone followed de Keyser and a tradition well established in England by working as a mason as well as a sculptor. In this capacity he became eminent in the royal service, being appointed Master Mason at Windsor Castle in 1626 and Master Mason of the King's Works in England in 1632. From 1631 onwards he also designed and erected buildings for non-royal patrons, both private and institutional. The two branches of his profession were, however, in no way separate for many of his church monuments have architectural features and his official appointments entailed a certain amount of carving.

The survival rate of Stone's sculpture varies greatly according to its type. Numerous chimneypieces are mentioned in the Note Book and Account Book but of these we have only one overmantel which can be identified with any degree of certainty, an elaborate early work dating from *c.*1615–16 whose superb quality gives an indication of what has been lost. It stands in the Big Dining Room at Newburgh Priory, North Yorkshire and is in the style of the French, mid-sixteenth century school of Fontainebleau, adorned with standing *putti* (figures of small children) and classical deities flanking a mythological relief. All that has been traced of the garden statuary listed in the two books is a heavily weathered Hercules and a mutilated female figure, probably Diana or Juno. Both appear to have been removed to their present

Nicholas Stone's overmantel in the Big Dining Room at Newburgh Priory, Yorkshire (c.1615–16), his only work of this kind which can be positively identified.

location at Blickling Hall, Norfolk from Oxnead in the same county where Stone's greatest patron, Sir William Paston, had his seat. A statue of Queen Elizabeth (London, Guildhall Art Gallery) is the sole survivor of four figures of English sovereigns which Stone executed for the Royal Exchange in the City of London (*c.*1623–5) and owes its preservation to having been rejected by the City Corporation and removed from the building, probably because it looked more like an image of the Virgin Mary than of the Queen herself.

On account of this destruction we are forced to judge Stone's sculpture largely by his church monuments, the great majority of which are still extant. They are of great variety, some following, others breaking free from the late Elizabethan and early Jacobean stereotypes. The best of the effigies reveal a capacity to observe and portray the human form in the round which had not been seen in Britain since the Reformation, witness the exquisite figure of Elizabeth, Lady Carey at Church Stowe, Northamptonshire (1618–*c.*1620).

Part of Stone's originality lay in the range of art from which he drew inspiration: antique, medieval and continental Renaissance. This breadth of awareness was evidently shared by some of his patrons whose taste and influence can on occasion be discerned in his more inventive as well as his more traditional works. As early as 1614–15 the monument to Henry, Earl of Northampton broke new ground by adapting a French royal pattern of the sixteenth century with the effigy kneeling on top of the canopy and full-size allegorical figures at the corners. The allegories, notably that of *Prudence*, show a marked classical influence which was probably assimilated from the sculpture collection of Thomas, Earl of Arundel, Northampton's great nephew who played a part in drawing up the contract. Significantly for the French connexion he had been in Paris since learning of the death of his relative.

A bolder, more explicit classicism appears in the effigies of the Hon. Francis Holles and his uncle Sir George Holles in Westminster Abbey which are both dressed as Roman soldiers, the former seated on a pedestal derived from a Roman sepulchral altar. The adolescent brothers John and Thomas Lyttleton (Oxford, Magdalen College Chapel) are shown standing with legs crossed, a pose common in antique sculpture which evidently was also studied for the straight, parallel folds of the boys' toga-like garments.

Stone's creative powers were equally stimulated by a new, though still limited tolerance of religious subject-matter on the part of the Jacobean and early Carolean church. The floorslab to William Curll at Hatfield in Hertfordshire alludes discreetly to the resurrection of the dead at the Last Judgment by means of the phoenix incised at the feet of the deceased, who is portrayed in bas-relief stirring from slumber and beginning to emerge from his shroud. The sculptor's most famous image is of the great poet and divine John Donne, rising from an urn in his graveclothes (St Paul's Cathedral, 1631–2). This bizarre conceit was of Donne's own choosing and he posed for a portrait from which Stone derived a refined and ethereal representation of him in a state of true spiritual rapture.

That Stone could rise to prominence so swiftly suggests a vacuum waiting to be filled, yet at the time he was a newcomer among able men. The most eminent of them, by virtue of his position at Court, was Maximilian Colt

(active 1602–28), a native of Arras in modern France who came to England
via Utrecht, probably as a Huguenot refugee, and was living in the City of
London by the year 1595. His marriage to a niece of the King's Deputy
Serjeant Painter John de Critz may have helped to secure him his first
important commission, the tomb of Elizabeth I in Westminster Abbey
(1605–6). This is traditional in type with the effigy recumbent under a
canopy, which is in the heavily bastardised style of classical architecture
imported from the Low Countries and widely employed in England during
the previous quarter century; the most noteworthy feature is the Queen's
face, a naturalistic and unflattering likeness of a ruler who had been flattered
by artists to an extraordinary degree. Colt also made the tombs of King
James I's two infant daughters, Princess Sophia and Princess Mary
(Westminster Abbey). Both are fashionably portrayed as if they were still
alive; Sophia, who lies peacefully asleep in her cradle, started a fashion of her
own in child effigies of this kind.

In 1608 Colt obtained for himself the newly-created office of King's Master
Sculptor or Master Carver, an appointment which, as its title suggests,
required him to carve in wood as well as stone: thus, between 1611 and 1624
he did decorative carving on the royal barges and made effigies, which were
partly wooden, to be carried at the funerals of Queen Anne of Denmark and
King James I. More important, however, was his work for the King's Lord
Treasurer, Robert, Earl of Salisbury. This included elaborate chimneypieces
for Hatfield House, Hertfordshire (*c*.1609–12), notably that in the present
King James's Drawing Room which displays loyalty to the Crown by a
lifesize statue of the King in Caen stone standing above the fireplace. Colt's
masterpiece is Salisbury's monument in Hatfield parish church (*c*.1614–18).
The earl is represented lying on a bier supported at the four corners
by kneeling figures of the Cardinal Virtues while between them,
below the effigy, lies a skeleton, symbolising death and the corruption of the
body. The design is a free amalgam of continental sources, particuarly the
monument to Count Engelbert II of Nassau (*c*.1530) and relies for its
powerful effect on a simple contrast of black and white marble which was
new to Britain and far removed from the gaudy, vulgar Elizabethan tradition
of lavish painting and gilding.

While both Stone and Colt could produce work which looks more or less
anonymous, there is one sculptor of the period who carved in a consistently
individual style. Almost everything we know about Epiphanius Evesham
(active 1589–*c*.1623) marks him out from his peers. He was of gentle birth,
the son of a Herefordshire squire, and spent much of his career in Paris
where he was also active as a painter. His stay abroad, which lasted at least
from 1600 until 1615, is extensively documented; in England, by contrast, his
work is known very largely from his signature and comprises little more than
the usual church monuments.

These monuments, however, are very remarkable chiefly for their panels,
cut in low relief, which reveal a gift for free pictorial composition developed,
no doubt, in the paintings of the artist's Paris period. The children of Sir
Thomas and Lady Hawkins (Boughton under Blean, Kent), of Christopher
Roper, Lord Teynham and his wife (Lynsted, Kent) and of Sir Adrian

Maximilian Colt's monument to the 1st Earl of Salisbury (c.1614–18), in Hatfield parish church, Hertfordshire.

Scrope (South Cockerington, Lincolnshire) gave scope to this talent. Though they are placed in the conventional positions, kneeling in front of the tomb chests which bear the effigies of their parents, the imaginative groups in which they are arranged are far more animated than the standard rows of stiffly-posed figures. Most striking are the Hawkins and Roper daughters whose grief is plain to see, a display of emotion which is without precedent in British Renaissance sculpture and must have been inspired by the religious art of the Continent. Two attributed works of great charm, the wall tablets to Robert, Earl of Warwick and his wife Francis (Snarford, Lincolnshire) and to Cicile and Ellenor, the wives of Sir John Denham (Egham, Surrey) show Evesham at his most inventive in purely formal terms. They are truncated double portraits set in roundels and based on a type of image familiar from coins and medals. It is interesting to note that their creator's ability was recognised by a contemporary: in a book of epigrams published in 1624 the translator, John Penkethman, paid tribute to Epiphanius as a 'most exquisite artist'.

With the accession of Charles I Britain came under the rule of a passionate and highly discriminating patron and collector of art. From the new King's point of view the native sculptors lacked one crucial skill, that of working in bronze. Not only was this the most versatile and durable material for use on a large scale, but it was needed also for those articles without which no

Relief panel on the base of the monument to Christopher Roper, Lord Teynham by Epiphanius Evesham, in the Church of St Peter and St Paul at Lynsted, Kent.

connoisseur's collection was complete – statuettes. In 1612 Charles had inherited from his elder brother Henry, Prince of Wales, a collection of small bronzes cast by Pietro Tacca, an Italian whom James I had tried to entice into his service around 1619. It was not, however, until 1625 that the Stuart dynasty managed to recruit a foreign sculptor; in that year, the first of Charles's reign, the Frenchman Hubert Le Sueur left his employment with King Louis XIII in Paris and crossed the Channel.

Hubert Le Sueur's equestrian statue of Charles I (1630–3), Trafalgar Square, London.

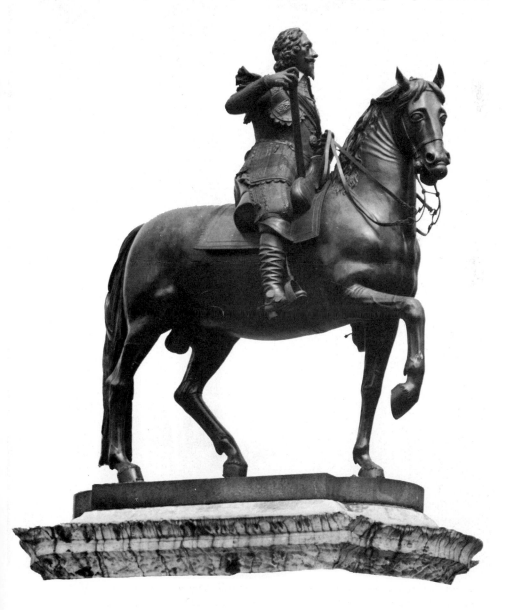

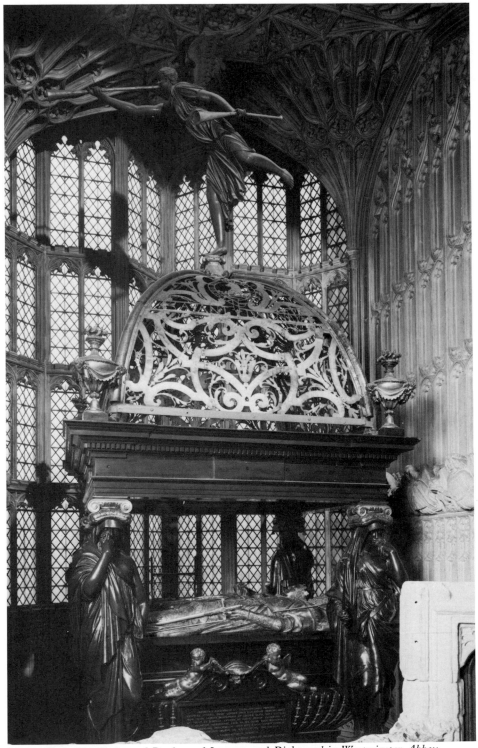

Monument to the Duke and Duchess of Lennox and Richmond in Westminster Abbey,
attributed to Hubert Le Sueur.

Le Sueur, who is known to have been active in 1602–43, had the prime credential of being an experienced bronze founder and his best work is technically of a very high standard. He also had command of a sophisticated, up-to-date French vocabulary of ornament which was largely unfamiliar in Britain and, once introduced, was much imitated. As a figure sculptor Le Sueur was, however, mediocre: his male busts and statues are notable for the meticulous rendering of the armour in which the sitters are generally clad – an effect, no doubt, of his origins as a master armourer's son – but the faces are bland, dead and over-generalised, while the bodies are unconvincingly articulated and tend to have a curious bloated look produced, perhaps, in the attempt to convey swagger and magnificence.

Inevitably the King required royal portraits from Le Sueur. The finest to survive of Charles himself is probably a bust at Stourhead, Wiltshire, which shows the monarch fearsomely attired in a helmet crowned by an open-mouthed dragon. An over-lifesize bust of James I wearing a crown (London, Whitehall Banqueting House) was paid for by a royal warrant dated 1639, together with the transport for statues of Charles and James which had been contracted for in the previous year and were erected in Winchester Cathedral on a new choir screen designed by Inigo Jones (the screen has been demolished but the statues survive in the Cathedral). Le Sueur's most famous image of royalty was not, however, a royal commission. The equestrian statue of Charles I which now stands at the south end of Trafalgar Square, London was executed for the Lord Treasurer Richard, Lord Weston in 1630–33 to adorn his gardens at Mortlake Park, Roehampton. It narrowly escaped being melted down on the orders of the Parliamentary party and was set up again after the Restoration on a new plinth.

Le Sueur's services appear to have been quite freely available to those connected with the Court who could afford to pay for them. Archbishop Laud made use of this opportunity by engaging him to provide statues of King Charles and Queen Henrietta Maria for the Canterbury Quadrangle at St John's College, Oxford and he appears also to have been chosen by the Duchesses of Lennox and Buckingham to make their husbands' memorials in Westminster Abbey. The Lennox monument is notable for its delicate openwork bronze canopy supported by four mourning caryatids (female figures used as columns) and surmounted by a figure of Fame, a composition which exploits most successfully the tensile strength of the metal.

King Charles cannot have failed to see Le Sueur's limitations and may have been mindful of them when despatching him to Italy in 1631 to obtain 'moulds and patterns' of famous antique statues for the artistically undemanding task of replicating them in bronze (five of them are at Windsor Castle). By 1635 the King had a more gifted, though to us more obscure, sculptor working for him, the Florentine Francesco Fanelli who in the following year was joined by the Fleming, François Dieussart. None of the court sculptors is heard of in Britain after the outbreak of Civil War when there would have been little for them to do but make their escape.

Detail of carving by Grinling Gibbons at Petworth House, Sussex (c.1692).

10 Decorative and Applied Arts

GEOFFREY BEARD

Introduction

When Sir Bathazar Gerbier wrote his book on *The Three Chief Principles of Magnificent Building* in 1662 he was careful to define on his crisply-printed title-page that 'Solidity, Conveniency and Ornament' were what he had in mind. The pursuit of ornament in particular was to lead him, his noble predecessors and successors, into a wild and extravagant chase to satisfy the dictates of Taste. There was need to break with the Jacobean style of the early seventeenth century, which was still largely derived from Elizabethan techniques and the influence of the Low Countries. Strapwork and arabesque, cartouche and mythological panel vied for attention with the great wooden screen and carved staircase. Timbered ceilings, one of the chief glories of medieval England, surrendered pride of place to the newcomers in plaster, ribbed, boldly compartmented and full of motifs and patterns derived from the emblem books, Bible stories or tales of travel.

Styles and moods could not ferment into much significant activity during the Civil War of the 1640s, but the urgent pace of building, decoration and encouragement of craft skills was resumed at the restoration of Charles II in 1660. Grinling Gibbons, Jonathan Maine and Edward Pearce were soon busy at wood and stone carving, the skilled French decorative smith, Jean Tijou, was creating filigree patterns in wrought iron, John Vanderbank inherited the traditions of the long-established tapestry manufacturers, and soon his exciting and colourful Soho chinoiseries were hanging over sombre wood wainscoting. Dufresnoy and Francis Lapière stretched their damasks and velvets over skilfully-wrought wood and papier-mâché and erected the great 'state-beds' which still adorn houses like Dyrham, Knole and Belton. Edward Goudge was the leading plasterer and, as the architect Captain William Winde wrote, was looked on as 'the beste master in England in his profession'. The level of individual achievement was also of paramount concern to patrons when they ordered delicately wrought locks with elaborate mechanisms from John Wilkes of Birmingham, or looked to Thomas Tompion or Joseph Knibb for their bracket and long-case clocks.

Into this scene came the youthful Christopher Wren (1632–1723), writer, scientist, Professor of Astronomy and seemingly, by accident, architect. He was able to witness and assist the process whereby, in house and City church, the settings were created to display such talent. Cedar and oak wainscoting were thus overlaid with soft fruit-wood carving of incredible dexterity (Burghley House); great compartmented ceilings of ovals and squares had ribs encrusted with plasterwork fruit and flowers (Belton). They contrasted with the embossed leather-hangings and simulated marble in paint (Dyrham). The new social standard set by 'a politer way of living', as John Evelyn put it, inspired a revolution in the design and arrangement of furnishings. More was made in walnut instead of oak and craftsmen skilled in the art of veneering and decorating surfaces with patterns of contrasting coloured woods (marquetry) pushed forward improvements in technique beyond what the traditional joiner understood. Side tables in the continental Baroque style with marble or carved and gilt gesso tops were set beneath tall pier glasses. They reflected silver-gilt toilet services, upholstered day-beds and armchairs, indeed every object which gave dignity and grandeur to reception rooms, a testimony to classical collecting coupled with the encouragement of skills akin to virtuosity.

The wainscoted room

English craftsmen who worked in wood in seventeenth century England were heirs to a long tradition of those who, since the Middle Ages, had built timber-framed houses and framed timber roofs for great churches and halls. Their talents found full expression in creating rooms in which by the use of oak wainscot they were made convenient, or as the chronicler William Harrison noted: 'warme and more close than otherwise they would be'. Framed panelling consisting of uprights and cross-pieces enclosing long panels had developed in design from forms which represented the linen pattern (linenfold), incorporated medallioned heads, or double ogee-scrolls and Renaissance strapwork patterns simulating leather-work. It was the wall cladding in commonest use in the early seventeenth century interior in northern Europe. Variety was obtained by grouping different sizes of panel, a long and a short, as in the room from the old Palace, Bromley-by-Bow (1606, now in the Victoria and Albert Museum, London).

In wainscoted rooms of the reign of Charles I the tendency was towards an architectural treatment. The wall was treated as an order, divided by pilasters into bays with the whole surmounted by a carefully worked frieze and cornice. Ornamental detail was provided by pedimented archways or openings and by a pediment over the chimneypiece. The wood was seasoned so that the panels would not warp. Shakespeare noted in *As You Like It*

> This fellow will but join you together as they join wainscot;
> Then one of you will prove a shrunk panel and like green timber, warp, warp.

Until the end of the seventeenth century it was usual to colour panelling; the framework often in red and designs in various colours on the panels

State Drawing Room door, Chatsworth, Derbyshire (c.1692).

themselves. Survivals of original decoration are rare. The most complete
surviving example is the Kederminster Library (1617) at Langley Marish
Church, Berkshire (colour pl. 6). The panels are painted with cartouches
(scroll ornaments) heraldic decoration and symbolic figures, and the screen to
the Kederminster Pew in the north transept of the church also shows the use
of painted and marbled decoration to depict geometric panels.

For wainscoting and all interior work the use of oak was universal. Whilst
oak varies in shade of colour it shrinks considerably in seasoning. It does not

combine easily with glue, as John Evelyn noted in his treatise on forest trees, *Sylva* (1664), and so it was invariably framed and pinned together by oak pegs. The alternative for panelling was walnut. English walnut had only been planted in the late years of the sixteenth century, and found ready use until black walnut was introduced in 1656. However, there were ready supplies in France at Grenoble and elsewhere but its use for wainscot (and for furniture) remained exceptional against the use of oak. The soft white woods (pine and fir) converted into 'deals' were imported from Norway. In December 1666 the Privy Council had referred to the committee charged with rebuilding London after the Great Fire the possible replacement of oak by fir and it was said that 'the Norwegians warmed themselves comfortably by the Fire of London'.

English craftsmen decorated panelling and screens with motifs associated with the new grammar of Italian Renaissance ornament. They copied pattern books and engravings and combined strapwork and fantastic figures in low relief carving to invade and overlay all suitable areas and indeed any available space. Strapwork appears on the cresting of the screens at Trinity College, Cambridge (*c.*1604–5) and at Knole in Kent (*c.*1606). At Croscombe Church, Somerset, the screen is surmounted by strapwork ornaments reaching almost to the roof – the sounding-board of the pulpit (dated 1616) is in the same style. What the Jacobean craftsman was trying to do in his panelled decoration was to adapt Flemish versions of the architectural design of the period, by emphasising the mouldings and surfaces in incised or low relief detail, and by introducing faceted and oval bosses which represented richly veined marble. By the time of Charles I in the 1630s unmodelled strapwork was in the main superseded by stronger architectural forms, concentrating in particular on the chimneypiece.

In an agreement of 1639 between Lord Cork and a Bristol mason, Christopher Watts, the latter contracted to make 'a very fair chimney' for his parlour which is to 'reach up close to the ceiling with coat of arms complete, with crest, helmet, coronet, supporters and mantling, and foot-pace, which he is to set up and finish as his own charges, fair and gracefull in all respects'. During the latter half of the sixteenth century the chimneypiece openings had been made rectangular. This allowed it to be flanked by columns or caryatid (female) figures, or both, and for an upper stage above the mantlepiece to be divided into two or three compartments filled in by arched or carved panels and heraldic achievements. It was a place for putting personal preferences in decoration: for illustrations from the Bible, such as 'The Parable of the Wise and Foolish Virgins' or 'The Sacrifice of Isaac'. Following an engraved source was also common. In the upper stage of the State Room chimneypiece at Boston House, Brentford (1623) the grotesque ornament of human figures, sea-horses and mermaids surrounding a centre medallion of Andromeda is taken from an engraving (1584) by Abraham de Bruyn.

In the type of marble chimneypiece designed by Inigo Jones, termed 'continued chimneypieces', the lower part was fashioned in marble, while the upper part, in wood, was painted and gilt. In some instances, as in the Double Cube Room at Wilton House, Wiltshire (*c.*1650), the chimneypiece projects boldly with the overmantel having a pediment, broken to receive an

armorial cartouche, with the centre of the overpiece recessed for a picture. Flanking it were 'thick clusters of fruit and foliage hung from scrolled cartouches' between the inset van Dyck portraits.

After the Restoration architects preferred the type of chimneypiece in which the chimneybreast was panelled, with additional emphasis given by the inclusion of a mirror, a picture, or applied soft-wood carving. The corner fireplace and the chimneypiece continued as a china-shelf (for example in the King's Dining Room at Hampton Court, or at Hopetoun House, near Edinburgh) are a Dutch derivation. The two or more tiers of receding shelves were most suitable for displaying the blue-and-white Delft china beloved of William III's Queen, Mary II. Whilst marble chimneypieces with an elliptical arch and key block are typical of the late years of the seventeenth century, the most elaborate were those in which the upper stages were decorated with applied lime-wood carvings.

Careful consideration was given to the proportions of the door. Sir Balthazar Gerbier (1591?–1667), who wrote a brief architectural treatise on the magnificence and convenience of buildings (1662), issued his *Counsel and Advice to all Builders* (1664) in which he wrote that 'the wideness of the door must serve for two to pass at once, that is to say, the doors of Chambers of a pallace', and that the height of a door should be double its width. In other rooms the door should be high enough for a man 'of compleat stature' to pass with a hat on his head. The door itself was divided into panels of varying size, with the eight-panelled door the most used (see p. 279). The architrave of the door in the late seventeenth century was frequently carved and surmounted by an overdoor picture or carving or (less commonly) a bracketed pediment.

The staircase

The selection of the place in which the staircase – often the best feature in a house – was to be placed required great judgment, and was one of the most difficult tasks in the formation of a plan. Palladio indicated in 1570 in his *Quattro Libri Dell'Architettura* that they needed to be placed so that no part of the building 'should receive any prejudice by them'. He noted that three openings were necessary to any staircase: the doorway leading to it, the windows by which it was lighted, and the landings by which one entered upper rooms. In the satisfaction of these requirements many splendid drawings of great mathematical complexity adorned manuals of practical instruction.

Staircases, the surrounding walls of which were often painted with great iconographic schemes (as at Petworth House, Sussex) are basically of two sorts, straight or winding. In proceeding with the house design and the interior decoration, the architect, often in consultation with a master carpenter, had to ensure that the person ascending had enough 'headway', and he had to settle the proper relation between the height and width of steps.

At the well edge each step was set into a 'string board'. The face of this was embellished with all forms of carved decoration. Above the string board

the balusters were set into part of the 'carriage' or framework on which the wooden steps were supported. Alternatively in the years from about 1650 to 1675 balusters were supplanted by panels of carved softwood ornamentation representing foliage. This part of the staircase was finished by a handrail into which the upper part of the balusters or panels was fitted.

When the arrangement of rooms one to the other, with appropriate access, had been settled and when the staircase was in position and the wainscoting done, it was time for the ceiling and wall decoration in plaster, plaster/paint or by carved wood embellishment.

Plasterwork

The most widely used form of plaster was composed of lime to which water and sand had been added, together with the important ingredient needed to give tensile strength – chopped animal hair. The art of plastering consisted in laying three coats of plaster at successive intervals on to an underlying structure of riven oak laths which had been nailed to the timber joists of the roof structure. Only at that point was it possible to ornament the surface with plaster ribs in interlocking geometric form – 'run' in situ from a profile mould – and to place heraldic or other low-relief ornament such as 'Tudor' roses within the compartments created. A surprising amount of this ornamentation was pre-formed, using wooden moulds which had been dusted with nut-oil to release the pattern, and it soon became usual to also form the ribs (in sections) within moulds. Work could proceed more economically within a workshop rather than in the incomplete and draughty structure of the house and be taken to the site in trays. A team of about four was considered usual to install the work.

Working from scaffolding the master plasterer was brought moulded ornament by the boy, from an array set out on a table mounted across the joists of the room below him. No floorboards were in position in order that messy wet debris could be easily discarded as it dropped. He would prepare the ornament with the aid of the 'sticker' (who cross-hatched the back of it, and coated it with a liquid slip of gypsum to aid cohesion to the ceiling) and then it was propped in position and allowed to set. Whilst it was drying the 'cleanser' indented nostrils and eyes and sharpened the ornament, freeing it from mould marks with bone modelling tools. Finally the work was lime-washed to give a creamy appearance. The shadow falling on the ribs and other relief ornamentation were sufficient to give it a robust outline, without any need for additional colourings.

In the years after the Restoration plasterwork moved in the direction of naturalism in detail in which festoons and wreaths of flowers, crossed and twisted tendrils and a profusion of modelled fruit, flower heads and sprays of wheat and barley, interspersed with billing doves and cherubic amorini disported themselves. The units (such as fruits and flowers) were made separately and mounted on a stalk of wire, lead, wooden twig or peg and even in one case strips of leather. It is this sharpness and vivacity of modelling which gives seventeenth-century plasterwork some of its interest. The

influence of a *Book of Freeze Work* by Edward Pearce in 1640 (reissued as *The Art of the Plasterer* by Edward's son in 1680), observation of emblem books and engravings by foreign artists such as Jean Lepautre, coupled with spirited improvisations, invested most major ceilings with pictorial interest. At Blickling Hall, Norfolk, thirty-one panels of the Long Gallery ceiling (*c*.1625) are filled with devices, and the central eleven are based on symbols copied from plates in Henry Peacham's *Minerva Britanna* (1612). At Forde Abbey, Dorset (where Richard or John Abbott, the Barnstaple plasterers, may have been involved) there is little knowledge of classical precedent. What is there is a spirited improvisation in the Saloon (*c*.1655) of Biblical stories, but with ornamental details several times too large.

In particular, English plasterers found it difficult to model figure subjects, and it is significant that the portrayal of the figure is absent even in London work of the 1670s. At the Palace of Holyroodhouse in Edinburgh it was probably due to the intervention of the 1st Duke of Lauderdale or his architect Sir William Bruce (*c*.1630–1710) that the human figure was well modelled on the plaster ceiling of the staircase well. Bruce had travelled in the Low Countries and France in about 1663 and it has been suggested that he may have brought back current architectural treatises.

The union of the Crowns of England and Scotland in 1603, and the establishment of a link between the two royal houses had opened the way for English ideas and craftsmen to enter Scotland more freely than hitherto,

Plasterwork ceiling in the Dining Room, Forde Abbey, Thorncombe, Dorset (c.1655).

mingling with a wide repertory of ideas bearing the marks of association with Scandinavia, France and the Low Countries. In this creamy-white froth of plaster Scotland was provided with more exuberant animals, demi-gods, well-fashioned pendants and proud heraldry than almost anywhere else. In one important decorative respect, the prolific use of the pendant (derived in form from the medieval roof boss), Scotland outstripped England. Starting as a device to cover the intersection of ribs, a decorative urge took over – at Auchterhouse there are twenty-three pendants on the Drawing Room ceiling alone.

During the last quarter of the seventeenth century the names of a number of plaster workers have been recorded. From many one might select Robert Bradbury and James Pettifer who fashioned the superb ceilings at Sudbury Hall, Derbyshire in the mid-1670s; and Edward Goudge, who, as the gentleman-architect Captain William Winde recorded in 1686, was undoubtedly considered to be the leading master-craftsman in his field. Goudge's work at Belton, Lincolnshire (1688; see also p. 229) and at Chatsworth (Long Library, 1696–7) ensure him a firm place among the

Plasterwork in the Drawing Room, Auchterhouse, Dundee, Scotland (c.1625).

masters of European decorative art. But by 25 March 1702 Goudge was lamenting, in a letter to his patron Thomas Coke of Melbourne, that

for some years past, for want of money occasioned by the War and by the use of ceiling painting, the employment which hath been my chiefest pretence hath always been dwindling away, till now its just come to nothing . . .

Wood and stone carving

The craftsmen who were able to both pierce wood and fashion it so that it resembled other materials and natural forms were the carvers. Frequently they were adept at carving in both stone and wood, and surviving accounts are not always informative about the choice of material. Carving in wood appears synonymous in the late seventeenth century with the achievements of Grinling Gibbons (1648–1721); however, he was also an accomplished statuary, with a dozen or more monuments with standing figures to his credit. There were also several other woodcarvers, such as Jonathan Maine of Oxford (colour pl. 4) and the younger Edward Pearce, who were almost his equal. Maine worked alongside Gibbons at St Paul's Cathedral and Pearce worked in several of Wren's City churches, as well as carving the staircase at Sudbury Hall, Derbyshire, a fine achievement of the mid-1670s.

Gibbons had been born of English parents at Rotterdam and was in England by *c*.1667. He had probably trained in the workshops of Artus Quellin and the influence of Dutch still-life and flower-painters made a profound impression on him. He was 'discovered' at Deptford (where he did ship-carving) in 1671 by the diarist John Evelyn, who introduced him to Charles II. A wood relief 'The Stoning of St Stephen' (Victoria and Albert Museum, London) is said to have been the work Gibbons was doing at the time. His evident abilities led the King to appoint him as Master Sculptor and Carver in Wood to the Crown when Henry Phillips, holder of the post, died in 1693.

Gibbons is best assessed as a woodcarver in work he did in a number of country houses, in the library of Trinity College, Cambridge, where there is also a marble statue by him of the 6th Duke of Somerset, his patron at Petworth. The coats-of-arms in the library are in light-coloured lime-wood, fashioned out of built-up blocks of planks about 2½ inches thick glued together, cut in the round and then applied to the panelling. The carvings on the west side relate to the Duke, those to the east are coats of masters or benefactors to the college. Gibbons received £405 for his work, of which £245 was for the statue of the duke, a number of 'bustos' (unspecified), nine named and other unnamed coats of arms.

The best work by Gibbons in lime-wood is undoubtedly the panel which Charles II sent in 1682 as a gift to Cosimo III, Grand Duke of Tuscany (now in the Bargello Museum, Florence) and the excellent work in the Duke of Somerset's country house, Petworth, Sussex (see p. 276). The latter work is mounted on the wainscoting of the Carved Room, which was originally two rooms, made into one about 1794 to contain all the carvings of the 1690s by Gibbons and his assistants. The most talented of these was the Petworth

Grinling Gibbons, choir stalls on the south side of St Paul's Cathedral (c.1696–7).

carver, John Selden (d.1715), whose own work in the Petworth Chapel and Hall of State is very competent. Selden also worked in stone and did such diverse jobs in wood as mouldings, festoons and a periwig stand. The walls of the Carved Room are covered overall with a riotous assemblage of carved foliage, musical instruments, trophies of the chase, and above the coronet of the 6th Duke of Somerset is held by fat cherubs so that it is easy to forget the underlying sombreness of the panelling. The same is true in the comparable work by the 'team' of carvers under Thomas Young at Burghley

House, Northamptonshire, *c.*1683–5. Working for the 5th Earl of Exeter their work is complementary to the lavish painted murals by the decorative painter Antonio Verrio in other rooms at Burghley. When the 'team' had finished at Burghley some of them moved on, by recommendation, to work for the Earl's brother-in-law, the 1st Duke of Devonshire at Chatsworth House, Derbyshire. Here they were helped by Samuel Watson (1663–1715) whose carved work in lime-wood, set over cedar wainscot in the Chapel, was rivalled by his skill in carving, in local alabaster, the great altar designed by Caius Gabriel Cibber.

The drawing together of the decorative teams responsible for the riches of late seventeenth-century interior decoration can be traced easily in the State Drawing Room at Chatsworth (1689–94). On the second floor of the south front the various State Rooms were ready for the joiners in the summer of 1690. In October wainscot wood was brought from Hull and the rooms were plastered ready for the painter. The carvers Joel Lobb, Roger Davies and Samuel Watson signed agreements to carve ornaments in lime-wood. The one portrait, an oval in the centre of the fine inlaid wood and attendant carved swags, is of the patron, the 1st Duke of Devonshire. The wainscoting is 'lost' beneath Mortlake tapestries (*c.*1630) depicting 'The Healing of the Lame Man at the Gate of the Temple', whilst the ceiling is occupied entirely by an oil on plaster, 'Assembly of the Gods' by the French decorative painter and godson of Louis XIV, Louis Laguerre (1663–1721).

Grinling Gibbons, carving above doorway in the choir stalls, north side, St Paul's Cathedral (c.1696–7).

Portrait of the 1st Duke of Devonshire, after William Wissing (1665–87), surrounded by carved limewood swags, above the fireplace in the State Drawing Room, Chatsworth, Derbyshire (1689–94).

Tapestry

Wall coverings were provided by tapestry-weavers and by the use of less durable silks and velvets. The tapestries were mostly of continental make, particularly from Brussels, with (in the late seventeenth century) some coming from its rival, the French ateliers of the Gobelins, set up by Louis XIV. What of English manufacture? An important tapestry enterprise had been established by the Sheldon family at Barcheston, Warwickshire in 1561, which was still active by the early seventeenth century. Indeed, four large and imposing tapestries of the Seasons, dated 1611 at Hatfield House, Hertfordshire, are attributed to the Sheldon looms.

The first quarter of the seventeenth century was a period of intense activity amongst tapestry-weavers. The success of the large manufactory Henri IV of France had set up at Paris in 1609 encouraged James I, at the instigation of his son, Charles, Prince of Wales to establish a similar enterprise in 1619 at Mortlake, Surrey. In 1620 fifty Flemish weavers and their families took up residence, led by the head weaver from the Paris factory, Philip de Maecht. Weaving began in September 1620 with nine tapestries representing the myth of Venus and Vulcan, from sixteenth-century designs. Designs were often repeated: at least three sets of the initial Venus and Vulcan series were woven before 1625. The factory used enough stitches in warp and weft to give, with the use of richly coloured silk and wool intermingled with metal thread, a fine weave which attracted customers. The Prince of Wales took a keen interest in production and ordered a set (still in the Royal collection) of the second weaving, the popular depiction of scenes related to the months of the year.

But innovation was needed and the Prince urged the appointment of Francis Cleyn (1582–1658) as designer. Taking up the position, Cleyn had immediate access to the Raphael cartoons which Charles I had bought in Genoa in 1623. Cleyn, who was born at Rostock in the Baltic provinces, had been sent to study in Italy and this Venetian and Roman training gave him extra work in England as a painter in tempera – his efforts (*c*.1638) can be seen only at Ham House, Surrey.

His tapestries based on Raphael's cartoons for earlier tapestries to hang in the Sistine Chapel were very popular. Part of the set woven for Charles I with the Royal arms in the border is in the Mobilier National, Paris. One of Cleyn's most popular subjects 'Hero and Leander' some 14 feet by 18 feet (wide) is in the Victoria and Albert Museum, London. Grotesques of the Five Senses' with a white ground are at Haddon Hall, Derbyshire. Cleyn's leadership allowed Mortlake to rival Paris and Brussels.

The approach of the Civil War brought considerable hardship to the 140 weavers and their families. Work was understandably scarce. After the execution of the King in 1649 Cardinal Mazarin acquired eagerly eleven sets of tapestries and there seemed hope when Cromwell ordered Mantegna's cartoons, 'The Triumph of Julius Caesar' (Hampton Court), to be woven. However, drastic reduction in the number of weavers brought by 1661 a petition from Sir Sackville Crow to Charles II, newly restored from exile, for a new, second Mortlake factory. Crow's favourite designs held their own

'Smelling', one of Francis Cleyn's tapestries from Haddon Hall, Derbyshire. Each tapestry has a centre vignette symbolising one of the senses, and a border made up of scenes from Aesop's Fables. *Woven at Mortlake, early 17th century.*

against inferior work coming to England from the Continent, but the Mantegna 'Triumphs' were still on the loom in the mid-1660s. In 1667 Crow resigned and was soon imprisoned for debt, being replaced by the princely Ralph, Earl (and afterwards) 1st Duke of Montagu, who became Master of the Great Wardrobe. The later Mantegna 'triumphs' (three of them) belong to the Duke's successor, the Duke of Buccleuch and Queensberry and are at Boughton House, Northamptonshire. In the interregnum the factory had been kept active by two good master weavers, Francis and Thomas Poyntz, and they prospered under Montagu's rule.

In 1685 new premises were found for the offices of the Great Wardrobe in Great Queen Street, Soho. In 1689 the chief arras-maker, Thomas Axton, was succeeded by the Flemish weaver, John Vanderbank. He was soon issuing the famous Soho chinoiserie tapestries, wonderful assemblages of figures in landscapes dressed in Indian costume on black, blue or brown grounds. In addition Soho produced versions of the Gobelins 'Les Eléments' tapestries after designs by Teniers, and many cushions and smaller hangings.

Costume and carpets

The English economy since medieval times had been bound, inextricably, with the fortunes of the wool trade. Sir Edward Coke, the Elizabethan lawyer, had stated that 'nine parts in Ten of our Exported Commodities doth

come from the Sheep's Back, and from hence alone is the spring of our Riches'. A strong broadcloth was made, but by the end of the reign of James I (d.1625) the worsted weavers of Norwich had set out the other types of worsted cloth, many of which had been improved in texture and weight by weavers from Flanders and Holland settling in England, and by further Dutch and Walloons fleeing from Spanish rule in the Netherlands. They settled at Norwich. What they produced was eminently suitable for dress and furnishing material and rivalled the staid production of Yorkshire and the West Country and, since the beginning of the seventeenth century, the linen and cotton weavers who had settled near Manchester. There was also the later trade towards the end of the seventeenth century encouraged by the journeyings of the ships of the East India Company, which had been founded in 1603. The Company's servants in India were weaving silks for the European market, although they were rivalled closely by the silk-weavers in France at Tours and Lyons.

The growing wealth in Europe during the second half of the seventeenth century brought about an ever-increasing demand for silks and luxury wares, and this encouraged new designs and patterns. Whilst James I had tried to establish French silk weavers in England about 1607 nothing much came from his efforts, but by the time James II confirmed a charter granted to the London Weavers' Company by Charles I in 1686 there was already an established silk-weaving industry in London. It claimed in 1676 that it could 'furnish all England with silk stuffs . . .' In the area around Spitalfields market there also settled large numbers of French Huguenots who fled across the Continent when religious freedom established by the Edict of Nantes was revoked by Louis XIV in 1685. Most of the community's members were skilled artisans and tradesmen, and several were silk-weavers. Whilst most of their activity gained strength after 1702 at the accession of Queen Anne, they were a means whereby good fabrics for costume could be sold to silk-merchants and subsequently to the public. In summary, however, grander seventeenth-century costumes relied for much of their effect on imported fabrics even if the lace was of English manufacture.

The almost complete eclipse of hand-knotted carpet making in England during the late seventeenth century may be explained by the ever-increasing use of imported oriental carpets. Portraits abound showing them in use and although the popularity of exotic matting and imitations of the Oriental types in both needlework and knotted pile technique was firm, it was the imports which dominated. Hand-knotted Turkeywork imitates Oriental pile carpets both in appearance and technique. A magnificent example, the Molyneux carpet (Victoria and Albert Museum), is dated 1672 and amid its repeating pattern incorporates a shield with the arms of Molyneux impaling Rigby. It is difficult to judge whether carpets such as the Molyneux example were for use on the floor or as a table carpet.

The Restoration period saw the growth of a fashion for richly embroidered velvet carpets, again used for tables and floors. Few have survived, although paintings of Dutch interiors of this time show similar velvets in use as table carpets. What took the place of carpets was a combination of rush matting and stencilled and parquetted floors. Robert Carew's *Survey of Cornwall* (1602) records that

women and children in the west of *Cornwall*, does use to make Mats of a small and fine kinde of bents there growing, which for their warme and well wearing, are carried by sea to *London* and other parts of the Realme, and serve to cover floores and wals. These bents grow in sandy fields, and are knit . . . in narrow bredths after a strange fashion.

The thick rush matting which came in braided strips that could be sewn together to fit a room was superseded after the Restoration by a taste for highly decorative imported mats described in accounts, variously, as: Portugal, Tangiers, Barbary, Africa or Dutch. The last were so-called because they were first shipped to Europe by the Dutch East India Company – the rest all originated in North Africa.

Furniture

English furniture, throughout its long history, incorporated many variations in quality with the deciding factor being fitness for purpose. Common or vernacular furniture was made in oak, elm, or ash, but that for use in more fashionable circles was made in walnut. A technical development of the mortise and tenon joint, popular from the sixteenth century onwards, and made stronger by the addition of a peg, was of benefit in construction. The introduction in the late seventeenth century of another effective joint, the dovetail, made possible the use of thinner pieces of wood, with the minimum of glue being needed to fasten one part to the other. In the seventeenth century the status of the upholsterer also gradually improved, with the Upholsterers' Company of London (founded in the fifteenth century) being granted a fresh charter in 1626. A detailed study of the seventeenth-century upholsterer and his materials shows that patrons were able to choose from a range of coverings brought from many distant parts of the world.

At the beginning of the seventeenth century patrons were also ready to adopt foreign ideas; they welcomed the Vitruvian ideals of harmony and symmetry in decor, and required that rooms should be suitably furnished for their purpose, whether 'office, entertainment or pleasure'. Knole, in Kent, provides interesting evidence of this, though it is surprising, in view of the rapid deaths of the first three Earls of Dorset and a disastrous fire in 1623, that any of the furniture (or the documents which record its history) have survived.

No firm conclusions can be drawn about the origins or makers of the early items at Knole, but some of the principal items were probably made for James I and Anne of Denmark. It is worth noting, but dangerous to exaggerate, the family connections of a leading cloth merchant, Sir Lionel Cranfield, with Lord Dorset's family; Sir Lionel's daughter married the 4th Earl's son and heir. Sir Lionel (who became Lord Treasurer in 1621) bought silks, velvets and taffetas from Italy, and linens and fustians from various parts of Germany. He speculated in woods for making dye with Sir Arthur Ingram, and he invested in a silk farm. He was obviously in a good position to supply exotic fabrics, and something of what he had in stock may have been acquired by the Knole embroiderers, and those working at Hatfield House, and for the Royal Wardrobe in London.

Whatever its source, the upholstered furniture at Knole provides adequate testimony to the rank of the owners. There are five X-frame 'chairs of state' intended to be set under a canopy for important persons – the Mytens portrait of James I at Knole shows him in such a chair made between about 1610 and 1625. One, *c.*1610, is covered in red silk and silver tissue, and another of slightly later date has a white and red painted frame with arabesque decoration. This obviously complemented the original scarlet and silver cover.

A little later in date than the elaborate X-frame chairs of state were the chairs of about 1630–40, with square joined frames, padded seats and low padded backs but no arms. They were given the name 'farthingale chairs' in the nineteenth century because they were made without arms to accommodate the farthingale or hooped petticoats worn in the reign of James I. The woodwork, of simple turned components, was undistinguished, although some examples have attractive fluted, baluster, bobbin-type or twisted components incorporated. Most of these chairs were covered with Turkeywork wool pile on a canvas backing, in imitation of Turkey carpets.

Often chairs were covered with leather, attached with brass-headed nails. Many of these leather-covered chairs survive, and they are often depicted in portraits of the period – Arthur, Lord Capel and his wife, for example, are shown seated on two red leather, nail-studded chairs in Cornelius Johnson's portrait of them with their attractive young children, dated 1639 (National Portrait Gallery, London).

The ravaging of property and the imposition of severe restraints on luxury and ornament during the Civil War and Commonwealth period in the 1640s and 1650s was disastrous for the creation or survival of upholstered furniture. Turned wood and leather might survive military depredation – upholstered

X-frame chair of state in the Spangled Bedroom, Knole, Kent (c.1610).

Detail from the Molyneux carpet (1672).

furniture did not to any extent. When Dame Mary Verney revisited her Buckinghamshire home, Claydon, in 1661, after soldiers had been quartered there, she wrote that the house was

most lamentably furnished, all the linnen quite worn out . . . the spitts, and other odd thinges so extreamly eaten with Rust thatt they canot be evor of any use againe . . . the cloath of the Musk-coloured stools soyled, and the dining-room chairs in Ragges . . .

The political turmoil of the mid-seventeenth century meant that some furniture after the Restoration of the King in 1660 was still being made in the style of earlier times. On the other hand, the journeyings of the Royalists who had fled abroad and returned to England after the Restoration heralded a new mood in the decorative arts in England. In May 1661 the King married the Catholic Catherine of Braganza by proxy. When she came from Lisbon a year later, it was to create an interest in what Portugal and its territories, such as Goa, could produce. The furniture makers soon had to create furniture to accommodate the Queen's predilection for drinking tea – tea-tables, tea-kettles, cups to use with what the poet Edmund Waller in 1680 called the 'best of herbs'.

The overwhelming influence on the King and his courtiers, however, came from Holland. Its successful East India Company had long vied with its English counterpart to import lacquer cabinets, and English makers soon set these on elaborate gilt-wood stands.

One of the King's principal ministers was his long-time Scottish friend, John Maitland, 2nd Earl and later 1st Duke of Lauderdale. By his marriage to Elizabeth Murray, daughter of the 1st Earl of Dysart, he came into possession of Ham House, in Surrey, which had been built in 1610. During the 1670s Lauderdale and his red-haired wife enlarged the house, adding new suites of rooms and furnishing them with a lavishness which transcended what was fitting to their exalted rank.

The contents of Ham House were listed in three inventories in the 1670s and much of the important furniture listed therein survives. There were cabinets from Antwerp, silver-mounted side tables, Japanese lacquer cabinets, cabinets veneered with ivory, cedar sideboards, armchairs with spiral-turned legs and cane seats and backs, kingwood writing boxes, ebony-framed mirrors and a strongbox with brass mounts. In the Duke's closet there were two damask and velvet covered sleeping chairs; there was also a Dutch form of 'scriptor', or writing-desk with a fall front, (see p. 297) made in walnut and mounted with silver. The decoration and furnishings at Ham justified John Evelyn's observation that the house was 'furnished like a great Prince's'.

From the Middle Ages onwards considerable attention was bestowed by patrons and furniture makers on beds; 'the best bed' often features in wills or probate inventories. In the seventeenth century the 'wainscot' bed, descendants of the medieval bedstead with panelled headboard, began to give way to beds with a lighter framework, although still with elaborate hangings. The frame was usually of beech, and the tester, cornices and back were covered with the same material as the curtains. The four posts were tall and slender, and were often covered in taffeta. About twenty-five grand state beds

made between 1670 and 1700 survive in England, including some made by
Huguenots who had fled from religious persecution on the Continent.
William III's bed at Hampton Court is one of these; it is 17 feet (5.2m) high
and is topped with vase-shaped finials with ostrich plumes. It is closely
rivalled in splendour by the bed made for the 1st Earl of Melville about 1697
(now in the Victoria and Albert Museum). This is some $14\frac{1}{2}$ feet (4.5m) high
and is decked in crimson silk and Genoa velvet, lined with white Chinese silk
damask and trimmed with crimson silk braid. The bed in the Venetian
Ambassador's Room at Knole seems to have been provided by the English
maker, Thomas Roberts, who worked in the Royal palaces for some thirty

Bed in the Venetian Ambassador's Room, Knole, Kent (c.1688), supplied by Thomas
Roberts.

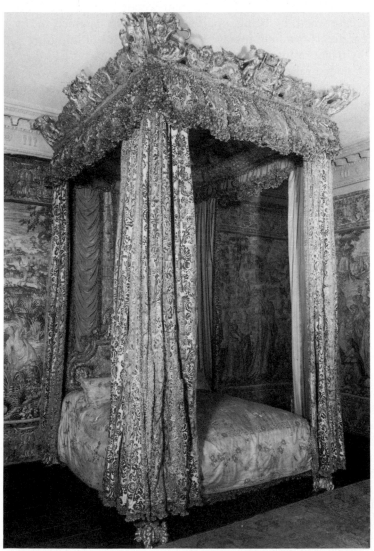

years at the end of the seventeenth and beginning of the eighteenth centuries. A royal warrant, dated 28 August 1688, required Viscount Preston, Master of the Wardrobe to James II, to obtain from Roberts: 'a bed of green and gold figured velvet with scarlet and white silk fringe', six stools and two armchairs for use at Whitehall Palace. The bed is decorated with James II's insignia, but within a few months of its completion the King and Lord Preston had fled abroad; the bed finally came into Lord Dorset's possession, and so to Knole, as part of his 'perquisites' as Lord Chamberlain.

When Celia Fiennes visited Chatsworth in 1696 she noted in the State Dining Room 'a Large Door, all of looking-class'. This had been provided by a craftsman of Dutch origin, Gerrit Jensen, who worked for the King at Hampton Court. His name is more usually associated with furniture decorated with marquetry or japan, and sometimes metal inlay. Marquetry differed from inlay (in which a pattern of different woods was set into incised grooves in the carcase wood) by being a pattern of such woods glued to the surface to be decorated. Japanning involved various methods of imitating oriental lacquer by using resins mixed with other materials, coloured, polished and with gilded reliefs.

In 1680 Jensen excelled in providing the famous suite of silver furniture (consisting of a dressing table, looking glass and pair of candlestands) to the 6th Earl of Dorset at Knole. The table and candlestands are thought to be those now in the Spangled Bedchamber but the pier glass is now missing. Jensen's work epitomises the high standards of late seventeenth-century furniture for Crown and Court: a pier glass at Hampton Court with the royal cypher and crown in blue glass must be the 'pannel of glass 13 feet long with a glass in it of 52 inches with a Crown and cypher and other ornaments' described in a bill of 1699.

What, however, gave a late seventeenth-century room its overall appearance was a lavish use of cane seated or of upholstered furniture contrasted with much that was handsomely veneered, with thin slivers of wood glued to the underlying frames. Some cabinets on stands were veneered inside and out in walnut with many concealed drawers, often outlined with precise borders, or 'stringing' lines, done in a contrasting wood such as holly. Alternatively, simulated flowers and foliage were inlaid, in stained colours, into black ebony grounds. By the clever staining and the careful arrangement of patterns the effect of the inlays is charming, and always enhanced, and sometimes surpassed, by the giltwood capitals of the supporting stand. Indeed few parts of a William and Mary period cabinet of the 1690s escaped the craftsman's attention, with a lavish exterior counter-balanced by the even greater sophistication of the interior. This is particularly true of the black, red, or other colour japanned cabinets with decoration of chinoiserie figures, exotic birds, scrolled acanthus, engraved brass escutcheons, hinges and corner – a rich assemblage owing much to the abiding interest in Oriental works of art, and to the appearance of a book on japanning by two English authors (John Stalker and George Parker) in 1688. Occasionally door panels could be of silk stump work (needlework in which much of the ornament is raised in relief) embroidered in silver and silk thread. The richer alternative was, however, always marquetry with some cabinets having veneers of dark slice-

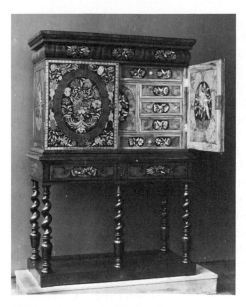

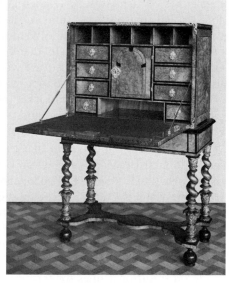

*Cabinet decorated with floral marquetry on ebony panels surrounded by walnut and holly, on a turned chestnut stand (*c.1675*). Victoria & Albert Museum.*

*A Dutch-style scriptor of walnut, inlaid with ebony, with silver mounts, Ham House, Surrey (*c.1675*).*

cut laburnum set against a light yellow ground to form radiating lobe and zig-zag patterns, or those in 'seaweed marquetry', where a simulation of seaweed was also done in a dark contrasting colour to a lighter ground. A third alternative was to form an oyster patterning of burr walnut veneers overall – small oval patterning of great distinction.

In design terms such cabinets owed something to an observance of Dutch examples and to Dutch influences at work in England. We need to bear in mind that a Dutch King, William III, sat on the English throne and this encouraged the presence in England, for at least three long visits, of one of the most active of the Huguenot designers, Daniel Marot (*c.*1660–1752). He had earlier been in William's service in Holland, and had then come to work for him and his Queen at Hampton Court. His engravings show many beds, chairs, cabinets and state beds capable of realisation by the many good furniture makers living in London. However, along with their provincial colleagues much was made for less grand settings than the Royal palaces and large country houses.

Ignoring for a moment those families with origins deep in post-Conquest lineage (who may have had the benefits of inherited wealth and favourable marriage alliances) there were many who made money through their own abilities and by astute management of their assets. The small country houses they built were certainly furnished much more simply by the many lesser London and provincial furniture makers. Whilst John Evelyn noted in 1690

that ladies of fashion were acquiring light tea-tables for their dining-rooms he could recall that the conditions in the home in which he had spent his youth were simple and had 'shovel board and other long tables, both in hall and parlour'. Made in oak, they stood alongside chairs with pegged joints, or those elaborately fashioned from turned wood components. Upholstery was scarce in the smaller house, and the long-case clock was by a provincial rather than a London maker such as Thomas Tompion. An upholstered day-bed and gilded looking-glass were rare, and it was an array of simple oak chests, coffers, cupboards and settles which predominated.

It was not until about 1700 that the influence of designs and techniques made popular by Marot, Jensen and others, and well used in London, spread to the provincial towns. The Jacobean style, long embedded in the native tradition of panel-back chairs, gate-leg tables and framed chests and cupboards, gave way only slowly to the newer fashions. Early in the seventeenth century even the popular dresser (from the old French word *dresseur* – a sideboard or table in a kitchen on which food was dressed) had been generally found only in the servants' quarters, but they continued to be made on traditional lines for farmers and yeomen long after they had been supplanted in grander houses. It is the stylised flowers, lozenges and other simple geometric patterning which give character. Similar to the earlier motifs found on church woodwork, it is indicative of a strong vernacular or common furniture tradition that may eschew published pattern but still give great visual pleasure.

Clocks

Up to the age of Charles II it was necessary for both clocks and watches to be set right daily by comparison with the sundial. J. Smith in his *Horological Dialogues* (1675) noted 'observe also to set your watch continually by one sun-dial . . . If you set it sometimes by one, and sometimes by another, you will never know when your watch or clock goeth right'. The cause of the bad timekeeping was faults in the mechanism which was changed by the use of a pendulum, which followed the natural law of gravity with a uniform swing. This regularity could be transmitted to the train of wheels, driven by the weight or spring. It was a principle discovered by Galileo Galilei and applied to the clock by the Dutch astronomer, Christiaan Huygens.

One of the first pendulum spring clocks made in England was signed 'A Fromanteel London, Fecit 1658', that is Ahasuerus Fromanteel, a craftsman of Dutch descent. It was the family's connection with Holland which gave them ready access to Huygens's discovery and speed in introducing it into England. Perhaps the most significant family of clockmakers in Charles II's reign was that of Knibb, headed by Samuel and with several brothers and children in succeeding generations. Joseph Knibb built up a significant circle of patrons headed by Charles II and many members of his court. With distinctive design (noteworthy for the elegance of the dials and hands) and with his invention of a striking mechanism according to Roman notation, Knibb led by high standards of craftsmanship with no betrayal of provincial origin: clocks by him and by John Knibb are fairly numerous.

A celebrated watch and clockmaker who belonged to the same rank as his celebrated rival Thomas Tompion was Daniel Quare (1649–1724). He invented the repeating mechanism in watches, enabling time to be ascertained in the dark by pressing a spring which caused the watch to repeat the nearest hour and quarter. Quare, a staunch Quaker, was also a distinguished maker of mercurial barometers (an innovation of the time of Charles II), and a prominent member of the Clockmakers' Company. His clocks, watches and barometers exhibit great variety – he invented, for example, a portable barometer supported by hinged feet – and had a large export trade in watches and clocks to the Continent.

Perhaps the most famous clockmaker of all time was Thomas Tompion (1639–1713). Robert Hooke, who was in almost daily contact, wrote in his diary that he was 'a person deservedly famous for his excellent skill in making watches and clocks, and not less curious and dexterous in constructing and handworking of other nice mechanical instruments'. Tompion's clockwork was of a very high order. He introduced refinements beyond the ability of his contemporaries, such as perpetual calendar work, equation work, elaborate repeating and astronomical work. The brass clock dials were of excellent design, restrained and put into clock cases of ebony and walnut with little elaborate marquetry or japan, although the table clocks were given more lavish settings. Supremely he may be judged, from a considerable output, by the long-case clock made, *c.*1695–1700 (colour pl. 5), for William III, whose cypher adorns the pedestal which supports the figure of Minerva (Colonial Williamsburg Foundation, Virginia). The movement goes for three months without rewinding and the perpetual calendar makes allowance for leap year.

Tompion died in 1713 and was buried in Westminster Abbey.

Gold and silver

In 1622 King James I declared his dissatisfaction with the 'mixture of mean trades' which were mingling with the London goldsmiths in Cheapside. He wanted speedy 'reformation' in order that the chief street in the city could be restored to its former splendour – the houses and shops of workers in the premier metals, gold and silver. But not a great deal is known of the early makers as so many only stamped devices or initials on their work.

It has been shown that the rarity of Stuart plate is due less to the demands of the Civil War but to the decline of the English economy in general after 1620. However, the war did reduce rentable income, and as a result there was a decline in conspicuous consumption. In particular, the purchase of gold and silver could be avoided by families without any undue discomfort: Faced with such a situation goldsmiths relied on their native talent, cut the cost of making items by reducing the amount of metal used and standardised design. The provincial trade at York and elsewhere declined, leaving work only to London craftsmen.

The most characteristic form of early Stuart silver is the standing cup with cover. Many had steeple or obelisk finials of Gothic form raised on cast scrolls. Some cups were given a gold colour by mercury or fire gilding the

gold mixed with mercury was melted in a crucible and after the excess of mercury was evaporated by heat the solution was brushed on to silver to leave a thin film of gold.

If a 1613 Steeple Cup (Wallace Collection, London) is compared to the Pepys Cup (*c*.1677, Clothworkers' Company, London) the advances in technique can be assessed, the latter cup having pierced and *repoussé* foliage, meaning that its design had been hammered into relief from the reverse side with rounded punches. This is on a sleeve which contains the bowl, whilst the cover and base of the stem have embossed acanthus leaves in relief. By the 1650s these important ceremonial pieces of silver were joined in display on the buffet or table by a plentiful supply of two-handled cups (again embossed with naturalistic foliage derived from Netherlandish patterns), flagons, punch bowls, ewers, wine cups, beakers and tankards. For less alcoholic beverages tea and coffee pots were plentiful as the drinks themselves became popular in the late seventeenth century. Dressing the table, formal or occasional, needed salvers to carry items, bowls of various forms, sugar and sweetmeat boxes, castors, various dishes; sconces and candlesticks to light the domestic scene, and knives, forks and spoons to eat with by their flickering light.

When the King in exile was restored as Charles II in 1660, the growing demands of a court used to the luxuries of those on the Continent gave much employment to the London goldsmiths. John Evelyn's published *Diary* gives many instances of the ostentation: in gold and silver it was the toilet set which epitomised it. Evelyn saw 'her Majesty's rich toylet in her dressing roome, being all of massive gold, presented to her by the King, valued at 4000L'. He also saw Queen Mary II's 'great looking glasse' and toilet of beaten and massive gold at Hampton Court. Two of the best toilet sets of the 1680s are the Calverley service (1683, Victoria and Albert Museum) and the Countess of Kildare's service by David Willaume (1698, Wernher Collection, Luton Hoo). The first comprises thirteen pieces: an oblong mirror, footed salvers, caskets, covered bowls and vases and a pin-cushion, all embossed with a riot of scrolled acanthus and fruit amidst which joyous cherubs romp.

Large toilet services like the Kildare one were considered fashionable wedding presents from a groom to his bride. It has twenty-eight pieces and is one of the larger services to have survived in its entirety. All is in silver-gilt engraved with the Earl of Countess' armorials and complete with monkey supporters, the coronet and the family's motto.

The demand for plate after the Restoration was too great to be met by the bullion available. In 1697 an Act was introduced which set a 'new sterling' or 'Britannia' standard which remained current until 1719 with reversion to the previous standard. The old standard gave a greater hardness to finished articles and guaranteed a longer life.

It was usual in earlier years to attribute to the Huguenot craftsmen who came to England after 1685 'a greater influence on English style than they actually exercised'. Native-born goldsmiths bred on Carolean styles of design and decoration and influenced by the powerful Dutch connexions in the reign of William and Mary were anxious to preserve their livelihoods from immigre rivals. Bold embossed ornament, grotesque forms and chinoiseries

gave way to embossing with vertical flutes, and by the turn of the eighteenth century interlaced strapwork and trelliswork typical of the Régence style in France was common. This was done by casting as 'cut-card work', or by engraving, and owed much to the vast variety of ornamental designs which had helped to create the Louis XIV style, in particular those issued by engravers such as Jean Bérain (1637–1711) and Jean Lepautre (1618–82). Embossing had meant working the metal thin to stretch over the design but the new style was more extravagant in its use of silver and the cast ornament, made and applied separately, added to the overall weight.

It would be as wrong to think that all silver of the 1670s was lavishly embossed as it would to believe that all Huguenot silver was also over-ornamented. English patrons had a taste, long developed, for sober wares of simple design, and those without long purses had in any case to use pewter vessels. These were made from an alloy, chiefly of tin, with varying amounts of copper, lead, antimony or bismuth included, but owed something, in the overall shape, to the silver forms. This demand for plainer wares had been led by the English Royal family who had given most of their orders to English-born goldsmiths. Some of these however, like Francis Garthorne, who worked for William III, adopted the French style, but the King did also patronise the Huguenots, Philip Rollos and Pierre Harache.

Scottish silver was also at its most impressive in the latter half of the seventeenth century. The quaich, a drinking cup with two or more handles, was by that time being made in silver rather than being built up, as earlier, of carved stays or even hollowed from the solid. Foreign influences on Scottish silver were numerous, with the links with the Low Countries marked in the appearance of communion plate, and with Scandinavia in the forms of Restoration period tankards. Only with the union of 1707 was the way opened to English patterns to be adopted easily by Scottish craftsmen.

Communion silver is perhaps the most important branch of Scottish silver. New types of vessel were demanded by the Reformed church and Presbyterianism required the participation of all communicants at Sacrament. This led to large-bowled cups for use in populous parishes. The beaker type of cup, modelled on German and Dutch secular forms, was also often adapted for church use.

The first mention of the 'Monteith', a form of punch bowl with a scalloped rim, was made by the Oxford antiquary Anthony à Wood in 1683. He noted the introduction of the vessel notched at the brim to let drinking glasses hang there by the foot, so cooling the bowl. It was called after 'a fantastical Scott called Monsieur Monteigh . . . who wore the bottom of his cloake or coate so notched'. Whilst made frequently between about 1685 and 1705 they are rare in Scotland, because the national drink of gentlemen was claret, and that was best done from a wine glass of Venetian or English crystal.

Wrought iron

The use of iron for decorative purposes was virtually non-existent until the early seventeenth century. At that time it became fashionable to erect

balconies on house façades, a trend probably encouraged by Inigo Jones who had seen Renaissance examples in Venice where he is said to have lived for some time, *c*.1601. But at a time when an ecclesiastical need for screens was catered for by joiners and a domestic one (the province of masons) had yet to emerge, development was slow. After the Restoration returning Royalists wanted to assert a fashion for gates, grilles and other iron embellishments, deftly gilded and coloured on the appropriate finials and arms, and the Fire of London in 1666 encouraged a greater use of iron rather than wood in churches and houses.

Little work of the 1660–70 period remains, but in Scotland, untroubled by the Civil War, a local Glamis smith, John Walker, provided the cresting to Glamis Castle in 1673; and the stairs at Raith House, Fife, completed in the mid 1690s to a design of James Smith, are as good as anything in England, naturalistic in style, with flowing tendrils. This style compares to the more restrained gates to Ham House, Surrey, erected in 1671 to the designs of the Scottish architect, Sir William Bruce.

It is recorded in the painter's bill of 1673 that the gates were painted blue and partly gilded. Three further gateways on the south and east sides were erected in 1675–6, and two still retain their imposing wrought iron gates; one has the Tollemache coat of arms and motto in the overthrow.

Wrought-iron rails were a conspicuous feature of French architecture, and the French smith, Jean Tijou (whose *A New Booke of Drawings . . .* was published in London in 1693) exerted much influence over English metal-working. The book (and the pirated French edition by Louis Fordrin) was a handsome testimony to the Huguenot's skill. With a title-page designed by Tijou's son-in-law, the decorative painter Louis Laguerre (who also worked in England), we can trace the range of his work at Hampton Court, Chatsworth, Derbyshire (where he was first paid in March 1688) and at Burghley House, Nothamptonshire, where he did the Golden Gates in the west tower. The stair balustrade to the Great Stairs at Chatsworth (charged at £250) was all profit to Tijou. He received further sums for the purchase of iron and tools and the payment of his men's wages; even four shillings spent on a gallon of linseed oil for priming the iron. It was, perhaps wisely, his pupil, a local smith from Baslow, John Gardom, who 'produced in the west wing ironwork hardly inferior to his master's'.

It is Tijou's work, under Sir Christopher Wren's direction, at St Paul's Cathedral, London which has given him a lasting fame. He provided gates on the north and south sides of the sanctuary, flanking the altar. He also provided great chains to stabilise the dome structure. His gates are rich with acanthus decoration, are richly gilded and separated one from the other – there are three on both the north and south sides of the Choir – by Corinthian pilasters. He was paid at the rate of 40s. a foot and his work shows a restraint which may indicate Wren's ideas dominating as opposed to the flamboyant *repoussé* work, scrolls and mask faces he introduced in his work at Hampton Court (where he received £2160) or Burghley House.

Thomas Robinson, who later executed the fine gates at New College, Oxford, seems to have worked at St Paul's under Tijou, providing the iron rails to the Morning Prayer Chapel, the cast window for the dome and various chains and girdles to strengthen the structure. He was a typical

representative of the Worshipful Company of Blacksmiths (incorporated in 1325) who enriched churches, colleges and country houses with durable, well-fashioned ironwork. It was a trade well-established by the time Tijou left England in 1712, with smiths such as John Warren (who erected the splendid thirteen bay screen and gates at Denham Place, Buckinghamshire in 1692) showing, like Gardom and Robinson, skills little short of those of the Huguenot master.

Wrought-iron gates, south side of choir, St Paul's Cathedral (c.1698), by Jean Tijou.

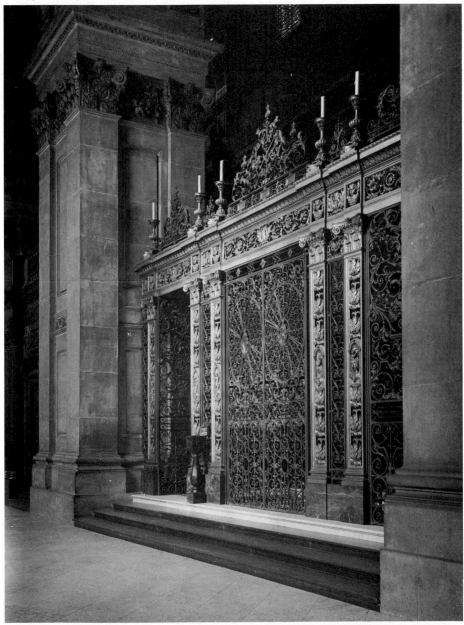

Glass and pottery

In 1615 Admiral Sir Robert Mansell, who was destined to develop the English glass industry on a national scale and control it for the next forty years, joined his activity with that of Sir Edward Zouche who had obtained a patent for melting 'all manner of glasses' in 1611. This had been amended in 1613 to cover 'drinking glasses, broad-glass and other glasses and glasswork'. With Zouche and others Mansell plunged at once into his industrial career. By 1618 he had bought out all his partners and alone held the monopoly, though in the next few years he had to fight hard to maintain it. A 'Statute of Monopolies' in 1624 declared that previous grants were void and only those who had genuinely new inventions could therefore be considered. Mansell was excepted and Lord Dudley was allowed also to melt iron with coal. By careful utilisation of the Staffordshire clay needed to make the glass-melting pots Mansell survived, with glasshouses as far north as Newcastle. He was helped by a ban on the importation of all glass, particularly Venetian, but Mansell had neatly invited Venetians to help in training his English artisans. A renewed patent of 1623 gave him the sole right to make a wide range of drinking glasses, window and looking glasses, bottles '. . . or vessels whatsover'.

When Charles II returned from exile a new spirit was soon apparent. One of the minor acts was a grant in 1664 of a charter to the reformed Worshipful Company of Glass Sellers and Looking-Glass Makers. This could then expand and campaign successfully against glass imports. Mansell had died in 1656 and an early contender for his former leading position was George Villiers, 2nd Duke of Buckingham (1628–87). With technical help he was soon involved in making 'rock-crystal glass', procuring patents and securing any rival licence. The Duke's glass was good and well blown. John Evelyn visited the Vauxhall glasshouse in 1676 and wrote appreciatively of the 'huge vessels of mettal as clear, ponderous and thick as chrystal'.

As Buckingham's patents lapsed technical advances in ordinary glass manufacture in England were being made by George Ravenscroft at his Savoy and Henley glasshouses, where he introduced both Italian glass-makers as his assistants, and, within his mix, lead oxide to reduce crizzling. He experimented with the proportions to give a crystal which combined strength, tractability and above all else, clarity. By 1677 he felt able to announce in the *London Gazette* 'no crizzling or money returned'. However, Ravenscroft did not understand or overcome the problem of the crizzling (or minor crazing of the surface) caused by leaving too high a proportion of alkali and lime in the mix. It was Ravenscroft's successor Hawley Bishop who by increasing the lead content at the expense of silica made a stable, durable glass available at the reopened Savoy glasshouse. The advantages of Bishop's new technique meant that an ever-increasing demand placed English glasshouses in a position to rival Venice. This was a little ironic in that it was an Italian, Jacob Verzelini, who had obtained from Queen Elizabeth I in 1575 the sole privilege of making glass in London in the Venetian style. Examples after 1685 are therefore the first of English glass which can be represented moderately easily in a collection.

In 1671 John Dwight of Fulham was granted a patent for using a salt glaze on stoneware. He was following a long line of unsuccessful experimenters and indeed proceeded against several potters in 1693–4 when they tried to infringe his patent (1684). Dominant in the action were John and David Elers, also of Fulham, and they moved, eventually, to Staffordshire to continue production of red stonewares based on imported Chinese pots. The Elers were Dutch born and also had experience as silversmiths. This led them to be efficient in the use of the lathe for ridding an object of excess clay and they understood, better than most, working in gold, with enamel colours and with moulded elements made in metal dies. Their combination of experimental and practical production advanced North Staffordshire as a place of pottery manufacture.

Another contemporary development was that of 'slipware', in which white liquid clay was trailed over the natural red or brown body. It reached a high degree of decorative sophistication during the reign of Charles II, especially in the large dishes produced in the 1670s by Thomas and Ralph Toft and Ralph Simpson. However, much of what William III and Queen Mary used at Hampton Court was either Dutch Delft made in the factory of Adriaen Kocks in blue and white, or inspired by that. The elaborate tulip vases and orange tree pots catered for the fascination with collecting botanical specimens, and this soon led to the English factories at Lambeth and Bristol copying the blue and white Dutch originals. (There is a good collection at Dyrham Park, Wiltshire).

Ravenscroft-style glass (c.1680), containing lead oxide to reduce crizzling, or surface crazing.

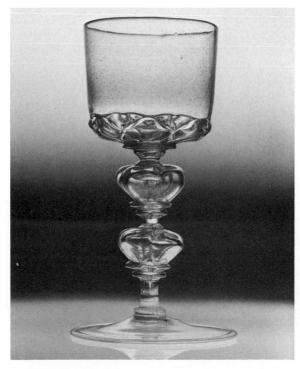

Bookbindings

There is only space to mention a handful of bookbinders to represent this minor but attractive applied art.

John Bill's name appears in each of the imprints of five dedication copies of works presented to James I, two of them rich in gilt white vellum. His binding of Jacques de Charron's *Histoire Universelle* (Paris, 1621; British Library) is rich in olive morocco, gold-tooled with the Royal Arms surrounded by fleur-de-lys and thistles and with a wide border built up with small tools as a precise gilded surround.

At Little Gidding, Nicholas Ferrar and his nieces bound up the 'Harmonies of the Gospels' and various other books of the Bible in the 1630–40 period in gold-tooled velvet, morocco or vellum. The Harmonies, called 'Concordances', are now scattered. The Hervey Concordance (No

Tooled leather bookbinding by Samuel Mearne (1669), for Charles II.

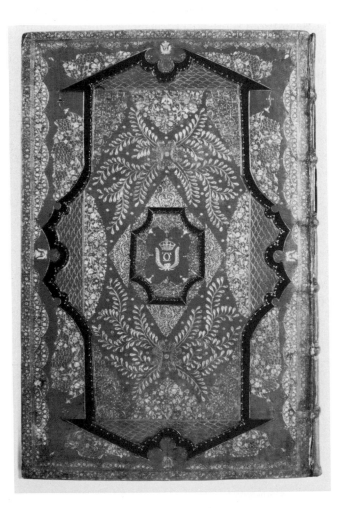

VIII) is preserved at the National Trust house of Ickworth, and the Gaussen volume (No IX) is in the Royal Library at Windsor. In the *Acta Apostolorum* and *The Revelation of St John the Divine*, the text cut from a Bible was pasted onto blank leaves and was additionally illustrated with engravings at Little Gidding, *c.*1635–40 (now in the British Library). It is bound in gold-tooled black morocco and owes something to the instruction given to the community by a Cambridge bookbinder's daughter, Katharine Moody, herself skilled in the craft. However, the elaborate design of small black diamonds with a stylised floral border owes more to London ideas of design than those current in Cambridge.

Four different shops produced the twenty-eight extant bindings of the Queens' Binder. The red morocco panel of Charles II's *Articles to Establish Good Government and Order in our Court*, signed by the King (British Library), has a splendid ribbon pattern, similar to the so-called 'cottage' bindings by Samuel Mearne in that the gold-tooled decoration resembles a cottage roof. The prayer-book Mearne bound for Charles II is one of his royal bindings now held in the British Library. The book is bound in close-grained red morocco with an inset fillet of black leather, with tooled gables at the top and bottom. A golden fish-scale pattern fills the interior spaces formed by these gables, while the whole of the red ground of the leather is ornamented with tooled gilding. Another lavish binding is in orange morocco, with gold toolwork and no fillet, but patterns of a golden lily, silver six-petalled flowers and silver tulips.

Mearne's all-over style consists of panels filled with sprays and arabesques – splendid on blue leather – with little inlays of yellow leather on the knots. Some of Mearne's other bindings are as crowded in pattern as a Persian carpet. One, for example, bound for Charles II, is of red morocco inlaid with black and yellow. The central polygonal-shaped panel is of black leather, dotted with gold filigree in the midst of which is the Royal Arms, within the Garter. Bunches of grapes outline the oval and beyond them are corner pieces in pale yellow leather. Sir Sacheverall Sitwell has described Mearne as a supreme artist 'who was as much a mannerist as Aubrey Beardsley': imaginative, creating bindings of lasting quality by superlative workmanship, and raising English bookbinding to a level where it could stand against the earlier riches of sixteenth century bindings for the great French collector, Jean Grolier, or those created by King Henry's Binder.

Part III
Appendix: Further Reading and Artists' Biographies

MARTIN BUTLER

Contents

Introduction

Given the confines of space, what follows is a tiny sampling from some of the most authoritative or most accessible books in these fields. Asterisks have been placed against a few books which include particularly helpful bibliographies of their own. There are also detailed listings of relevant literature for most of the arts in *The Age of Milton*, eds. C.A. Patrides and R.B. Waddington (Manchester, 1980). Also included in the relevant sections are short biographies of some of the major artists of the age.

In the Music section, the abbreviation *MB* refers to the series *Musica Britannica*; in the bibliographies of architects the abbreviations *Tipping* and *ECH* denotes references to the *English Country House* volumes edited by H.A. Tipping (1922–27, 1929) and by J. Lees-Milne, O. Hill and J. Cornforth (1966, 1970), full details of which are given in the section on 'The Gentry House'; and for *CL* read *Country Life*. Unless otherwise indicated, the place of publication is London.

For considerably more detailed bibliographies see the hardcover edition of this volume, published under the series title *The Cambridge Guide to the Arts in Britain*.

1 The Cultural and Social Setting

Society and politics

Ashton, R., *Reformation to Revolution, 1558–1660* (1984)
Hill, C., *The Century of Revolution 1603–1714* (2nd edn, 1980)

*Hirst, D., *Authority and Conflict: England 1603–1658* (1986)

Houlbrooke, R., *The English Family 1450–1700* (1984)

*Jones, J.R., *Country and Court: England 1658–1714* (1978)

Kamen, H., *The Iron Century: Social Change in Europe 1550–1660* (1971)

Kenyon, J.P., *Stuart England* (Harmondsworth, 1978)

Laslett, P., *The World We Have Lost* (rev. 1983)

Pennington, D.H., *Seventeenth-Century Europe* (Harlow, 1970)

Roots, I., *The Great Rebellion 1642–60* (1966)

Russell, C., *Crisis of Parliaments: English History 1509–1660* (Oxford, 1971)

Sharpe, J.A., *Early Modern England: A Social History 1550–1760* (1987)

Slater, M., *Family Life in the 17th Century* (1984)

Spufford, M., *Contrasting Communities: English Villages in the 16th and 17th Centuries* (Cambridge, 1974)

Stone, L., *The Crisis of the Aristocracy* (Oxford, 1965)

Wilson, C., *England's Apprenticeship 1603–1763* (rev. 1985)

Wrightson, K., *English Society 1580–1680* (1982)

Intellectual change

Collinson, P., *The Religion of the Protestants* (Oxford, 1982)

Cressy, D., *Literacy and the Social Order: Reading and Writing in 17th-Century England* (Cambridge, 1980)

Cross, C., *Church and People 1450–1660* (2nd edn, 1979)

Feingold, M., *The Mathematician's Apprenticeship: Science, Universities and Society in England 1560–1640* (Cambridge, 1984)

Hall, A.R., *The Revolution in Science 1500–1750* (rev. 1983)

Hunter, M., *Science and Society in Restoration England* (Cambridge, 1981)

Hill, C., *Society and Puritanism in Pre Revolutionary England* (1964)
The World Turned Upside Down (2nd edn, Harmondsworth, 1975)

Rossi, P., *Francis Bacon: From Magic to Science* (1968)

Thomas, K., *Religion and the Decline of Magic* (1971)

Schochet, G.J., *Patriarchalism in Political Thought* (Oxford, 1975)

Sharp, A., *Political Ideas of the English Civil War* (1983)

Sommerville, J., *Politics and Ideology in England 1603–40* (Harlow, 1986)

Walker, D.P., *The Ancient Theology: Studies in Christian Platonism from the 15th to the 18th Centuries* (1972)

Watkins, O.C., *The Puritan Experience* (1972)

Webster, C., *The Great Instauration: Science, Medicine and Reform 1626–1660* (1975)

The court, patronage and collecting

Akrigg, G.P.V., *Jacobean Pageant: or The Court of King James I* (Cambridge, Mass., 1962)

Dickens, A.G. (ed.), *The Courts of Europe: Politics, Patronage and Royalty 1400–1800* (1977)

Ede, M., *Artists and Society in England under William and Mary* (1977)

Foss, M., *The Age of Patronage: The Arts in Society 1660–1750* (1971)

Howarth, D., *Lord Arundel and his Circle* (New Haven, 1985)

Impey, O. and MacGregor, A. (eds), *The Origin of Museums: The Cabinet of Curiosities in 16th and 17th Century Europe* (Oxford, 1985)

Jackson-Stops, G., *The Treasure-Houses of Great Britain* (1985)

Millar, O., *The Queen's Pictures* (1977)
The Tudor, Stuart, and Early Georgian Pictures in the Collection of Her Majesty the Queen (2 vols, 1963)

Orgel, S. and Fytch Little, G. (eds), *Patronage in the Renaissance* (Princeton, 1981)

Parry, G., *The Golden Age Restor'd: The Culture of the Stuart Court 1603–42* (Manchester, 1981)

Smuts, R.M., *Court Culture and the Origins of a Royalist Tradition in Early Stuart England* (Philadelphia, 1987)

Strong, R., *Prince Henry and England's Lost Renaissance* (1986)
Splendour at Court: Renaissance Spectacle and the Theatre of Power (1973)

Trevor-Roper, H.R., *The Plunder of the Arts in the 17th Century* (1970)
Princes and Artists: Patronage and Ideology at Four Habsburg Courts 1517–1633 (1976)

Vertue, G.R., *A Catalogue of the Collection of Pictures &c Belonging to King James II* (1758)
A Catalogue and Description of King Charles I's Capital Collection of Pictures (1757)
The Notebooks of George Vertue Relating to Artists and Collections in England,

Walpole Society 18 (1929–30), 20 (1931–2), 22 (1933–4), 24 (1935–6), 26 (1937–8), 29 (1940–2) and 30 (1948–50)

2 Applied and Decorative Arts

Bookbinding

[Bodleian Library,] *Fine Bindings 1500–1700 from Oxford Libraries* (Oxford, 1968)

Davenport, C., *Samuel Mearne, Binder to King Charles II* (1906)

Nixon, H.M., *English Restoration Bookbindings* (1974)

Clocks

Bird, A., *English House Clocks 1600–1850* (1977)

Britton, F. and Baillie, G.H., *Old Clocks and Watches and their Makers* (9th edn, 1982)

Lee, R.A., *The Knibb Family, Clockmakers* (Byfleet, 1964)

Robinson, T., *The Longcase Clock* (Woodbridge, 1982)

Symonds, R.W., *Thomas Tompion: His Life and Work* (1951)

Furniture

Beard, G.W., *The National Trust Book of English Furniture* (Harmondsworth, 1985)

Beard, G.W. and Gilbert, C. (eds), *The Dictionary of English Furniture Makers 1660–1840* (Leeds, 1986)

Beard, G.W. and Goodison, J., *English Furniture 1500–1840* (Oxford, 1987)

Fastnedge, R., *English Furniture Styles from 1500 to 1830* (Harmondsworth, 1967)

Gilbert, C. and Walton, K. (eds), *English Furniture Upholstery 1660–1840* (Leeds, 1973)

Jourdain, M., *Stuart Furniture at Knole* (1952)

MacQuoid, P. and Edwards, R., *The Dictionary of English Furniture* (rev. edn, 3 vols, 1954)

Symonds, R.W., *Furniture Making in 17th and 18th-Century England* (1955)

Wills, G., *English Furniture 1550–1760* (1971)

Glass

Charleston, R.J., *English Glass* (1968)

Godfrey, E.S., *The Development of English Glassmaking 1560–1640* (Oxford, 1975)

Thorpe, W.A., *A History of English and Irish Glass* (repr. 1971)

Gold, silver and jewellery

Evans, J., *A History of Jewellery 1100–1870* (2nd edn, 1970)

Glanville, P., *Tudor and Stuart Silver: Catalogue of the National Collection in the Victoria and Albert Museum* (1988)

Hayward, J.F., *Huguenot Silver in England 1688–1727* (1959)

Heal, A., *The London Goldsmiths 1200–1800* (1935)

Oman, C.C., *British Rings 800–1914* (1974) *Caroline Silver 1625–1688* (1970) *English Domestic Silver* (7th edn, 1968) *English Engraved Silver* (1978)

Interior decoration

Beard, G.W., *Decorative Plasterwork in Great Britain* (1975) *Craftsmen and Interior Decoration in England 1660–1820* (Edinburgh, 1981)

Bullock, A.E., *Grinling Gibbons and his Compeers* (1914)

Gloag, J.E., *Georgian Grace: A Social History of Design 1660–1830* (1956)

Jourdain, M., *English Interior Decoration 1500–1830* (1950)

Thornton, P.K., *Authentic Decor: The Domestic Interior 1620–1920* (1978) *Seventeenth-Century Interior Decoration in England, France and Holland* (1978)

Thornton, P.K. and Tomlin, M.F., *The Furnishing and Decoration of Ham House* (1980)

Ironwork

Harris, J., *English Decorative Ironwork 1610–1836* (1960)

Hoever, O., *Handbook of Wrought Ironwork from the Middle Ages to the End of the 18th Century* (1962)

Lister, R., *Decorative Cast Ironwork in Great Britain* (1960) *Decorative Wrought Ironwork in Great Britain* (1957)

Pottery and porcelain

Britton, F., *London Delftware* (1987)

Cooper, R.G., *English Slipware Dishes 1650–1850* (1968)

Haggar, R.G., *English Pottery Figures 1660–1860* (1947)

Lane, A., *A Guide to the Collection of Tiles* (V&A, 1960)

Lipski, L.L. and Archer, M., *Dated English Delftware: Tin-Glazed Earthenware 1600–1800* (1984)

Textiles

Bunt, C.G.E., *Tudor and Stuart Fabrics*
(1969)

Cumming, V., *A Visual History of Costume:
The 17th Century* (1984)

Kendrick, A.F., *English Needlework* (rev. P.
Wardle, 1967)

Levey, S.M., *Lace: A History* (1983)

Nevinson, J.L., *Catalogue of English
Domestic Embroidery of the 16th and
17th Centuries* (V&A, 2nd edn, 1950)

Tattersall, C.E.C., *A History of British
Carpets* (rev. S. Reed, Leigh-on-Sea,
1966)

Thomson, W.G., *A History of Tapestry*
(3rd edn, 1973)

Wardle, P., *Guide to English Embroidery*
(V&A, 1970)

Gibbons, Grinling (1648–1721)
Born Rotterdam, father a London citizen.
'Discovered' by John Evelyn at Deptford,
1671; appointed Master Carver in Wood to
Charles II. Working at Windsor, 1677–82;
Trinity Library, Cambridge, 1689–90;
Trinity Chapel, Oxford, 1691; St Paul's
Cathedral choir 1694–7; Hampton Court
1691–1710. Last dated work 1710; a master
warden of the Drapers' Company 1712–15.

Green, D., *Grinling Gibbons, His Work as a
Carver and Statuary* (1964)

Tipping, H.A., *Grinling Gibbons and the
Woodwork of his Age* (1914)

Whinney, M., *Grinling Gibbons in
Cambridge* (Cambridge, 1948)

3 Architecture

General

Airs, M., *The Buildings of Britain: Tudor
and Jacobean* (1982)

*Colvin, H.M., *Biographical Dictionary of
British Architects 1600–1840* (rev. 1978)
(gen. ed.), *The History of the King's
Works*, vols 3–5 (1976–82)

Downes, K., *English Baroque Architecture*
(1966)

Dutton, R., *The Age of Wren* (1951)

Harris, J., *The Palladians* (1981)

Jenkins, F., *Architect and Patron* (1961)

Kaye, B., *The Development of the
Architectural Profession in Britain*
(1960)

Knoop, D. and Jones, G.P., *The London
Mason in the 17th Century* (1935)

Lees-Milne, J.A., *The Age of Inigo Jones*
(1953)

Mercer, E., *English Art 1553–1625* (Oxford,
1957)

Morris, R., *The Buildings of Britain: Stuart
and Baroque* (1982)

Pevsner, N. (ed.), *The Buildings of England*
(46 vols, Harmondsworth, 1951–74;
revision in progress)

Summerson, J., *Architecture in Britain
1530–1830* (6th edn, Harmondsworth,
1977)

Wittkower, R., *Palladio and English
Palladianism* (New York, 1974)

The Gentry House

Airs, M., *The Making of the English
Country House 1500–1640* (1975)

Colvin, H.M. and Harris, J. (eds), *The
Country Seat: Studies in the History of
the Country House* (1969)

Girouard, M., *Life in the English Country
House* (New Haven, 1978)

Harris, J., *The Design of the English Country
House 1620–1920* (1985)

Hill, O. and Cornforth, J., *English Country
Houses: Caroline 1625–85* (1966)

Jackson-Stops, G. and Pipkin, J., *The
English Country House: A Grand Tour*
(1985)

Lees-Milne, J., *English Country Houses:
Baroque 1685–1715* (1970)

Summerson, J. (ed.), *The Book of
Architecture of John Thorpe, Walpole
Society*, **40** (1966)

Tipping, H.A. (ed.), *English Homes, Period
III: 1588–1649* (2 vols, 1922–7) and
Period IV: 1649–1714 (2 vols, 1929)

Other

Brunskill, R.W. and Clifton-Taylor, A.,
English Brickwork (1977)

Cave, L.F., *The Smaller English House*
(1981)

Hay, G., *The Architecture of Scottish
Post-Reformation Churches* (Oxford,
1957)

Lang, J., *Rebuilding St Paul's* (1956)

Mercer, E., *English Vernacular Houses*
(1975)

Spiers, W.L. (ed.), *The Notebook and
Account Book of Nicholas Stone,
Walpole Society*, **7** (1918–19)

Whiffen, M., *Stuart and Georgian Churches
Outside London* (1947–8)

Wood-Jones, R.B., *Traditional Domestic
Architecture of the Banbury Region*
(Manchester, 1963)

Architects

Bruce, Sir William (c.1630–1710)
Younger son of Perthshire laird. Involved
in negotiations for the Restoration, 1659?

Obtained court offices from Charles II; baronet 1668; Scottish customs farmer 1672. Surveyor-General in Scotland, 1671–8; remodelled Holyrood House. Retired from public life on Charles's death; as a gentleman architect pioneered the gentry style in Scottish country houses.

Dunbar, J.G., 'Kinross House', in *The Country Seat* (ed. H.M. Colvin and J. Harris, 1969)
Sir William Bruce 1630–1710 (Edinburgh, 1970)
Fenwick, H., *Architect Royal* (Kineton, 1970)

Hooke, Robert (1635–1703)
Son of curate. At Oxford, 1658, developed scientific interests which led to long association with the Royal Society. Gresham professor of geometry, 1665. As a surveyor for rebuilding London, 1666, was responsible for the Monument, Bethlehem Hospital and the Merchant Taylors' School. Surveyor to the Dean and Chapter of Westminster, 1691–7.

Espinasse, M., *Robert Hooke* (1956)
Hussey, C., 'Ramsbury Manor, Wiltshire', *CL* **130** (1961), 1376–80, 1526–9, 1580–3
Robinson, H.W. and Adams, W., *The Diary of Robert Hooke* (1935)
Wren Society, 20 vols (1927–43), passim

Jones, Inigo (1573–1652)
Son of London clothworker. Early visit to Italy (with Earl of Rutland?). First of numerous designs for court masques, 1605. Surveyor to Prince Henry, 1610. Second Italian journey (with Arundel), 1613–14; met Scamozzi. As Surveyor-General of King's Works responsible for major royal building 1615–43, and Covent Garden church and piazza. With Charles in Yorkshire 1642. Captured at siege of Basing House, 1645, and fined as a malignant.

Allsopp, B. (ed.), *Inigo Jones on Palladio* (facsimile of Jones's copy of Palladio, 2 vols, Newcastle-upon-Tyne, 1970)
Colvin, H.M. *et al, Inigo Jones and the Spread of Classicism* (The Georgian Group, 1987)
Fosco, A.C., *Inigo Jones, Vitruvius Britannicus* (1985)
Harris, J., 'Inigo Jones and the courtier style', *Architectural Review* **154** (1973), 17–24
Orgel, S., Strong, R. and Harris, J., *The King's Arcadia: Inigo Jones and the Stuart Court* (1973)
Palme, P., *Triumph of Peace: A Study of the*

Whitehall Banqueting House (Stockholm, 1956)
Summerson, J., *Inigo Jones* (Harmondsworth, 1966)
See also **8 Masques and Pageants**

May, Hugh (1621–84)
Son of Sussex gentleman. Servant to Duke of Buckingham; with the exiled court, 1656. Paymaster of the King's Works, 1660; Comptroller, 1669; Comptroller of the works at Windsor, 1673. Surviving works are mainly country houses.

Briton, J., *Cassiobury Park* (1837)
Hope, W.H.St J., *Windsor Castle* (2 vols, 1913)
Hussey, C., 'Cornbury Park, Oxfordshire', *CL* **108** (1950), 922–6
See also *ECH: Caroline*, 131–6 (Cornbury Park) and 150–4 (Eltham Lodge)

Mills, Peter (1598–1670)
Son of Sussex tailor; apprenticed to bricklayer, 1613. Bricklayer to city of London, 1643. Master of Tylers' and Bricklayers' Company, 1649–60. Collaborated on coronation arches, 1661. Supervised staking-out of streets after Great Fire. Surveyor to Christ's Hospital, 1667–8.

Colvin, H.M. and Harris, J., *The Country Seat* (1969), 42–7
Godfrey, W.H. (ed.), *The Survey of Building Sites in the City of London after the Great Fire (London Topographical Society*, 1946, 1956)
Reddaway, T.F., *The Rebuilding of London* (repr. 1951)
See also *ECH: Caroline*, 102–10 and Tipping, Period IV vol. 1, 23–52 (Thorpe Hall)

Pratt, Sir Roger (1620–85)
Gentleman amateur architect. Oxford, 1637; Inner Temple 1639. Touring abroad, 1643–9. Houses date mainly from 1660s; one of three royal commissioners for rebuilding London, 1666. Knighted 1668. Plans for palace for Duke of York, *c*.1672 (unexecuted).

Gunther, R.T., *The Architecture of Sir Roger Pratt* (Oxford, 1928)
Oswald, A.R., *Country Houses of Dorset* (1959)
Silcox-Crewe, N., 'Sir Roger Pratt 1620–1685', in R. Brown (ed.), *The Architectural Outsiders* (1985), 1–20
See also *ECH: Caroline*, 90–6 and Tipping, Period IV vol. 1, 1–22 (Coleshill)

Talman, William (1650–1719)
Younger son of Wiltshire gentleman. King's waiter in the port of London, 1678. As

Comptroller of Works from 1689, working mainly at Hampton Court. Quarrelled with Wren and several aristocratic patrons; dismissed 1702. Leading Whig architect of 1680s and 90s, but overtaken by Vanbrugh.

Girouard, M., 'Dyrham Park', *CL* 122 (1962)

Harris, J., 'The Hampton Court trianon designs of William and John Talman', *JWCI* 23 (1960) 139–449

'Thoresby House, Notts', *Architectural History* 4 (1961), 11–22, and 6 (1963), 103–5

William Talman, Maverick Architect (1982)

Whinney, M., 'William Talman', *Journal of the Warburg and Courtauld Institute* 18 (1955), 123–39

See also *ECH: Baroque*, 70–84 (Chatsworth), 85–94 (Dyrham Park) and 95–102 (Drayton House); and Tipping, Period IV, vol. 1, 313–50 (Chatsworth) and 351–62 (Dyrham Park)

Webb, John (1611–72)
Born London. Merchant Taylors' School, 1625; successively pupil and assistant to Jones, 1628–43. With royalists at Beverley, 1643; attended the King at Carisbrooke with designs for additions to Whitehall. Failed to be appointed Surveyor, 1660; working at Greenwich (King Charles II block) and Woolwich, 1663–6. Stage designs for Davenant's *Mustapha*, 1666.

Colvin, H.M., 'The South front of Wilton House', *Archaeological Journal* 111 (1954), 181–90

Eisenthal, E., 'John Webb's reconstruction of the ancient house', *Architectural History* 28 (1985), 6–31

Nares, G., 'The Vyne, Hampshire', *CL* 121 (1957), 16–19

Oswald, A., 'Lamport Hall, Northamptonshire', *CL* 112 (1952), 932–5, 1022–5, 1106–9

Whinney, M., 'John Webb's drawings for Whitehall palace', *Walpole Society* 31 (1942–3), 45–107

See also *ECH: Caroline*, 75–89 (Wilton) and 97–101 (Lamport Hall)

Winde, Captain William (d.1722)
Member of family of Norfolk royalists (father in exile 1647–58). Gentleman usher to Queen Elizabeth of Bohemia, 1661. Career as cavalry officer, 1667–88, but left when passed over for promotion. Earliest architectural work at Hampstead Marshall, 1662; also worked as landscapist. FRS 1662–85; wrote (unpublished) work on mathematics, military architecture and cartography.

Beard, G.W., 'Castle Bromwich Hall, Warwickshire', *CL* 111 (1952), 1408–11

'William Winde and interior design', *Architectural History* 27 (1984), 150–62

Colvin, H.M, 'Letters and papers relating to the rebuilding of Combe Abbey, Warwickshire 1681–8', *Walpole Society* 50 (1984), 248–309

Cornforth, J., 'The Sheffields at Buckingham House', *CL* 132 (1962), 86–8

See also *ECH: Caroline*, 137–49 and Tipping, Period IV vol. 1, 155–78 (Combe Abbey); and 4 **Belton House**

Wren, Sir Christopher (1632–1723)
Born Wiltshire, of High Church family. At Wadham College, Oxford (1649) and All Soul's (1653) earned early reputation as scientist. Professor of astronomy at Gresham College, 1657, and Oxford, 1661–73. First architectural designs, 1663. After Great Fire, primarily responsible for new city churches and St Paul's cathedral. Surveyor-General of King's Works 1669; Comptroller at Windsor, 1684, and Greenwich, 1696. President of the Royal Society, 1681–3; MP 1685 and 1701. Dismissed from the Works, 1718, though remained surveyor of St Paul's and Westminster Abbey.

Beard, G., *The Work of Christopher Wren* (Edinburgh, 1982)

Downes, K., *The Architecture of Wren* (St Albans, 1982)

Furst, V., *The Architecture of Sir Christopher Wren* (1956)

Sekler, E.F., *Wren and his Place in European Architecture* (1956)

Summerson, J., *Sir Christopher Wren* (1953)

Webb, G., *Wren* (1937)

Whinney, M., *Wren* (1971)

Wren, S., *Parentalia, or Memoirs of the Family of the Wrens* (1750)

Wren Society (20 vols, 1927–43)

4 Belton House

Beard, G.W., 'Belton House', *Connoisseur*, 152 (1963), 213–19

Beard, G.W. and Gouge, E., ' "The Beste Master in England" ', *National Trust Studies* (1979)

Cust, E., *The Brownlows of Belton* (*Records of the Cust Family*, 2nd series, 1909)

Jacques, D., *Georgian Gardens* (1983)

Marsden, J., *Belton House, Lincolnshire* (National Trust, 1985)

Triggs, H.I., *A History of Gardening in England, Wales and Scotland* (1902)

Turner, L., *Decorative Plasterwork in Great Britain* (1927)

See also *ECH: Caroline* 193–202; *Tipping Period IV*, vol. 1, 205–28; and **Grinling Gibbons** under **2 Applied and Decorative Arts.**

5 The Bible

Allen, W., *Translating the New Testament Epistles 1604–11* (1977)

Butterworth, C.C., *The Literary Lineage of the King James Bible 1340–1611* (2nd edn, New York, 1971)

The Cambridge History of the Bible (3 vols, Cambridge, 1963–70)

Daiches, D., *The King James Version of the English Bible* (2nd edn, Hamden, Conn., 1968)

Hammond, G., *The Making of the English Bible* (Manchester, 1982)

Opfell, O.S., *The King James Bible Translators* (1972)

Paine, G.S., *The Learned Men* (New York, 1959)

Weigle, L.A., *The English New Testament: From Tyndale to the Revised Standard Version* (New York, 1949)

Westcott, B.F., *As General View of the History of the English Bible* (3rd edn, 1905) [still hardly superseded]

6 Literature and Drama

General

Bredvold, L.I., *The Literature of the Restoration and the 18th Century* (New York, 1962)

Bush, D., *English Literature in the Earlier 17th Century* (rev. edn, Oxford, 1962)

*Ford, B. (ed.), *The New Pelican Guide to English Literature*, vol. III, *From Donne to Marvell* (Harmondsworth, 1982); vol. IV, *From Dryden to Johnson* (Harmondsworth, 1982)

Hobby, E., *Virtue of Necessity* (1987) [women's writing]

Keeble, N.H., *The Literary Culture of Nonconformity in Later 17th-Century England* (Leicester, 1987)

Norbrook, D., *Politics and Poetry in the English Renaissance* (1984)

Parry, G., *Seventeenth-Century Poetry: The Social Context* (1985)

Saunders, J.W., *The Profession of English Letters* (1964)

Sinfield, A., *Protestantism and Literature 1560–1660* (1983)

Spufford, M., *Small Books and Pleasant Histories: Popular Fiction and its Readership* (1981)

Sutherland, J., *English Literature of the Late Seventeenth Century* (Oxford, 1969)

The Restoration Newspaper and its Development (Cambridge, 1986)

Wright, L.B., *Middle Class Culture in Elizabethan England* (repr. New York, 1958)

Drama

Bentley, G.E., *The Profession of Dramatist in Shakespeare's Time* (Princeton, 1970)

*Braunmuller, A.L. and Hattaway, M., *The Cambridge Companion to English Renaissance Drama* (Cambridge, 1990)

Butler, M.H., *Theatre and Crisis 1632–1642* (Cambridge, 1984)

Dollimore, J., *Radical Tragedy* (Brighton, 1984) [Jacobean drama and ideas]

Gibbons, B., *Jacobean City Comedy* (rev. edn, Cambridge, 1980)

Gurr, A., *Playgoing in Shakespeare's London* (Cambridge, 1987)

The Shakespearean Stage 1576–1642 (rev. edn, Cambridge, 1981)

Harbage, A., *Cavalier Drama* (2nd edn, New York, 1964)

Holland, N.N., *The First Modern Comedies* (Cambridge, Mass., 1959)

Hotson, L., *The Commonwealth and Restoration Stage* (Cambridge, Mass., 1928)

Hume, R.D., *The Development of Drama in the Late Seventeenth Century* (Oxford, 1976)

Lever, J.W., *The Tragedy of State* (1971)

McCluskie, K., *Renaissance Dramatists* (1989)

Morgan, F., *The Female Wits: Women Playwrights on the London Stage 1660–1720* (1981)

The Revels History of Drama in English: vol. III, 1576–1616 (ed. C. Leech and T.W. Craik, 1975); vol. IV, 1613–60 (ed. L. Potter, 1981); vol. V, 1660–1750 (ed. T.W. Craik, 1976)

Poetry

Alvarez, A., *The School of Donne* (1961)

Chernaik, W., *The Poetry of Limitation* (New Haven, 1968)

Farley-Hills, D., *The Benevolence of Laughter: Comic Poetry of the Restoration* (1974)

Freeman, R., *English Emblem Books* (1948)

Grundy, J., *The Spenserian Poets* (1969)
Hammond, P.F., *John Oldham and the Renewal of Classical Culture* (Cambridge, 1983)
Hunter, J., *The Metaphysical Poets* (1965)
Lewalski, B.K., *Protestant Poetics and the 17th-Century Lyric* (Princeton, 1979)
Martz, L.L., *The Paradise Within* (New Haven, 1964)
 The Poetry of Meditation (rev. 1962)
Selden, R., *English Verse Satire 1590–1765* (1978)
Summers, J.H., *The Heirs of Donne and Jonson* (1970)
Skelton, R., *The Cavalier Poets* (1970)
Vickers, B.W., *Classical Rhetoric in English Poetry* (1970)

Prose

Boyce, B., *The Theophrastan Character in England* (2nd edn, 1967)
Fish, S., *Self-Consuming Artifacts* (Berkeley, 1972)
Mitchell, W.F., *English Pulpit Oratory from Andrewes to Tillotson* (1932)
Salzman, P. *English Prose Fiction 1558–1700* (Oxford, 1985)
Smith, N., *A Collection of Ranter Writings* (1983)
Webber, J., *The Eloquent 'I': Style and Self in 17th-Century Prose* (1968)
Williamson, G., *The Senecan Amble* (1951)

Authors

Beaumont, Francis (1584–1616)
Born Leicestershire, younger son of Justice of Common Pleas. Oxford, 1597; Inner Temple, 1600. Writing plays for boys' companies, 1605, subsequently in collaboration with John Fletcher (1579–1625; born Rye, son of future bishop of London). After Beaumont's retirement (1613) Fletcher became principal dramatist of the King's Men.

Works of Francis Beaumont and John Fletcher (gen. ed. F. Bowers, in progress, Cambridge, 1966–)
Finkelpearl, P.J., *Court and Country Politics in the Plays of Beaumont and Fletcher* (Princeton, 1990)
Waith, E.M., *The Pattern of Tragicomedy in Beaumont and Fletcher* (New Haven, 1952)
Wallis, L.B., *Fletcher, Beaumont and Company* (New York, 1947)

Browne, Sir Thomas (1605–82)
Born London, son of mercer. Broadgate Hall, Oxford, 1623; MA 1629; MD at

Leyden, 1634. Settled as doctor in Norwich, 1636. Occasional author of philosophical and scientific tracts, including *Religio Medici* (1634–5)

Works (ed. G.L. Keynes, rev. edn, 4 vols, 1964)
Huntley, F.L., *Sir Thomas Browne* (Minnesota, 1962)

Bunyan, John (1628–88)
Born Elstow (Beds.), son of tinker. Followed father's trade. In parliamentary army, 1647. Member of Bedford Baptists, 1653; itinerant preacher. Much writing done when imprisoned for unlicensed preaching, 1660–72. On release, returned to preaching; died in harness.

Miscellaneous Works (gen. ed. R. Sharrock, in progress, Oxford, 1976–)
Hill, C., *A Turbulent Seditious and Factious People: John Bunyan and his Church* (Oxford, 1988)
Kaufmann, U.M., *The Pilgrim's Progress and Traditions in Puritan Meditation* (New Haven, 1966)
Sharrock, R., *John Bunyan* (repr. 1968)

Chapman, George (*c.*1559–1634)
Born near Hitchin; studied at Oxford? Served in Flanders wars? Early association with intellectual circle around Raleigh. Working as dramatist for Henslowe, 1595, and for boys' companies 1600–8. Client of two ill-fated patrons, Prince Henry and the Earl of Somerset; *The Whole Works of Homer*, 1616. Much of life in poverty; later years obscure.

Comedies (ed. A. Holaday and M. Kiernan, Urbana, 1970)
Tragedies (ed. A. Holaday, Urbana, 1987)
Poems (ed. P.B. Bartlett, New York, 1941)
Jacquot, J., *George Chapman* (Paris, 1951) [in French]
MacLure, M., *George Chapman, a Critical Study* (1966)

Congreve, William (1670–1729)
Born Bardsey, W. Yorks; raised in Ireland (father an army officer); Trinity College, Dublin. Middle Temple, 1691. *Incognita* (novel), 1692. Four comedies and a tragedy, 1693–1700; pamphlet war with Jeremy Collier, 1698. Retired from stage and held government sinecures; member of the Kit-Cat club; attached to the Duchess of Marlborough. Buried in Westminster Abbey.

Works (ed. F.W. Bateson, 1930)
Complete Plays (ed. H. Davis, 1967)
Love, H., *William Congreve* (Oxford, 1975)

Novak, M.E., *William Congreve* (New York, 1971)

Taylor, D.C., *William Congreve* (Oxford, 1931) [biography]

Williams, A.L., *An Approach to Congreve* (New Haven, 1979)

Daniel, Samuel (1562–1619)

Born near Taunton, son of music master. Magdalen Hall, Oxford, *c*.1577. Servant to English ambassador to France, 1586; tutor in the Herbert and Clifford families. Two court masques, 1604, 1610; groom of the Queen's Chamber, 1607. Retired to Somerset.

Complete Works (ed. A.B. Grosart, 5 vols, repr. New York, 1963)

Rees, J., *Samuel Daniel* (Liverpool, 1964)

Seronsy, C., *Samuel Daniel* (New York, 1967)

Donne, John (1572–1631)

Son of prosperous London citizen; brought up a Catholic. Oxford, 1584; Lincoln's Inn, 1592. With Essex at Cadiz and the Azores, 1596–7. Secretary to Lord Keeper Egerton, 1596; dismissed after secret marriage to Egerton's ward, 1601. Lived in poverty at Mitcham. Travelled with family of Sir Robert Drury, 1611–12. Ordained, 1615; royal chaplain. Dean of St Paul's, 1621–31.

Complete English Poems (ed. A.J. Smith, Harmondsworth, 1974)

Sermons (ed. G.R. Potter and E.M. Simpson, 10 vols, Berkeley, 1953–62)

Bald, R.C., *John Donne, A Life* (Oxford, 1970)

Carey, J., *John Donne: Life, Mind and Art* (1981)

Roston, M., *The Soul of Wit* (1971)

Stein, A., *John Donne's Lyrics* (Minneapolis, 1962)

Webber, J., *Contrary Music* (Madison, 1963)

Dryden, John (1631–1700)

Born Aldwinkle, Northants; Westminster school; Trinity College, Cambridge. Served Cromwell's chamberlain. *Astraea Redux* 1660 (poem celebrating the Restoration). FRS 1662. Married Lady Elizabeth Howard 1663. Regular work as playwright 1663–81. Poet laureate 1668, historiographer royal 1670, post in the Customs 1683. Political satires in verse 1678–82. Catholic conversion 1686, defended in *The Hind and the Panther* 1687. Lost offices after 1688 revolution. Later career as translator. Buried in Westminster Abbey.

Works (ed. E.N. Hooker *et al.*, 21 vols, in progress, Berkeley, 1956–)

Poems and Fables (ed. J. Kinsley, Oxford, 1958)

Of Dramatic Poesy and Other Essays (ed. G. Watson, 2 vols, 1962)

Frost, W., *Dryden and the Art of Translation* (New Haven, 1955)

Hammond, P., *John Dryden: A Literary Life* (1991)

Harth, P., *Contexts of Dryden's Thought* (Chicago, 1968)

Hughes, D., *Dryden's Heroic Plays* (Lincoln, Ne., 1981)

Hume, R.D., *Dryden's Criticism* (Ithaca, 1970)

Etherege, Sir George (*c*.1635–91)

Son of court office-holder who followed court to France, 1644. Apprenticed by grandfather to a lawyer, 1654. Travelled? Three comedies, 1663–76; one of the court wits. Gentleman of the Privy Chamber, 1668; secretary on mission to Turkey, 1668–71; envoy to Ratisbon, 1685–9. Jacobite exile in France; died at Paris.

Plays (ed. M. Cordner, Cambridge, 1982)

Poems (ed. J. Thorpe, 1963)

Fujimara, T.H., *The Restoration Comedy of Wit* (Princeton, 1952)

Underwood, D., *Etherege and the 17th-Century Comedy of Manners* (New Haven, 1957)

Fletcher, John (1579–1625)
See **Beaumont, Francis**

Ford, John (1586–*c*.1640)

Son of Devonshire gentry; Oxford, 1601; Middle Temple, 1605, where pursued a legal career and acquired literary friendships. Earliest surviving play, 1621; five collaborations with Dekker, 1621–5; major plays *c*.1628–33. Later life obscure.

Works (ed. W. Gifford, rev. A. Dyce, 2nd edn, 3 vols, 1895)

Anderson, D.K., *John Ford* (New York, 1972)

Neill, M. (ed.), *John Ford: Critical Re-Visions* (Cambridge, 1988)

Sergeaunt, M.J., *John Ford* (Oxford, 1935)

Herbert, George (1593–1633)

Born Montgomery Castle; brother of Lord Herbert of Cherbury. Westminster School; Trinity College Cambridge, 1609; fellow 1614. University Orator 1619–27; MP 1624. Abandoned hopes of preferment for the ministry; rector of Bemerton, near Salisbury, 1630.

Works (ed. F.E. Hutchinson, Oxford, 1941)

Charles, A., *A Life of George Herbert* (Ithaca, 1977)

Fish, S., *The Living Temple* (Berkeley, 1978)

Tuve, R., *A Reading of George Herbert* (1952)

Vendler, H., *The Poetry of George Herbert* (Cambridge, Mass., 1975)

Jonson, Ben (1573–1637)
Born Westminster; stepfather a master bricklayer. Westminster school; apprentice bricklayer. Served in Flanders wars; strolling player. Early success with 'humours' plays for boys' companies, 1598–1601; major plays for adult actors, 1603–16. Court masques annually, 1604–25; court pension 1616. Retired from stage 1616–25, but returned after loss of court favour. Stroke 1628: died in some poverty.

Works (ed. C.H. Herford, P. and E. Simpson, 11 vols, Oxford, 1925–52)

Masques (ed. S. Orgel, New Haven, 1969)

Poems (ed. G. Parfitt, Harmondsworth, 1975)

Barish, J.A., *Ben Jonson and the Language of Prose Comedy* (Cambridge, Mass., 1960)

Barton, A., *Ben Jonson, Dramatist* (Cambridge, 1984)

Duncan, D., *Ben Jonson and the Lucianic Tradition* (Cambridge, 1979)

Dutton, R., *Ben Jonson: To the First Folio* (Cambridge, 1983)

Jackson, G.B., *Vision and Judgment in Ben Jonson's Drama* (New Haven, 1968)

Partridge, E.B., *The Broken Compass* (1958) [on Jonson's language]

Peterson, R.S., *Imitation and Praise in the Poems of Ben Jonson* (New Haven, 1981)

Riggs, D., *Ben Jonson: A Life* (Cambridge, Mass., 1989)

See also **8 Masques and Pageants**

Marston, John (1576–1634)
Born Oxfordshire, son of lawyer. Brasenose College, Oxford, 1591–4; Middle Temple, 1595–1609. Plays for boys' companies, 1600–9; major role in 'War of the Theatres', 1601; imprisoned with Jonson over *Eastward Ho* (1605). Ordained, 1609; minister at Christchurch, Hants, 1616–31.

Plays (ed. H.H. Wood, 3 vols, Edinburgh, 1934–9)

Poems (ed. A. Davenport, Liverpool, 1961)

Caputi, A., *John Marston, Satirist* (Ithaca, 1961)

Finkelpearl, P.J., *John Marston of the Middle Temple* (1969)

Marvell, Andrew (1621–78)
Born Hull, son of minister. Trinity College Cambridge, 1638; travelling abroad 1642–6.

Tutor to family of General Fairfax in Yorkshire, 1651–3, and to a ward of Cromwell's, 1653. Assisting Milton as Latin secretary, 1657; MP for Hull 1659–78. Accompanied embassy to Baltic states 1663–5.

Poems and Letters (ed. H.M. Margoliouth, rev. edn, 2 vols, Oxford, 1971)

Chernaik, W.L., *The Poet's Time* (Cambridge, 1983)

Colie, R.L, *My Echoing Song* (Princeton, 1970)

Friedman, D.M., *Marvell's Pastoral Art* (1970)

Hunt, J.D., *Andrew Marvell: His Life and Writings* (1978)

Legouis, P., *Andrew Marvell, Poet, Puritan, Patriot* (Oxford, 1965)

Patterson, A.M., *Marvell and the Civic Crown* (Princeton, 1978)

Wallace, J.M., *Destiny his Choice: The Loyalism of Andrew Marvell* (Cambridge, 1968)

Middleton, Thomas (1570–1627)
Born London, son of moderately prosperous citizen. Queen's College, Oxford, 1598. Pamphleteering, 1597–9; plays for boys' companies, 1602–8; associated with the King's Men from 1615. City pageants most years 1613–26; city chronologer 1621–6. Scandalous success with political satire, *A Game at Chess* (1624).

Works (ed. A.H. Bullen, 8 vols, 1885–6)

Heinemann, M.C., *Puritanism and Theatre* (Cambridge, 1980)

Holmes, D.M., *The Art of Thomas Middleton* (Oxford, 1970)

Schoenbaum, S., *Middleton's Tragedies* (New York, 1955)

Milton, John (1608–74)
Son of prosperous London citizen. St Paul's School; Christ's College, Cambridge, 1625. Studying privately in the country, 1632–8. Travelled to Italy, 1638–9; on return, pamphleteered extensively on political and religious issues. *Poems*, 1645. Latin secretary to Cromwell's government, 1649; series of pamphlets defending the regime, 1649–55. Became blind, 1652. Escaped with nominal imprisonment, 1660. *Paradise Lost* pub. 1667.

Works (ed. F.A. Patterson *et al.*, 20 vols, New York, 1931–40)

Complete Prose Works (ed. D.M. Wolfe *et al.*, New Haven, 1953–74)

Barker, A.E., *Milton and the Puritan Dilemma* (Toronto, 1942)

Burden, D., *The Logical Epic* (1967)

Daiches, D., *John Milton* (rev. 1966)
Empson, W., *Milton's God* (rev. 1965)
Fish, S., *Surprised by Sin: The Reader in 'Paradise Lost'* (Berkeley, 1967)
Hanford, J.H., *A Milton Handbook* (4th edn, 1961)
Hill, C., *Milton and the English Revolution* (1977)
Martz, L.L., *Poet of Exile* (New Haven, 1980)
Parker, W.R., *Milton: A Life* (2 vols, Oxford, 1968) [the standard biography]
Radzinowicz, M.A., *Toward 'Samson Agonistes'* (1978)
Ricks, C., *Milton's Grand Style* (Oxford, 1963)
Summers, J.H., *The Muse's Method* (1962)
Woodhouse, A.S.P., *Heavenly Muse* (Toronto, 1972)

Raleigh, Sir Walter (*c*.1552–1618)
Son of Devonshire gentry; Oriel College, Oxford; fighting on the continent and Ireland, 1569–80; career as courtier, 1579–1603; expeditions to Guiana (1595), Cadiz and the Azores (1596–7); disgraced under James I and imprisoned for alleged treason, 1603–16; began a *History of the World*; executed after failure of expedition to the Orinoco, as a sop to Spain.

Poems (ed. M.C. Latham, 1951)
Selected Writings (ed. G. Hammond, 1984)
Edwards, P., *Sir Walter Ralegh* (1953)
Greenblatt, S.J., *Sir Walter Ralegh: The Renaissance Man and his Roles* (New Haven, 1973)
Strathmann, E., *Sir Walter Ralegh: A Study in Elizabethan Skepticism* (New York, 1951)

Shakespeare, William: see volume 3

Wilmot, John, Earl of Rochester (1647–80)
Born Ditchley, Oxfordshire, succeeded to Earldom 1658. Wadham College, Oxford, 1660; Grand Tour 1661–4. Fought in Dutch Wars, 1665–6. Career as notorious court rake and libertine; converted in last illness by Bishop Burnet.

Poems (ed. K. Walker, Oxford, 1984)
Letters (ed. J. Treglown, Oxford, 1980)
Farley-Hills, D., *Rochester's Poetry* (1978)
Griffin, D.H., *Satires against Man* (Berkeley, 1973)
Treglown, J., *Reconsiderations of Rochester* (Oxford, 1982)

Vaughan, Henry (*c*.1622–95)
Born Newton-by-Usk, Brecknockshire, son of gentleman; Jesus College, Oxford, 1638.

Studied law in London, 1640; returned to Wales, 1642. Fought for the King, 1645. Settled as doctor at Newton-by-Usk, *c*.1650.

Works (ed. A. Rudrum, New Haven, 1976)
Durr, R.A., *On the Mystical Poetry of Henry Vaughan* (Cambridge, Mass., 1962)
Hutchinson, R.E., *Henry Vaughan: A Life and Interpretation* (Oxford, 1947)

Webster, John (*c*.1580–*c*.1634)
Son of wealthy London coachmaker; Middle Temple, 1597; freeman of Merchant Taylors' Company, 1615. Intermittent career as a dramatist: early plays written in collaboration, *c*.1602–5; major tragedies *c*.1609–14; later work mainly collaborative.

Works (ed. F.L. Lucas, 4 vols, rev. 1958)
Bliss, L., *The World's Perspective: John Webster and the Jacobean Drama* (New Brunswick, 1983)
Bogard, T., *The Tragical Satire of John Webster* (Berkeley, 1955)
Bradbrook, M.C., *John Webster, Citizen and Dramatist* (1980)
Forker, C.R., *Skull Beneath the Skin: The Art of John Webster* (Carbondale, Ill., 1986)

Wycherley, William (1641–1716)
Born near Shrewsbury; father a nobleman's steward. In France, 1656–9; Inner Temple, 1659; Oxford, 1660. Military service(?), 1662–5. Four comedies, 1671–4; favoured by Duchess of Cleveland (King's mistress). Army commission, 1672–4; disgraced at court by secret marriage to Countess of Drogheda. Crippled by financial lawsuits; imprisoned for debt 1685–6. In retirement, 1688; deathbed marriage to fortune huntress.

Complete Works (ed. M. Summers, 4 vols, repr. 1965)
Plays (ed. A. Friedman, Oxford, 1979)
Chadwick, W.R., *The Four Plays of William Wycherley* (The Hague, 1979)
Zimbardo, R.Z., *Wycherley's Drama* (New Haven, 1965)

7 London

Beier, A.L. and Finlay, R., *London 1500–1700: The Making of the City* (1986)
Bell, N.G., *The Great Fire of London in 1666* (1920)
Brett-James, N., *The Growth of Stuart London* (1935)
Evelyn, J., *The Diary* (ed. E.S. de Beer, Oxford, 1959)

Finlay, R., *Population and Metropolis: The Demography of London 1580–1650* (Cambridge, 1981)

Glanville, P., *London in Maps* (1972)

Greater London Council, *The Survey of London* (in progress, 42 vols to date, 1909–)

Lillywhite, B., *London Coffee Houses: A Reference Book of Coffee Houses of the 17th, 18th and 19th Centuries* (1963)

Magalotti, L., *Travels of Cosmo III, Grand Duke of Tuscany, through England in the Reign of Charles II* (1821)

Manly, L. (ed.), *London in the Age of Shakespeare* (1986)

Misson, H., *M. Misson's Memoires and Observations on his Travels over England* (trans. H. Ozell, 1719)

Pearce, N., *London's Mansions* (1986)

Pepys, S., *The Diary* (ed. R. Latham and W. Mathews, 11 vols, 1970–83)

Pevsner, N., *The Buildings of England:* vol. 1, The Cities of London and Westminster (3rd edn, rev. B. Cherry, Harmondsworth, 1973); vol. 2, *London Except the City and Westminster* (rev. as 3 vols, in progress, Harmondsworth, 1983–)

Prockter, A. and Taylor, R., *The A-to-Z of Elizabethan London* (London Topographical Society, 1979)

Rasmussen, S.E., *London, the Unique City* (1984)

Reddaway, T.F., *The Rebuilding of London after the Great Fire* (1940)

Stow, J., *A Survey of London* (ed. C.L. Kingsford, 2 vols, Oxford, 1908) [a contemporary view, full of valuable detail]

Ward, E., *The London Spy* (1698) [vignettes of London life]

8 Masques and Pageants

Bergeron, D., *English Civic Pageantry 1558–1642* (1971)

Gordon, D.G., *The Renaissance Imagination* (ed. S. Orgel, 1975)

Kipling, G., *The Triumph of Honour* (Leiden, 1977)

*Lindley, D. (ed.), *The Court Masque* (Manchester, 1984)

Nicoll, A., *Stuart Masques and the Renaissance Stage* (1938)

Orgel, S., *The Jonsonian Masque* (Cambridge, Mass., 1965)
 The Illusion of Power (Berkeley, 1975)

Orgel, S. and Strong, R., *Inigo Jones: The Theatre of the Stuart Court* (2 vols, 1973)

Sabol, A.J. (ed.), *Songs and Dances from the Stuart Masque* (expanded, 1978)

Wells, S. and Spencer, T.J.B. (eds), *A Book of Masques* (Cambridge, 1968)

Welsford, E., *The Court Masque* (Cambridge, 1927)

9 Music

General

Abraham, G. (ed.), *New Oxford History of Music*, vol. IV, *The Age of Humanism 1540–1630* (1968)

Ashbee, A., *Records of English Court Music* (4 vols, in progress, Snodland, 1986–)

Blume, F., *Renaissance and Baroque Music: A Comprehensive Survey* (trans. M.D. Herter Norton, 1967)

Harley, D., *Music in Purcell's London* (1968)

Harman, A. and Milner, A., *Late Renaissance and Baroque Music* (repr. 1969)

Mace, T., *Music's Monument* (1676; facsimile ed. J. Jacquot and A. Souris, Paris, rev. 1966)

Morley, T., *A Plain and Easy Introduction to Practical Music* (1597; ed. R.A. Harman, 2nd edn, 1963)

Price, D.C., *Patrons and Music of the English Renaissance* (Cambridge, 1981)

*Sadie, S. (ed.), *The New Grove Dictionary of Music and Musicians* (20 vols, 1981)

Woodfill, W.L., *Musicians in English Society from Elizabeth to Charles I* (Princeton, 1953)

Instrumental

Abraham, G., *The New Oxford History of Music*, vol. VI, *Concert Music 1630–1750* (Oxford, 1986)

Apel, W., *The History of Keyboard Music to 1700* (Bloomington, Indiana, 1972)

Dart, R.T. and Coates, W. (eds), *Jacobean Consort Music*, MB 9 (rev. 1962)

Hutchings, A., *The Baroque Concerto* (3rd edn, 1978)

Meyer, E.H., *English Chamber Music* (2nd edn, 1982)

Routh, F., *Early English Organ Music from the Middle Ages to 1837* (1973)

Theatre, opera and vocal music

Chan, M., *Music in the Theatre of Ben Jonson* (Oxford, 1980)

Cutts, J.P., *Seventeenth Century Songs and Lyrics* (Reading, 1959)

Day, C.L. and Murrie, E.B., *English Song Books 1651–1702* (2nd edn, Norwood, Penn., 1971)

Dearnley, C., *English Church Music, 1650–1750* (1970)

(ed.), *The Treasury of English Church Music, 1650–1760* (1965)

Dent, E.J., *Foundations of English Opera* (2nd edn, New York, 1965)

Doughtie, E., *English Renaissance Song* (Boston, Mass., 1987)

Fellowes, E.H., *The English School of Lutenist Song-writers* (rev. T. Dart, 1965–69)

The English Madrigal School (rev. T. Dart, 1958–64)

Le Huray, P., *Music and the Reformation in England 1549–1660* (2nd edn, Cambridge, 1978)

(ed.), *The Treasury of English Church Music 1580–1640* (1965)

Lewis, A. and Fortune, N. (eds), *The New Oxford History of Music*, vol. IV, *Opera and Church Music 1630–1750* (Oxford, 1975)

Long, J.H. (ed.), *Music in English Renaissance Drama* (Lexington, 1978)

MacClintock, C.C., *The Solo Song 1580–1730* (New York, 1973)

Manifold, J.S., *The Music in English Drama from Shakespeare to Purcell* (Rockliff, 1956)

McGuinness, R., *English Court Odes 1660–1820* (Oxford, 1971)

Mellers, W., *Harmonious Meeting: A Study of the Relationship Between English Music, Poetry and Theatre c.1600–1900* (1965)

Northcote, S., *Byrd to Britten: A Survey of English Song* (1966)

Price, C.A., *Henry Purcell and the London Stage* (Cambridge, 1984)

Simpson, C.M., *The British Broadside Ballad and its Music* (New Brunswick, 1966)

Spink, I., *English Song: Dowland to Purcell* (1974)

Sternfeld, S.W., *Music in Shakespearean Tragedy* (1963)

Thorp, W. (ed.), *Songs from the Restoration Theatre* (Princeton, 1934)

White, E.W., *The Rise of English Opera* (2nd edn, 1972)

Composers

Blow, John (1649–1708)
Born Newark, of humble origins. Most of career centred on Chapel Royal, as chorister (1660), gentleman and master of the children (1674), organist (1676) and composer (1700). Master of choristers at St Paul's (1687).

Coronation Anthems and Anthems with Strings (ed. A. Lewis and W. Shaw, *MB* 7 [rev. 1969]); *Anthems with Orchestra* (ed. B. Wood, *MB* 50 [1984])

Venus and Adonis (ed. A. Lewis, Paris, 1939)

Complete Organ Works (ed. W. Shaw, 1958)

Six Suites (ed. H. Ferguson, *English Keyboard Music*, 5 [1965])

Amphion Anglicus [songs and odes] (1700; facsimile, New York, 1965)

Campion, Thomas (1567–1620)
Son of London legal official. Cambridge, 1581–4; entered Gray's Inn 1586; (?) military service with Essex, 1591. MD (Caen), 1605. Author of English and Latin poems, and treatises on verse and music. Music for court masques, 1607, 1613. Suspected of complicity in Overbury murder 1615, but exonerated.

Ayres (ed. E.H. Fellowes, *The English School of Lutenist Song-Writers*, 2nd series, 1–2 [rev. edn, 1969], 10–11 [1926])

Works (ed. W.R. Davis, New York, 1967)

Kastendieck, M.M., *England's Musical Poet: Thomas Campion* (rev. edn, New York 1963)

Lindley, D., *Thomas Campion* (Leiden, 1986)

Dowland, John (1563–1626)
Born Westminster(?). Served ambassador to Paris, 1580–4; converted to Catholicism. Much of 1594–1606 spent abroad; lutenist at the Danish court, 1598. Returned in poverty, 1606; with Lord Walden 1609–12. One of the King's lutes, 1612.

Lachrimae (ed. P. Warlock, 1927)

Airs (ed. E.H. Fellowes, *The English Lute-Songs*, rev. T. Dart, 1st series, 1–2, 5–6 and 10–11 [2nd edn 1965–70])

Collected Lute Music (ed. D. Poulton and B. Lam, 1974)

Poulton, D., *John Dowland* (rev. 1982)

Ward, J.M., 'A Dowland miscellany', *Journal of the Lute Society of America* 10 (1977), 5–152

Farnaby, Giles (*c*.1563–1640)
Son of London joiner and keyboard builder. BMus, Oxford 1592. *c*.1602–8 tutor to family of Sir Nicholas Saunderson, near Lincoln. Later life obscure; compositions mostly for keyboards. Died at London.

Keyboard Music (ed. R. Marlow, *MB* 24 [1965])

Canzonets to Four Voices (ed. E.H. Fellowes, *The English Madrigalists* 20 [rev. T. Dart, 1962])

Glyn, M.H., *Elizabethan Virginal Music* (rev. edn, 1934)

Gibbons, Orlando (1583–1625)
Born Oxford, son of one of the city waits. Choir of King's college Cambridge (1596–8), his brother being Master of the Choristers; Gentleman of the Chapel Royal, 1603, probably as an organist. MusB (Cambridge), 1606. Gift of £150 from the King, 1615; one of the King's Musicians for the virginals, 1619. DMus (Oxford), 1622. Organist at Westminster Abbey 1623.

Services and Anthems (ed. P.C. Buck *et al.*, *Tudor Church Music*, IV, 1925)
Keyboard Music (ed. G. Hendrie, *MB* 20 [1962])
Verse Anthems (ed. D. Wulstan, *Early English Church Music*, III [1964])
The First Set of Madrigals and Motets (ed. E.H. Fellowes, *The English Madrigalists* V [rev. T. Dart, 2nd edn, 1964])
Consort Music (ed. J. Harper, *MB* 48 [1982])
Fellowes, E.H., *Orlando Gibbons and his Family* (Oxford, 1925; rev. 1970)

Humfrey, Pelham (1647–74)
Nephew of prominent Cromwellian. Chorister of Chapel Royal; known as composer by 1663. Sent abroad by the King, 1664–7. Gentleman of the Chapel Royal, 1667, and Master of the children, 1672; Warden of the city's Corporation of Music 1672–3.
Complete Church Music (ed. P. Dennison, *MB* 34–5, 1972)
Dennison, P., *Pelham Humfrey* (Oxford, 1987)

Jenkins, John (1592–1678)
Son of Maidstone carpenter. Much of life spent in service of East Anglian families. Performed in *The Triumph of Peace* (1634). Theorbo-player in the King's Music, 1660. Died at Norfolk home of Sir Philip Woodhouse.

Consort Music of Four Parts (ed. A. Ashbee, *MB* 26 [rev. edn 1975]) and *Six Parts* (ed. D. Peart, *MB* 39 [1977])
Consort Music in Five Parts (ed. R. Nicholson [1971])
Fancies and Ayres (ed. H.J. Sleeper, *Wellesley Edition*, 1, 1950)
Three-Part Fancy and Ayre Divisions (ed. R.A. Warner, *Wellesley Edition*, 10 [1966])
Ashbee, A., 'John Jenkins 1592–1678: the viol consort music in four, five and six parts', *Early Music* 6 (1978), 492–500

Lanier, Nicholas (1588–1666)
Son of court musician of French descent. Working for Cecil family 1605–13. Lutenist in the King's music 1616; composed and sang in court masques. Master of the Prince's music, 1618, and of the King's music, 1625. Three visits to Italy, buying pictures for Buckingham, 1625–8. Abroad during the Civil War.

English Songs 1625–1660 (ed. I. Spink, *MB* 33 [1971])
Six Songs (ed. E. Huws Jones, 1976)
A Score for 'Lovers Made Men' (ed. A.J. Sabol, Providence, R.I., 1963)
Duckles, V., 'English song and the challenge of Italian monody', in V. Duckles and F.B. Zimmerman (eds), *Words to Music* (Los Angeles, 1967), 3–42
Emslie, McD., 'Nicholas Lanier's innovations in English song', *Music and Letters*, 41 (1960), 13–27

Lawes, Henry (1596–1662)
Son of lay-vicar of Salisbury cathedral. Gentleman of the Chapel Royal, 1626. Music for court theatricals, Milton's *Comus* (1634) and Davenant's 'operas', 1658. Music tutor to several noble families; wrote 434 songs. Reinstated in Chapel Royal, 1660.

English Songs 1625–1660 (ed. I. Spink, *MB* 33 [1971])
Evans, W.McC., *Henry Lawes, Musician and Friend of Poets* (rev. edn, New York, 1966)
Willetts, P.J., *The Henry Lawes Manuscript* (1969)

Lawes, William (1602–45)
Younger brother of above. Private musician to Prince Charles before 1625. Musician in ordinary for lutes and voices, 1635. Music for theatre and court masques, 1633–40. With the King at Oxford, 1642; killed at siege of Chester.

English Songs 1625–1660 (ed. Spink; see previous entry)
Select Consort Music (ed. M. Lefkowitz, *MB* 21 [2nd edn 1971])
Trois Masques à la Cour de Charles Ier (ed. M. Lefkowitz, Paris, 1970)
Lefkowitz, M., *William Lawes* (1960)

Locke, Matthew (1621/22–77)
Chorister at Exeter cathedral. In Netherlands with Prince Charles, *c.*1648; converted to Catholicism. Living in Herefordshire, 1654. Music for Davenant's 'operas', 1658–9. Composer to the King,

1660. Quarrelled with members of the
Chapel Royal, 1666. Writing for the
playhouses, 1673–6.

Cupid and Death (ed. E.J. Dent, *MB* **2** [rev.
 edn 1965])
Chamber Music (ed. M. Tilmouth, *MB*
 31–2 [1971–2])
Anthems and Motets (ed. P. Le Huray, *MB*
 38 [1976])
Dramatic Music (ed. M. Tilmouth, *MB* **51**
 [1986]
Harding, R.E.M., *A Thematic Catalogue of
 the Works of Matthew Locke* (Oxford,
 1971)

Purcell, Henry (1659–95)
Son of tenor singer. Chorister of Chapel
Royal before 1673. Composer in ordinary
for the violins, 1677. Organist of
Westminster Abbey, 1679, and the Chapel
Royal, 1682. Keeper of the King's
Instruments, 1683. Works include 5
semi-operas, music for 40 plays, 70 anthems
and 250 songs.

The Works of Henry Purcell (Purcell
 Society, 1898–1965; rev. edn in
 progress, 1961–)
Complete Harpsichord Works (ed. H.
 Ferguson, 1964)
Holland, A.K., *Henry Purcell: The English
 Musical Tradition* (2nd edn,
 Harmondsworth, 1948)
Holst, I. (ed.), *Henry Purcell (1659–1695):
 Essays on his Music* (Oxford, 1959)
Lewis, A., *The Language of Purcell* (Hull,
 1968)
Moore, R.E., *Henry Purcell and the
 Restoration Theatre* (1961)
Price, C. (ed.), *Dido and Aeneas, An Opera*
 (New York, 1986) [edition, analysis and
 anthology of criticism]
Westrup, J.A., *Purcell* (4th edn, 1980)
Zimmerman, F.B., *The Anthems of Henry
 Purcell* (New York, 1971)
 Henry Purcell (1967)
 *Henry Purcell, 1659–1695: An Analytical
 Catalogue of His Music* (1963)

Tomkins, Thomas (1572–1656)
Son of vicar-choral of St David's Cathedral.
Instructor of the choristers at Worcester,
1596. Period in 1620s as gentleman and
organist of the Chapel Royal, but later life
spent at Worcester.

Keyboard Music (ed. S.D. Tuttle, *MB* **5**
 [2nd edn 1964])
Songs of 3, 4, 5 and 6 Parts (ed. E.H.
 Fellowes, rev. T. Dart, *The English
 Madrigalists*, 18 [2nd edn 1960])
Musica Deo Sacra (ed. B. Rose, *Early*

English Church Music, vols 5, 9 and 14
 [1965–73])
Stevens, D., *Thomas Tomkins* (2nd edn,
 1967)

Wilbye, John (1574–1638)
Born Diss, Norfolk. Life spent in service to
the Kitson family in Bury St Edmunds,
Colchester and London.

Madrigals (ed. E.H. Fellowes, *The English
 Madrigalists* 6–7 [2nd edn, rev. T.
 Dart, 1966])
Brown, D., *John Wilbye* (1974)

10 The Visual Arts

General

Bazin, G., *Baroque and Rococo* (trans. J.
 Griffin, 1974)
Croft-Murray, E., *Decorative Painting in
 England 1537–1837* (2 vols, 1962)
Ede, M., *Artists and Society in England
 under William and Mary* (1977)
Freidrich, C.J., *The Age of the Baroque*
 (New York, 1952)
Hale, J.R., *England and the Italian
 Renaissance: The Growth of Interest in
 its History and Art* (rev. 1963)
Harris, J., *The Artist and the Country House*
 (1979)
Haskell, F., *Patrons and Painters* (rev. New
 Haven, 1980)
Hook, J., *The Baroque Age in England*
 (1976)
Levey, M., *Painting at Court* (New York,
 1971)
Mercer, E., *English Art 1553–1625* (Oxford,
 1962)
Millar, O., *The Age of Charles I* (1972)
Phillips, J., *The Destruction of Images: The
 Reformation of Art in England
 1535–1660* (Berkeley, 1973)
Tapie, V.-L., *The Age of Grandeur:
 Baroque and Classicism in Europe* (1960)
Waterhouse, E., *Painting in Britain 1530 to
 1790* (2nd edn, Harmondsworth, 1969)
Whinney, M. and Millar, O., *English Art
 1625–1714* (Oxford, 1957)

Miniatures

Foskett, D., *British Portrait Miniatures*
 (1963)
Murdoch, J., *Seventeenth-Century Portrait
 Miniatures in the Collection of the
 Victoria and Albert Museum* (1988)
Murdoch, J., Murrell, V.J., Noon, P.J. and
 Strong, R., *The English Miniature*
 (1981)

Reynolds, G., *English Portrait Miniatures*
(1952) [new edition in progress]
Strong, R., *The English Renaissance
Miniature* (1983)

Portraiture

Collins Baker, C.H., *Lely and the Stuart
Portrait Painters* (2 vols, 1912)
Judson, J.R., *Gerrit van Honthorst* (The
Hague, 1959)
Piper, D., *A Catalogue of 17th-Century
Portraits in the National Portrait
Gallery 1625–1714* (Cambridge, 1963)
Stewart, J.D., *English Portraits of the 17th
and 18th Centuries* (Clark Memorial
Library, California, 1974)
Strong, R., *Tudor and Jacobean Portraits*
(1969)
Talley, M.K., *Portrait Painting in England:
Studies in the Technical Literature
before 1700* (Paul Mellon Center, 1981)

Prints

Corbett, M. and Lightbowne, R., *The
Comely Frontispiece: The Emblematic
Titlepage in England 1550–1660* (1979)
Eerde, K.S. van, *John Ogilby and the Taste
of his Times* (Folkestone, 1976)
Godfrey, R., *Printmaking in Britain*
(Oxford, 1978)
Hodnett, E., *Francis Barlow: First Master
of Book Illustration* (Ilkley, 1978)

Sculpture

Avery, C., *Essays in European Sculpture*
(1981)
Faber, H., *Caius Gabriel Cibber* (Oxford,
1926)
*Gunnis, R., *Dictionary of British Sculptors
1660–1851* (rev. edn, 1968)
Haynes, D.E.L., *The Arundel Marbles*
(Ashmolean Museum, 1975)
Howarth, D., *Lord Arundel and his Circle*
(New Haven, 1985)
Kemp, B., *English Church Monuments*
(1980)
Mercer, E., *English Art 1551–1625* (Oxford,
1962)
Michaelis, A.T.F., *Ancient Marbles in Great
Britain* (trans. C.A.M. Fennel,
Cambridge, 1882) [still important]
Norris, M., *Monumental Brasses* (1978)
Spiers, W.L. (ed.), *The Notebook and
Account Book of Nicholas Stone,
Walpole Society* **7** (1918–19)
Whinney, M., *Sculpture in Britain
1530–1830* (Harmondsworth, 1964)

Artists

Cooper, Samuel (1608 or 1609–72)
Born London; orphaned *c.*1625 and worked
in studio of his uncle, the miniaturist John
Hoskins, near van Dyck in Blackfriars.
Worked abroad, late 1630s? Possibly with
the King at York, 1640. From 1642, the
leading society miniaturist, with studio near
Covent Garden.

Foskett, D., *Samuel Cooper 1609–1672*
(1974)
Samuel Cooper and his Contemporaries
(HMSO, 1974)
Murdoch, J. *et al.*, *The English Miniature*
(1981)
Reynolds, G., *Samuel Cooper's Pocket-Book*
(V&A, 1975)

Cross, Peter (*c.*1646–1724)
Born London, younger son of draper.
Apprenticed to Cooper? Work for Duke of
York, *c.*1678. Leading miniaturist of 1680s
and 90s with fashionable clientele.

Murdoch, J. *et al.*, *The English Miniature*
(1981)

Dobson, William (*c.*1611–46)
Son of petty gentleman, probably a painter
and legal official. Apprentice to William
Peake, *c.*1626. Working in studio of Francis
Cleyn, *c.*1632. Imprisonment (for debt?),
*c.*1641. Joined court at Oxford, 1643.

Rogers, M., *William Dobson 1611–46*
(National Portrait Gallery, 1983)
Vaughan, W., *Endymion Porter and William
Dobson* (Tate Gallery, 1970)

Hollar, Wenceslaus (1607–77)
Born Prague. Producing etchings for
publishers in Germany, 1627–33. Met Earl
of Arundel at Cologne, 1636, and followed
him to London; married member of his
household, 1641. In Netherlands, 1644–52.
Prosecuted for recusancy, 1656. Royal
'Scenographer', 1666; official draughtsman
on Tangier expedition, 1673.

Denkstein, V., *Hollar Drawings* (transl. D.
Orpington, 1979)
Eerde, K.S. van, *Wenceslaus Hollar –
Delineator of his Time* (Charlottesville,
1970)
Griffiths, A. and Kesnerova, G., *Wenceslaus
Hollar: Prints and Drawings* (1983)
Parry, G., *Hollar's England: A
Mid-Seventeenth-Century View*
(Salisbury, 1980)
Parthey, G., *Wenzel Hollar* (Berlin, 1853)
[in German]

Pennington, R., *A Descriptive Catalogue of the Work of Wenceslaus Hollar* (Cambridge, 1982)

Hoskins, John (*c.*1590–1665)
Miniaturist. Head of a busy studio in 1620s and 1630s, which included his nephew, Samuel Cooper; came to specialise in miniature copies after van Dyck. Limner to Charles I; annuity of £200, 1640, but financial difficulties followed the collapse of the court. Died in some poverty. Studio work includes that of his son, John (*c.*1615–*c.*1690).

Kneller, Sir Godfrey (1646–1723)
Born Lubeck; studied with Rembrandt. In Italy, 1672–5. Arrived in England, *c.* 1676. 1684–5 sent by King to France to paint Louis XIV. Appointed principal painter, 1688. Knighted 1692; at signing of Treaty of Rysbrack, 1697. Knight of Holy Roman Empire, 1700; baronet, 1715. Elected governor of a London Academy for Painting, annually 1711–18.

Stewart, J.D., *Sir Godfrey Kneller* (National Portrait Gallery, 1971)
　Sir Godfrey Kneller and the English Baroque Portrait (Oxford, 1983)

Lely, Sir Peter (1618–80)
Son of Dutch infantry captain. Arrived in England from the Hague *c.*1643. Freeman of the Painter-Stainers' Company, 1647; studio in Covent Garden, 1650. Project for paintings commemorating parliament's achievements, 1653. Principal court painter, 1661. Knighted, 1680.

Beckett, R.B., *Lely* (1951)
Collins Baker, C.H., *Lely and the Stuart Portrait Painters* (2 vols, 1912)
Millar, O., *Sir Peter Lely, 1618–80* (National Portrait Gallery, 1978)

Oliver, Isaac (*c.*1565–1617)
Son of Huguenot goldsmith; brought to London 1568. Trained under Hilliard. Visited Low Countries, 1588, and Venice, 1596. Limner to Queen Anne, 1605; patronised by Prince Henry, 1610–12. After his death, his place as leading court miniaturist was taken by his son Peter (*c.*1594–1647), now best known for his miniature copies of Italian paintings in the King's collection.

Edmond, M., *Hilliard and Oliver* (1983)
Murdoch, J. *et al.*, *The English Miniature* (1981)
Strong, R., *The English Renaissance Miniature* (1983)

Rubens, Sir Peter Paul (1577–1640)
Born Westphalia; Master Painter at Antwerp, 1598. In service of the Duke of Mantua, 1600–8; court painter to the Regents of the Netherlands, 1609. Negotiations for pictures with Sir Dudley Carleton (English ambassador at the Hague), 1616–18; pictures sent for Prince Charles, 1621 and 1625. Banqueting House ceiling commissioned during visit to England as ambassador for Anglo-Spanish peace treaty, 1629–30; delivered 1635; paid for 1638.

Millar, O., *Rubens: The Whitehall Ceiling*, (Oxford, 1958)
Palme, P., *Triumph of Peace: A Study of the Whitehall Banqueting House* (Stockholm, 1956)
Strong, R., *Britannia Triumphans: Inigo Jones, Rubens and the Whitehall Palace* (1975)

van Dyck, Sir Anthony (1559–1641)
Son of Antwerp merchant, and pupil of Rubens. First London visit, 1620–1. In Italy, 1621–7, and Antwerp, 1628–32; painter to the Regent of Flanders, 1630. Second London period, 1632–41, as principal painter to Charles I. Further visits to Flanders (1634–5) and Paris (1641); died at London.

Brown, C., *Van Dyck* (Oxford, 1982)
Larsen, E., *L'Opera Completa di Van Dyck* (2 vols, Milan, 1980)
Millar, O., *Van Dyck in England* (National Portrait Gallery, 1982)
Piper, D., *Van Dyck* (1968)
Strong, R., *Van Dyck: Charles I on Horseback* (1972)

van de Velde I, Willem (1611–93) and
van de Velde II, Willem (1633–1707)
Born Leiden, father master of a militia transport vessel. Willem I employed in an official capacity to sketch naval engagements during Anglo-Dutch wars, 1652–4, 1665–7; also in the Baltic 1658. Emigrated to England, 1672; worked with Willem II in studio in the Queen's House, Greenwich; salaried by Charles II and the Duke of York. With English fleet in third Anglo-Dutch war, 1672–3; moved to Westminster 1691.

Robinson, M.S., *Van de Velde Drawings* (2 vols, Cambridge, 1973–4)
The Art of the Van de Veldes (National Maritime Museum, 1982)

Sources of Illustrations

The publishers gratefully acknowledge the help of the many individuals and organisations who cannot be named in collecting the illustrations for this volume. In particular they would like to thank Callie Crees for her help with picture research. Every effort has been made to obtain permission to use copyright materials; the publishers apologise for any errors and omissions and would welcome these being brought to their attention.

2, 40, 109, 111, 126, 137, 161, 198, 238, 241, 306 By permission of the British Library
13, 240 Ashmolean Museum, Oxford
43 Courtesy of University College, London
47 By permission of the Syndics of Cambridge University Library
52, 64, 66, 77r, 83, 98, 286, 287 A.F. Kersting
55 from Oxford Illustrated Dictionary © OUP 1975
57 English Heritage
59, 61, 62l, 75, 77l, 81, 85, 88, 95, 96, 101, 279, 283, 288, 303 Royal Commission on the Historical Monuments of England
62r The British Architectural Library, RIBA, London
68, 167, 169, 173, 176b, 193, 213 Courtesy of the Trustees of the British Museum
70 By courtesy of the Earl of Pembroke, Wilton House
73, 224, 229t, 232t Andor Gomme
86 Conway Library, Courtauld Institute of Art
90 Oxford County Libraries
91 The Warden and Fellows of All Souls College, Oxford
102, 104 Guildhall Library, City of London
113–7 Devonshire Collection, Chatsworth. Reproduced by permission of the Chatsworth Settlement Trustees/Photographic Survey, Courtauld Institute of Art
118 Shakespeare Centre Library, Stratford-upon-Avon
133 G. Wickham, Early English Stages, vol 2, Routledge & Kegan Paul/© Glynne Wickham. Published by Columbia University Press. Used by permission.
164 The Master and Fellows, Magdalene College, Cambridge
166, 168, 172, 176t Museum of London
169 The Worshipful Company of Goldsmiths
170, 175 Edinburgh University Library
178 Tony Bingham
189 National Trust/Kenneth Mobbs

222, 232b, 276, 295 National Trust Photographic Library
225, 226, 229b, 231 National Trust Photographic Library/Graham Challifour
234, 236l, 242, 244, 247, 248t, 255 Reproduced by Gracious Permission of Her Majesty the Queen
236r C. Cottrell-Dormer; photograph: Courtauld Institute of Art
243 The Metropolitan Museum of Art, Gift of Kate T. Davison in memory of her husband, Henry Pomeroy Davison, 1951 [51.194.1]
245 Reproduced by permission of The Huntington Library, San Marino, California (RB 98526)
248b, 253, 293r, 297 By courtesy of the Board of Trustees of the Victoria & Albert Museum
252 In the collection of the Duke of Buccleuch and Queensbury, K.T.
254l Birmingham Museums and Art Gallery
254r, 265 The National Maritime Museum, London
256, 263 National Portrait Gallery, London
266, 268, 273, 274 Conway Library, Courtauld Institute of Art
271 By courtesy of The Marquess of Salisbury/Photographic Survey, Courtauld Institute of Art
284 Geoffrey Beard/photograph by Joseph McKenzie
290 Reproduced by kind permission of His Grace, the Duke of Rutland, C.B.E.
293l National Trust Photographic Library/Horst Kolo
305 Cinzano/Dennis Balmer

Colour Plates

1 Museum of London
2 Crown copyright. Reproduced with the permission of the Controller of Her Majesty's Stationery Office
3 By courtesy of the Board of Trustees of the Victoria & Albert Museum
4 A.F. Kersting
5 Colonial Williamsburg Foundation
6 By courtesy of the Trustees of the Kederminster Library
7, 8 Reproduced by Gracious Permission of Her Majesty the Queen
9, 10 By courtesy of the Board of Trustees of the Victoria & Albert Museum
11 By courtesy of the Earl of Pembroke, Wilton House

Index

Major entries are shown in capital letters.
Individual works are listed under the artist
where known. Page numbers of illustrations are
shown in italics.